PHOTOGRAPHING
FARMWORKERS

in California

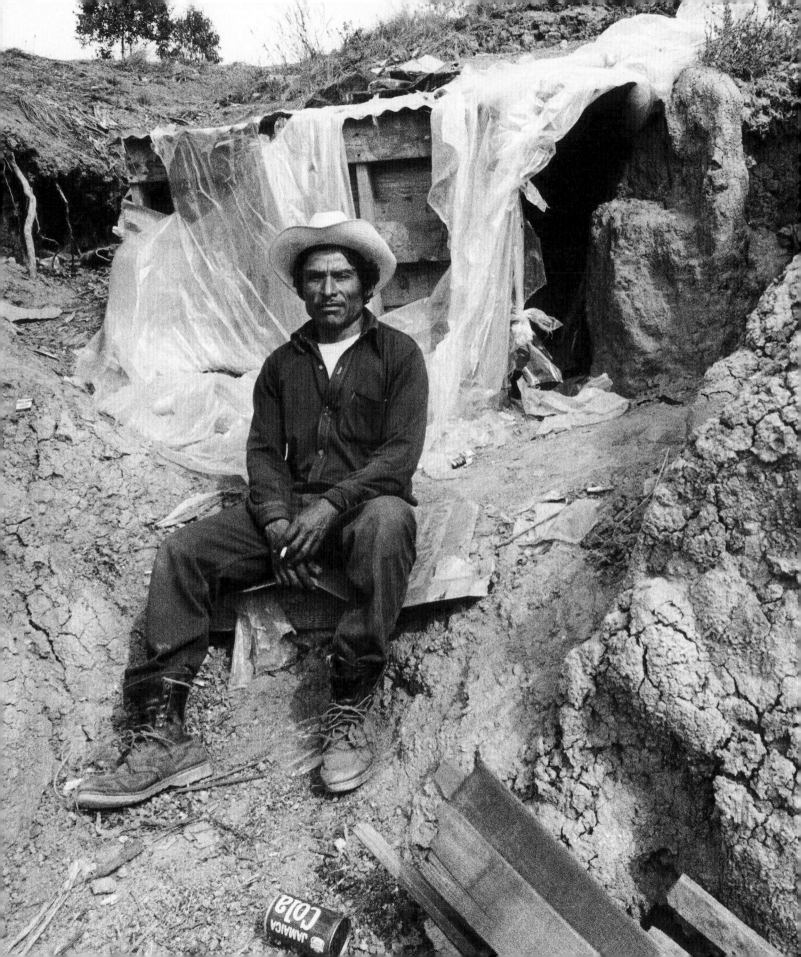

(*left*) Unable to afford housing, undocumented workers live in a cave dug into a hillside while working in the tomato fields near Oceanside in north San Diego County, 1978. Photograph by Roger Minick. Courtesy of Roger Minick.

(*overleaf*) Improvising with what is available, undocumented workers bathe in a plastic-lined tomato bin near Oceanside in north San Diego County, 1978. Photograph by Roger Minick. Courtesy of Roger Minick.

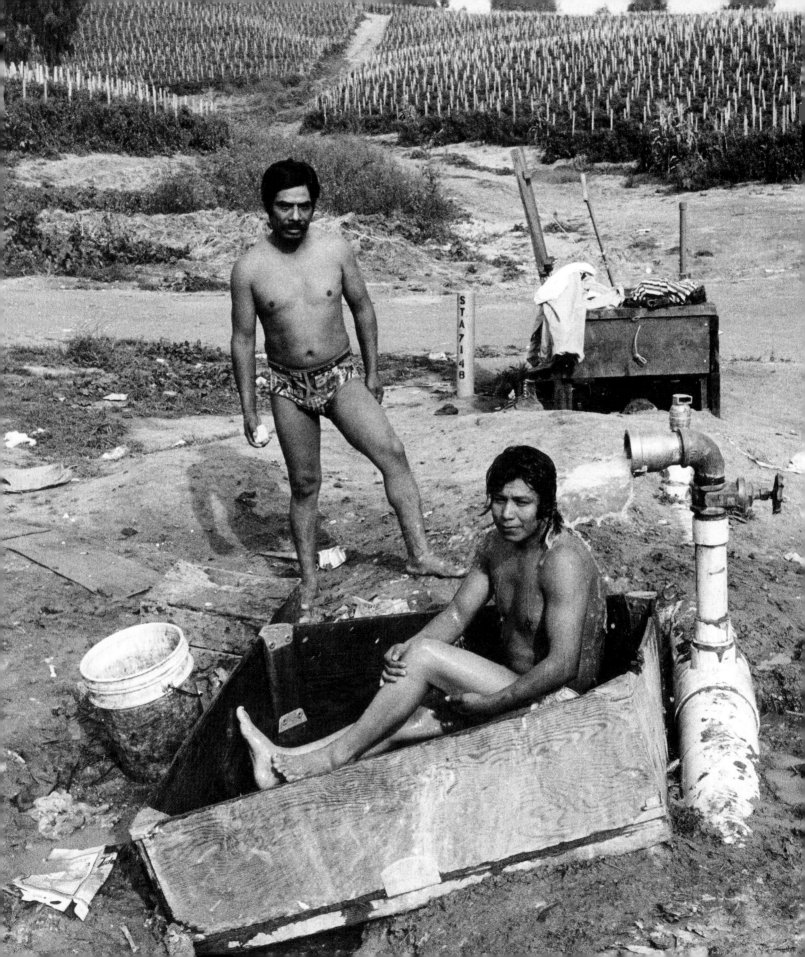

Richard Steven Street

PHOTOGRAPHING
FARMWORKERS

in California

STANFORD UNIVERSITY PRESS

STANFORD, CALIFORNIA 2004

Stanford University Press
Stanford, California

© 2004 by the Board of Trustees of the Leland Stanford Junior University.
All rights reserved.

Published with the assistance of the Edgar M. Kahn Memorial Fund,
the Guggenheim Foundation, and the Millard Meiss Publication Fund
of the College Art Assocation.

Printed in the United States of America on acid-free, archival-quality paper.

Library of Congress Cataloging-in-Publication Data

Street, Richard Steven.
 Photographing farmworkers in California / Richard Steven Street.
 p. cm.
 ISBN 0-8047-4092-5 (alk. paper)
 1. Agricultural laborers—California—Pictorial works. 2. Documentary
photography—California. I. Title.
HD1527.C2S844 2004
331.7'63'09794—dc22 2004045447

Original Printing 2004

Last figure below indicates year of this printing:
13 12 11 10 09 08 07 06 05 04

Typeset by James P. Brommer in 10/13 Sabon and Univers display

In memory of

Paul Schuster Taylor, 1895–1984

California Social Scientist, and

Dorothea Lange, 1895–1965

Documentary Photographer

Contents

Across more than thirty years of involvement with the farmworkers of California, Richard Steven Street has worked in many modes. He has been a journalist, a photojournalist, a critic of photography, a tireless archivist, and the single most comprehensive and compelling historian of farm labor in the history of the state, as is evident in the first volume of his epic two-volume history of farm labor in California, also published by Stanford University Press this year (*Beasts of the Field: A Narrative History of California Farmworkers, 1769–1913*). The present volume, then, serves as an introduction to Street's impressive achievements and diverse talents, each of them in the service of history.

First of all, *Photographing Farmworkers in California* is nurtured in significant measure by Street's long career covering farmworkers in the fields as a print- and photojournalist; indeed he was an eyewitness to many of the events described in this volume and took many of the most arresting of its photographs. Possessing a doctorate in history, Street knows his way around libraries and archives. He is an indefatigable researcher as well as a writer extraordinaire. But he is also among the best on-the-ground journalists ever to have covered farm labor in California. Street has spent thousands of hours in libraries and archives, but he has also met hundreds of print and photographic deadlines. He has taken to the field for months at a time, shared meager meals with farmworkers, slept on the ground in their camps, and walked with them on picket lines in times of danger. In combining the academy with field journalism, history with present-tense observation, Street shows the influence of his mentor—the famed Paul S. Taylor, professor of labor economics at the University of California, Berkeley —who took to the field in the 1920s as an essential component to his research methodology.

This volume bears testimony to Street's skills as a photo archivist. He has personally located and annotated many of these photographs, tracking them down when necessary in the most obscure places, sometimes snatching them from the very brink of destruction. Once again, Street shows the in-

Foreword

KEVIN STARR

fluence of Taylor, who, when covering the cotton strike of 1933 with the assistance of graduate student Clark Kerr, omnivorously gathered every possible form of evidence that would document the conflict. Were it not for Street, in fact, a number of important photo collections might have been lost or would be still languishing in obscurity. The photo historian in Street is evident in the informative essays and captions of this volume.

Above all else, however, *Photographing Farmworkers in California* offers testimony to the capacity of photographs—when properly selected, annotated, and integrated into text—to present history via the testimony of a medium that is at once document and art. From one perspective, the camera is a mechanical device obeying the laws of light, optics, instrumentation, and chemistry. As such, photography gives us a record of what is seen. Ever since the emergence of the daguerreotype in the late 1830s, we have had the satisfaction of seeing the great men and women of history as their contemporaries saw them. In time, as photography improved, we were also able to glimpse moments of high historical action, caught forever by camera and photographer.

Yet as this volume shows so dramatically, even the photography of photojournalism—swift, spontaneous, created in the intensity of the moment—is conditioned by complexities of light, lens, occasion, and the artistic vision that is operative in even the most documentary-minded photojournalist. Because Street is so accomplished in each of these fields, he constantly informs us regarding the historical, photojournalistic, artistic, and even archival interactions and complexities of what we are seeing. In certain cases—Dorothea Lange, most conspicuously—Street is treading familiar ground. Yet even here his insights are unique as he gives us the surprisingly true, and somewhat secretive, story of the "Migrant Mother" photograph that is perhaps one of the best-known images of all American photography. In other cases—the photojournalistic dimension to Paul Taylor's research, for example, the surprisingly activist work of Ansel Adams, the previously unrecognized talents of eighteen-year-old high-school student

Ralph Powell during the cotton strike of 1933, or the continuing and courageous documentation by German refugees Otto and Hansel Hagel—Street is breaking new ground.

The historical scholarship of Street in this volume and in *Beasts of the Field* represents, like the work of the Hagels themselves, a continuing and courageous commitment. No one—literally, no one—has achieved anything resembling the epic of documentation regarding the long history of farm labor in California that Street has displayed. From this perspective, this volume can be considered as an end in itself, complete and satisfying, or as the visual preface to a forthcoming epic of historical narrative.

Through these photographs we are presented with the visually defining moments, as they have survived through photography, of the farm labor history of the leading agricultural state in the nation. There is a stately serenity to the early photographs, perhaps because the workers were posing so formally for the camera out of technical necessity. Yet even in these early images—especially that of the first steam combine to come into the Pajaro Valley in 1870 or the wheat threshing machinery at Greenfields Ranch, photographed in 1888 by Carleton Watkins—there is evidence of the technology that would drive the agriculture of California to epic proportions. So many times in these nineteenth-century photographs—the Buena Vista Vineyard in Sonoma, as photographed by the great Eadweard Muybridge; the Nestell Vineyard in Fresno, photographed by an unknown photographer—there is an almost overwhelming encounter of landscape and sky reflective of the California-born philosopher Josiah Royce's observation that there was something bold and abstract in the physical environment of California, leading to certain habits of thought and behavior. Vineyards run toward a distant horizon, and in the foreground of so many of these nineteenth-century photographs there are near-ritualistic displays of produce, teeming in abundance. Attendant workers—Anglo-American in the main, but Mexican and Chinese as well—stand tall amid the harvest like acolytes in a liturgy of abundance. Picking or packing citrus, laying endless rows of fruit

out in the sun to dry, pruning trees, fumigating crops, moving across vast landscapes behind team upon team of horses and mules, leaning nonchalantly against a great steam-driven threshing machine or a small but serviceable field locomotive, the farmworkers of the nineteenth century, as revealed in these photographs, seem almost Homeric in their contentment, simplicity, and strength. Here, too, occasionally, there are scenes suggestive, if only obliquely, of the satisfactions of nineteenth-century farm life: a farmyard, in the stillness of a late afternoon; a chuck wagon with smiling workers standing or sitting around; two little girls bearing on a pole an oversized cluster of grapes, as if returning from the land of Canaan; more children, this time in Marysville, snatching a rare day of leisure in an era when children more than held their own in the fields; a family of Native Americans resting beneath fruit trees from their work. Yet in the mug shot of a fourteen-year-old boy, charged with the murder of a foreman who had molested him, we glimpse other realities as well.

There is a surprising predominance of Anglo-American faces in the nineteenth-century photographs. The more this book moves into the present, however, the more diverse become the workers, as Japanese, Mexican, and East Asian Indians find employment in the fields. From the beginning, an expanding California agriculture would always be running out ahead of its workforce. More and more people would constantly be needed, but only at certain times of the year, and therein remained the rub, the tragic imbalance, of an agricultural empire that was producing food first for itself, then for the nation, then for the world. The pastoral contentment of the early photographs—their emphasis upon field, sky, crop, and willing workers—now yields to photographs documenting the remorselessness of piecework in the fields, the inadequacy of housing, the early efforts at organization, and the browning of the workforce. Because the photojournalists of the era are now seeing these things as well, perhaps becoming consciously aware of them for the first time, the reposeful figures in the nineteenth-century fields, regarding the camera impassively, become twentieth-

century images of gnarled hands, torn fingernails, bent backs, creased faces, most of them of color, and, by the early 1930s, the militant eyes of striking workers. We see them being called from the fields, riding in trucks adorned with picket signs. We see the highway patrolmen and the hastily sworn-in deputies. We see a worker dying on the ground in a pool of his own blood.

In the midsection of this book, Street seems at times to be struggling with comparisons and contrasts of art and documentation. The photographers at work in the fields at this time—most notably Ansel Adams, Otto and Hansel Hagel, Arthur Rothstein, F. Hal Higgins, Dorothea Lange—were among the most talented in the nation at a time of high achievement in American photography. In the nineteenth century, in photographs by Carleton Watkins and Eadweard Muybridge especially, art and artfulness are frequently in play, but they never seem to predominate, much less overwhelm, their subject matter. The photographs of the 1900– 1930 era, by contrast, seem spontaneous, however artful they may be. Subject matter predominates, and only the most experienced of critical practitioners, such as Richard Steven Street, are aware of the art and artfulness from which even these photographs originate. In the great works of the mid- and late 1930s, however, we are aware of art as well as subject matter. They are one and the same. Does that make these artistic photographs any less valuable as historical record? Perhaps not. But when we learn that the Missouri farmer photographed by Dorothea Lange in February 1935 at the wheel of his model-T on Highway 99 in the San Joaquin Valley—his eyes so seemingly haunted and desperate, his face so set in stoic desperation—was actually sitting alongside his wife, who was looking rather comfortable, Street tells us, in a nice coat—and she cropped by Lange from the picture!— then we also must join Street in struggling with the interaction of documentation and aesthetics, especially when art is offering, or so it seems, a shortcut to a more fundamental truth. From this perspective, Lange's cropped and altered photograph of Florence Thompson and her three young chil-

dren, the "Migrant Mother," remains the most controversial image in this debate.

Much more spontaneous, however, are the photojournalistic depictions of truckloads of lettuce rolling past jeering picketers in downtown Salinas or the fistfights between strikers and nonstrikers in the same city or the California highway patrolmen drawing a line on the ground beyond which Salinas lettuce picketers cannot pass or the police barraging strikers with gas grenades and shells, all these by *San Francisco Examiner* photographer Harold Ellwood, emphasizing the fact that even amid the confusion of conflict on the street a good photojournalist can at once get the story and produce images astonishing in their composition and narrative verve.

In the late 1930s and throughout the war years, photographers seemed once again interested in close-ups, individualized portraits, or domestic scenes, as if to emphasize, as the first photographers of farm labor in California knew so well, the fact that farm labor was intensive labor, people-intensive labor, and could only be understood in terms of the people who were actually in the fields. Now we catch images of individual workers. An African American farm laborer plows a field behind a horse in an image from time immemorial. A woman washes her hair in a farm ditch, her bent back and her arms reminiscent of an ancient poem or a painting of a bathing Susanna by an Old Master. Farmworkers dine alfresco in the fields, attend a labor rally, play baseball or checkers, worship on a Sunday morning, visit while in uniform—this a Japanese American soldier—a mother picking strawberries at the Manzanar War Relocation Camp. Other incarcerated Japanese Americans, shovels over their shoulders, move into a field at Manzanar under the supervision of an armed sentry. A railcar full of braceros smile for the photographer (possibly Lange) as they head north to Sacramento in September 1942, or braceros stand naked for medical examination or to be sprayed with DDT in two 1958 photographs by Leonard Nadel, in graphic testimony to the vulnerability of their position. A bracero, beet knife in hand, bends deeply over a field on the Otto Mueller ranch near Stockton,

the pain in his back visible to the camera. There are also from this period photographs of children at work in the cotton fields. And the first instance of an issue—pesticides, first evident in the photograph by Joe Munroe of a crop duster spraying herbicides across a field near Colusa in the northern Sacramento Valley—that would bring such misery to children in the fields in the second half of the twentieth century and that would result in the most heart-wrenching of photographs near the conclusion of this book, a child damaged from birth beyond imagination by pollution in the fields.

In Leonard Nadel's 1958 photograph of a parish priest ministering to braceros, together with other photographs of the living and working conditions of farmworkers, is anticipated the spiritual energies and the attempted social reforms of the next era. It could not go on any longer like this. The more prosperous California became, the more it seemed to neglect its farmworkers. Here is the period that Street himself began to cover as a young photojournalist, an era ushered in so dramatically by Harvey Richards's September 1965 photograph of Dolores Huerta holding aloft a large sign exclaiming *Huelga!* (Strike!). Now ensues the photographic documentation of the single most dramatic strike in California history, a movement crystallizing around the charismatic figure of César Chávez, but possessed as well of a *la raza*–wide energy that pulsates through Jon Lewis's photograph of *la peregrinación*, in which the strikers move across a mystic and moody landscape like medieval pilgrims in a film by Ingmar Bergman. César Chávez appears and reappears in these photographs, his face at once so distinct and yet so much the face of the hundreds of other striking men and women being depicted. Now comes again the violence of the 1930s, the gas grenades, the raised fists and rifles, the angry voices, but something else as well—images of a fasting Chávez, touching depths analogous to those touched by Martin Luther King Jr. in a comparable struggle for civil rights, which is to say, the redemption of America itself.

We still await that redemption in the fields and elsewhere. There is no final triumph in this book. Its main chapters end

tragically with the image of the damaged child, together with the sight of bent workers still wielding the short-handled hoe outlawed two decades ago. If anything, the camps depicted toward the millennium are worse than those of the Great Depression. *Photographing Farmworkers in California* is, however, not without some hope. But it is not the hope that comes from easy answers or permanent solutions. It is the hope, rather, that comes from witnessing farmworkers enduring the unendurable without surrendering their fundamental humanity. This humanity, individualized and communal, makes farmworkers more than the sum total of their deprivations or impossible work. This fundamental humanity demands that the farmworkers of California not be denied, not be relegated to the fields, far from the highways, where they cannot be seen, put out of mind forever. Thanks to this book, the farmworkers of California can now be seen in history, and they can be seen in the here and now by the camera and by us. They are triumphant in their endurance. They demand justice. They remind us, finally, that we can never enjoy California or the bounty of its fields until they, too, are treated fairly and can share equally in the goodness of the earth.

Scholars are sometimes vague about the exact origins of a book, especially when the research and writing span more than half their lifetime. Not me. Although I devoted thirty years to this study, I can still recall its violent and bloody birth.

On Tuesday, July 31, 1973, while beginning my career as an agricultural photographer, I followed the United Farm Workers Union (UFW) in the Coachella and San Joaquin valleys of California. The year had been a disaster for the UFW. In January, the union had held more than 150 contracts covering fifty thousand workers. Seven months later, it was down to twelve contracts and sixty-five hundred workers. Now striking grape pickers were engaging in massive civil disobedience. They intended to win back lost contracts and overturn the way courts and law enforcement officials used injunctions to restrict picketing, and they were putting their bodies on the line, submitting to mass arrests, clogging rural jails from Indio north to Delano. During one of those confrontations, in the Giumarra Vineyards near the dusty Kern County farm town of Arvin, I witnessed the aftermath of two deputies dragging a sixteen-year-old farmworker named Marta Rodríguez out of a vineyard. She was struggling to free herself and screaming for help.

Photographers and news crews were everywhere. A news helicopter hovered overhead. But only one photographer, a tall, blond man named Bob Fitch, was in position to get Marta's picture. Crouched behind the fender of a car, where police billy clubs could not reach, he recorded a sequence of images, several of which focused on Marta. Here was a photographer bearing witness, fully engaged, with minimal time to react, other than to spin on his heels and fire off a string of pictures. Both high art and on-the-spot photojournalism, the dramatic photograph of Marta—and several equally dramatic shots of other farmworkers being arrested and dragged out of the vineyards—haunted me for weeks thereafter. While covering the continuing strikes and funerals of two murdered farmworkers, I could not forget that terrified young woman.

As I pondered that image, I became consumed by the goal of attempting a comprehensive inquiry into the photographic

history of California farmworkers. It seems odd now that it did not occur to me or someone else even earlier. As exploited and colonized workers, California farmworkers seemed an especially alluring source of visual study. So massive is their visual record and so dramatic is their history that any such study would present an opportunity to contemplate the nature, development, and ongoing plight of a class of people. What most excited me, however, was not the opportunity to illustrate any particular dimension of the farmworker story, although that is certainly a residual benefit of any such study. Rather, I was interested in opening a window on the world of photography. Flourishing on an unprecedented scale since its advent a century and a half ago, photography is an especially alluring topic for exploration because it has become such an extraordinarily ubiquitous and universal language—something that historian Naomi Rosenblum has described as "the common currency of visual communication in the industrialized nations." By examining photography's involvement with California farmworkers, I hoped to contribute to this growing understanding of the photographic medium, its evolution, and the dimensions and shape of its history. And by adopting a broadened historical perspective, I hoped to overcome the artificial truncation of knowledge splitting visual culture into discrete and unconnected parts. Troubled by the common use of photographs merely as illustrative material rather than as documents important in their own right, and by the way academic historians have disregarded the opportunities of photographic research and interpretation, I wanted to nudge visual history into the domains of agricultural history, labor history, and the history of the American West, as well as California studies, cultural studies, ethnic studies, and intellectual history.[1]

As a topic for study, the photographic history of California farmworkers is especially valuable because virtually every California photographer of consequence—ranging from landscape photographer Ansel Adams to commercial photographer Max Yavno—photographed in the fields. So alluring are farmworkers as subjects for photographic documentation and so central are they to the story of photography in the American West that they have attracted the attention of such unlikely artists as twentieth-century fashion photographer Richard Avedon, nineteenth-century master of the grand view Carleton Watkins, and World War II combat photographer Joe Rosenthal (who won the Pulitzer Prize for his photograph of American soldiers raising the flag atop Mt. Suribachi at the battle of Iwo Jima). Encompassing the artistic, photojournalistic, documentary, and commercial genres, these and other photographers produced countless images that are nothing more than agricultural propaganda—marvelous to see and illustrative of the highest and finest qualities of visual communication—but more often than not they went beyond the ordinary and threw themselves into their work, capturing images of people sliding into chaos or living a life so hazardous and marginal as to defy belief. Many of their images evoke feelings of pity and depict nobility within tragedy. A few underscore seemingly contradictory elements, simultaneously pleasing, prodding, publicizing, educating, and generating a tension that raises difficult moral questions about the numbing and seductive effects of beauty and the relationship between aesthetics and politics. Some photographs implicitly assign blame. By shifting attention beyond agricultural products to the process by which crops are harvested, they underscore conspicuous abundance if not opulence and incredible beauty side by side with grinding poverty, naked ugliness, and inspiring determination. Countless others comprise a litany of grief and terror, murder and violence, humiliation and inhumanity, making their cumulative case against the farm labor system as an instrument of poverty, repression, and exploitation. The best images go far beyond exposé and are at once visual documents and beautiful works of art dealing with circumstances that are disturbing, horrifying, even repulsive. The most challenging and complex pause long enough to reveal that growers struggle mightily with their circumstances, that labor contractors have a tough and important job, and that field hands are complex individuals with a life of their own beyond the shadow of their employers. But

by then we have seen so many people bent double and burnt by the sun, beaten and teargassed, carried in coffins during mass funerals, struggling against abject poverty, and overcoming their circumstances through shear willpower that it is difficult to accept a softer version of events.[2]

Often yielding information comparable to more traditional evidence, the photographic record of California farmworkers is of central importance to matters of labor relations, ethnic conflict, immigration policy, social relations, working-class culture, and environmental history, as well as photojournalism and documentary photography. With the power to inform as well as misrepresent, to inspire as well as repel, this body of work can clarify instants in time, cut through layers of ignorance and indifference, and remain fixed in memory in ways that escape words. Seldom mentioned in academic studies, this quality of reminding us who we are is absolutely essential to meeting the challenge that the novelist Robert Stone identified as "the moral necessity to perceive ourselves within reality." To accomplish that, we need to stand back, freeze time, review deeds and events, and ponder what is real. "We must always be trying to understand," writes Stone, "and we have nothing to work with besides stories and our imaginations." Contemplating the arch of farmworker photography, we can extract useful images from the swirl of history feeding our imagination. Our initial response may well be that of wonder, admiration, and appreciation. But there is often a deeper meaning at work. By engaging farm labor on many levels over a long period of time, photography intentionally and unintentionally, knowingly and unknowingly, confronts the role that farmworkers play in our system of agriculture, forcing us to reflect on the extent to which as a society we require the subservience of an entire class of people to place food on our tables. If one transcendent truth emerges from this record, it is that beyond sun, water, and fertilizer, modern fruit and vegetable farming extracts a price in human sweat and toil.[3]

I have employed an unusual approach in this exploration of the photography of California farmworkers. Trained as an academic historian but making my living as an agricultural photographer, I decided to exploit the travel opportunities and contacts of my own agricultural photography business and, over a period of thirty years, structured assignments in a way that allowed me to visit hundreds of different photographers, photographic archives, and photo agencies in the United States, Mexico, Germany, and the U.S. Virgin Islands. Although these sources supplied the bulk of the images and information, I also discovered a surprisingly large number of photographs and vast stores of archival material in tin sheds, barns, attics, private collections, and libraries and museums far off the academic research circuit. While allowing the material to determine the pace and course of research rather than fitting it into a tenure-track publishing schedule, I was able to meander, pause, and double back as the work proceeded. In some cases I waited twenty years to obtain images.

The odd locations of important images never ceased to amaze me. Once, acting on a vague tip scribbled down while shooting a cover story for *Fortnightly* magazine on a manure-powered electric generating plant in the Imperial Valley, I ventured into the basement of the El Centro Courthouse. Sorting through some unlabeled cardboard boxes, I found a stockpile of police mug shots of farmworkers arrested for protesting the hiring of bracero (Mexican national) strikebreakers at the Danny Danenberg Farms near El Centro in the winter of 1961. The cache even preserved the original mug book numbers and an accompanying arrest biography. Capturing a wide spectrum of farmworkers—blacks, Anglos, and Mexicans—these photographs were unlike anything I had seen previously and revealed a side to the photographic story that is normally omitted from the record: images created not for insight, news, commerce, art, or social documentation, but for detention and prosecution. Had I not been out and about and constantly searching far from the usual archives, I would never have discovered this and other similar treasures.[4]

Going about my own work as an agricultural photographer while also studying the photography of California farm-

workers created a unique convergence of historical research and day-to-day business. So much of what the photographers of California farmworkers had done in the past overlapped with my own experiences in the present that I often found myself photographing in the same places, in the same ways, and for the same reasons (both adulatory and probing) as my predecessors. On countless other occasions, I was confronted by images taken by photographers whom I knew very well, had worked with, even competed against while on assignment covering various farm labor developments for clients ranging from *California Business* and *California Farmer* to *GEO* and *U.S. News and World Report*. In many cases, I had to evaluate their images alongside my own. These experiences taught me two lessons. First, that the photographic history of California farmworkers repeats itself. And second, as documentary photographer Mary Ellen Mark has said, all photographers exploit or manipulate their subjects, some only by the happenstance of framing and the moment they opened the shutter, others more overtly, through the basics of the medium—previsualization, choice of lenses, lighting, and so on. Such a realization neither undermines concepts such as truth and reality, nor does it negate faith in photography's role as the "mortar of history." Rather, it helps identify the various ordering principles that make up our visual past, thereby freeing us of any fixed version of history and permitting a new, more critical historical perspective.[5]

As I explored the photography of California farmworkers, I could not stop chuckling at the contortions, postmodernist double talk, and academic gobbledygook employed by scholars and niggling historians. Frequently, I read incredible, imaginative, and inaccurate descriptions of situations that I had personally witnessed. I have often been dismayed by critics describing my work and that of my colleagues, however glowingly, as falling into this or that genre, exemplifying this or that trend, or reflecting this or that type of thinking. These descriptions were so often at variance with the complicated circumstances of how my colleagues and I went about our tasks as to be fiction.

Of all that I encountered in the course of my double life as scholar/photographer, nothing angered me more than the important bodies of farmworker photography that survived only by the grace of God. A typical story surrounded the work of commercial photographer Frank Day Robinson who, in the course of a thirty-five-year career, shot hundreds of pictures of farmworkers in and around Merced County before World War I. But after he died in 1948, his glass plates resided at his home for several decades until, following the death of his wife, they apparently were discarded as garbage. Only at the last minute did a curious individual recognize their value and rescue them from the dump. Another story centers on the hundreds of images of Mexican field hands photographed by University of California economist Paul S. Taylor in 1927 and 1928. After keeping the negatives in a shoe box for fifty years, Taylor loaned them to his student, Reesa Tansey. Destroyed when Tansey's home burned down in the Oakland Hills fire of 1991, Taylor's images appear in these pages only because he had once allowed me to shoot slides of a dozen key pictures for a *History of Photography* essay I was writing about his documentary work. An even worse fate befell the photography of UFW photographer Chris Sánchez, who shot hundreds of images of the farmworker struggle beginning in the late 1960s. After he died in 1993, his family lost, misplaced, or inadvertently destroyed his entire archive. I obtained a few of his images only because the UFW included them in material deposited at the Archives of Urban and Labor History at Wayne State University, in Detroit, Michigan. But even when photographers preserved their work, it often remained unavailable and unknown and required a considerable amount of detective work to find. This was the case with the photography of Jon Lewis, an intrepid photojournalist who photographed some of the most important images of the first two years of the Delano grape strike. Too broke to properly archive thousands of negatives, Lewis in 1970 quit photography and deposited his archive in a friend's garage. Unable to provide images when I first contacted him in 1985, he nevertheless kept my project

in mind, and fifteen years later, after his fortunes improved, he retrieved his negatives and allowed me to make prints, just as I was completing my research.

Working my way through these and other obstacles, I eventually compiled an archive of about ten thousand images, excluding my own work. Realizing that the project had grown to such massive proportions that it could not be presented in a single volume, I decided to split off the study of the photography from the narrative of the photographers. A somewhat artificial truncation of knowledge, the approach nevertheless allows me the singular opportunity of presenting a comprehensive and affordable account of a dramatic and heretofore untold history. This volume, the first part of that account, focuses on the images and lays out the record. A second and more traditional book, illustrated with different images, narrates the story of the photographers.

Selecting cover photographs for this volume proved to be an especially daunting task. I wanted to avoid the usual approach of choosing images as an afterthought, or leaving the process to the publisher.[6] Here the problem was not only which images to use, but how many, and why. From the beginning, one photograph stood out. The dramatic image taken by Bob Fitch of Marta Rodríguez seemed to best illustrate the central theme of modern farmworker history—the long, difficult, still evolving, possibly impossible struggle to organize a viable union as well as the key role that photographers played in documenting that aspect of the farmworker story. Toward the end of the project, however, I concluded that a single image of this kind presented a highly politicized and skewed picture. Eventually I added one other photograph, a classic 1958 documentary shot by Ernest Lowe of a bracero "stoop laborer" using a short-handled hoe. So painfully destructive of body was the short-handled hoe that it would be banned, declared an illegal tool, although photographers would subsequently discover and document its continued use decades later by unsuspecting immigrant laborers. If organizing was the predominant theme of the twentieth century, it was second only to the centrality of work. For this reason I concluded that Lowe's image deserved also to be placed on the cover. Few other images so perfectly capture the essence of fieldwork and the taxing nature of stoop labor.

Sorting through these and thousands of other images and placing them in rough chronological order, I became acutely aware that I would have to reject a catalog scheme and the usual practice of isolating images within what photographic historian Martha Rosler calls the "gallery-museum-art-market nexus."[7] Instead, I employ a broadly sequential, chronological, and scholarly version of the modern photo essay (a narrative sequence of photographs accompanied by text), albeit on a far greater scale. At times I pause where necessary to reflect on certain phases of the story while elsewhere I quickly push through redundant material. My primary focus is always on the evolving vision of farmworkers and only secondarily on farmworkers themselves. Several early chapters encapsulate developments spanning several generations and consider the work of dozens of different photographers; one chapter concentrates on two pivotal years from the Great Depression; another narrates the photographic record of a single dramatic strike; a concluding chapter walks the viewer into the present, unfolding a picture as seen through the lens of still living photographers. Following the long parabola of this imagery, I consider key turning points and important technological changes, as well as where, when, and why certain developments begin and end.

Countless photographic approaches appear and disappear. Changing over time and influenced by ideology, employers, politics, money, personal values, or lack of them, and countless other details, the relationship between photography and farmworkers does not unfold along neat, predictable lines. Hardly unified in its approach, photography embraced a multitude of perspectives, developed as many points of view as there were individual photographers, and elicited a complicated spectrum of insights, questions, and reflections. For the first seventy-five years, commercial matters dominated the relationship between photography and

farmworkers. From the mid-1930s until about 1942, the documentary impulse dominated coverage. A key discovery, seen here for the first time, is that a handful of photographers, largely motivated by their own personal reasons, were engaged in quasi-documentary work among farmworkers many years before Dorothea Lange and others established the genre. Among those photographers was Lange's husband, Paul S. Taylor, who was well on his way to practicing the technique popularized later by Lange; he gave it all up out of love for the partnership he so cherished. Quite surprisingly, Ansel Adams, who has never been noted as a documentary photographer, in fact photographed farmworkers on and off for more than thirty years.

Various standards influenced the selection of specific images. One was the capacity of a photograph to be unforgettable. This sounds easier than it is. An unforgettable image could be fascinating, disturbing, haunting, brutal, strange, humorous, or shocking; it could be technically excellent or amateurish; and it could be the sole surviving example of a particular phase of the story. Above all, an unforgettable image had to quickly convey its geopolitical location, along with a sense of the event being depicted, and have a lasting visual impact. If it had aesthetic value, so much the better.

Another standard was more problematic. Some images, while not particularly unusual or outstanding from a stylistic or technical standpoint, appear because they document an important development in photographic coverage or call into question criteria by which images are valued as art. Some are typical news photographs taken by photojournalists in the course of their beat work and are illustrative of that genre. I have also included scratched, discolored, cracked, folded, and torn photographs, including some with mold growth and other defects, including writing, as well as images printed from flaking and deteriorating nitrate negatives. I have made no attempt to clean them, digitally retouch them, or in any way improve or alter their appearance. Such images are useful in showing how much of the photographic record exists on the edge of destruction, if not spontaneous self-combustion.

Sections from the original layouts of several important photo essays, as well as contact sheets from pivotal assignments, appear in order to demonstrate the working methodology of key photographers. And because the first eighty-three years of the farmworker experience developed before the advent of photography, I have laid a foundation for understanding photographic coverage by including a few examples of the very best representations of California farmworkers before the advent of photography.[8]

Because a comprehensive visual survey could have easily filled many volumes, I have not included every photographer and every type of photograph. Several well-known images by famous photographers did not make it into the final cut, while many images by unknown photographers appear on these pages. Often photographs by "nonphotographers," amateur photographers, even fashion and celebrity photographers, as well as freelance photographers and those pursuing a personal project, emerged as the best images of a given subject. One of the most surprising discoveries was the large amount of very fine work by photographers who, walking in the footsteps of Lewis Hine and W. Eugene Smith, pursued their stories for extended periods of time, and at great personal cost, only to ultimately be denied publication by media outlets that regarded their work as too strong, too controversial, or too far ahead of its time. Other more familiar photographers, such as "father of the motion picture" Eadweard Muybridge, appear here in an unfamiliar environment, one that reveals a new and broadened view of their art, while certain iconic photographers like Dorothea Lange are surrounded by the work of contemporary photographers who in some cases surpassed Lange, went places she avoided, and recorded aspects of the story that she overlooked. By including the myriad of unappreciated photographers who have worked in the fields, as well as portrait photographers, amateur photographers, police photographers, and even anonymous photographers, I hope to breach the confines of formalist photographic categories, fill the voids in a heretofore fragmented, episodic, and broken record, and shift the picture beyond that of Lange

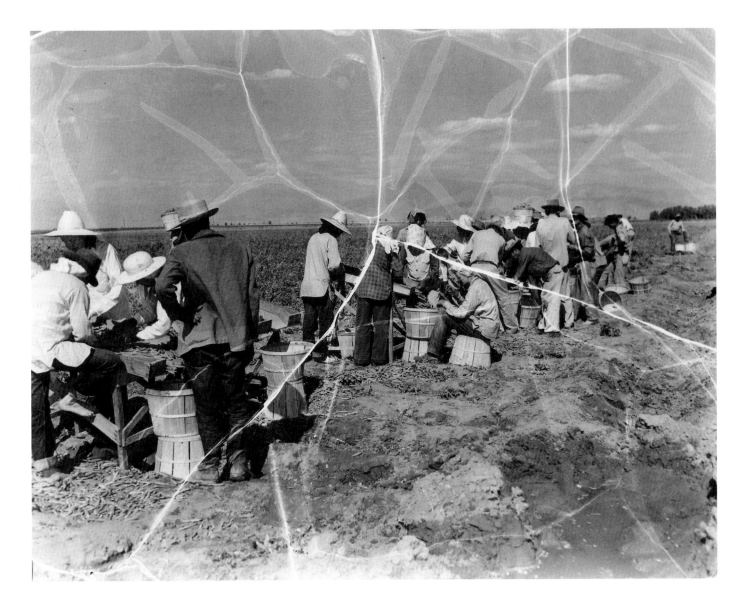

With an acetate film base, the negative used to make this print of field hands harvesting peas on May 9, 1949, near Bakersfield, will continue to deteriorate unless archival conservation techniques are soon applied. Photographer unknown. Courtesy of the Kern County Museum, Bakersfield, California.

and a few other canonical photographers and the cherished icons that they created. And by highlighting the work of exemplary photographers I hoped to call attention to people who exemplify the best qualities of the completely engaged modern artist.

One small group excluded from this volume are those studio photographers who photographed Korean farmworkers in the fields and in portrait sessions during the years 1915–25. While such images are rare, those I discovered lacked both the artistry and technical quality required for publication. Another barely represented group are photographers who were farmworkers themselves. Unlike African Americans, who possess a rich photographic record, rarely were the photographers of California farmworkers drawn from among the different ethnic groups who comprised the farmworker class. A third, largely excluded, group were photographers who worked in color. Kodachrome became available about 1935, and a few photographers, like Otto and Hansel Mieth Hagel, immediately used color film to record California farmworkers, and others like Bob Fitch, Paul Fusco, Ed Kashi, and Jon Lewis incorporated it into their reportage. However, most neglected color, indeed categorically excluded it. As far as I know, I am the only photographer to have worked mostly in color while documenting California farmworkers over an extended period of time. While I have always found that color did not overwhelm or divert from content, and that it was possible to let exploitation and beauty make their simultaneous statements beside one another, most photographers disagree, preferring to work in what the critic Max Kozloff calls "the spectrum of suffering and pity." So strong is this anticolor bias that the photographic record of California farmworkers remains overwhelmingly one of black-and-white images. But there is another reason why I have used only a few essential color images and converted them to black and white—they are too expensive to publish and, when converted to black and white, do not fully represent the original images. Consequently, what follows is monochromatic, a record that is itself an abstraction and "defor-mation" of the unmitigated chromatic power of the agricultural environment.[9]

For all that photography and photographers have done to shape public perceptions of life and labor in the fields, information has not flowed in only one direction. Photography and photographers have also been shaped by their encounter with farmworkers. For many modern photographers this has taken the form of a reaction against the imagery of oppression and an attempt to go deeper, to move beyond victimization, to create counterimages focused on what was in fact normal, beautiful, dignified, successful, and fulfilling. For them the day-to-day reality and routine of farm labor is much more important and revealing than the dramatic events and spectacular struggles. Whatever the approach, however, photographers and photography today form such an important subplot in the farmworker story and have become so ubiquitous that they must be considered in every discussion of organizing activity, along with such traditional labor relations factors as the nature of the industry, composition of the workforce, poverty, immigration, law, and leadership. So important is this work that today at farmworker strikes, on picket lines, and at boycott rallies and mass marches, it is normal to see not only photojournalists but also security guards, police, growers, and farmworkers, together with assorted bystanders, all armed with cameras, each awaiting some decisive moment.

Captioning this photography proved to be a challenge but is central to the book design. Before a photograph can be accepted as a document it must itself be documented—"placed in time and space"—as Beaumont Newhall observed in *The History of Photography*. Photographers have always struggled with this task, searching for ways to amplify their images, give them meaning, and convey completely and accurately what they captured. For Hansel Mieth Hagel, who produced a stunning photographic record that spans three decades of farm labor, the task centered on making words "extend beyond mere identification." Good captioning went hand in hand with good photography. A similar concern for

captions distinguished the work of Dorothea Lange. Extremely diligent in captioning her photographs, Lange frequently combined excerpts from her extensive field notes with data extracted from social science studies and government reports. Tedious and time-consuming, this practice elevated Lange's photographs. For her it was both redundant and lazy to describe a photograph of a man leaning on his hoe as "Man leaning on his hoe." Rather, Lange aimed at creating a dynamic relationship between images and words. "I don't like the kind of written material that tells a person what to look for or that explains the photograph," she said in her oral history memoir. "I like the kind of material that gives more background, that fortifies it without directing the person's mind. It just gives him more with which to look at the picture."[10]

Whenever possible, I have constructed my captions with these ideas in mind, composing and writing the kind of amplifying descriptions that would have pleased Lange and Hagel and met Newhall's test for documentation. But while attempting to be expansive and comprehensive, I make no claims that what follows is gospel. Nor is it static, or the last word. The story continues, something I hope the reader understands. Another scholar, with a different background, would have certainly employed a different combination of words and images, with different priorities, points of digression, aesthetics, and sequence. Subsequent researchers will no doubt flesh out additional dimensions and discover images and photographers that I missed. Certainly my selections will puzzle, amaze, and disappoint. But for those of us who photographed farmworkers, sat with them in the fields, lived with them in their camps, enjoyed their company, benefited from their generosity, witnessed their struggles, photographed a good chunk of their recent history, and have been arrested, detained, and chased while going about our business, nothing rekindles old memories more powerfully than the most trenchant and ruthlessly realistic images seen here. Looking at these photographs is often less like studying history than browsing through an old family album while re-

calling some of the most important, challenging, and treasured experiences of our lives.[11]

In a work of this sort, there is always the possibility of being attacked for retracing the paths of Dorothea Lange and Paul S. Taylor, two great chroniclers of rural California, whose pioneering study, *An American Exodus*, has been called the real-life counterpart to *The Grapes of Wrath*. Although I never met Dorothea Lange, I have for most of my adult life been aware of the revered place that she holds in the pantheon of American photography. I know her photography like the back of my hand and consider it a model of humanistic concern. Paul Taylor, a University of California economist whose work set the tone of debate over rural society, was for a decade my unofficial mentor. It was my great fortune to have enjoyed the privilege of his company, to have walked the Berkeley campus with him, photographed him at the Bancroft Library and at various university functions, to have sat with him at the table where he shared meals and conversation with Lange, and to have spent countless hours with him in his cluttered office. While this study is not an attempt to imitate Lange and Taylor, certainly there will be some who will quarrel with something that in many ways might appear to expand or exploit *An American Exodus*. My approach is that of someone who of necessity assimilated and amalgamated the visual and intellectual components of the Lange-Taylor union. I dedicate this book to that life of ideas and images, to the amalgamation of photography and social science that propelled Taylor and Lange forward in marriage and defined their relationship to each other, California, the American West, and the larger world around them. I hope that this history, in which their work figures so prominently, will help this generation understand how profoundly photography has shaped, and been reshaped, by life and labor in the fields of California since the 1850s.

San Anselmo, California
OCTOBER 17, 2003

NOTES

1. Quote from Naomi Rosenblum, *A World History of Photography* (New York, 1984), 9. See also Jim Hughes, *W. Eugene Smith, Shadow and Substance: The Life and Work of An American Photographer* (New York, 1989), vii.

2. Charles N. Wollenberg review of Charles Shindo, *Dust Bowl Migrants and the American Imagination* (Lawrence, Kans., 1997), in *Pacific Historical Review* 67 (Dec. 1998), 639–40. See also Shindo, *Dust Bowl Migrants*, 2, 7–9, 218; John Berger, *About Looking* (New York, 1980).

3. Quotes from Robert Stone, introduction to James Nachtwey, *Deeds of War* (New York, 1989), 7. Concepts and phrases from Mark Lapin, "Truth in the Age of Teflon: Ten Years of Documentary Photography," *Photo District News* 10 (Feb. 1990), 71–80; Jonathan Kozol, "A Reporter at Large: The Homeless," *New Yorker* (Feb. 1, 1988), 66–67; Vicki Goldberg and Robert Silberman, *American Photography: A Century of Images* (San Francisco, 1999), 173; E. Ethelbert Miller, "In My Father's House, There Were No Images," in Deborah Willis, ed., *Picturing Us: African American Identity in Photography* (New York, 1996), 57.

4. Finding the photographs and photographers was only part of the challenge. I obtained many photographs only after long and torturous negotiations. In a few cases, for reasons beyond my comprehension, I failed in my attempts to secure publication rights. Of living photographers, only Richard Avedon and Ron Kelley refused to allow me to use their pictures. This is why Avedon's portrait of César Chávez, shot on June 27, 1976, at Keene, California, on assignment for *Rolling Stone Magazine*, does not appear in this book, and why Kelley's image of Yemeni farmworkers watching television in a labor camp when an image of "Migrant Mother" appears, are omitted from the record. See Amy Rule and Nancy Solomon, eds., *Original Sources: Art and Archives at the Center for Creative Photography* (Tucson, Ariz.: 2002), 50; Jennifer Landwehr to author, Dec. 11, 2002, author's possession.

5. Quote from Michael Penn, "Noise of the Edge of Silence," *On Wisconsin* 104 (summer 2003), 33. See also Lapin, "Truth in the Age of Teflon," 80; Alan Trachtenberg, "From Image to Story: Reading the File," in Carl Fleischhauer and Beverly Brannan, eds., *Documenting America: 1935–1943* (Berkeley, 1988), 70.

6. For an example of the book cover as an afterthought, see Stephanie A. Shields, "When a Book Cover Speaks Volumes," *The Chronicle of Higher Education* (June 6, 2003), B5. See also Raphael Samuel, *Theaters of Memory: Past and Present in Contemporary Culture* (London, 1994), 1: 27, urging historians to begin using photographs much as they use manuscripts and other sources, rather than merely as illustrations; Mary Price, *The Photograph: A Strange, Confined Space* (Stanford, 1994);

W. J. T. Mitchell, *Picture Theory* (Chicago, 1994); James Guimond, *American Photography and the American Dream* (Chapel Hill, N.C.: 1991), viii–ix.

7. Quote from Martha Rosler, "In, Around, and Afterthoughts [on documentary photography]," in Richard Bolton, ed., *The Contest of Meaning: Critical Histories of Photography* (Cambridge, Mass., 1999), 325. See also Francis Fralin, *The Indelible Image: Photographs of War, 1846 to the Present*, with essay by Jane Livingston (New York, 1985).

8. In a few cases I chose photographs taken in Texas, Arkansas, Arizona, and Mexico because they captured important developments that crossed state boundaries, had national, transnational, or interstate implications, and were closely related to developments in California.

9. Quotes from Max Kozloff, "Picturing Mexico in Color," in Carole Nagger and Fred Ritchin, eds., *Mexico through Foreign Eyes, 1850–1990* (New York, 1993), 176; Henri Cartier-Bresson, *The Decisive Moment* (New York, 1952), 9. On color see also Sally Stein, "FSA Color: The Forgotten Document," *Modern Photography* 43 (June 1979), 90–99, 162–65; *The Real West*, commentary by Patricia Nelson Limerick (Denver, 1996), 17. Although men dominated farmworker photography, Gayanne Fietinghoff, Hansel Mieth Hagel, Dorothea Lange, Margery Mann, Tina Modotti, Cathy Murphy, Mimi Plumb-Chambers, Reesa Tansey, and Linda Troeller have produced a large body of important work.

10. Quotes from Beaumont Newhall, *The History of Photography: From 1839 to the Present Day* (New York, rev. and enlarged, 1978), 150; Hansel Mieth Hagel, interview by the author, Jan. 9, 1981, Santa Rosa, California, author's possession; Dorothea Lange, "The Making of a Documentary Photographer," oral memoir by Suzanne Riess, 1968, 206, Regional Oral History Project. On the need for words to explain photographs, see Alfred Appel, *Signs of Life* (New York, 1983). On captions, see Eugenia P. Janis and Wendy MacNeil, eds., *Photography Within the Humanities* (Danbury, Conn., 1977), 35; Johanna Neuman, *Lights, Camera, War: Is Media Technology Driving International Politics?* (New York, 1996), 71, 79; Oscar Handlin, *Truth in History* (Cambridge, Mass., 1979), 236–43. See also Arthur Rothstein, *Words and Pictures* (New York, 1979). I have spent considerable time trying to correct captioning errors and misidentifications. For example, a photograph of Mexican field hands loading oranges at Santiago Orange Growers Association (an antecedent of Sunkist) was dated to the 1890s in Pamela Hallan-Gibson, *Golden Promise: An Illustrated History of Orange County* (Santa Ana, 1986), 152. This was an obvious error, as the modern rubber tires on the bobtail truck and the attire of the men indicate that they were braceros from at least the 1950s. The original image is in the

Charles Bowers Memorial Museum, Anaheim, California. Even sillier was the mistake in T. H. Watkins, *California: An Illustrated History* (New York, 1973), 409. Publishing an image of lettuce pickers working in the fields during the 1936 Salinas Valley lettuce strike, Watkins identified a crew of Filipino men as black field hands imported to work as strikebreakers. Nothing of the kind ever occurred; blacks never harvested lettuce in the Salinas Valley. The original image is in the California Room, San Francisco Public Library. Although unattributed, it is probably by a San Francisco press photographer. Another commonly misidentified Dorothea Lange photograph is usually captioned "Hop Harvesting, Wheatland, 1935," but, in fact, depicts construction work. See *Dorothea Lange: Photographs of a Lifetime*, essay by Robert Coles, afterword by Therese Heyman (Millertown, N.Y., 1982), 57. The miscaptioning was apparently Lange's error. On caption-ing, see also Susan Sontag, *On Photography* (New York, 1973), 70–71, 108–9.

11. *The Documentary Photograph as a Work of Art: American Photographs, 1860–1876* (Chicago, 1976), 17–22; Bill Moyers, "History Still Matters," *San Francisco Chronicle*, May 11, 1986; David J. Garrow, *Bearing the Cross: Martin Luther King Jr. and the Southern Christian Leadership Conference* (New York, 1987); Garrow, *Protest at Selma: Martin Luther King and the Voting Rights Act of 1965* (New Haven, Conn., 1978), 160; Harold M. Mayer and Richard C. Wade, *Chicago, Growth of a Metropolis* (Chicago, 1969), vii–ix; James Borchert, "Analysis of Historical Photographs: A Method and Case Study," *Studies in Visual Communication* 7 (fall 1981), 31. See also William Shawcross, "A Tourist in the Refugee World," in Carole Kismaric, ed., *Forced Out: The Agony of the Refugee in Our Time* (New York, 1986), 30.

PHOTOGRAPHING
FARMWORKERS

in California

The visual history of California farmworkers begins during the summer of 1767 in Baja California, where Father Ignacio Tirsch, a Bohemia-born Jesuit who had arrived in Baja California five years earlier, climbed to the roof of a mission church at San José del Cabo mission and created a vivid watercolor, with an almost medieval look, of field hands, represented as small and dark figures, who carry sacks of grain, run across a bridge, and bend under the weight of their burdens. With the sun setting on the horizon and supervisors dressed in archaic costumes looking on, the painting projects an idealized sense of ordered beauty in what seems to be a lively, self-sufficient agricultural community. Over the next eighty years, as field hands from the Baja California missions were marched north to help Franciscan padres found the first of twenty-one Spanish missions in Alta California, the depiction of native field hands hardly changed. Although tens of thousands of native field hands were gathered on to the missions of Alta California and at one point constituted fully one-third of the mission population, another nineteen years would pass before an artist even bothered to include a farmworker in a picture.

On those rare occasions when they did notice field hands, artists followed Tirsch's approach. Drawing maps and sketching landmarks, birds, plants, Hispanic women, and Spanish soldiers but largely ignoring a countryside that during the grain harvest teemed with agricultural activity, mission-era artists—unlike their European counterparts at this time—ignored bulging muscles and human anatomy and reduced field hands to tiny decorations in idealized landscape sketches or ephemeral elements in sketches of mission life. With essential and even picturesque features of farm labor undocumented, the visual record contributes little to the debate over the thousands of natives who harvested and tended the crops required to feed the Spanish outposts that would eventually extend along the coast of Alta California as far north as present-day Sonoma. Rarely painted and sketched during the 1820s and 1830s, thousands of field hands employed on hundreds of newly established Mexican ranchos also suffered from a kind

From Sketch Artists to Lensmen

of visual amnesia, interrupted only by a few scattered water-colors of men rendering tallow or surveying the aftermath of the *matanza*—the cattle slaughter.

Not until a few years after the Gold Rush, when thousands of fortune-seeking men poured into the state and agriculture underwent explosive growth, did photography begin to enter the world of California farmworkers, and then only peripherally. At this time, photographs came only in the form of the daguerreotype, a remarkable process that had been invented by Louis Daguerre in France in 1839. Direct positive images imprinted on silver-plated copper, daguerreotypes were small, one-of-a-kind works of art. Few, if any, recorded people at work in the fields. Market factors and logistics dictated that daguerreotypists capture images that sold. And what sold on the broad market were not images of farming and farmworkers but rather anything having to do with mining, coupled with the usual array of commercial work within easy reach of the daguerreotypist's studio—the new storefront, home, or machine.

Beginning in 1851 or 1852, large numbers of former gold miners moved into farmwork and began commissioning daguerreotype portraits. After sitting for three daguerreotypes at Charles E. Hamilton's Washington Street studio in San Francisco on May 8, 1858, Mountain View field hand Alfred Doten enclosed them in leather cases with a lock of hair and sent them back home, along with a description of his new life in California. The portraits were illusions. Dressed in "California fixin's"—which one field hand described as "check shirt & overalls—shirt collar standing up over his ears—hat on"—these daguerreotypes were little more than theatrical narratives. And very expensive. Three images cost five dollars, far beyond the means of natives who handled most of the farmwork at this time. Few of these daguerreotypes have survived. Today all that remains is a single image of jumbo potatoes arranged in a still life, apparently to record the results of John Horner's record harvest near San Jose mission in 1852; an unsigned drawing of native field hands at John Sutter's Hock Farm near Marysville, based on a daguerreotype

done by John Wesley Jones in that same year; and a group portrait of Mechoopda field hands posed with John Bidwell on the steps of his store at Rancho Chico about 1852.

With no dependable market, most daguerreotypists had little inclination to record field hands. But even in those rare instances where they documented agriculture during the early years of the Gold Rush, daguerreotypists demonstrated no interest in any of the harsh realities or salient details of farmwork. They saw no news value in natives who had been kidnapped or native children working under indenture arrangements. Nor were they interested in living conditions, work accidents, the work motions of men swinging scythes, or members of an outcast class or underclass requiring documentation. Despite their talents and expertise, photographers remained essentially businessmen and friends of agriculture and, notwithstanding a certain creative and artistic flair, preferred to duck the issues. They did not see photography as a voice for transcendent moral values, a way to inspire or express political feelings, or a mechanism for changing society. They lacked not only the ability but, more important, the will to criticize the status quo, interpret the world before them, humanize the story of farm labor, or see farmworkers as individuals. Their images, however enchanting and astonishing and however valuable as artifacts, ignored the low points in the historical record and neither confronted directly life or labor in the fields nor valued what Lewis Hine labeled "social photography" and art historian Paul Von Blum calls an "attitude of engagement."

Native field hands had neither reason nor opportunity to obtain a daguerreotype. Many were indentured laborers, had no access to studios, little use for daguerreotypes, and neither the money nor desire to commemorate their hard labor in the fields. Certainly the main reason people frequented daguerreotype studios—to have a likeness made for shipment to relatives back home as evidence of their success or survival—had no meaning whatsoever to native field hands, their tribes, or their families. Anglo field hands wishing to record their image encountered a new photographic medium toward the end of

the 1850s—the tintype. A thin piece of iron sheeting coated with black lacquer, the tintype was cheap, usually costing only ten to twenty-five cents each, and small, with an average size measuring 2 ¼ by 3 ½ inches. Studios known as gem galleries provided postage-stamp–sized tintypes for as little as twenty-five cents per dozen, something even the lowest paid field hand could afford.

During the early 1860s, an even more popular and economical process known as wet-plate collodion photography quickly replaced daguerreotypes and tintypes. With glass-plate negatives, photographers could make an unlimited number of inexpensive prints from a single exposure. Soon farmworkers of all backgounds began posing for small and economical photographic prints known as *cartes de visite* (calling cards). Measuring 4 by 2 ½ inches and costing about twenty-five cents, *cartes de visite* (which came in several other sizes) were common from 1861 to about 1890. After about 1867, farmworkers could also sit for larger cabinet-card portraits measuring 6 ½ by 4 ½ inches and costing about fifty cents. Whichever image type they chose, farmworkers could easily mail the photographs to friends and relatives. But even as they became the most popular method for making portraits, *cartes de visite* and cabinet cards did not substantially alter the appearance of farmworkers. As with daguerreotypes, well-washed and trimmed farmworkers dressed in neat clothes, sat on a stool amid props, and projected an air of accomplishment. Hardly authentic representations of their actual situation, *cartes de visite* and cabinet cards, noted one critic, had a certain "resistance to meaning."

Compounding these distortions, early camera technology constricted the technique of photographers working outside of the studio. A glass-plate photographer employed a staggering amount of equipment that often required several hours to assemble. Awkward, cumbersome, and tedious even within the predictable confines of a studio, wet-plate collodion photography became even more difficult in the field, where the photographer had to work within the confines of a small, portable, dark tent. This usually prevented photog-raphers from recording anything other than posed scenes. Action was out of the question. And while the wet-plate process finally allowed photographers to make pictures that were large enough to convey a sense of life and labor in the fields, market realities still dictated how, when, where, and why farmworkers were photographed.

Hired to document crops, machinery, fields, and farms, wet-plate photographers followed prevailing notions of the picturesque. Stressing productivity and beauty, photographers used farmworkers as decorations in compositions displaying big alfalfa fields, gigantic fruit drying operations, lush grape crops, or the bounty of this or that agricultural region. Typical of this approach was a photograph taken of winemaking at L. J. Rose's Sunny Slope Vineyards (near present-day Pasadena) in 1864. To commemorate his first vintage, Rose hired Los Angeles photographer William M. Godfrey. Following standard photographic practices, Godfrey gathered a group of sixteen Mexican and Indian harvesters for a group portrait. Posing them with fifty-pound boxes and baskets of grapes, he positioned Rose atop a two-thousand-gallon vat and directed an overseer to stand in the right foreground. With Rose dressed in a white shirt, dark vest, and fancy hat, the picture had little to do with documenting the workers or their labor, and everything to do with recording Rose's triumphant moment. Although several of the field hands shortly dumped grapes into the vat, stripped naked, and began tramping out the vintage, Godfrey did not record their work. There was simply no interest in, or market for, such images.

Although hardly motivated by a desire for social betterment, wet-plate collodion photographers slowly began to expand the number of images of farmworkers. Taking the lead in this effort was Eadweard Muybridge, an English-born photographer who had changed his name from Edward James Muggeridge. Arriving in California in the 1850s, Muybridge had moved from bookselling into photography, and after completing assignments for the U.S. Coast Guard and Geodetic Survey, expanded into full-scale commercial work and began prospecting scenes throughout northern Califor-

nia. Advertising that "HELIOS is prepared to photograph private residences, animals, or views in the city or any part of the coast," he visited Buena Vista Vineyard and Winery in Sonoma in 1872, where he used both his regular view camera (mainly for his patrons) and a stereoscopic camera (for the larger mass audience) to produce a massive photographic record, the equivalent of the first photographic essay on vineyard labor in California. Returning again the following spring and summer to complete a series he called *The Vintage in California*, Muybridge surveyed every aspect of the grape harvest and wine-making operations. He was especially attentive to creating optimum visual effects and composed his stereoscopic views with items of interest in both foreground and background.

Marketed aggressively by the Bradley and Rulofson Art Gallery in San Francisco, Muybridge's images were displayed at public exhibitions and fairs and made available to a wide viewing audience that otherwise would never have seen farmworkers. Of the twenty-eight stereoscopic views of Buena Vista Winery offered for sale in *Catalogue of Photographic Views Illustrating the Yosemite, Mammoth Trees, Geyser Springs, and other Remarkable and Interesting Scenery of the Far West*, all but five included farmworkers. Most were Euro-Americans. They loaded grapes; drove wagons; hauled pomace away from the winery; washed, filled, and labeled wine bottles; disgorged sediment from champagne bottles and recorked them; made barrels; plowed, planted, and fertilized young grapevines; and pressed grapes. But several of Muybridge's views also depict Chinese field hands in various aspects of winemaking. One of these images, called "The Heathen Chinee Bottle Washer," is a rare picture showing a Chinese field hand playing a prominent role in the country's preeminent winery.

While Muybridge was photographing at Buena Vista Winery, countless rivals were moving into the Central Valley to document the most colorful group of farmworkers in the state—the vast army of men who cut and threshed wheat. Whether they were hired by growers, attracted by the dra-

matic allure of the harvest, or perceived the commercial opportunities of group portraits commemorating a summer's hard labor, early commercial photographers in Healdsburg, Sacramento, Marysville, Fresno, Stockton, and San Francisco immediately recognized the challenges that these men and their machines presented. Posing crews in front of their machinery and arranging them in simulated harvest operations, wet-plate photographers often brought all activity to a halt. If they were in a hurry, photographers simply arranged the men in two or three rows in front of their machinery, but if they had time and the crew was a large one, they might climb onto a wagon to achieve an elevated perspective and arrange everyone in a composition in which the entire crew and its equipment were posed at their various stations, flags flying, and horses at the ready.

Early wet-plate photographers recorded wheat threshers and harvesters in every imaginable way. Some documented crews as they awoke from a night's sleep on a pile of wheat straw, entitling their composition "Sleeping Beauties." Some captured crews moving through town with their cavalcade of equipment, caught them waiting beside their equipment as it was being repaired, or photographed them extracting steam engines that had fallen through wooden bridges or rolled off a ferry while crossing a river. Others focused on field hands hauling heavily loaded wagons full of sacked wheat to river landings. A few photographers even recorded crews in the middle of a threshing job beside the giant grain separator amid a cloud of wheat chaff with key individuals holding their tools. Extremely detailed from edge to edge, these images captured a wonderful and terrible reality.

A few of the more intrepid photographers also found something beyond spectacle. Sometimes it was a particular setting or piece of machinery. During the mid-1870s, many photographers documented Chinese cooks and wheat sack sewers. Others recorded cookshacks and wagons, whose appearance for various reasons attracted their attention. But no matter how thoroughly they surveyed a scene, photographers never really captured everything. Threshing and har-

vesting took up so much of the landscape that it could not fit easily into the arbitrary, rectangular dimensions of most cameras. There were always too many people spread out too far across the flat fields. A photographer standing on ground level—or even on top of a wagon—could never accurately represent wheat threshers and harvesters and their relation-ship to the environment. Struggling with their chemicals and limited by their equipment and technology, early wet-plate photographers simply could not accommodate the wide per-spective required to convey the nature of life and labor in the fields. Well into the 1870s, that task still fell to landscape painters and sketch artists.

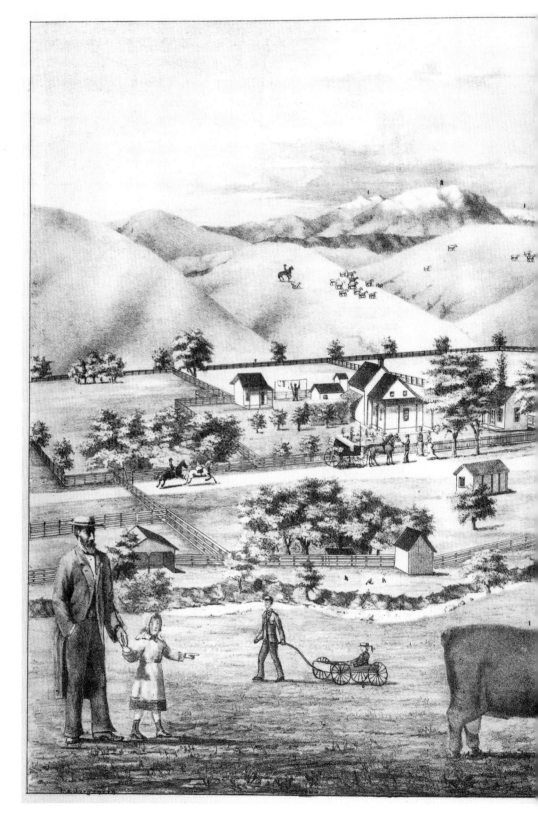

"Allito Farm, Property of U. S. Nye." Artist and lithographer unknown. This illustration, from the collection *Colusa County, California*, is typical of those images depicting an idealized landscape. Reflecting on these lithographs, longtime Colusa County farmer Arthur B. Domonoske recalled: "Strangely . . . [left center] only one person . . . can be positively identified as a Chinaman . . . the loose square cut blouse, baggy pants and queue, or pigtail, wound around his head proclaim the nationality of the man hanging out clothes. . . . On Chinese New Year, these cooks brought the farm family welcome presents of sugar, candy, litchi nuts, China lilies, and the small boy's delight, firecrackers." Elliot and Moore, *Colusa County, California: Illustrations* (San Francisco, 1880), xiv, 151. Artist unknown. Courtesy of the California History Section, California State Library.

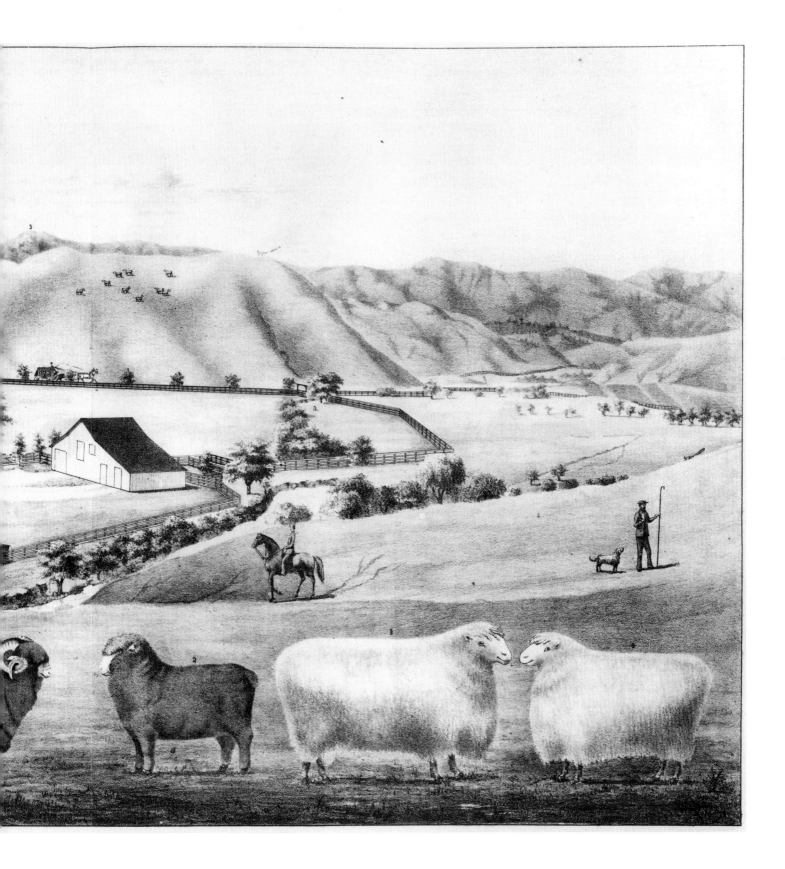

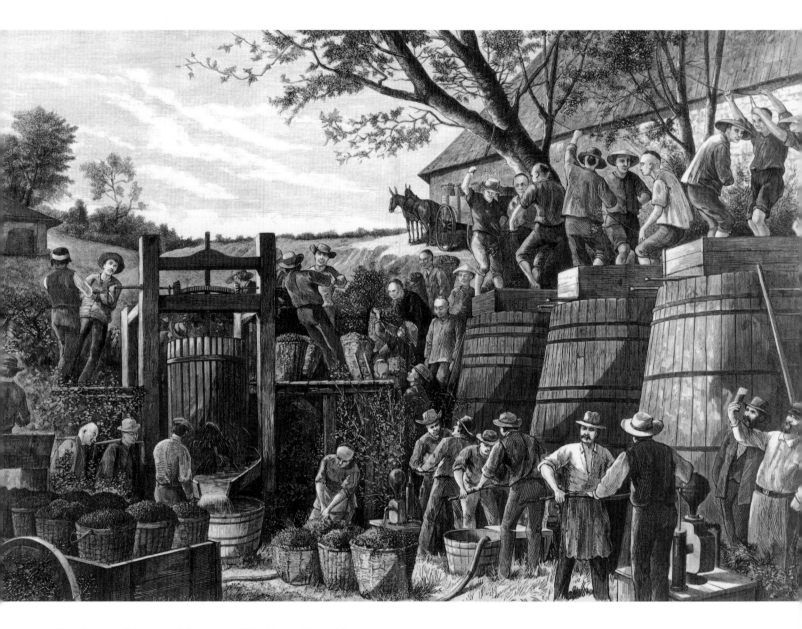

"The Vintage In California—At Work At The Wine Presses," by Paul Frenzeny, provoked a storm of controversy for its depiction of Chinese stomping grapes. Woodcut print from *Harper's Weekly*, October 5, 1878.

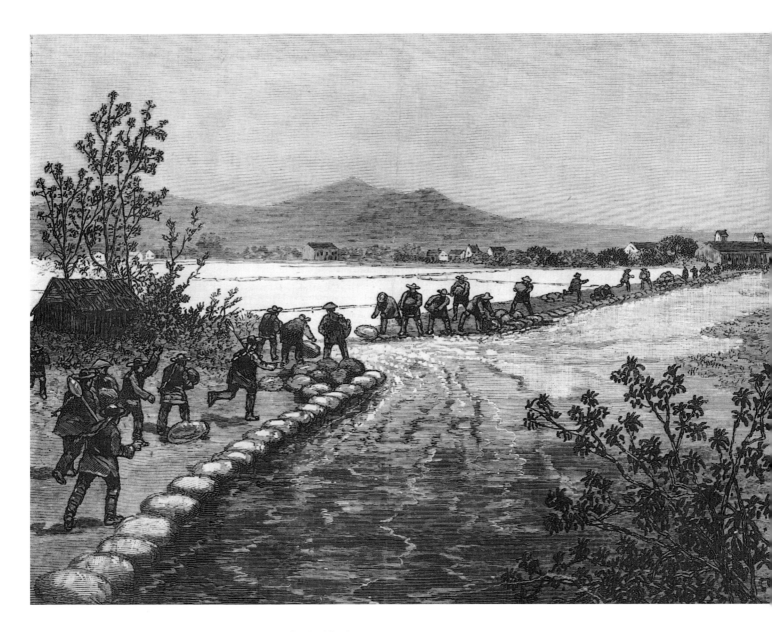

"Breaking of the Foot Levee on San Joaquin River, Four Miles South of Stockton, April 18th, 1884," a rare sketch by F. J. Howell, captured Chinese field hands fighting to save the land that they had reclaimed during the previous fifteen years of mass gang labor. From *Frank Leslie's Illustrated*, May 10, 1884.

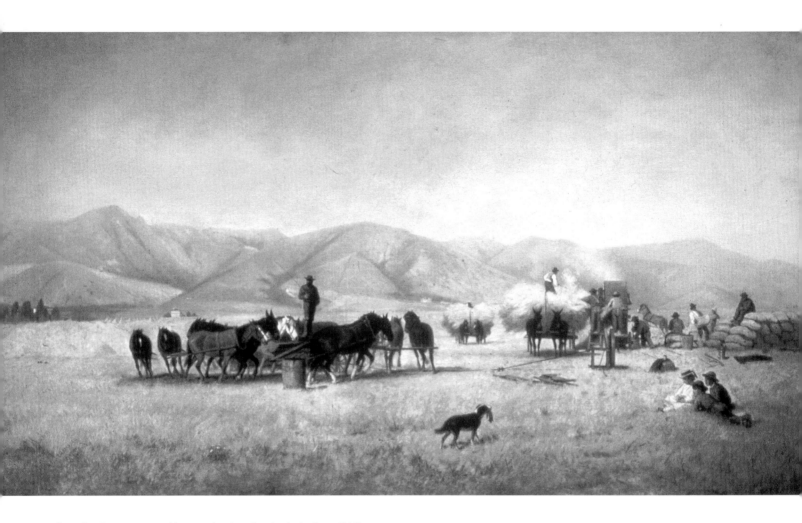

Capturing the emergence of large-scale wheat farming in the Central Valley, William Hahn's "Harvest Time, Sacramento Valley" (1873) was one of the few paintings to depict threshing by horse power. Measuring thirty-six by seventy inches, the action-packed painting still retained romantic touches such as the dog retrieving a squirrel for the children playing nearby. In reality, the men would have been soaked with sweat and the air choked with suffocating wheat chaff. Courtesy of The Fine Arts Museums of San Francisco. Gift of Mrs. Harold R. McKinnon and Mrs. Harry L. Brown.

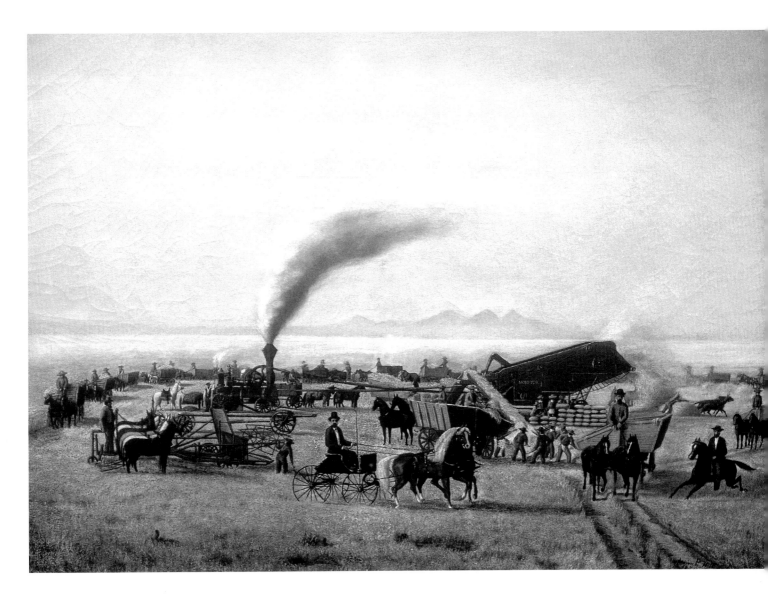

The first attempt at a fully realistic rendering of bonanza wheat harvesting and threshing, Andrew P. Hill's 1876 painting "A California Harvest Scene" was also the first agricultural scene to be widely reproduced and seen by the general public. Courtesy of The California State Library, Sacramento, California.

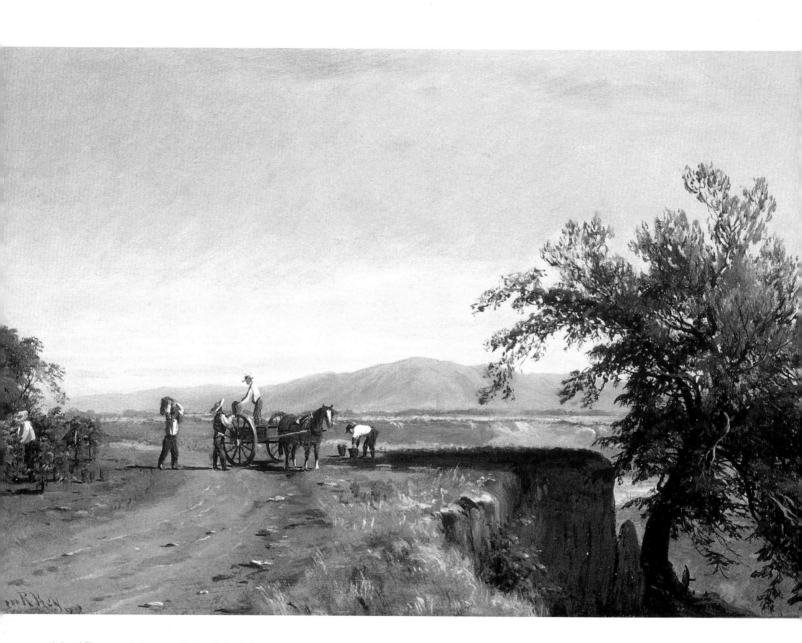

(*above*) The second of two nearly identical paintings, John R. Key's idyllic 1887 representation of grape pickers in General Henry M. Naglee's vineyard compresses the perspective to bring the distant foothills close to the actual location along the Coyote Creek floodplain just north of William Street in present-day San Jose. Anonymous owner. Courtesy of Alfred Harrison, North Point Gallery, San Francisco.

(*right*) Depicting a slow-paced, agricultural paradise, Edwin Deakin's 1874 painting "Farming in the Livermore Valley" was full of clichés and unreal agricultural technology. By this time, no farmer used teams of oxen. Nor did any endanger young children by allowing them to ride on top of a wagon so overloaded with hay that it was in danger of toppling over. Courtesy of the California Historical Society, San Francisco. Gift of Mrs. W. A. Reynolds.

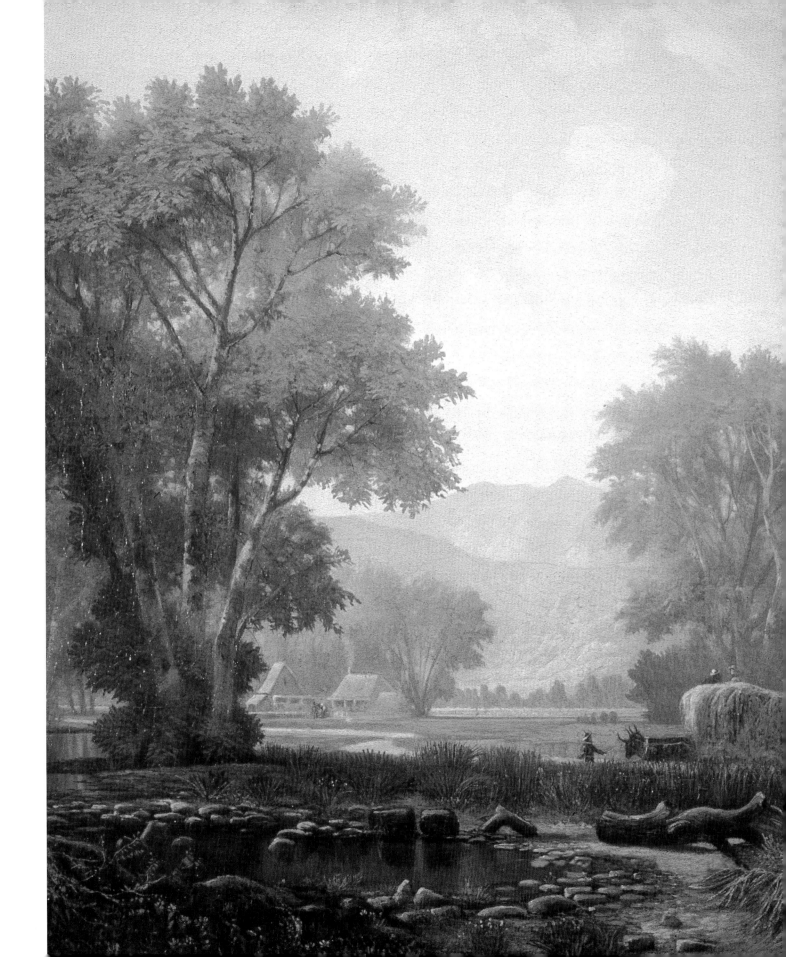

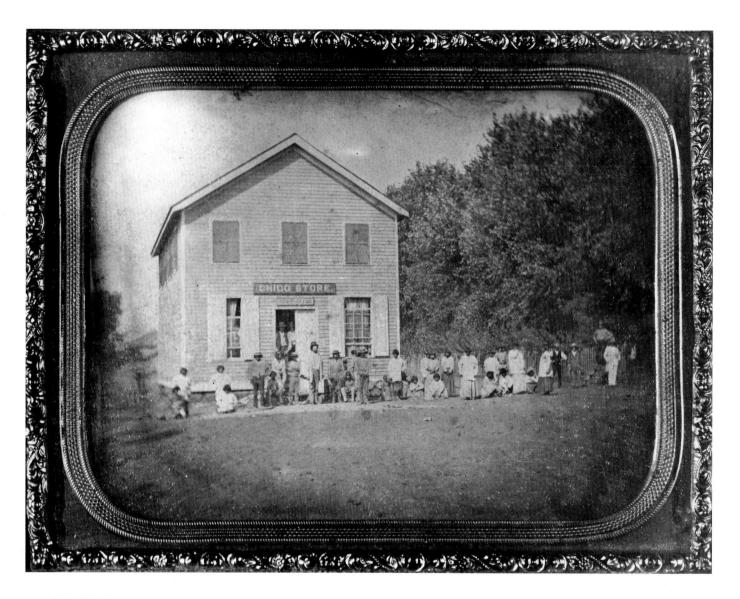

(*above*) "The Chico Store," a quarter-plate daguerreotype, depicts John Bidwell (on doorsteps, center) surrounded by Indian field hands and their families at his general store on Rancho Chico about 1852. It is the earliest surviving photographic image of California farmworkers. Photographer unknown. Courtesy of Special Collections and Archives, Meriam Library, California State University, Chico/Bidwell Mansion State Park.

(*right*) Victoriano, the *alcalde* who had supervised fieldwork at San Gabriel mission, was said to be 136 years old when this photograph was taken about 1885. Photographer unknown. Courtesy of Title Insurance and Trust Photo Collection/California Historical Society, Department of Special Collections, University of Southern California.

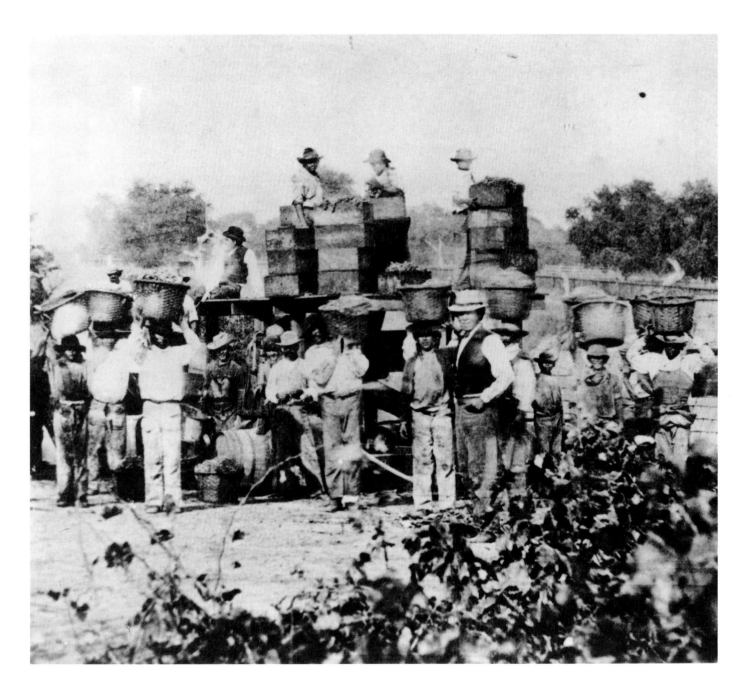

(*above*) Los Angeles photographer William M. Godfrey made this view of the 1864 harvest at Sunny Slope as part of a commission he executed for the L. J. Rose family. Courtesy of the Huntington Library, San Marino, California.

(*left*) Because it was so inexpensive, the tintype was available to everyone, including field hands, such as this pair who posed about 1865. Photographer unknown. Courtesy of Peter Palmquist.

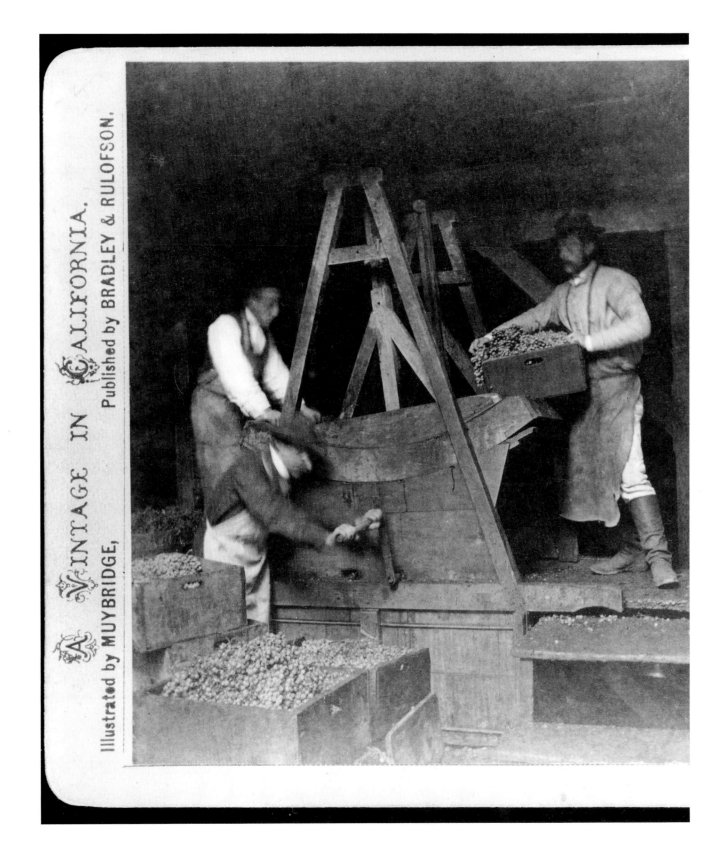

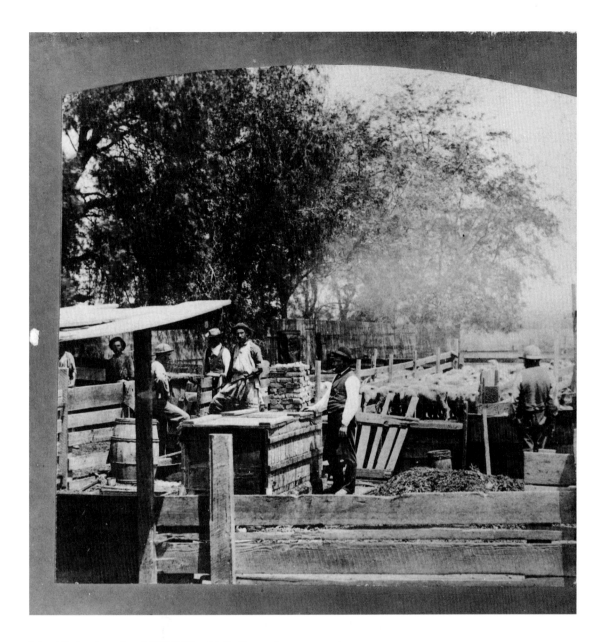

(*above*) During the spring of 1872, William M. Godfrey made a stereograph of field hands at Rancho Los Cerritos dipping sheep. In the center, wearing a vest and white shirt, is Los Cerritos owner Jonathan Bixby. Left frame of the stereograph. Courtesy of Rancho Los Cerritos, Long Beach, California.

(*left*) As part of his survey of Buena Vista Winery during the fall of 1872, Eadweard Muybridge made a stereograph of a man hand cranking the grape crusher as others fed in grapes and tended to the mechanism. Left frame of the stereograph, from the series *The Vintage in California*. Courtesy of the Bancroft Library, University of California, Berkeley.

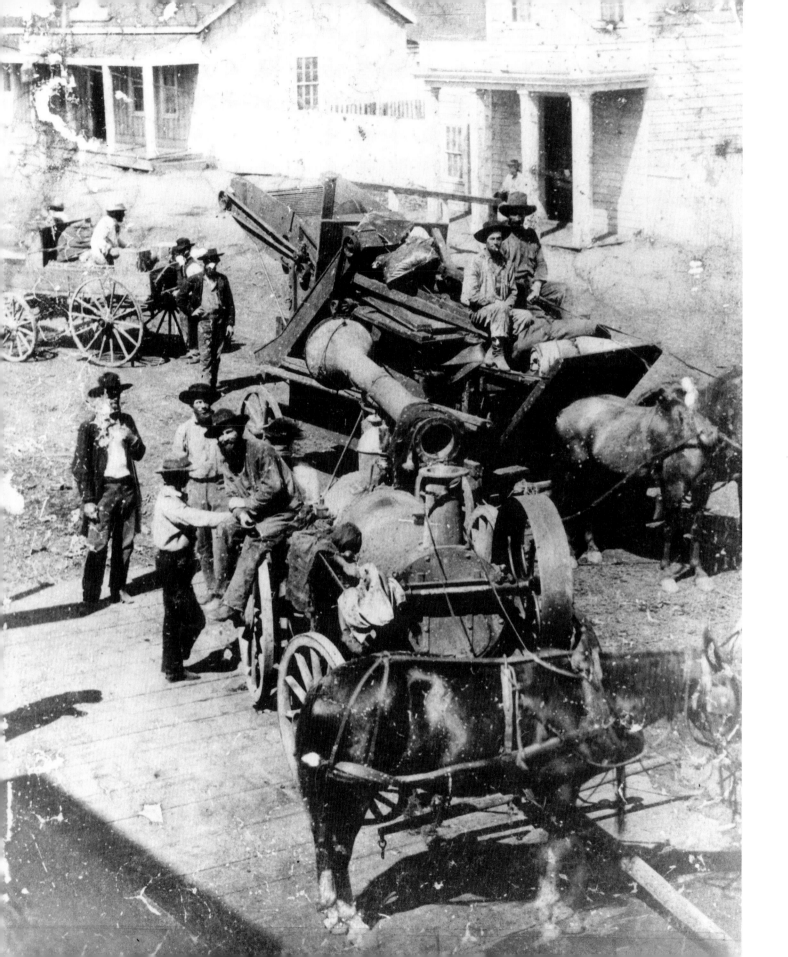

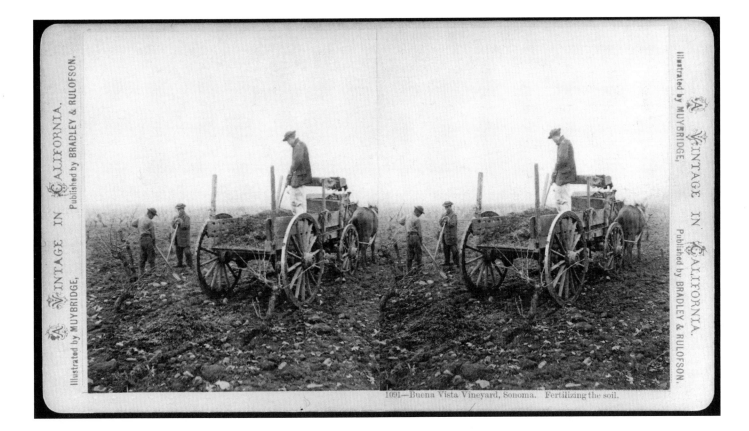

1091—Buena Vista Vineyard, Sonoma. Fertilizing the soil.

(*above*) While surveying operations at Buena Vista Winery in the winter of 1872, Eadweard Muybridge captured a stereographic scene of workers spreading fertilizer in the vineyards on a foggy morning. From the series *The Vintage in California*. Courtesy of the Bancroft Library, University of California, Berkeley.

(*left*) Late in the summer of 1870, when the first steam thresher arrived in the Pajaro Valley, an anonymous photographer shot the outfit as it pulled into town. Courtesy of the Pajaro Valley Historical Society, Watsonville, California.

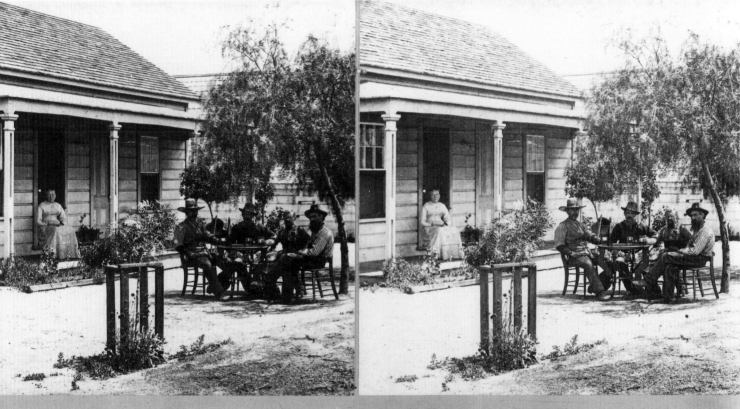

Wine Maker's Cottage, Sunny Slope, San Gabriel. 4802.

(*above*) While surveying operations at Sunny Slope Winery about 1877, Carleton E. Watkins made this stereograph, entitled "The Wine Maker's Cottage." Courtesy of the California History Section, California State Library.

(*left*) One of the first photographers to record Chinese in the wine industry, Eadweard Muybridge made this photograph in Sonoma, at Buena Vista Winery, in 1872. The printed title is "The Heathen Chinee Bottle Washer." Left frame of a stereograph, from the series *The Vintage in California*. Courtesy of the California Historical Society.

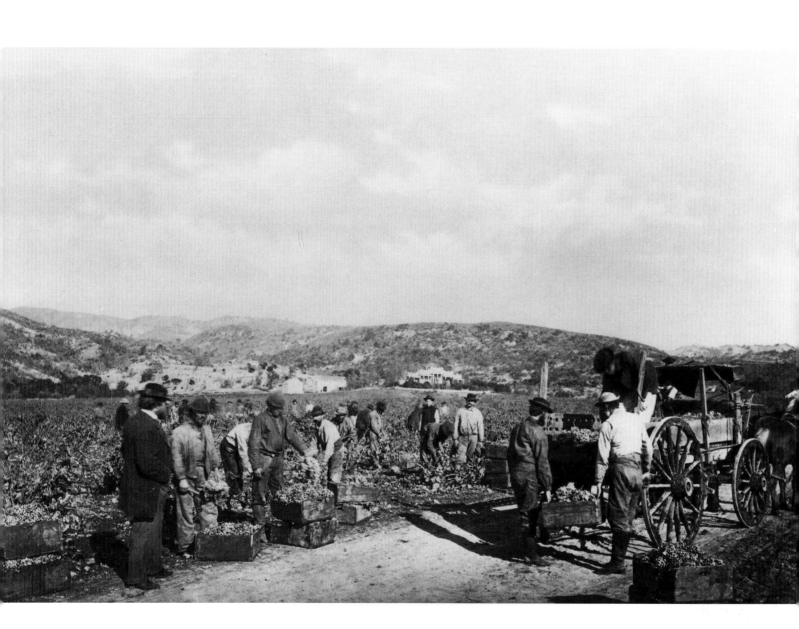

Eadweard Muybridge captioned this image "Loading Grapes, Buena Vista Vineyard, California." The gentleman with a coat in the foreground is probably Captain E. P. Cutler, superintendent of the vineyard. Courtesy of the Wine Institute, San Francisco, California.

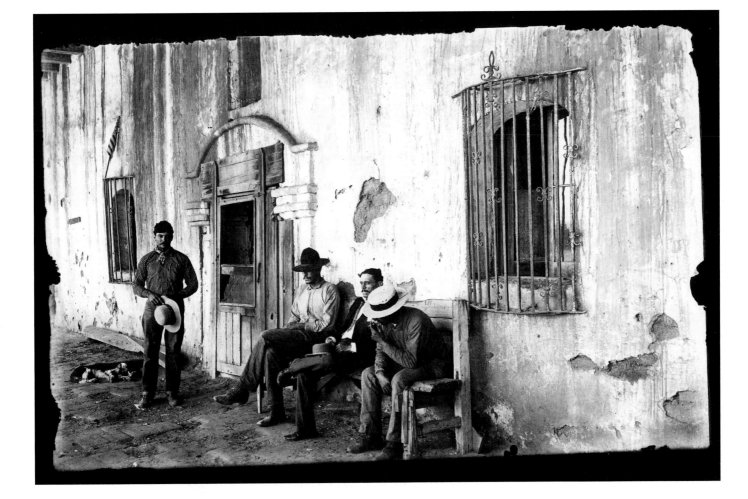

About 1880, Los Angeles photographer Adam Clark Vroman made this portrait
at San Fernando mission. Antonio Bandini is seated between the two field
hands. Courtesy of the Huntington Library, San Marino, California.

From Dry Plates to Halftones

During the 1880s, technology dramatically altered photography's relationship with farmworkers, laying the foundation for a revolution not only in how photographs were made but in who made them and why. At the heart of this change was the introduction of factory-made dry-plate, glass negatives. Precoated with a silver-bromide gelatin emulsion, dry plates were far easier to use than wet plates. Eliminating the need for huge quantities of chemicals and on-site processing, dry plates were also more light sensitive and allowed photographers to employ much faster shutter speeds. For the first time, amateur photographers could record farmworkers under conditions that were not carefully controlled and orchestrated.

This new freedom could not have occurred at a more opportune moment. Following completion of the transcontinental railroad in 1869 and construction of a system of interconnected rail lines within the state, perishable agricultural products were beginning to find a wider market, both within California and in the larger cities of the eastern United States. As a result, California agriculture underwent a rapid and dramatic change. By 1900, the state's farmers were producing 25 percent of the nation's canned fruits and vegetables, 65 percent of the prunes and plums, 18 percent of the pears, 95 percent of the apricots, most of the oranges, lemons, figs, and olives, and a significant portion of the sugar beet crop. Suddenly photographers encountered not only a much broader range of subjects and regions but also a huge, heterogeneous class of farm laborers that had grown from 16,231 in 1870 to 67,493 in 1900. With native field hands dying out and Euro-American settlers increasingly avoiding farmwork, large numbers of Chinese and Japanese immigrants began moving into the fields, often working in proximity (if not directly alongside) family groups from local communities and bindlemen (seasonal migrants who pocketed their belongings in a bindle) who drifted with the harvests. On larger farms, each group lived and worked separately from the other, dividing the most odious and exhausting farm and harvest tasks between them. But on

smaller farms, one or another group often handled the entire harvest.

Quickly adopted by both professional and amateur photographers, the new dry-plate technology dramatically expanded coverage of farmworkers and soon yielded a series of spectacular surveys. The first of these was completed in 1886 by George C. Husmann, the manager of Vina, Leland Stanford's gigantic, ultramodern wine-making operation in the northern Sacramento Valley. Acquiring a six-by-eight-inch camera in the fall of 1886, Husmann recorded every aspect of life and labor around Vina, bound his best photographs together in a thick album, and presented it as a gift to Leland Stanford. Capturing the complex work arrangements on the largest winery in the world, Husmann's sharp, well-composed, and perfectly exposed pictures went far beyond Muybridge's earlier effort at Buena Vista Winery, illustrating the high technical quality that even a talented amateur photographer, with less than a year's experience, could achieve.

Another important body of work was produced in 1887 by San Francisco's W. R. Nutting. Owner and manager of the California View Publishing Company, Nutting decided to publish a series of illustrated books on aspects of California. Beginning his series by focusing on farming around Vacaville, Nutting in 1885 hired *Pacific Rural Press* editor Edward J. Wickson to write *California Illustrated No. 1: The Vacaville Early Fruit District*. After Wickson completed the text, Nutting, who had learned to photograph for the specific purpose of illustrating this book, used it as a shooting script and made several hundred photographs documenting everyone and everything Wickson had mentioned. A lively and informed account of the challenges, geography, and day-to-day activities of fruit farming in what was, at that time, the state's premier agricultural district, *The Vacaville Early Fruit District* was not specifically concerned with farmworkers. But by surveying every aspect of fruit culture, as well as various crop varieties, packing sheds, and fruit drying yards, it necessarily included a farmworker in virtually every image.

Although reviewers praised the book lavishly, no one at the time used the term "photo essay" to describe the layout. Nevertheless, the technique employed by Nutting—of first producing a text and then fleshing it out in a sequenced series of images—resembles the way photo essays are produced by magazines such as *Life* and *National Geographic* a half-century later. More important, the close linkage of words and images was very effective. Reviewers immediately identified with this quality. Contrasting the book with the profusion of cheap, quickly forgotten pamphlets that were produced by various communities at the time, they praised *Vacaville Early Fruit District* as a work that would be "saved up, read and re-read by the seekers after knowledge of this country." What particularly attracted readers were the eighty-six colored lithographs produced by San Francisco printer H. S. Crocker and Company, which were made by artists who visited the location of every scene with the original photographs in hand in order to note the proper colors. Filling the first section of the book, these images—the first sustained effort to capture farm labor and agriculture in color—provoked extensive praise as the equal of anything done on the Atlantic Coast. All three thousand first edition copies sold out at one dollar each, as did a second edition published in May 1888.

Of all these photo surveys, none surpassed the work done by renowned landscape photographer Carleton E. Watkins in the San Joaquin Valley in 1888. Employed by land barons James B. Haggin and Lloyd Tevis, and cattle magnates Henry Miller and Charles Lux (who later formed Kern County Land Company), Watkins conducted a massive photographic reconnaissance that surely drained the fifty-eight-year-old photographer, who for years had suffered from rheumatism and leg problems. Work must have proceeded very slowly, as Watkins transported equipment between widely scattered sites, averaging about ten photographs each day, with between three and six scenes at each site. Most of his pictures suggest a routine of taking an overview, photographing the entrance to a farm, then moving on to document barns, stables, horses, orchards, fields, an artesian well, a special cow,

a champion racehorse, an especially fine garden, or some special asset. Farmworkers apparently qualified as among those special assets, and Watkins seems to have moved among them freely, capturing them in the middle of activities like hitching up teams, irrigating, plowing or cutting hay, or resting in the shade at ranch headquarters.

To overcome the limitations of the flat landscape, Watkins documented many farmworkers from an elevated perspective, climbing to the roof of a building whenever possible or photographing from atop his traveling wagon, usually in the soft light of early morning. He paid especially close attention to various ethnic groups and went to great pains composing some unusually fine images. Outside Tejon Ranch headquarters, he posed a Mexican in full regalia with a huge knife. The man appears in a number of photographs taken on the ranch and in several other locations, both alone and with many different groups, an amount of attention suggesting that he was a trusted *mayordomo* (foreman). Watkins also photographed Chinese field hands employed as milkers, hay stackers, irrigators, boiler tenders, and, perhaps most important, cooks posed alongside a family on the porch of a fine building in a way suggesting their key role and elevated status. Of all his farmworker photographs, by far the ones that seemed to most inspire Watkins were those centered on wheat threshing. To illustrate the work, Watkins made a sequence on the Greenfields Ranch in which he moved progressively closer. In the last of five photographs, he framed a threshing crew with heavy black machinery and obscuring clouds of dust to create a haunting portrait of nineteenth-century men engaged in hot, dirty, dangerous, exhausting farm labor.

At the end of his sojourn, Watkins had 756 views of Kern County, roughly one-third of them focusing on farmworkers. But while the work was widely praised and provoked intense curiosity and admiration, it never became a probing force for change. Like most photographers of the era, Watkins did the bidding of his employers. Hired to produce beautiful photographs, not to probe the status of farmworkers, Watkins saw no reason to stress their hard life, had no interest in scrutinizing their working conditions, and depicted farmworkers essentially as props or elements of scale in his landscape photographs. But even if Watkins had been inclined toward a more critical perspective, his work would have remained unseen except by those able to afford his albums or attend his exhibition at the Mechanic's Institute Faire. Photographers of California farmworkers needed a new mechanism of mass reproduction in order to reach the general public. When the technology finally emerged toward the end of the nineteenth century, it dramatically increased the demand for and use of photographs of farmworkers.

Essential to the change was the introduction of the halftone process, which allowed publishers to reproduce photographs without employing a specialized artist to redraw them for the printing plate. Far more accurate than any previous process, halftones (in which the gradation of tone from black and white is obtained by a system of minute dots) preserved a wealth of detail and most of the tonal qualities of the original images, while allowing publishers to publish unlimited numbers of images quickly, faithfully, and economically. As agricultural journals like the *Pacific Rural Press* quickly incorporated halftone reproductions onto the front page of their publications, photographers began supplying images of virtually every kind of agricultural activity. With the halftone process, farmworkers became common sights in the pages of the farm press and rural press. But the way in which they were portrayed—as props in a commercial photograph or elements of scale in a landscape—did not change.

Just as new publishing technologies failed to alter established patterns, so too did the democratization of photography fail to produce new forms of representation. When prosperous Chinese cooks and Japanese labor bosses finally acquired the means to commission portraits, they visited a studio rather than hiring a photographer to come out to the field. Seeking to display their status for relatives and friends back home, they sat or stood in front of painted, orientalized canvasses in carefully staged, well-scrubbed portraits. They also posed standing proudly on the front steps of the home

where they worked and lived or at the back door to a cook-shack where they fed hungry threshing crews.

Although passage of a series of laws designed to curb Chinese immigration required each immigrant to obtain a passport photograph, these mug shots revealed little about life and labor in the fields. Further distorting the picture of farmworkers at this time was the way photographers shamelessly romanticized the dwindling numbers of native Californians. Focusing on anything that appeared different or exotic and therefore salable, photographers like George Wharton James, Frederic Hamer Maude, and Adam Clark Vroman never passed up an opportunity to record Indians picking hops, threshing grain crops, or otherwise displaying further evidence of a people in the last throes of extinction. A few were not above fabrication. Capitalizing on the popularity of Helen Hunt Jackson's 1884 novel *Ramona*, Ventura photographer John Calvin Brewster built a thriving business around a series of thirteen images reenacting the story of Alessandro, the noble, full-blooded Indian field hand, and Ramona Ortenga, the beautiful Scottish-Indian half-breed, as they meet, fall in love, and cavort at Rancho Camulos according to scenes from the novel.

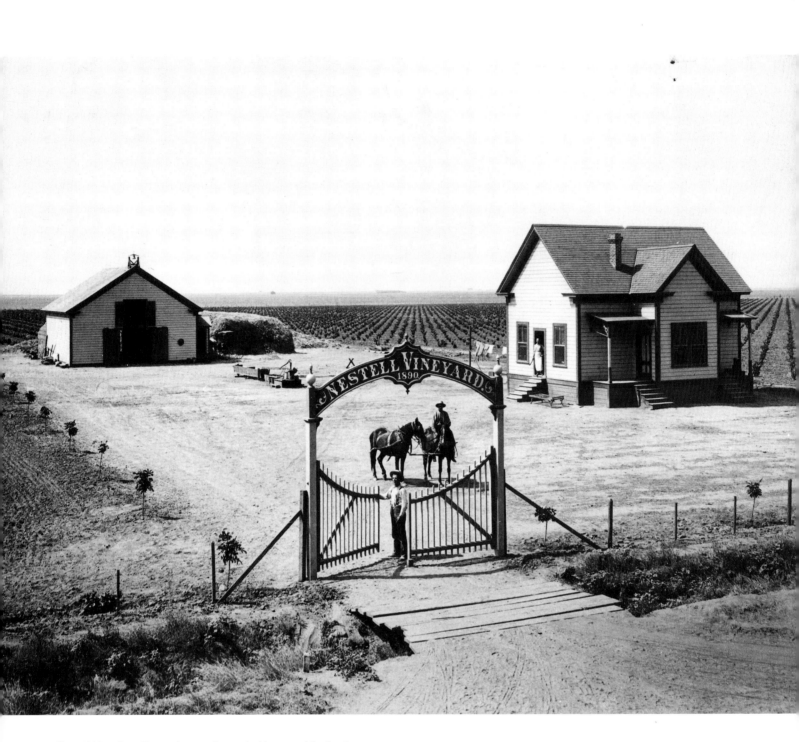

About 1890, a clever Fresno photographer made this composition framing a field hand as he opens the gate to work in the surrounding vineyards on the Nestell Vineyard. Photographer unknown. Courtesy of the Fresno County Historical Society, Kearney Park, Fresno.

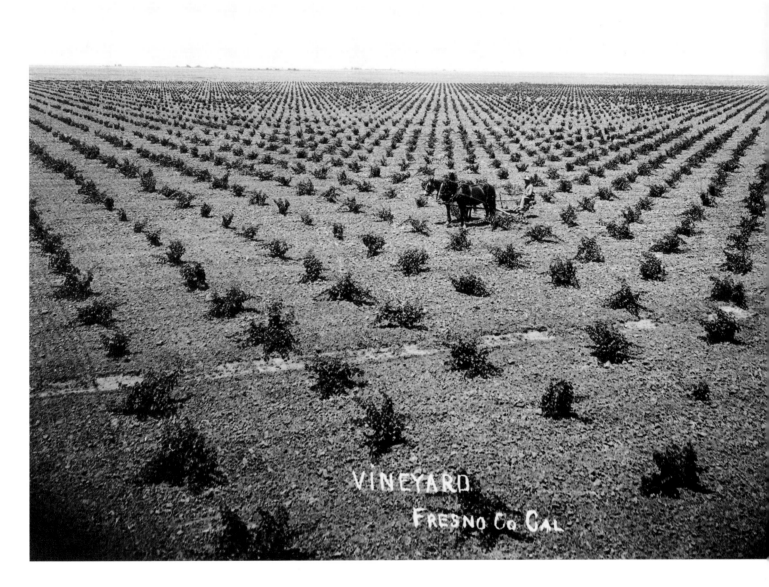

VINEYARD

FRESNO Co CAL

A year later, the same photographer who had photographed the Nestell Vineyard transformed the hot and monotonous task of plowing newly planted, head-trained vines on the Avellana Vineyard into a beautiful landscape photograph. Photographer unknown. Courtesy of the Fresno County Historical Society, Kearney Park, Fresno.

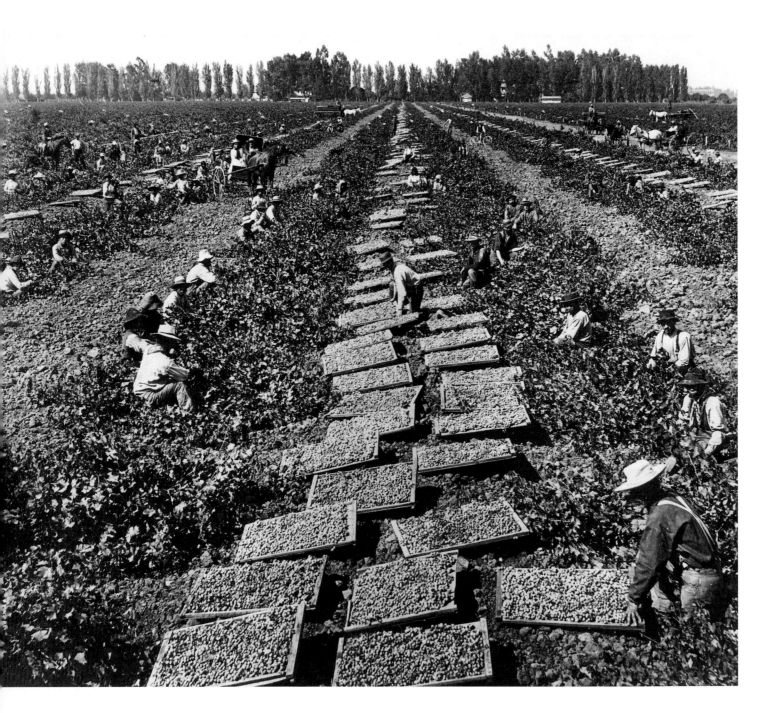

When the newly planted Hedgerow Vineyard was ready to harvest, a Fresno photographer traveled out and arranged this scene, complete with owner Minnie Austin, dressed in white, supervising workers laying the grapes on drying trays. Photographer unknown. Courtesy of the Fresno County Historical Society, Kearney Park, Fresno

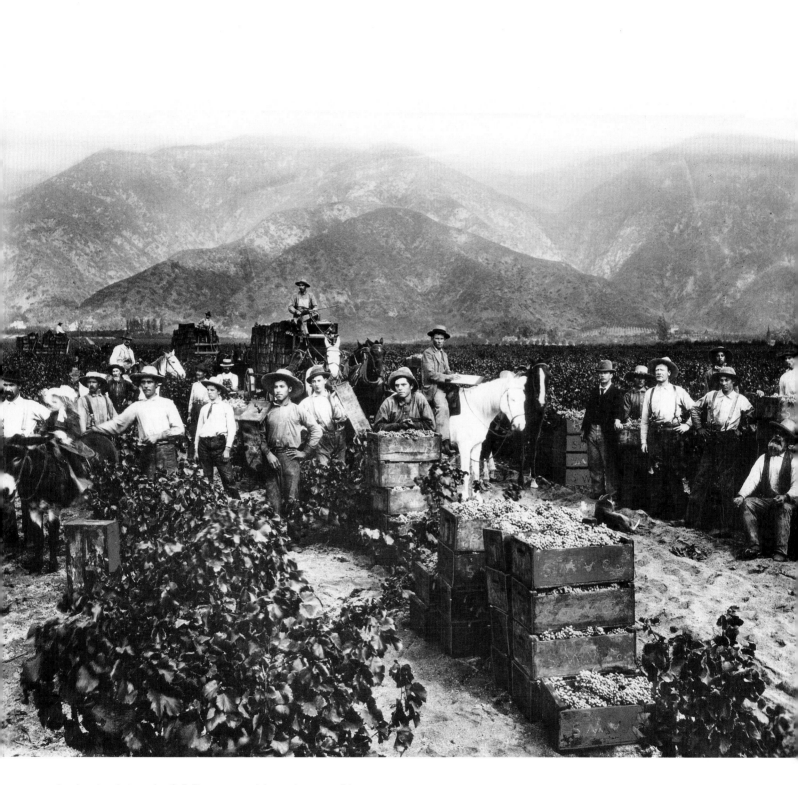

Los Angeles photographer C. C. Pierce arranged these wine grape pickers on the Hastings Vineyard near Pasadena about 1898. Courtesy of the Title Insurance and Trust Photo Collection/California Historical Society, Department of Special Collections, University of Southern California.

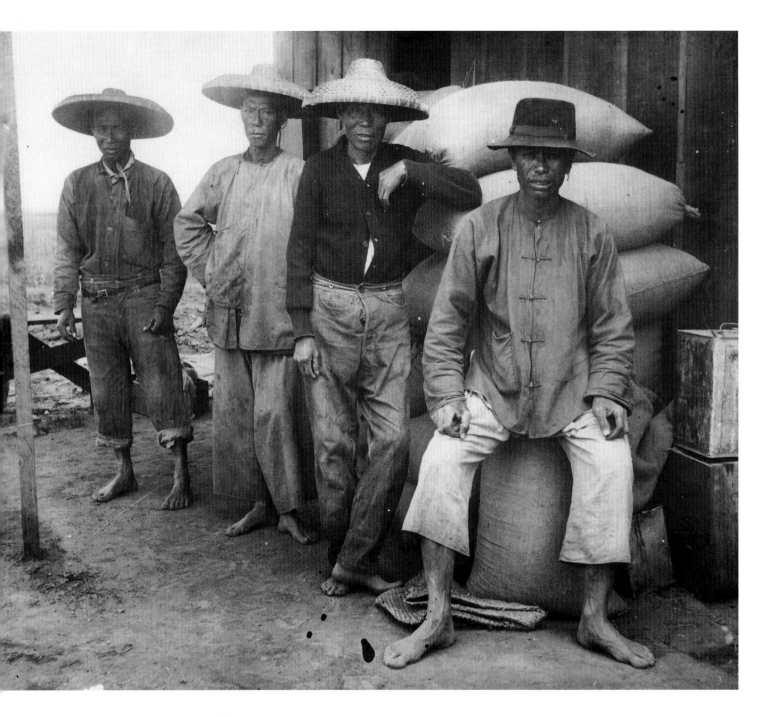

Los Angeles photographer, possibly C. C. Pierce, traveled to the San Fernando Valley in the fall of 1898 to record the wheat harvests. While there, he made this unique portrait of Chinese sack sewers and stackers. Because the little canvass awning that shaded them from the sun and showers of wheat resembled a doghouse, they were often referred to as "the doghouse crew." Courtesy of the Huntington Library, San Marino, California.

34

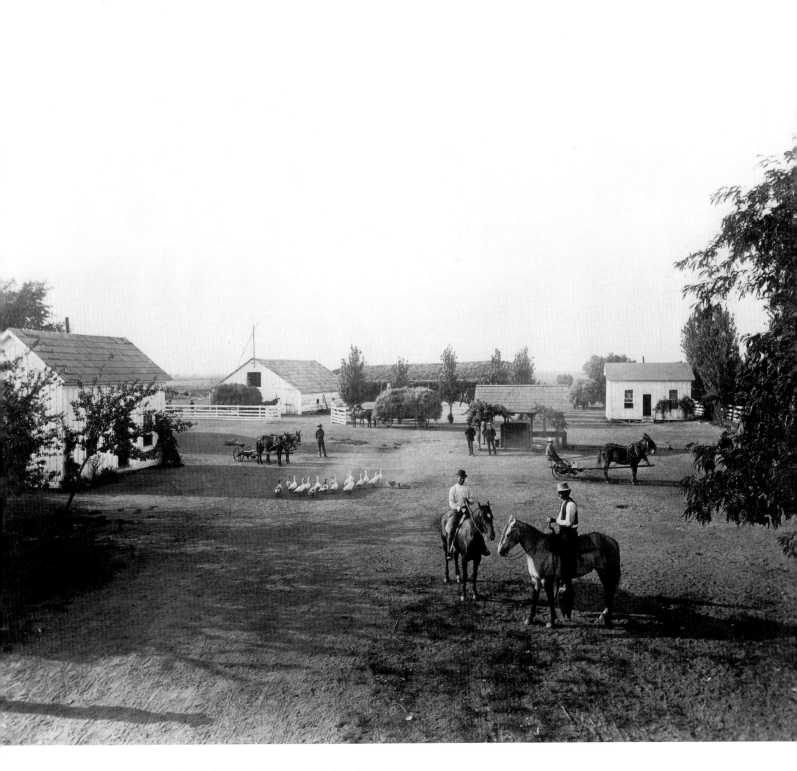

Sculpting the scene in the early morning light and photographing from the roof of
a nearby building on the Lakeside Ranch, south of Bakersfield, Carleton E. Watkins
captured this picture of mowers moving out and crews delivering their first loads
of hay as two authoritative ranch managers stand by the roofed artesian well, one
of five on the property, which produced thirty thousand gallons of "splendid" water
each day. Photograph 1888. Courtesy of the Library of Congress.

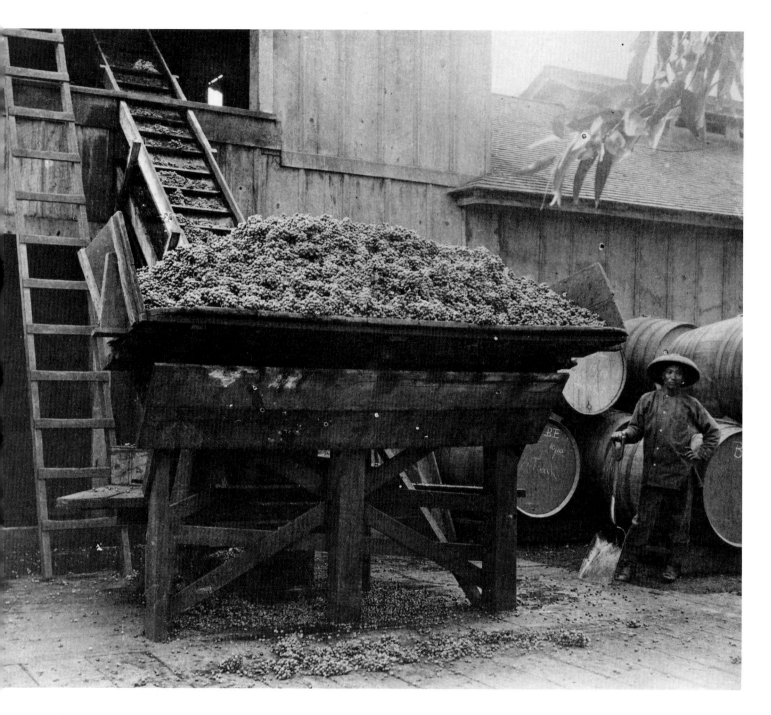

"On the Endless Belt Going to the Crusher" is the title of this photograph of
Chinese field hands bringing in the grapes at Fair Oaks Winery in the San
Gabriel Valley, about 1890. Photographer unknown. Courtesy of the Huntington
Library, San Marino, California.

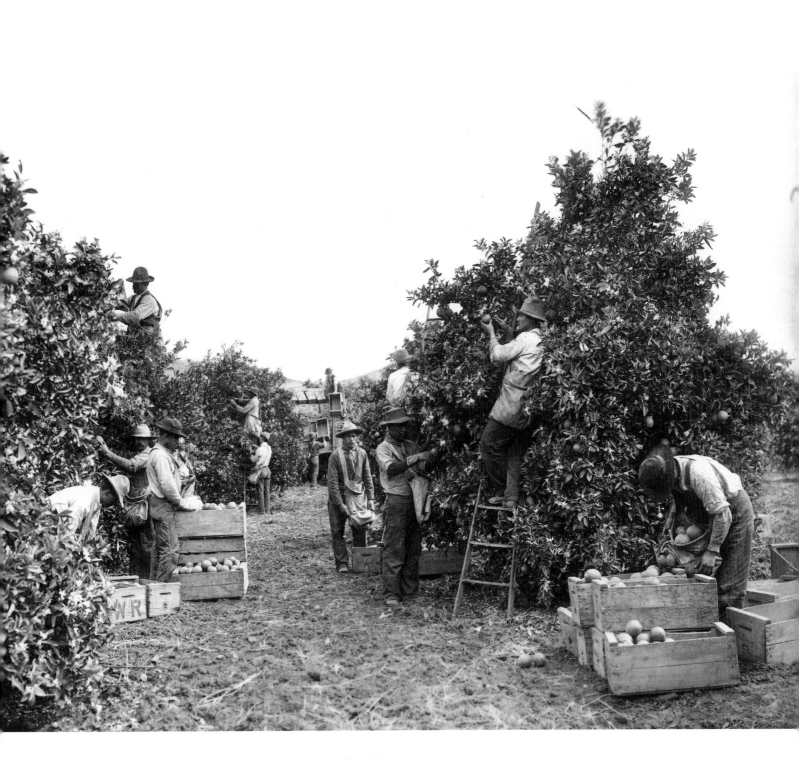

This classic photograph of Mexican field hands picking citrus around Riverside in 1890 was repeated with minor variations thousands of times by hundreds of photographers over the next century. Photographer unknown. Courtesy of the Seaver Center for Western History, Los Angeles County Museum of Natural History.

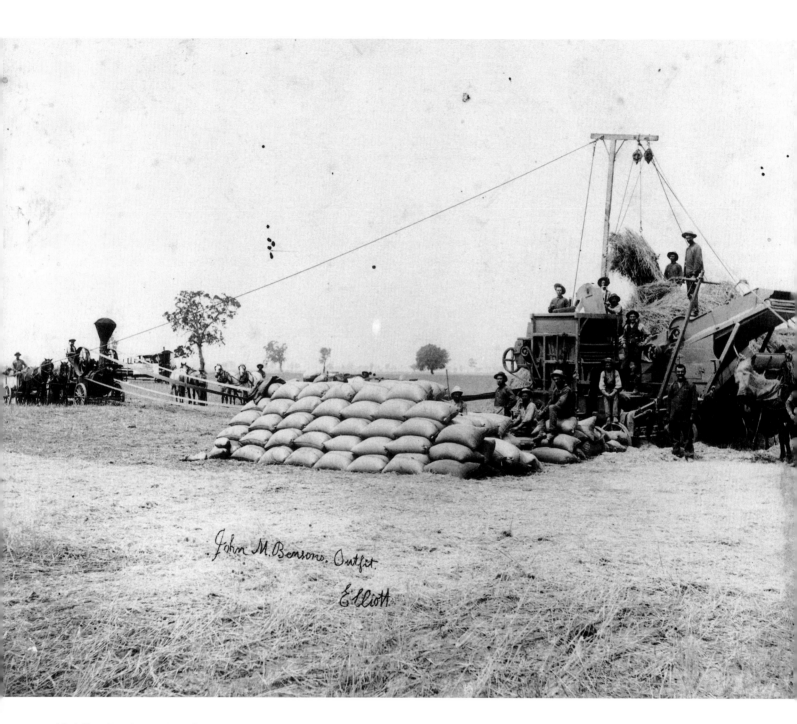

John M. Benson's Outfit.

Elliott

Much like other photographers of wheat threshing operations, this unknown
photographer working about 1890 produced a kind of inventory, taken at that
moment early in the morning, when John M. Benson's threshing outfit paused
to admire their work. Courtesy of the California Historical Society.

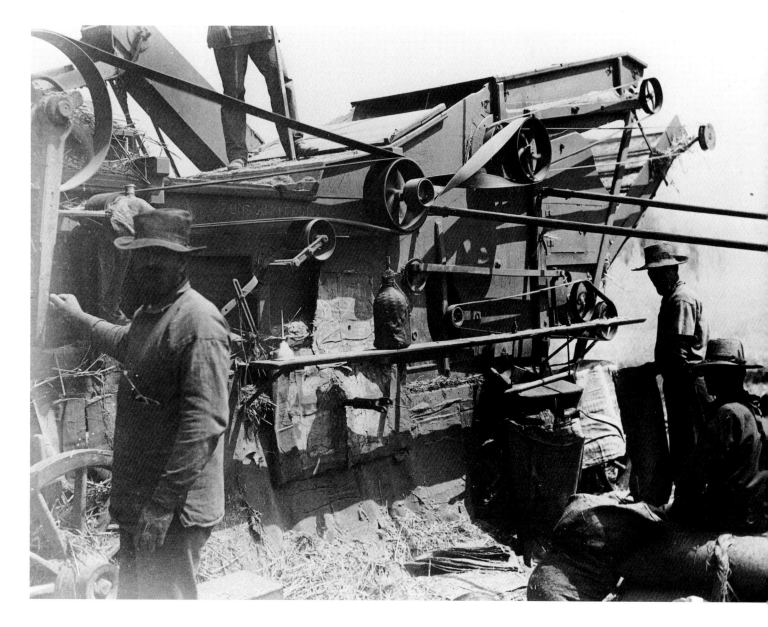

The last in a series of five progressively closer photographs of wheat
threshing on the Greenfields Ranch in 1888, this Carleton E. Watkins image
focuses in on the dark machinery and dusty work. Courtesy of Tenneco
West, Bakersfield, California.

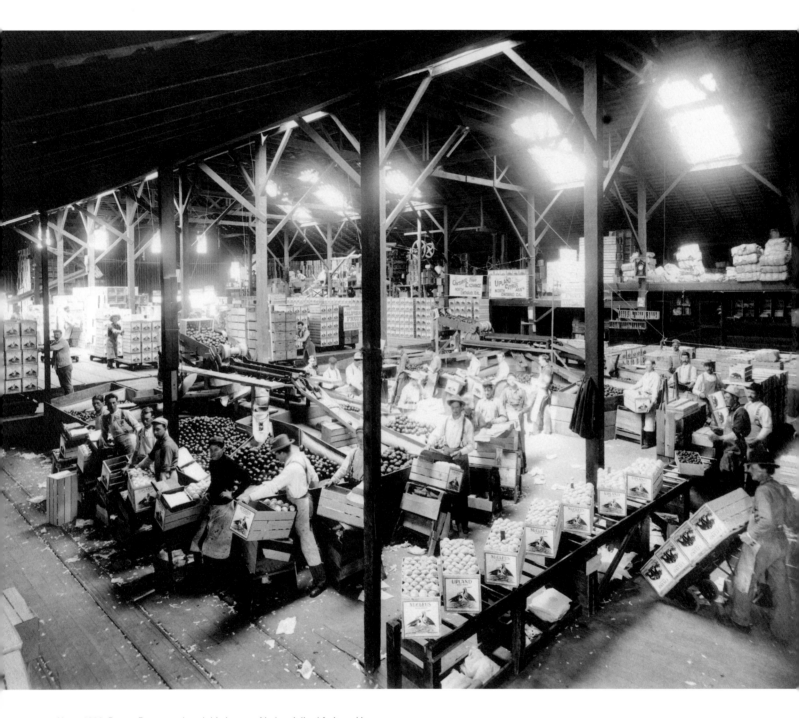

About 1900, Burton Fraser produced this image of industrialized fruit packing operations in the Upland Citrus Association packing plant. Courtesy of the Ontario Public Library.

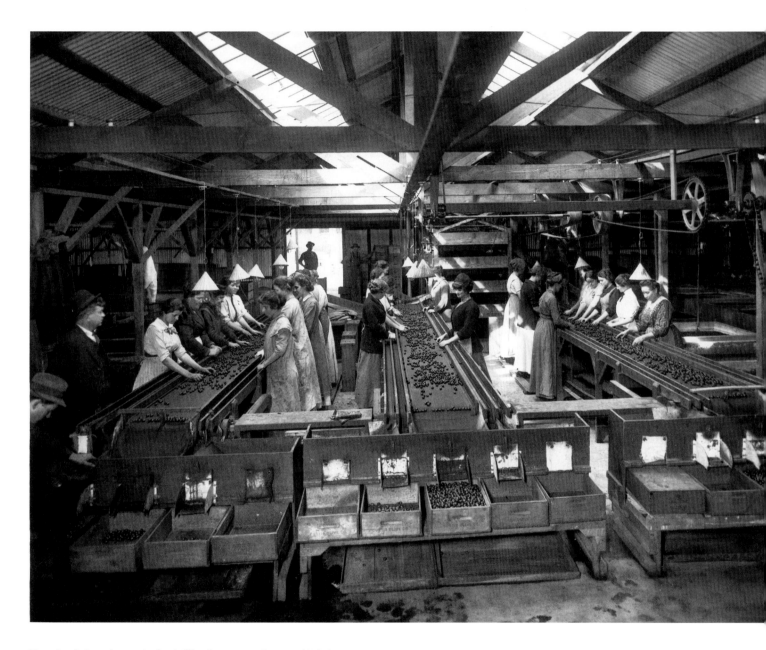

Like other fruit producers, the Curtis Olive Company took great pride in its modern facilities and in 1895 brought in a photographer to capture this image of women at work sorting olives for pickling. Courtesy of the Seaver Center for Western History, Los Angeles County Museum of Natural History.

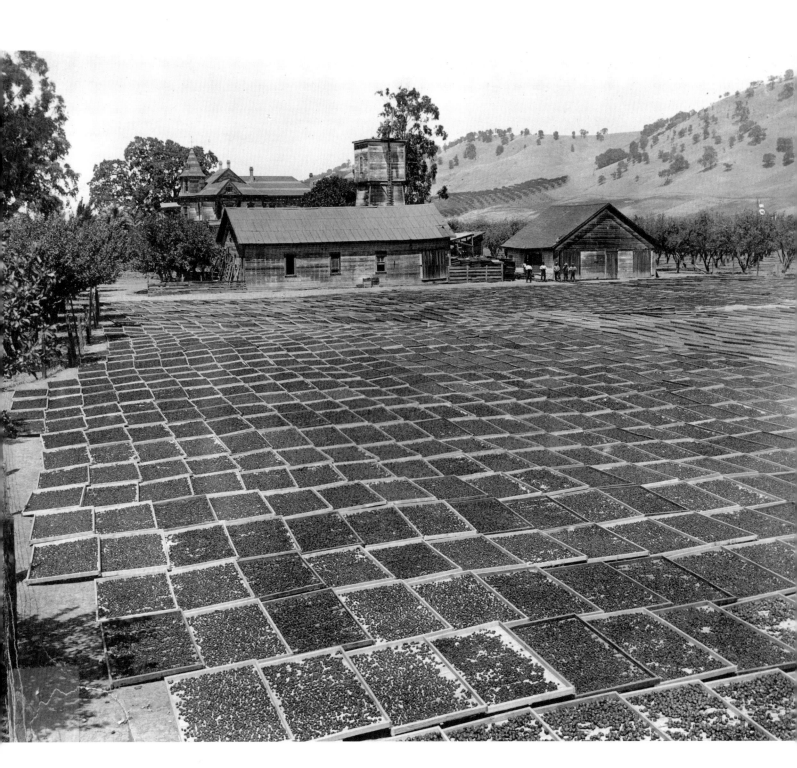

Shortly after fruit drying began on a massive scale around Vacaville in the late 1880s, an unknown photographer made a two-picture panorama of a proud farmer surveying his fruit drying yards west of town. Courtesy of the Vallejo Naval and Historical Museum.

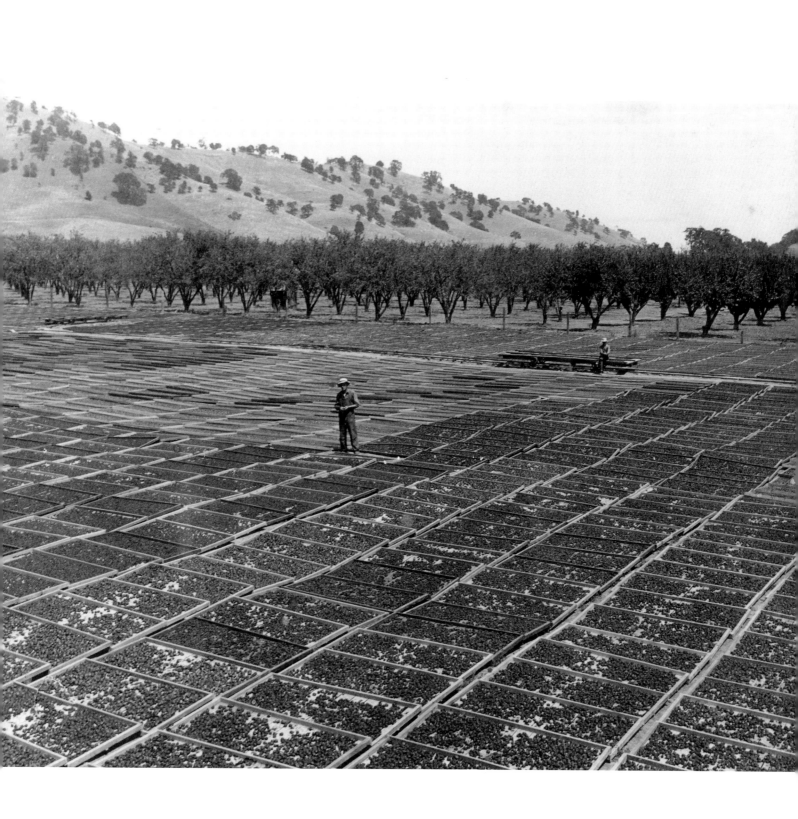

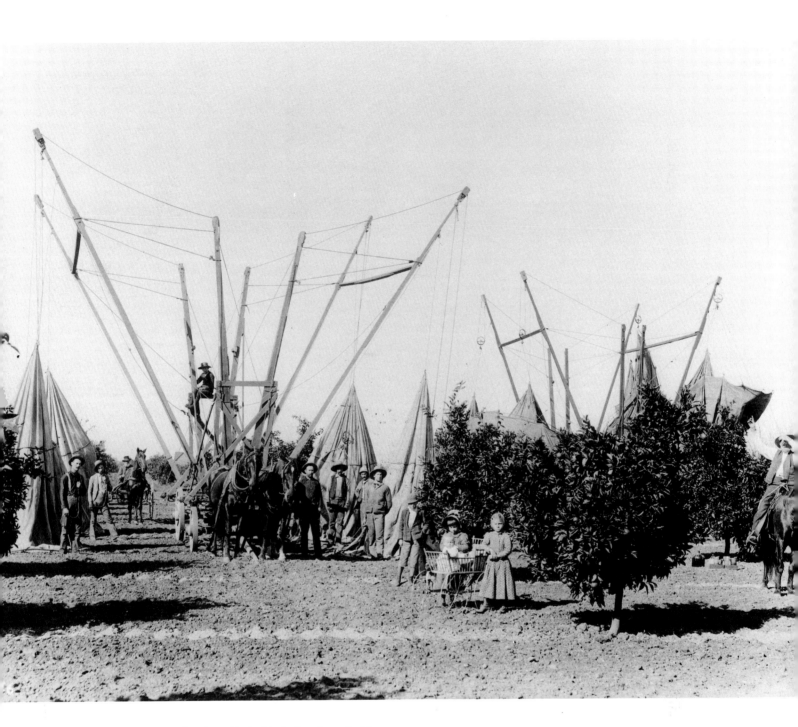

In 1892, shortly after the invention of portable derricks for lowering and raising fumigation tents, Los Angeles photographer C. C. Pierce made this image and incongruously included two children pushing a baby carriage in the foreground just as the foreman gives the signal to raise the tents. Photograph circa 1900. Courtesy of Title Insurance and Trust Photo Collection/California Historical Society, Department of Special Collections, University of Southern California.

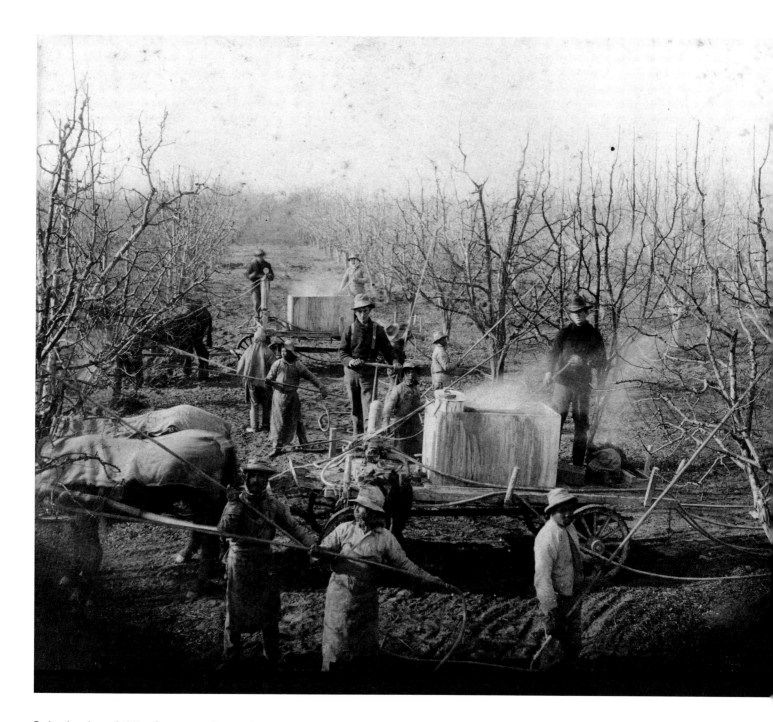

During the winter of 1900, a Sacramento photographer captured this rare image of Chinese field hands spraying dormant oil on C. W. Reed's pear orchard in the Sacramento Delta. Courtesy of the Department of Special Collections and Archives, University of California, Davis.

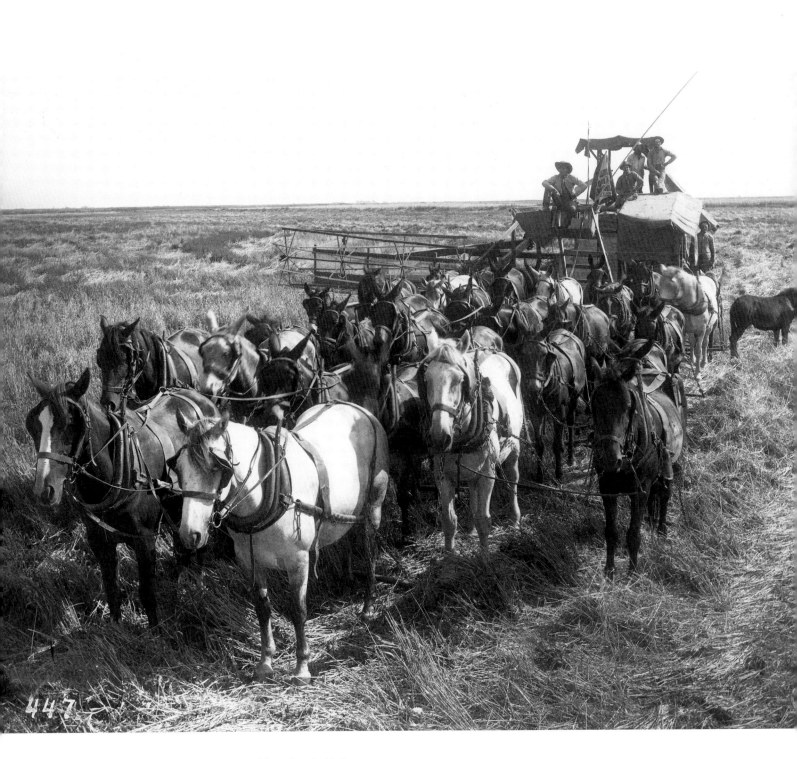

On August 20, 1901, Fresno photographer John F. Maxwell made this front view of Oliver Whiteside's team of horses pulling this combined harvester. Courtesy of the Maxwell Studios, Fresno.

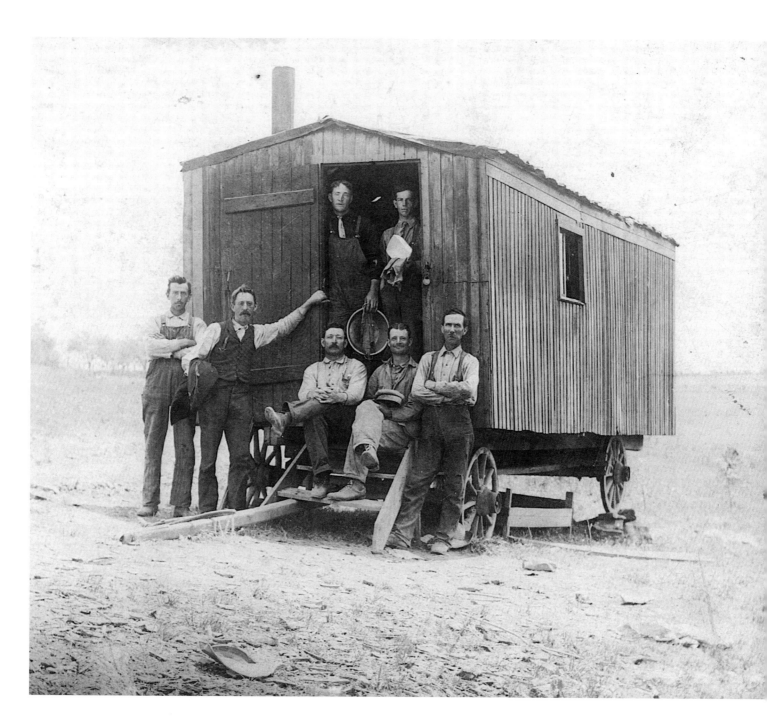

When threshing operations near Willows moved so far away from a ranch headquarters that men could not return at night, farmers employed chuck wagons to feed and house men. In this rare view, a typical cookhouse or chuck wagon has been leveled with blocks as the threshing crew poses on the front steps for an unknown Willows photographer somewhere in Glenn County. Photograph circa 1889. Courtesy of John Nopel, Chico, California.

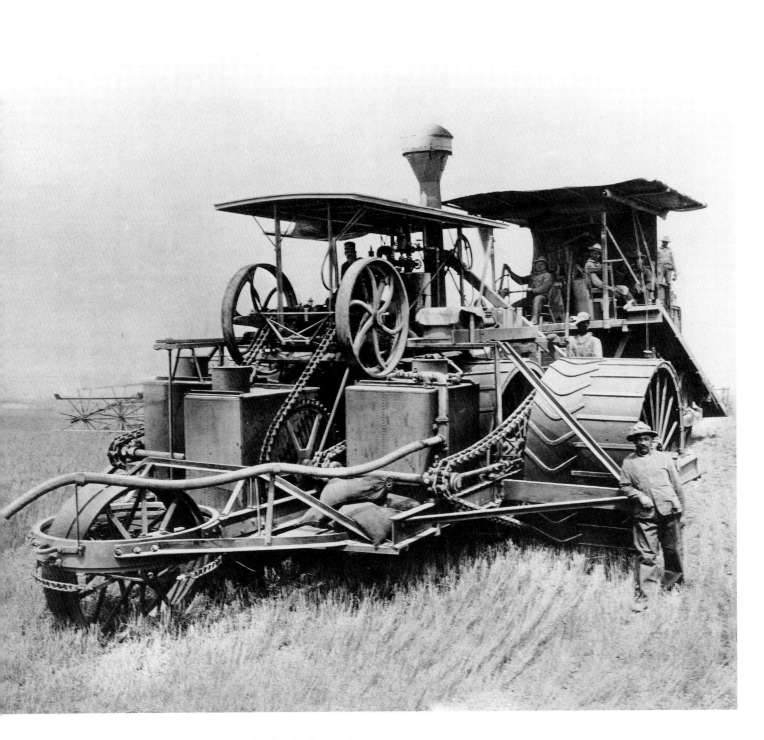

Impressed with this gigantic combined thresher, Los Angeles photographer C. C. Pierce made a portrait of the machine and its six crew members as it stopped in a San Fernando Valley field in 1898. Courtesy of the Huntington Library, San Marino, California.

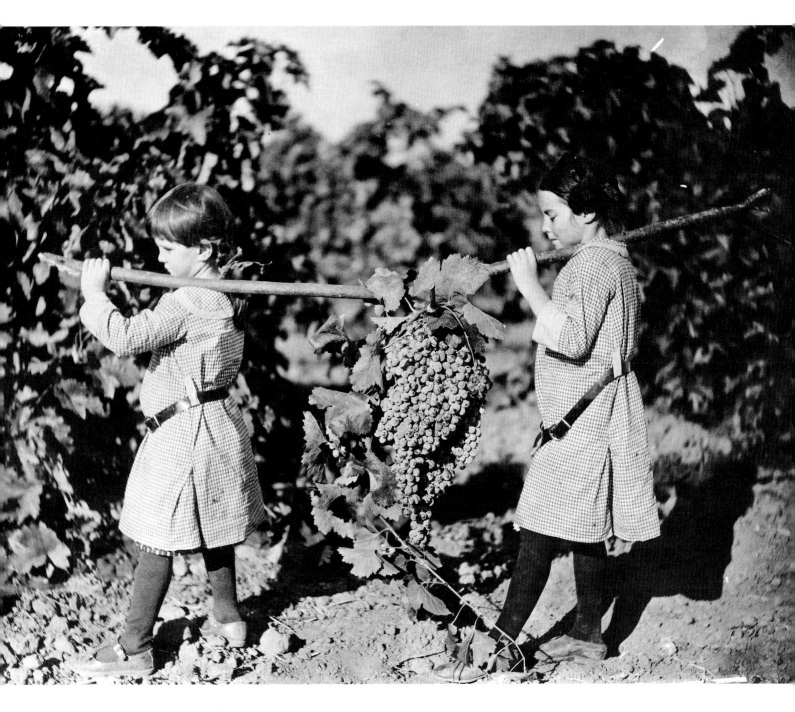

To emphasize the size of these grapes, C. C. Pierce hung the bunch on a pole and posed two youngsters hauling it out of this Pasadena-area vineyard. Photograph circa 1900. Courtesy of the Huntington Library, San Marino, California.

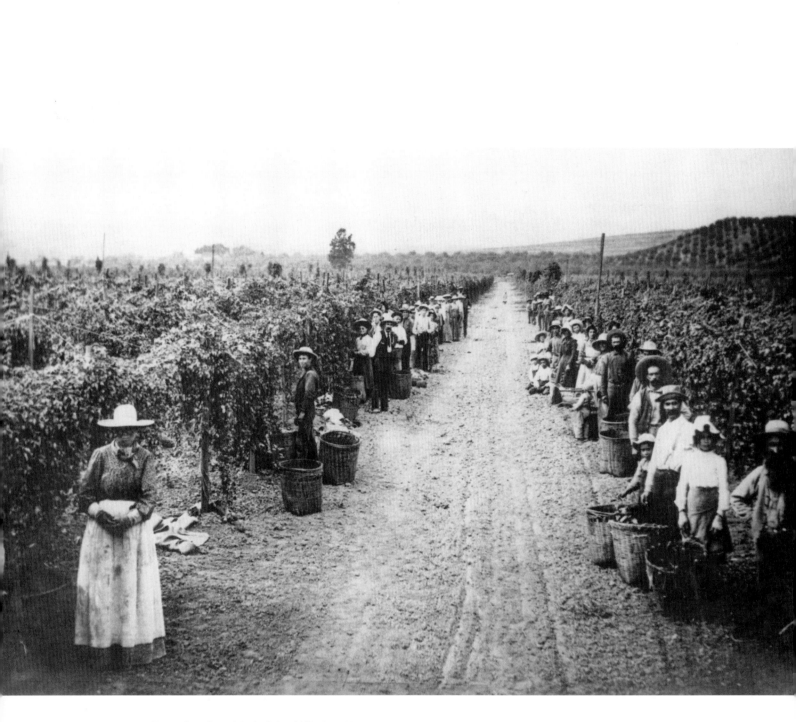

Hop harvesting on the Charles Cornell ranch in the Pajaro Valley in 1890 attracted extensive photographic scrutiny. But after expanding to nearly four hundred acres in 1889, hop growing around Watsonville declined rapidly and growers turned to sugar beets and apples. Photographer unknown. Photograph courtesy of the Pajaro Valley Historical Society, Watsonville, California.

About 1900, an unknown Marysville photographer made this photograph of children posed on the steps of a temporary shelter on a large hop farm. Along with the invitation in English to Sunday worship, signs in Italian and Spanish advertise free reading material and letter writing services. Courtesy of Juanita DeValentine/Wheatland Historical Society.

Postcards, Riots, Citrus, and Mexicans

Despite many technological advances that simplified and somewhat democratized their work, photographers after 1900 continued to see farmworkers as uncritically as ever. Demonstrating little more than a passing interest in farmworkers themselves, they rarely saw them as sufficiently important to warrant separate treatment. No photographer documented children in the fields the way Lewis Hine photographed children in the coal breakers of West Virginia and the spinning mills of Georgia. In fact, Hine himself for some reason avoided photographing in the fields of California, although he visited the state in 1915 and 1917 while attending exhibitions of his work in San Diego and San Francisco. Consequently, at a time when reform organizations like the National Child Labor Committee were employing a penetrating form of social documentary photography and the Progressive Party was gaining momentum in California, no photographer prowled the farm labor camps of California. No photographer focused on bindlemen, followed migrants drifting with the harvests, scrutinized work motions, focused on physical strength and muscles, or recorded the mundane realities of farm labor.

Only two California photographers during the first decade of the twentieth century took a different approach to farmworkers. One of these photographers was Clara Sheldon Smith. A Marysville commercial photographer, Smith earned between two and twenty-two dollars per month from September 1900 until June 1908 making mug shots of criminals, many of whom were farmworkers, who had been arrested for robbery, forgery, "working a flim-flam," stealing a roll of blankets, "nipping a new coat," and various other crimes. The other person attempting to inject reality into the visual record of California farmworkers at this time was Ira B. Cross, a doctoral student at Stanford University. Hired to gather information on migrant laborers for the U.S. Immigration Commission (1907–9), Cross traveled through the San Joaquin and Santa Clara valleys and several other agricultural areas, photographing Chinese, Indian Sikhs, Italian, and Japanese at work in the fields. Paying special attention

to farmworker quarters, Cross documented large, well-equipped communal bunkhouses as well as tent shelters and run-down shacks; moved into the ethnic enclaves around Fresno, Palo Alto, Ryde, Visalia, and Woodland; scrutinized employment offices, pool halls, alleyways, and bathhouses frequented by farmworkers; and photographed Mexicans shaping up for work in the city plaza. Returning to Stanford with more than one hundred photographs, he apparently offered them to the U.S. Immigration Commission, and after the commission found no use for them, filed them away in his personal papers, where they languished unseen and unappreciated for three-quarters of a century.

Outside of the work of Ira B. Cross and Clara Smith, realistic images did not appear until farmworkers began organizing and protesting. One of the first photographers to record such actions—albeit accidentally—was Harold Mc-Curry. A successful commercial and landscape photographer who operated the largest photography business in the Sacramento Valley, McCurry in August 1913 visited the huge labor camp that assembled on the Ralph Durst hop ranch about one mile east of Wheatland. Spread out across Durst's 641-acre hop ranch, the camp was a temporary tent city for twenty-eight hundred hop pickers. Recognizing an opportunity for massive sales, McCurry or one of his assistants made the first systematic photographic survey of a large farm labor camp.

Also present at the Durst hop camp that fateful day was seventeen-year-old Elizabeth Carney, who had been photographing the town of Wheatland and her family with a new Kodak Ensignette Number One camera. But on Sunday, August 3, while she was washing dishes and doing chores in the Wheatland Hotel, a riot erupted in the hop camp, and the sheriff, district attorney, and two hop pickers were shot and killed. As the melee escalated, young Miss Carney noticed the commotion, grabbed her Kodak, leaned out the window, and snapped several pictures. She then went onto the streets and photographed pickers fleeing town and congregating at the train depot. She was the first to use a small, handheld camera to record some aspect of a farmworker strike in California, and she continued her efforts into the following year, recording protest marches and organizing activity with a candid and spontaneous quality heretofore unseen in photographs of farmworkers. In doing so, she provided the first photographs of a farm labor union hall, posters and slogans demanding justice for farmworkers, and protest marches by agricultural workers and their sympathizers.

Overlooked in accounts of California's photographic heritage, Miss Carney's snapshots of events at Wheatland nonetheless represent a giant step toward a more realistic and spontaneous depiction of California farmworkers. Before 1913, the entire photographic record of California farmworkers had been the product of professional or semiprofessional photographers using slow, large-format, glass-plate view cameras to produce orderly and impressive studies that bore testimony to the glories of agriculture. Now, that older, more traditional approach was being challenged by spontaneous images produced by an amateur using small, handheld, roll-film cameras.

For a few years after the Wheatland hop riot, photographer seemed to devote more attention to the lives of farmworkers. During the January 1914 trial of Richard "Blackie" Ford, Herman D. Suhr, and two other alleged Wheatland hop camp rioters, defense attorneys and prosecutors introduced into the record dozens of photographs by Harold Mc-Curry. Photographs also became an important part of California's investigation into the causes of the riot and of efforts to rectify the situation and prevent (or at least deflect) any further incidents of violence. But little came of the effort. At no time in the years between the Wheatland hop riot and the beginning of World War I did any photographer anywhere in the state systematically study farmworkers. Nor did photographers record the beginning of the most significant farm labor development when, in 1917, large numbers of Mexican immigrants began arriving in California. Crowded into various company camps and private, unincorporated communities, the Mexicans quickly became a matter of concern to

leaders of the citrus industry, who concluded that there was a direct relationship between labor supply and housing. Believing that homes adjacent to the citrus groves offered the best chance to stem the decline in bachelor labor and promote the rise in Mexican family labor, citrus industry leaders embarked on a program to construct farmworker housing. Taking the lead in this effort, the California Fruit Growers Exchange in February 1918 began analyzing various projects, and in an effort to document the work, University of California, Riverside, plant pathologist Archibald D. Shamel produced a remarkable series of photographic essays on farmworker housing. But he was alone in these efforts.

No other photographers were inspired to explore—even in a superficial way—the triumphs, challenges, and hardships faced by Mexican immigrants, the nature of the work they were doing, the reasons why they came north, the places where they settled, and their various adaptive responses.

While Mexicans were the first farmworkers to use automobiles extensively as a means to migrate between crops and were also the first to work as family units in the fields, neither aspect of their lives attracted much more than passing photographic coverage. Not until the early 1920s did photographers finally focus on Mexican immigration and Mexican labor. But not in California. Encountering a crowd of several hundred newly arrived Mexican immigrants stranded and receiving handouts of bread in San Antonio, Texas, as they waited for word of work in California and elsewhere, Hugo Summerville used a Kodak Cirkut camera to capture the scene. Pregnant with information, Summerville's gigantic panorama—eight inches high and several feet across—suggests a different vision was at work, one that saw farmworkers less as adjuncts to a commercial image or decorations in a landscape than as living, breathing human beings worthy of documentation in and of themselves.

(*right, top*) One of three ground-level photographs of the Durst hop ranch on August 2, 1913, this one captures a crowd gathering to hear hop pickers and members of the Industrial Workers of the World. Photograph by McCurry Foto Company. Courtesy of the Archives of Urban and Labor History, Wayne State University.

(*right, bottom*) At the Cornell Ranch near Watsonville in 1888, a family pauses from hop picking to clown for a photographer by placing the two youngest children in hop baskets. Photographer unknown. Courtesy of the Pajaro Valley Historical Society.

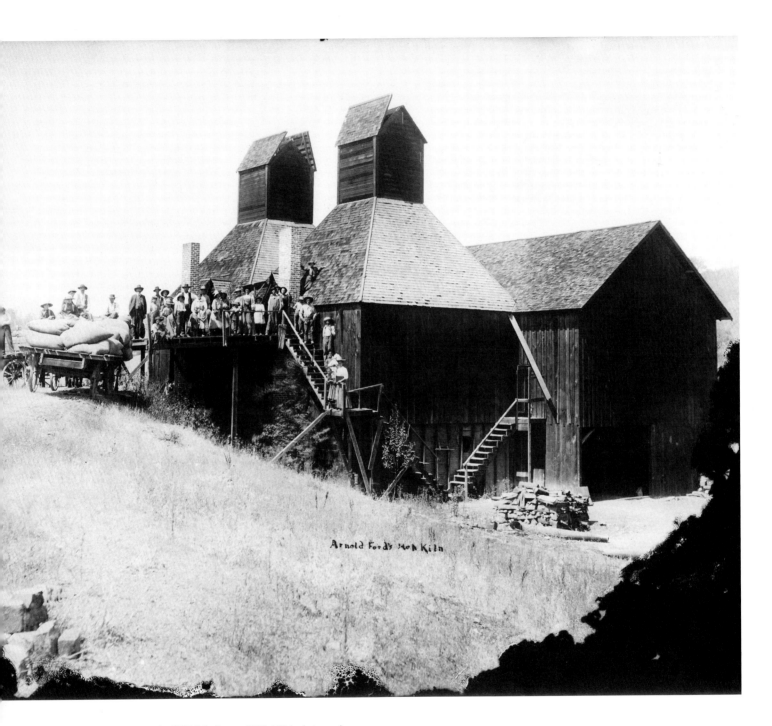

Arnold Ford's Hop Kiln

Traveling to Calpella north of Ukiah in August 1908, Ukiah photographer Robert Carpenter made this typical group portrait of men, women, and children outside of Arnold Ford's hop kiln. Photograph courtesy of the Robert Lee Collection, Mendocino City Historical Society.

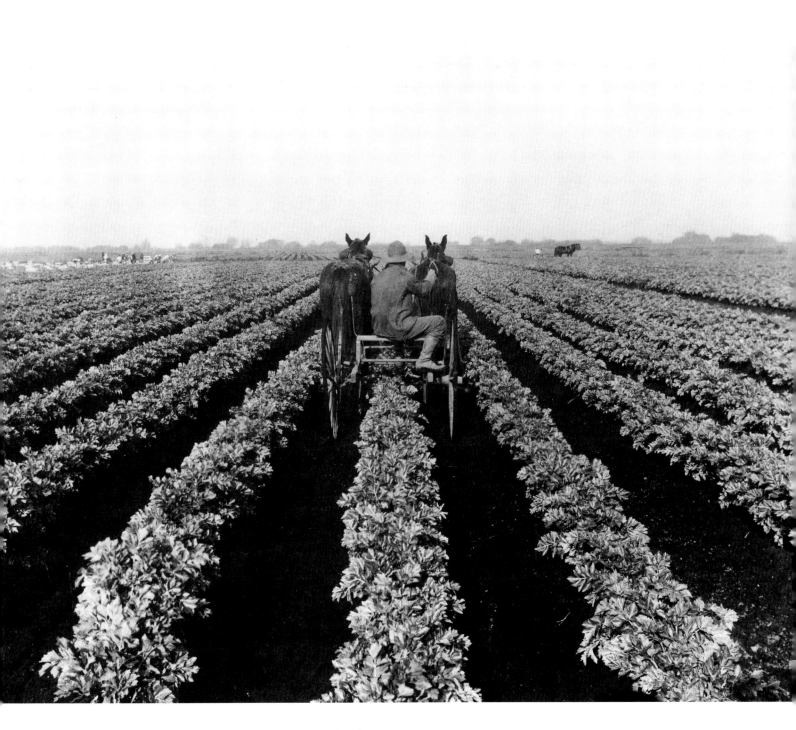

To make this 1925 photograph, McCurry Foto Company employees Merritt Nickerson and Dave Jack emphasized the perspective of rows of celery plants converging on the Sacramento Delta horizon. Courtesy of the California History Section, California State Library.

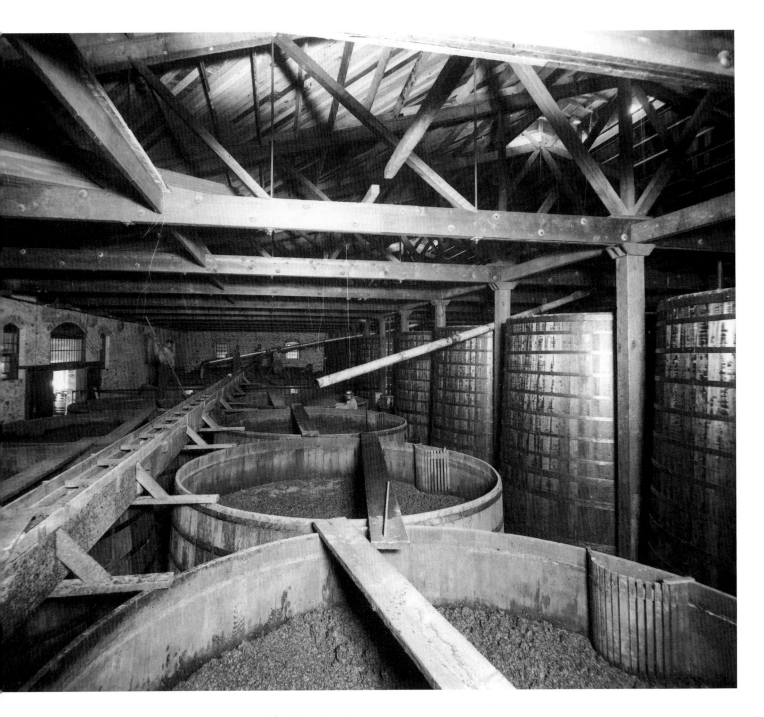

Challenged by the problem of adequately picturing the dark interior of the twenty-thousand-ton fermentation room at the Italian Vineyard Company at Guasti in 1907, this unknown photographer placed his camera on a tripod, made a long exposure, and then popped a flash light. Courtesy of the Museum of History and Art, Ontario, California.

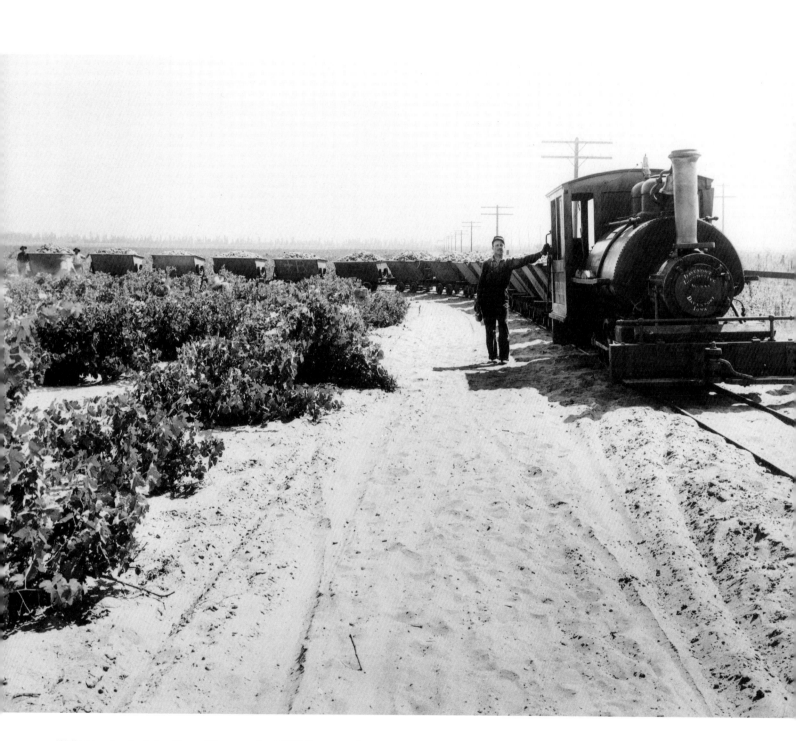

While surveying the Italian Vineyard Company about 1907, the same unknown photographer who documented the winery also photographed the small railroad used for hauling grapes out of the vineyard. Courtesy of the Museum of History and Art, Ontario, California.

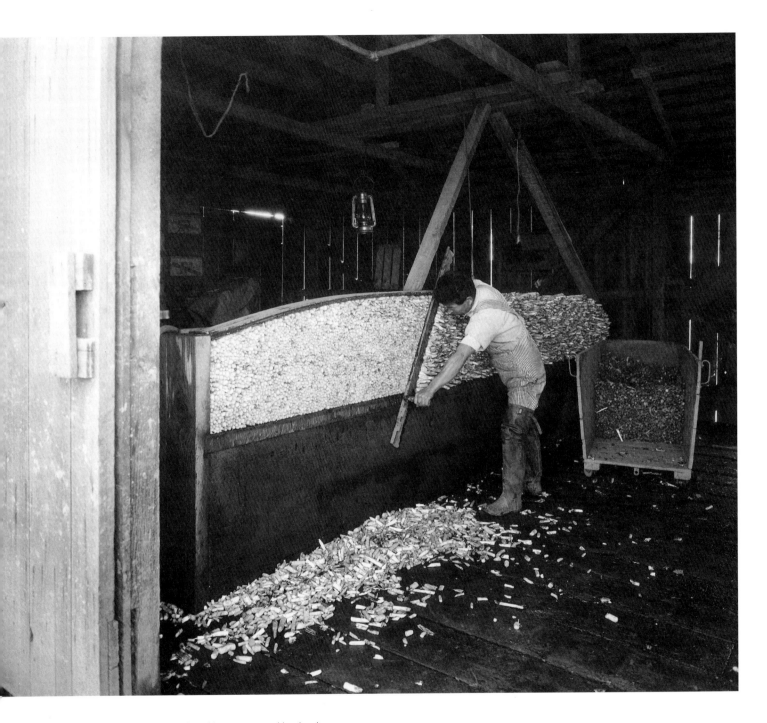

Impressed by the huge knife and stacking system used in trimming asparagus,
McCurry Foto Company photographers Merritt Nickerson and Dave Jack
made this photograph in a packing plant near Isleton in 1925. Courtesy of
the California History Section, California State Library.

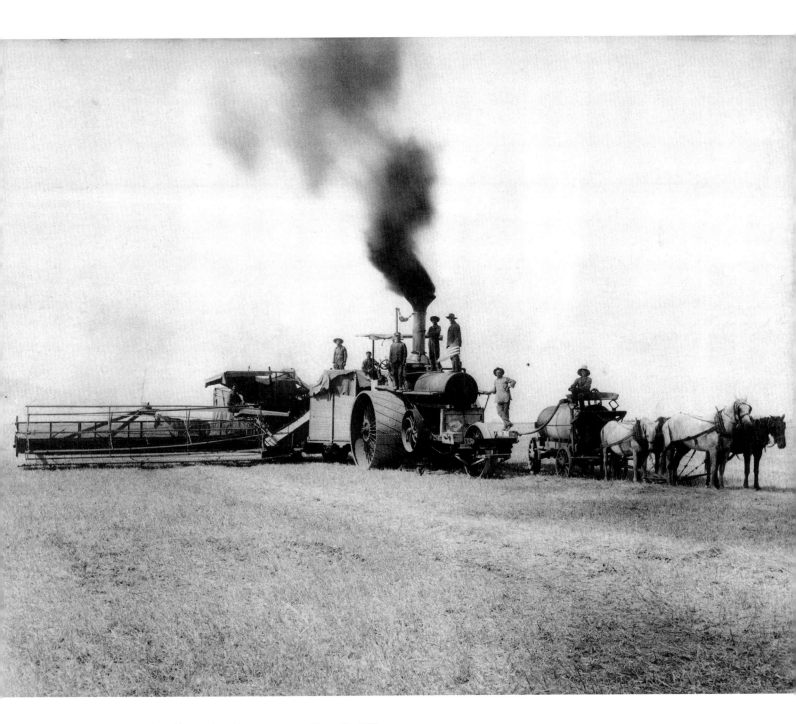

When steam-powered combines replaced horse-drawn machines after 1900, photographers made countless photographs like this one. The location is likely the Tulare Lake basin in the Central Valley, where the machines had their greatest impact. Photographer unknown. Courtesy of the Huntington Library, San Marino, California.

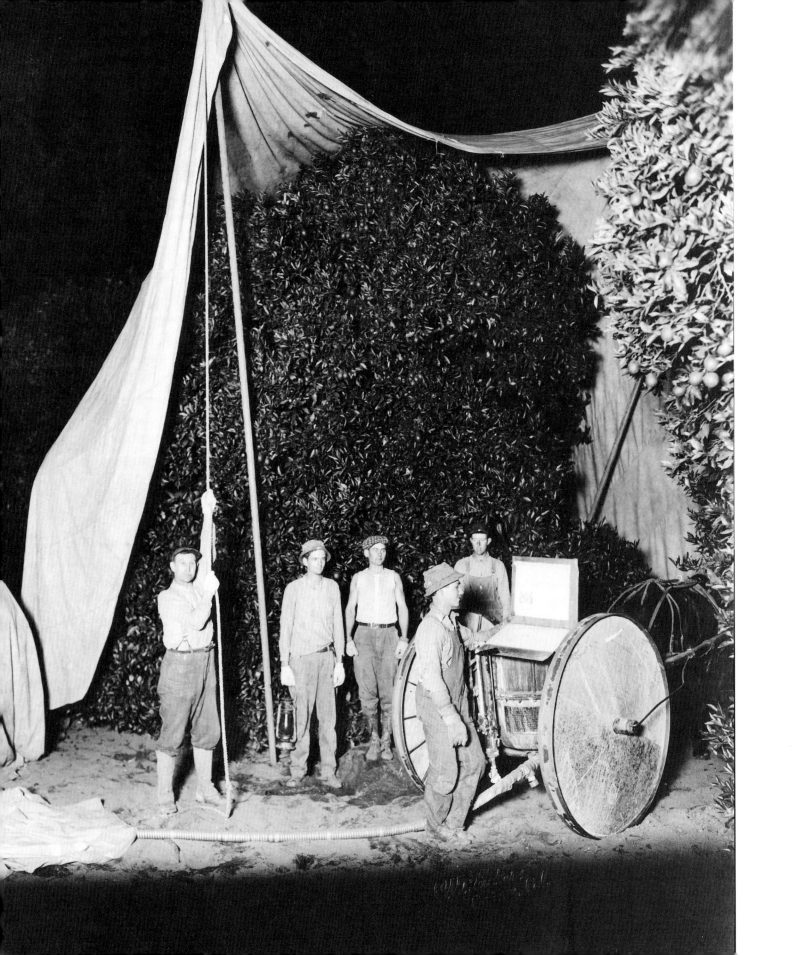

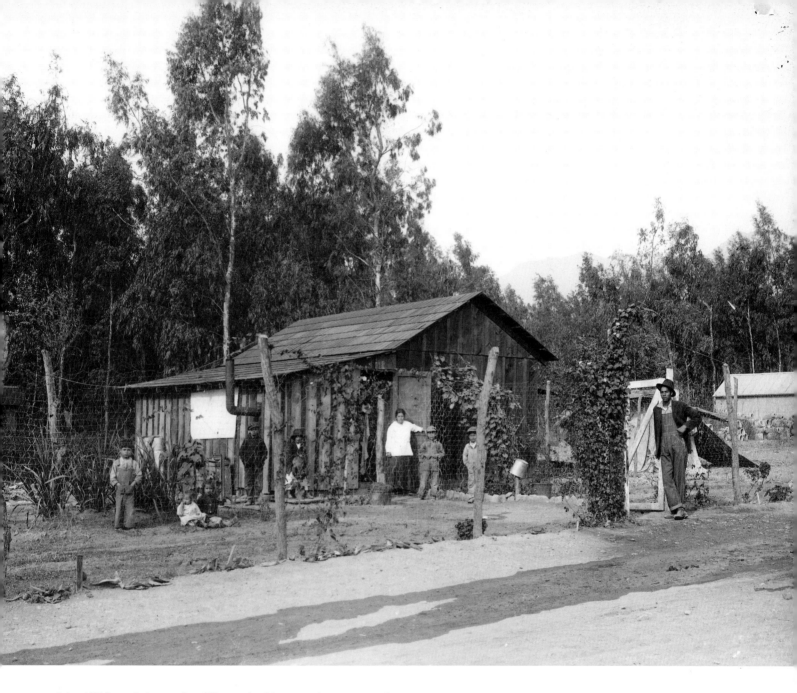

(*above*) While producing a series of illustrated articles on employee-sponsored citrus camps, University of California, Riverside, Professor Archibald D. Shamel undertook an extensive photographic survey of the very best housing facilities, including these cabins occupied by Mexican laborers on Rancho Sespe in March 1918. Courtesy of the Riverside Museum.

(*left*) Because conventional wisdom initially held that orchard fumigation worked best at night, photographers wishing to document crews laying tents employed flash lighting techniques. This image by William Feckler was taken near Covina in 1915. Courtesy of the Huntington Library, San Marino, California.

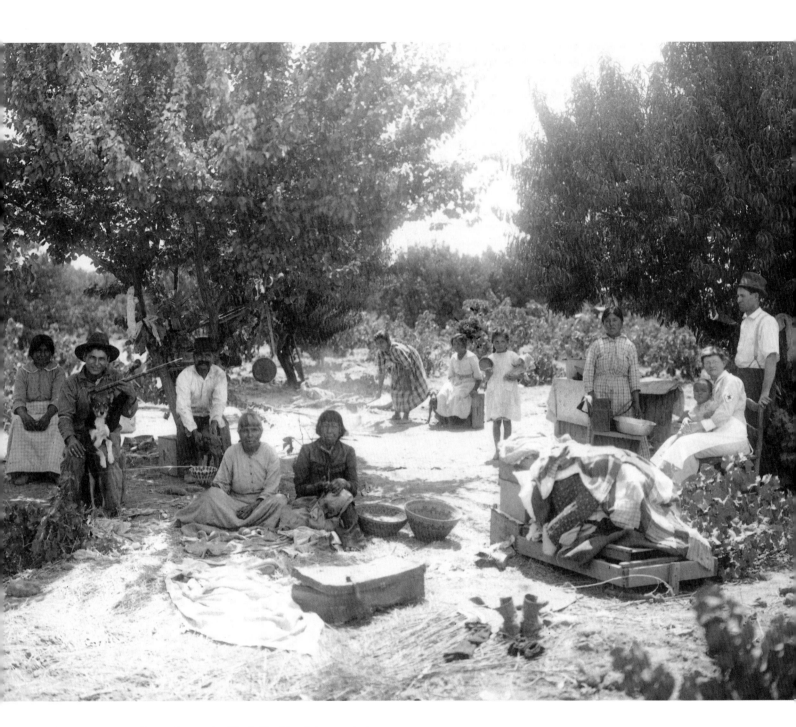

On August 23, 1918, Fresno photographer Claude "Pop" Laval photographed these Indians camped amid young olive trees while picking grapes in a nearby Clovis vineyard. The Indians had been brought in to overcome the labor shortage caused by World War I. Courtesy of Jerome D. Laval/Claude "Pop" Laval Collection, Fresno.

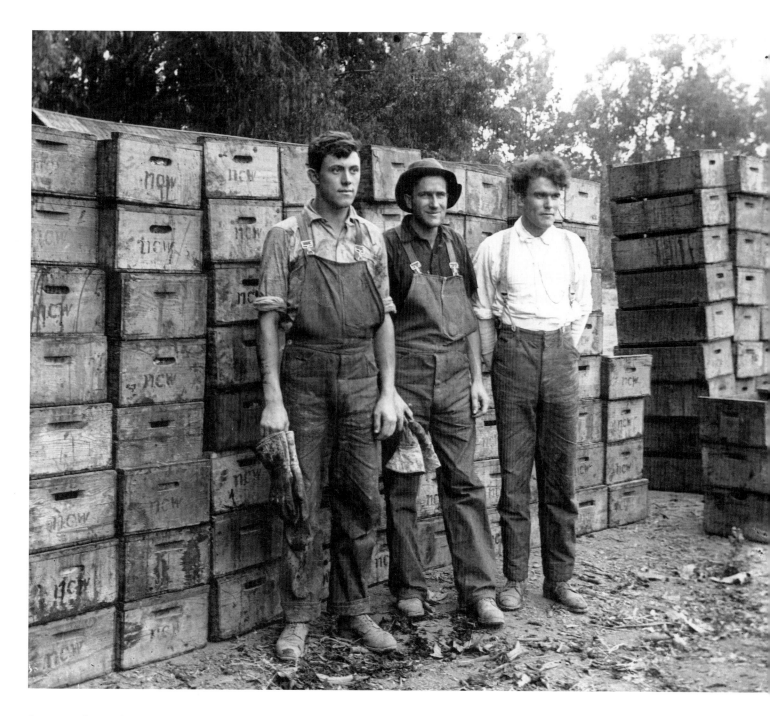

An amateur photographer of great talent, Simi Valley honey farmer John Sparhawk Appleton photographed his neighbors Lester Reed, Hershel Shumard, and Hugh Reed on the N. C. Woods prune ranch during the September 1920 harvest. Courtesy of Bill Appleton/Simi Valley Historical Society.

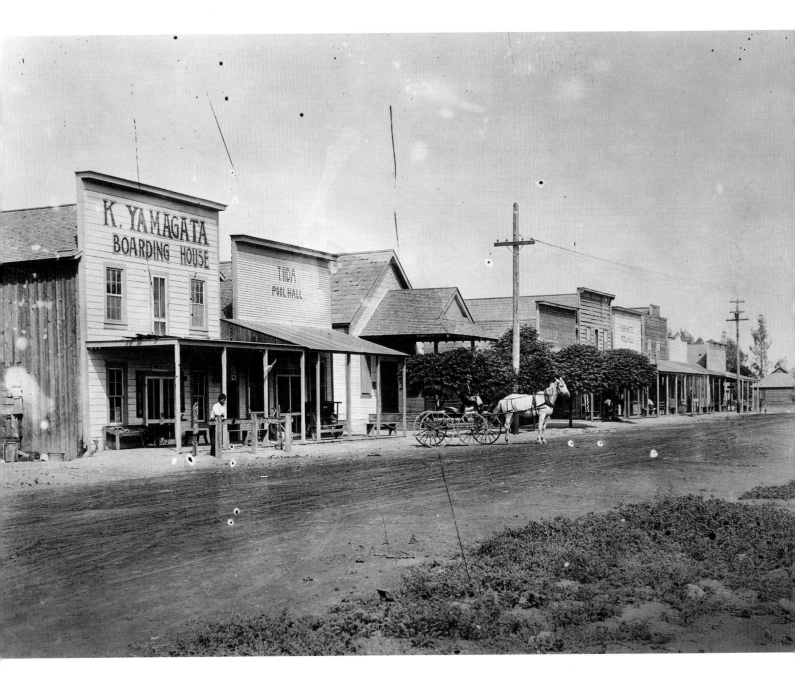

(*above*) Another talented amateur photographer, Fowler resident Paul Hutchinson, photographed all aspects of his hometown between 1905 and 1915, including the K. Yamagata Boarding House in the Japanese section. Moving down Eighth Street, Hutchinson also documented a labor contractor's business, a pool hall, and a restaurant catering to Japanese field hands. Courtesy of the Hutchinson Collection, Fresno County Historical Society, Kearney Park, Fresno.

(*right*) Beginning in 1915, the Yuba Ball Tred [*sic*] Tractor Company compiled an album of cyanotype prints (blue-tinted photographs) documenting farmers and field hands who worked with its equipment. Photographer unknown. Courtesy of the Yuba Ball Tred Tractor Album, F. Hal Higgins Collection, Archives and Special Collections, University of California, Davis.

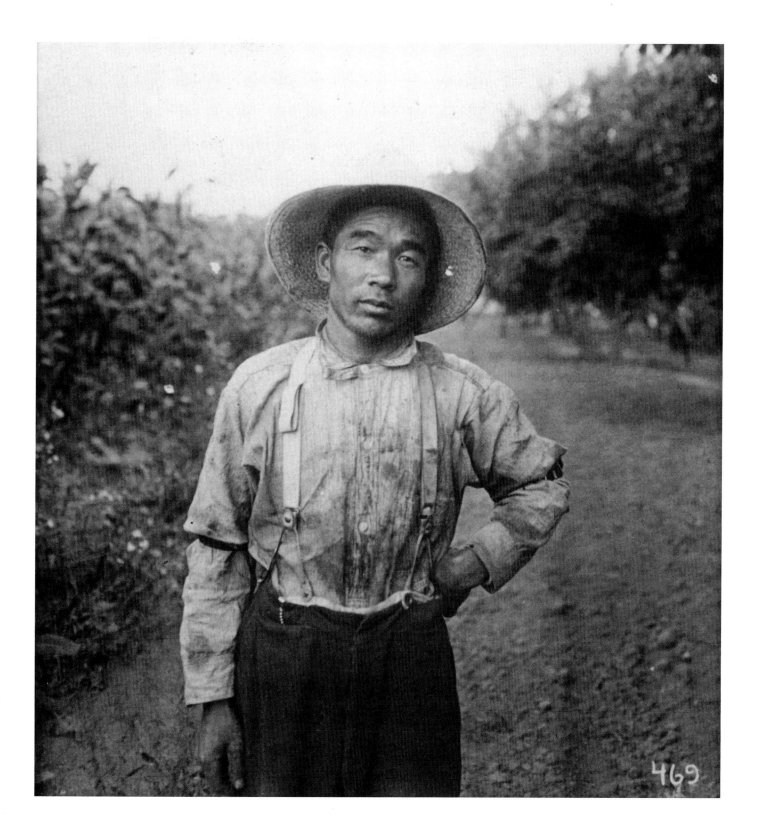

469

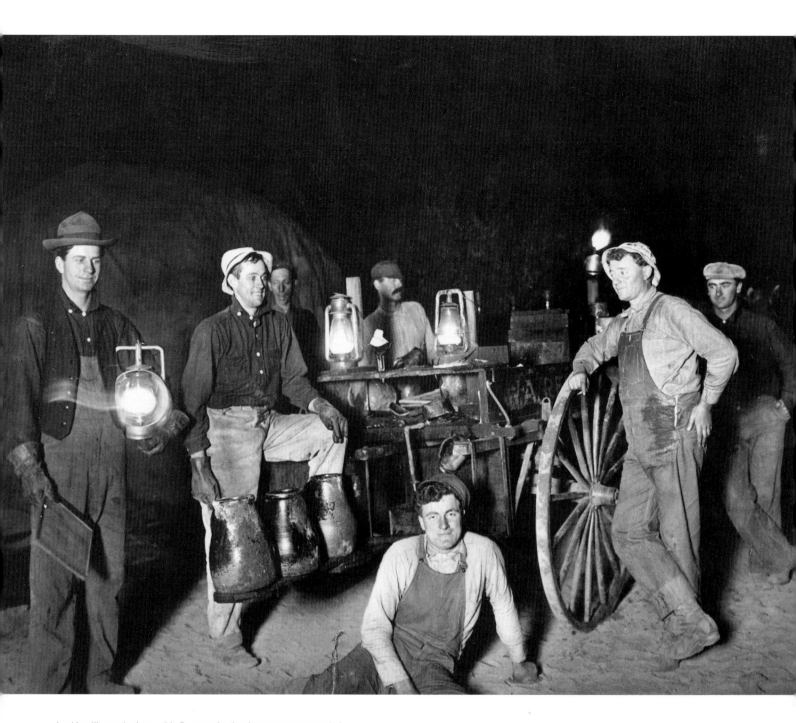

Looking like coal miners, this Pomona fumigation gang was recorded in 1907 by an unknown photographer using flash light. Courtesy of the Pomona Public Library.

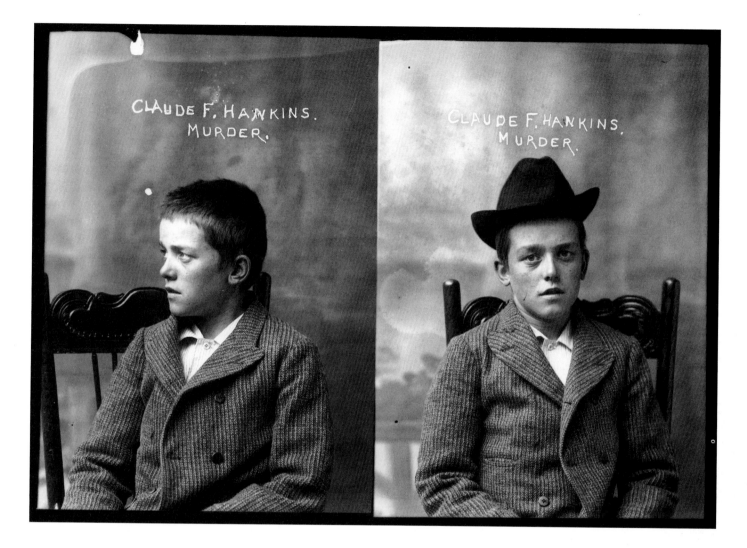

On July 23, 1904, Marysville photographer Clara Sheldon Smith photographed fourteen-year-old Claude F. Hankins, "an average-sized lad" with a lisp, who had murdered George Morse, a middle-aged foreman, braggart, and self-described "Guatemalan insurrectionist," near the Boles orchard on the George Thompson farm, six miles east of Marysville. Sent from his home in Palo Alto to work on the Boles farm, Hankins had been molested by a foreman, and in retaliation, stole a revolver, crept up behind the foreman, blew his brains out, and fled to town, where he was arrested, and later tried and convicted of murder. He served a twelve-year sentence in San Quentin Prison. After his release, he worked without incident as a merchant seaman for the rest of his life. Essentially a mug shot, Smith's haunting picture of a young farmworker/murderer hints at something beneath the surface and of the tensions and difficulties of child labor. Courtesy of Arne Svenson, copyright 1997, New York City.

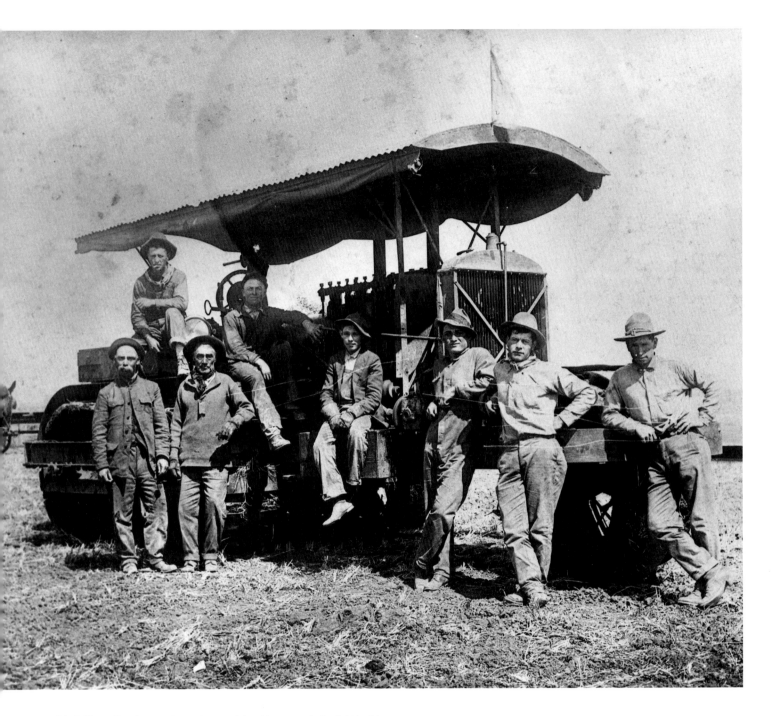

Much like earlier photographers who posed threshing crews in the field beside their huge machines, this unknown photographer used the same technique while recording this crew with its new, gasoline-powered engine somewhere in the reclaimed Tulare Lake region of the Central Valley in 1925. Courtesy of the Pomona Public Library.

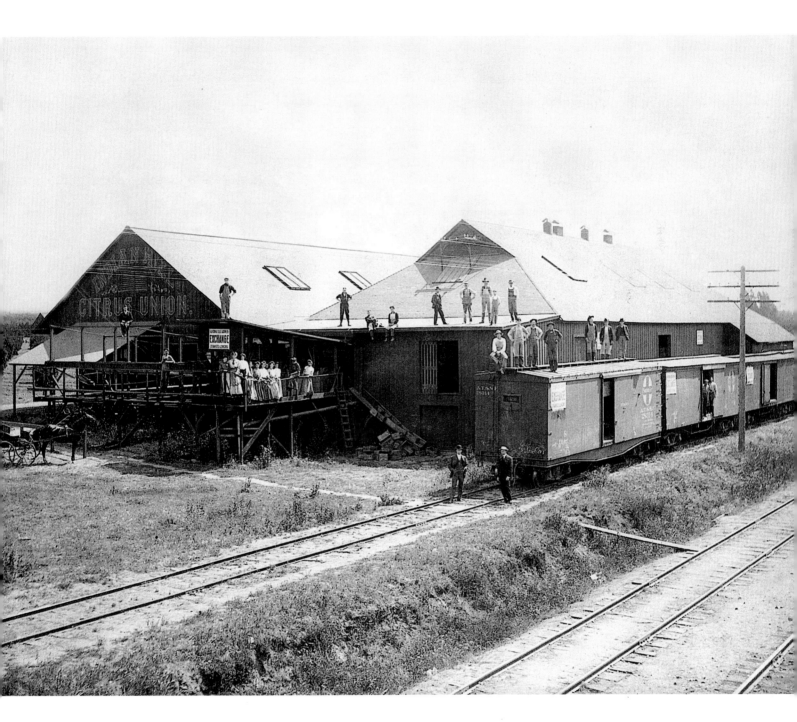

Representing well the split functions of men and women at the Indian Hills Citrus Association packing plant, this photographer has brought the women out onto the receiving dock and the men onto the roof of the shipping area where each group performed its tasks. Note the supervisors in coats and ties. Schwichtenberg Studio, Pomona. Courtesy of the Pomona Public Library.

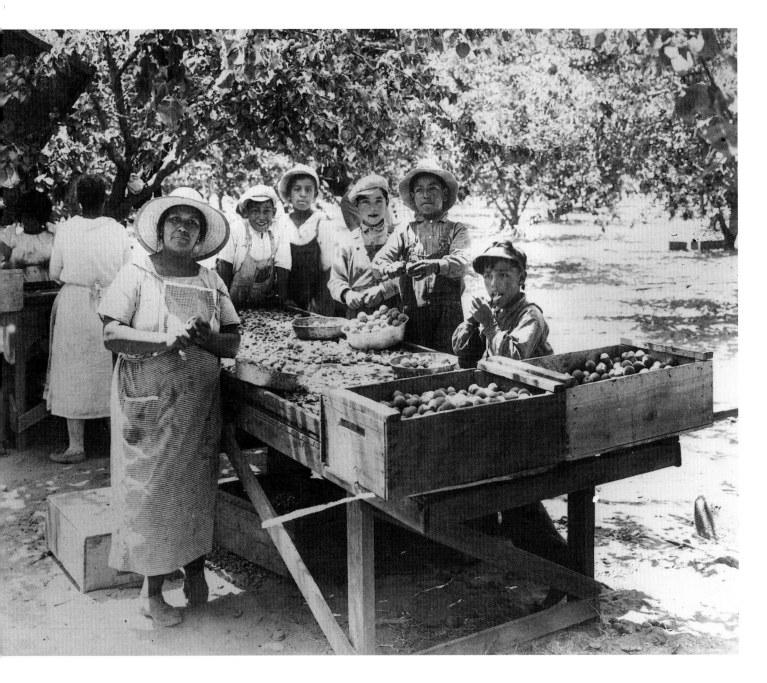

While photographing around Los Angeles, Frederic Hamer Maude captured
this image of a Mexican woman supervising a crew of children pitting apricots
near Pasadena in 1920. Courtesy of the Seaver Center for Western History,
Los Angeles County Museum of Natural History.

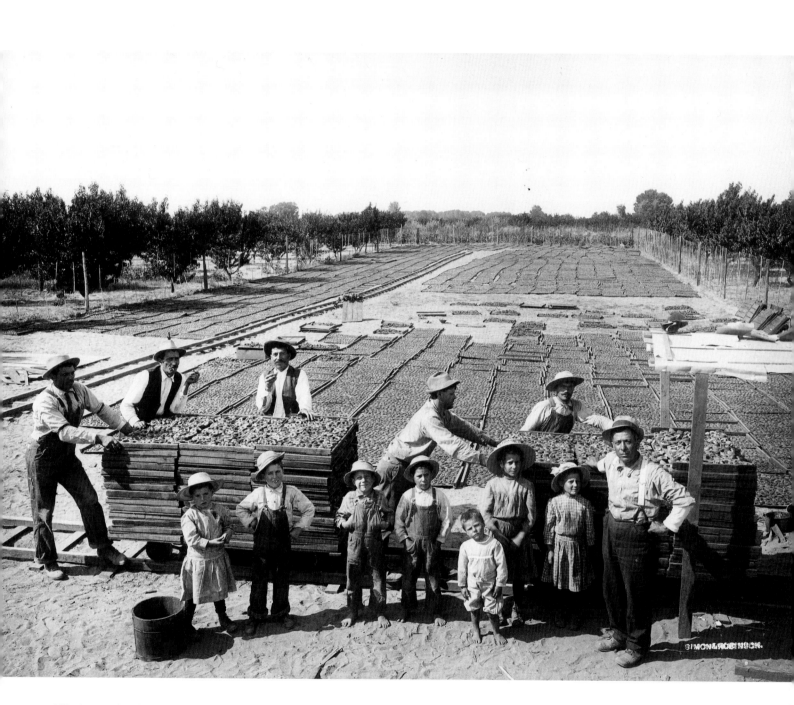

This photograph by Frank Day Robinson captures men and children working in the apricot drying yards around Merced in 1920. The men pushed loaded carts along railroad tracks and positioned drying trays in the yard, while the children worked as apricot pitters in a nearby shed. Note the high fence surrounding the yard to keep out deer and rabbits. Courtesy of Stephen Johnson.

On August 18, 1918, Fresno photographer Claude "Pop" Laval used a flash and long exposure to make this image of Francisco Palomares, a representative of the California State Commission of Immigration and Housing (and soon to be a leading figure in the San Joaquin Valley Agricultural Labor Bureau) on stage in the Nippon Building (a Japanese theater) urging the local Mexican population to avoid labor disputes during war times, practice frugality, and subscribe to the Red Cross. Courtesy of Jerome D. Laval/Claude "Pop" Laval Collection, Fresno.

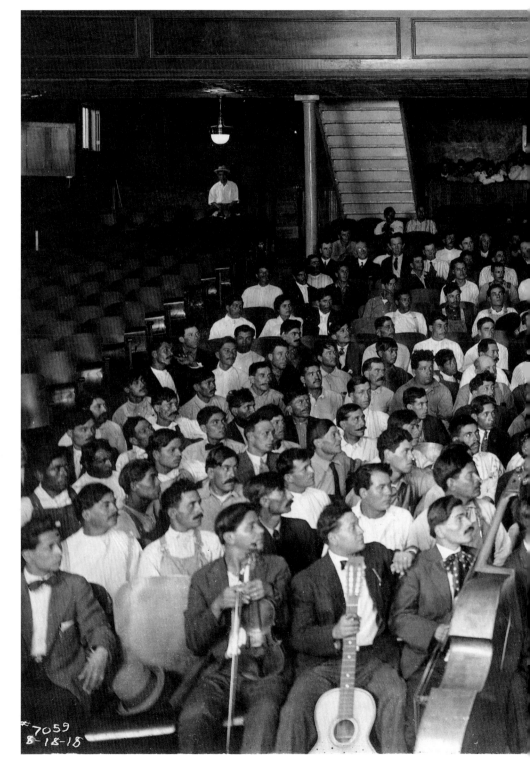

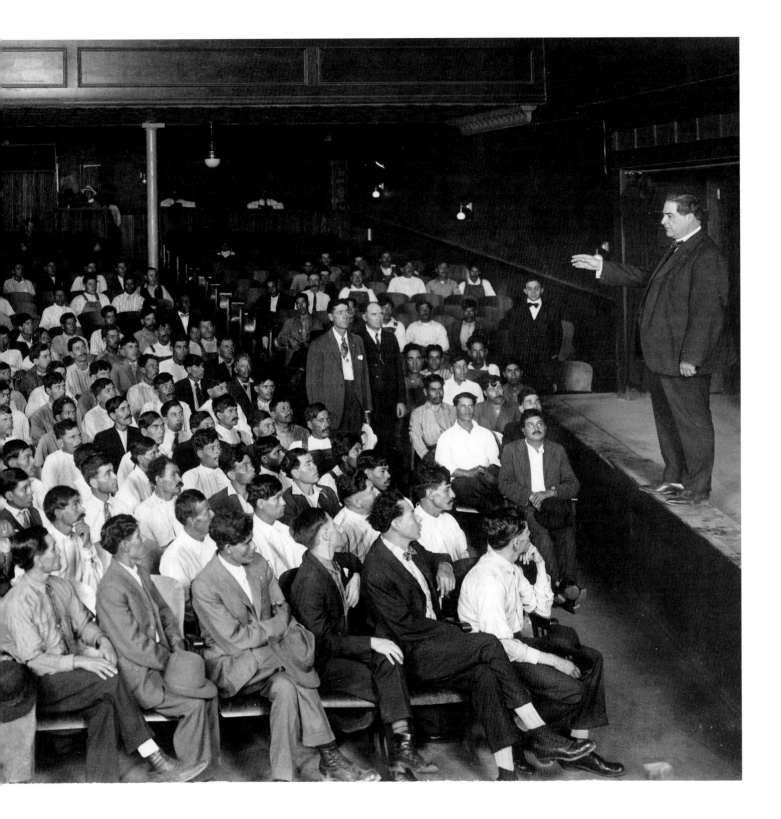

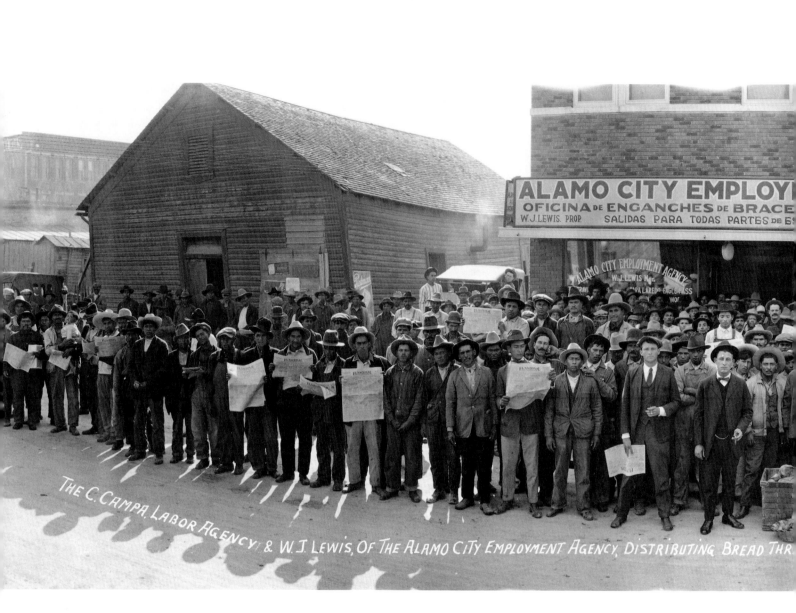

Specializing in large panoramas, San Antonio, Texas, photographer Hugo Summerville made this portrait on March 22, 1924, of the "C. Campa Labor Agency and W. J. Lewis of the Alamo City Employment Agency distributing bread three times a day to Mexicans who are in distress, waiting to be sent to a job." Mexican immigrants bound for California had to come north by way of railroads converging in Texas before being sent west. Courtesy of the Harry Ransom Humanities Center, University of Texas, Austin.

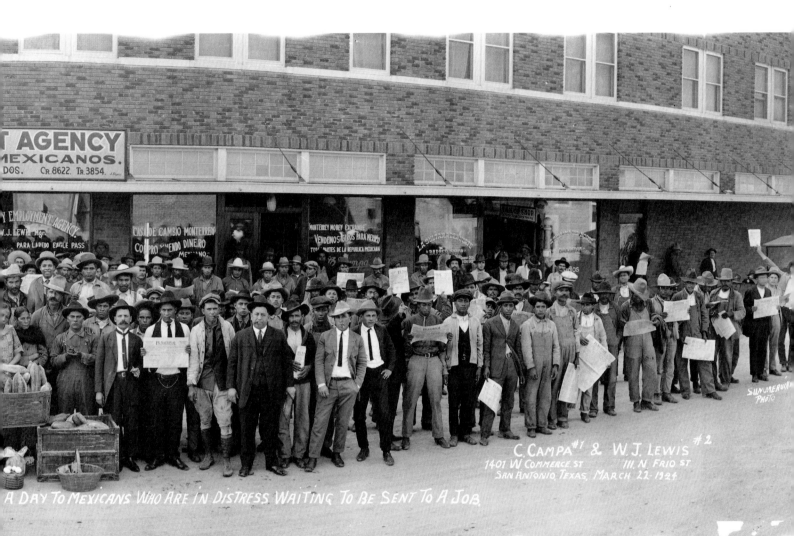

A DAY TO MEXICANS WHO ARE IN DISTRESS WAITING TO BE SENT TO A JOB.

C. CAMPA #1 & W. J. LEWIS #2
1401 W. COMMERCE ST. 111 N. FRIO ST.
SAN ANTONIO, TEXAS, MARCH 22-1924

Documentary Origins

Toward the end of the 1920s, a small and disparate group of photographers broke with established tradition, began focusing on rural reality rather than agricultural romance, and inaugurated an entirely new approach to photographing farmworkers. In the forefront of this movement was a remarkable individual, University of California economics professor Paul S. Taylor.

Taylor had become interested in photography while convalescing from a mustard gas attack suffered while serving as a Marine Corps second lieutenant in France during World War I. After obtaining his doctorate from the University of California, Berkeley, and becoming an assistant professor in the Economics Department, Taylor's interest in photography deepened when he became aware of the pioneering work being done by *Survey Graphic* magazine, a charity organization publication that featured such outstanding photographers as Lewis Hine and was publishing crude versions of what later came to be known as the modern photo essay. When the Social Science Research Council funded research for his massive, multivolume *Mexican Labor in the United States*, Taylor acquired a vest-pocket Kodak camera and began photographing as he interviewed field hands.

Taylor took another huge step toward a more probing photographic approach early in 1931 when he accepted *Survey Graphic*'s invitation to shed light on the so-called Mexican Question, then growing into a huge political issue, by writing a comprehensive article on Mexican immigration. Published as "Mexicans North of the Rio Grande," Taylor's essay was illustrated by a half-dozen of his photographs, along with four by Ansel Adams. The cover featured a dramatic Ansel Adams image of cotton pickers dumping their sacks into wagons. A second Adams photograph of a cotton picker ran full-page inside and was followed by other photographs of men bringing their sacks to the weigh master and older girls caring for younger children in a farm labor camp.

Ansel Adams is an odd name to associate with farmworker photography. Already considered a master of landscape pho-

tography, Adams above all was committed to making a living with his camera. Commissioned by San Francisco art patron Mrs. Charles Felton to photograph Mexican cotton pickers around Fresno in October 1930, Adams spent a day photographing a large cotton pickers' camp. Paying special attention to housing conditions, he documented children at play and everyday activities such as hanging out the wash. Upon returning to San Francisco, Adams delivered his portfolio to Mrs. Felton, who apparently forwarded it to *Survey Graphic*. Although never given credit for his accomplishment, Adams had completed the first photographic essay on California cotton pickers. It was a key turning point in the relationship between photographers and farmworkers.

Although Ansel Adams would become the most famous landscape photographer in the United States, he would never be that far from farmworkers, and over the next thirty years he photographed them on numerous occasions as part of commercial assignments for wineries and large corporate farming operations. Nor did Taylor's interest in photographing farmworkers end with publication of his multivolume Mexican labor series. Having familiarized himself with the latest camera equipment and learned "another language" for the social sciences, he vowed to integrate photography into his study of California farmworkers.

Taylor got his first chance on October 10, 1933, during the San Joaquin Valley cotton pickers' strike, when *San Francisco Chronicle* photographer Fred Smith photographed a murdered cotton striker. Lying in a pool of his own blood after being shot by vigilantes in what later came to be known as "the Pixley massacre," the mortally wounded Mexican collapsed and died shortly after Smith snapped his picture. Assigned to investigate the strike, Taylor obtained the photograph, along with a half-dozen other dramatic shots of picketing, armed deputies, riots, protest marches, fistfights, and mass funerals.

Of all the images that Taylor collected, those by Ralph H. Powell were by far the most important. An eighteen-year-old

high school student who had learned photography while assisting in his father's Hanford studio, Powell had grabbed a brace of cameras and over a period of several days documented the huge cotton strikers' camp at Corcoran, followed pickets out to the fields and captured images of picket line confrontations, and recorded dramatic images of trucks full of strikers rolling through Hanford. Powell was not acting out of any desire to expose injustice or support the cause of labor. Like any good photographer, he had simply refused to pass up good photographs, and in doing so, created images that were unprecedented in the annals of farmworker photography.

Merging with Taylor's survey of Mexican field hands and the work that Ansel Adams had done among Mexican cotton pickers, Powell's photo essay on the 1933 cotton strike complemented a body of images that broke dramatically with tradition. Now preoccupied with hard news and with the nature of life and labor in the fields, a handful of photographers began to focus on rural reality rather than agricultural romance. Using their cameras as tools of empowerment, they aimed at exposing evil and injustice and began producing hard-edged, deeply probing pictures that were often difficult to stomach.

Taking the lead in this effort were two adventuresome, idealistic German immigrants, Otto and Hansel Mieth Hagel. Fleeing the growing oppression of pre-Nazi Germany, Otto and Hansel arrived in California in 1930 and immediately hit the road as fruit tramps, photographing all along the way. Fluent in the latest technical elements of their profession, they aspired to take aesthetically pleasing images, but above all they intended to point out inequities and support political reforms that would shrink the gap between the classes.

To advance their goals, the Hagels abandoned the big Speed Graphics and Graflex cameras that were then standard equipment in favor of a secondhand Rolleiflex, an old Ermanox compact camera (which was about the size of a modern 35-millimeter camera), and a used Leica. Driven by

a desperate desire to succeed and possessing a chutzpah born of fear of failure, the Hagels were able to mingle freely with people, documenting all kinds of situations, some of them previously off-limits to photographers. At a moment's notice, in a melon field, or at an early morning shape-up, when a foreman left the area, or even when supervisors were present, they could produce a camera and in a few seconds make candid pictures.

Remaining on the road until Hansel took a job with *Life* magazine in 1937, the Hagels inaugurated an early version of reform-oriented, participant-observer photography. Together with Taylor, Powell, Adams, and a handful of other photographers, they were engaged in something that soon became known as documentary photography, although none at the time even used the term or thought of applying a label to their work.

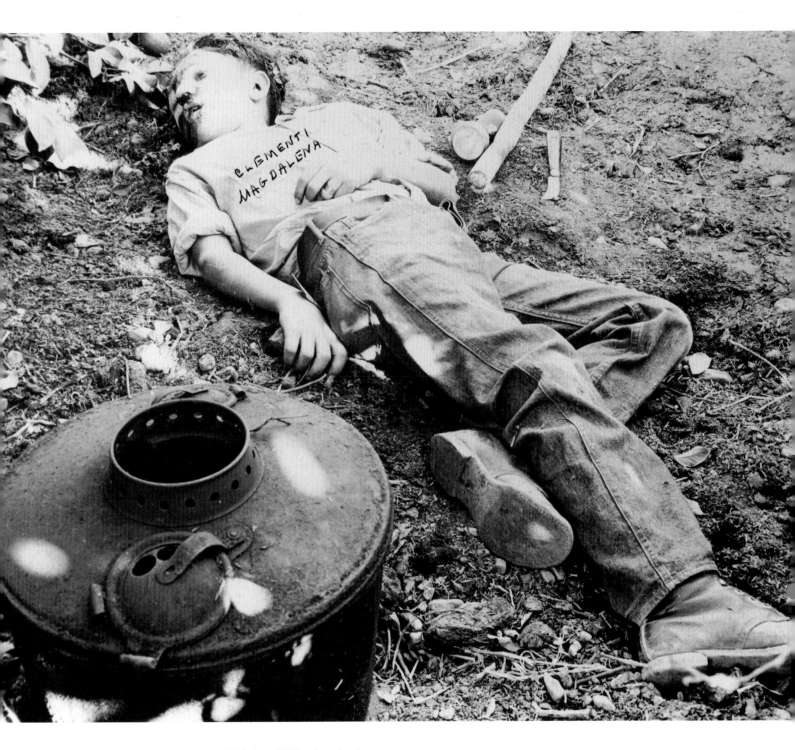

Clementi Magdalena, an eighteen-year-old Mexican field hand murdered while pruning citrus trees on the Limoneira Ranch, Ventura County, November 1, 1930. Photograph by Oliver L. Reardon. Courtesy of the Ventura County Coroner's Book of Violent Deaths, Ventura County Museum.

Often pigeonholed as a "master of the grand view" and a "landscape photographer" who did not interact well enough with people to produce fine portraiture, Ansel Adams was in fact a versatile photographer who completed many different assignments. Several images from his work among cotton pickers near Fresno in the fall of 1930 were used in Paul Taylor's pioneering *Survey Graphic* essay "Mexicans North of the Rio Grande" in May 1931. This picture graced the title page. Courtesy of the Ansel Adams Collection, Center for Creative Photography, University of Arizona, Tucson. Used by permission of the Trustees of the Ansel Adams Publishing Rights Trust. All Rights Reserved.

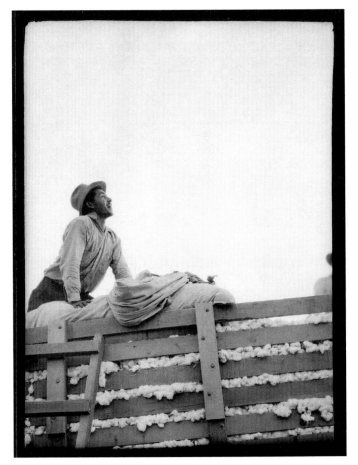

In the published version, Adams cropped this image in half along a vertical line and chopped off about 25 percent of the top. The caption reads: "Que tal?" (How goes it?). Photograph circa 1930. Courtesy of the Ansel Adams Collection, Center for Creative Photography, University of Arizona, Tucson. Used by permission of the Trustees of the Ansel Adams Publishing Rights Trust. All Rights Reserved.

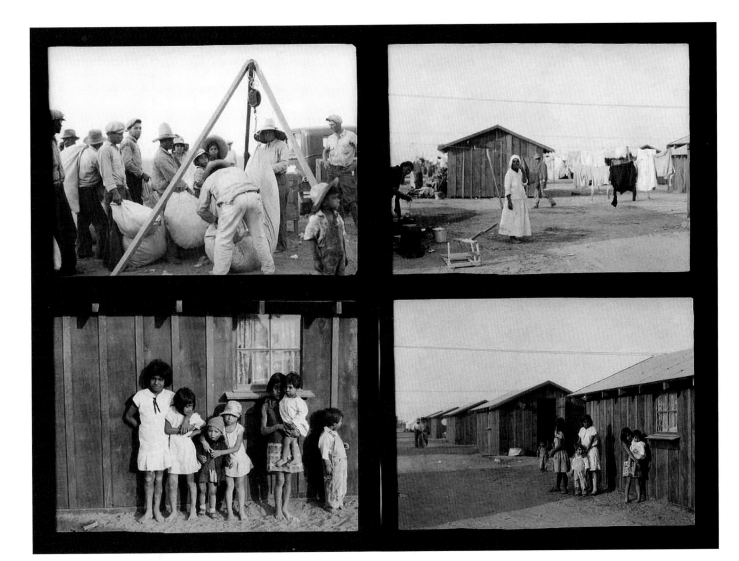

This Ansel Adams contact sheet of four-by-five inch negatives of Mexican cotton pickers in Fresno constitutes one of the earliest efforts at documentary photography among California farmworkers, although neither Adams nor anyone else used the term "documentary" to describe their work at this time. Photograph circa 1930. Courtesy of the Ansel Adams Collection, Center for Creative Photography, University of Arizona, Tucson. Used by permission of the Trustees of the Ansel Adams Publishing Rights Trust. All Rights Reserved.

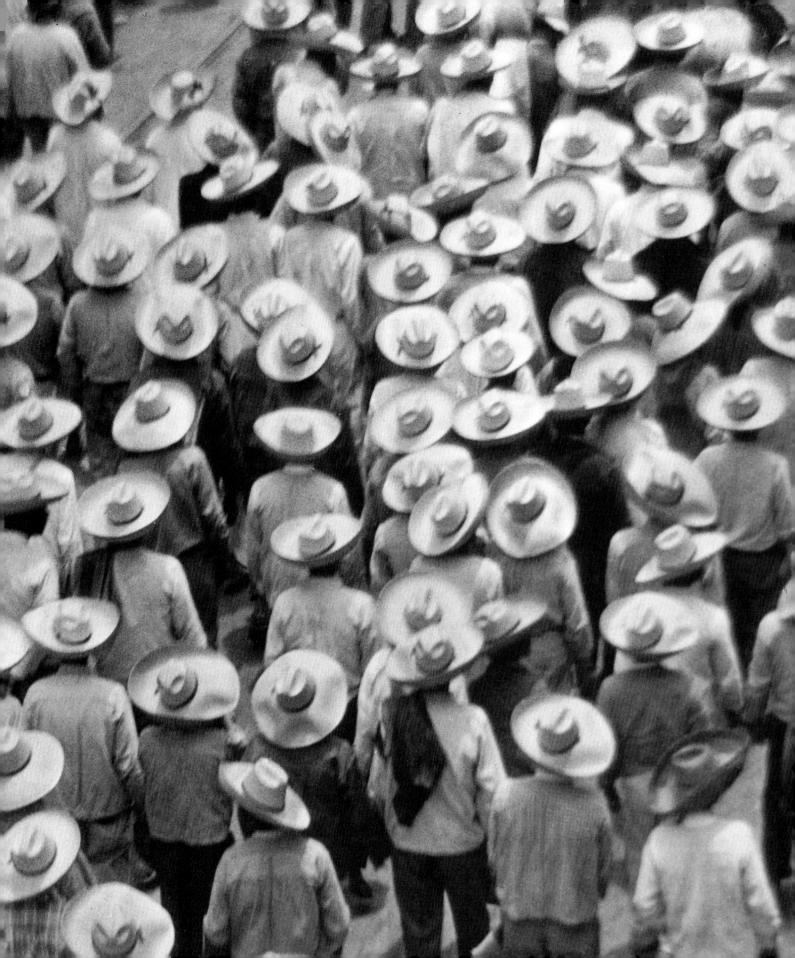

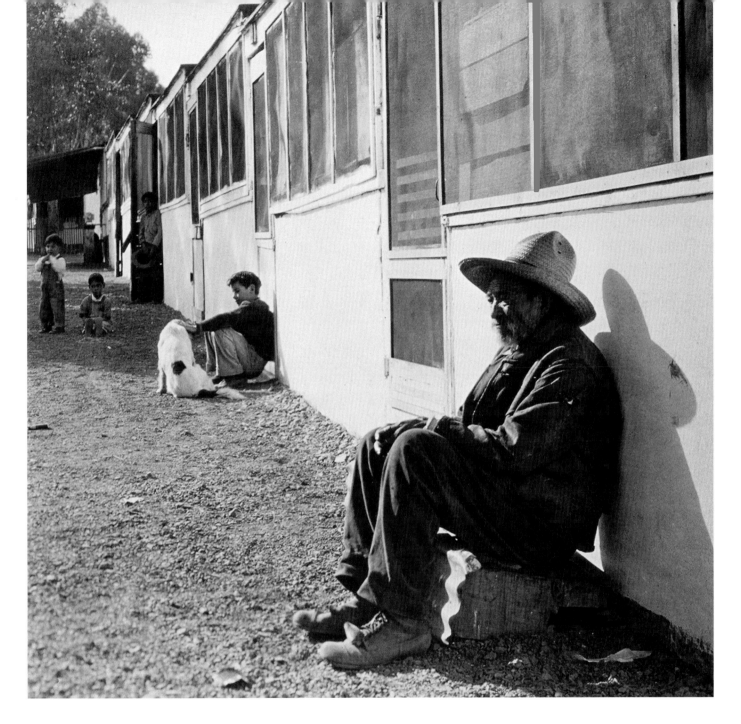

(*above*) An unknown photographer employed by the American Fruit Growers Exchange made this photograph of M. Llamas warming himself on the south-facing side of a Corona labor camp in December 1924. Courtesy of the Corona Public Library.

(*left*) Before she was expelled from Mexico for revolutionary activities in 1930, Italian expatriate photographer Tina Modotti abandoned the large-format camera techniques taught to her by Edward Weston and moved into the streets and countryside photographing with a handheld Graflex. Her image of Mexican campesinos on a May Day parade in 1926 suggests the surge of discontent propelling people north. Courtesy of Fototeca del I.N.A.H., Pachuca, Mexico.

ALIEN LABORER'S IDENTIFICATION CARD — No. 9168 — Triplicate
Spl. 125
U. S. DEPARTMENT OF LABOR
IMMIGRATION SERVICE
The bearer, a native and citizen of Mexico, has this day been granted the privilege of temporarily entering the United States in accordance with and under the conditions of Department Circular of June 12, 1918, as amended.
Name _Diaz, Jose_
Age _22_ Sex _M_ M. or S. _S_ Height _5.3_
Marks _cross eyed_
Read _no_ Last residence _Nogales, Son._
Destination _SPRECKELS SUGAR Co._ Employer _SPRECKELS, CALIF._
Accepted by _A. L. Knudsen_
Issued at El Paso _JUN 2 - 1919_, 191
Immigrant Inspector
14—1647

ALIEN LABORER'S IDENTIFICATION CARD — No. 9132 — Triplicate
Spl. 125
U. S. DEPARTMENT OF LABOR
IMMIGRATION SERVICE
The bearer, a native and citizen of Mexico, has this day been granted the privilege of temporarily entering the United States in accordance with and under the conditions of Department Circular of June 12, 1918, as amended.
Name _Garcia, Jose F._
Age _19_ Sex _M_ M. or S. _S_ Height _5.4_
Marks _faint scar on L. ck. bone._
Read _Yes_ Last residence _Nogales, Son._
Destination _SPRECKELS SUGAR Co._ Employer _SPRECKELS, CALIF._
Accepted by _A. L. Knudsen_
Issued at El Paso _MAY 31 1919_, 191
Immigrant Inspector

ALIEN LABORER'S IDENTIFICATION CARD — No. 9146 — Triplicate
Spl. 125
U. S. DEPARTMENT OF LABOR
IMMIGRATION SERVICE
The bearer, a native and citizen of Mexico, has this day been granted the privilege of temporarily entering the United States in accordance with and under the conditions of Department Circular of June 12, 1918, as amended.
Name _Gutierrez, Guillermo_
Age _20_ Sex _M_ M. or S. _S_ Height _5.9_
Marks _cheeks pitted_
Read _Yes_ Last residence _Nogales, Son._
Destination _SPRECKELS SUGAR Co._ Employer _SPRECKELS, CALIF._
Accepted by _A. L. Knudsen_
Issued at El Paso _MAY 31 1919_, 191
Immigrant Inspector
14—1647

ALIEN LABORER'S IDENTIFICATION CARD — No. 9124 — Triplicate
Spl. 125
U. S. DEPARTMENT OF LABOR
IMMIGRATION SERVICE
The bearer, a native and citizen of Mexico, has this day been granted the privilege of temporarily entering the United States in accordance with and under the conditions of Department Circular of June 12, 1918, as amended.
Name _Mexia, Jorge_
Age _23_ Sex _M_ M. or S. _S_ Height _5.10½_
Marks _scar L. ck. bone & R. chk._
Read _Yes_ Last residence _Nogales, Son._
Destination _SPRECKELS SUGAR Co._ Employer _SPRECKELS, CALIF._
Accepted by _A. L. Knudsen_
Issued at El Paso _MAY 31 1919_, 191
Immigrant Inspector
14—1647

ALIEN LABORER'S IDENTIFICATION CARD — No. 9131 — Triplicate
Spl. 125
U. S. DEPARTMENT OF LABOR
IMMIGRATION SERVICE
The bearer, a native and citizen of Mexico, has this day been granted the privilege of temporarily entering the United States in accordance with and under the conditions of Department Circular of June 12, 1918, as amended.
Name _Garcia, Lorenzo_
Age _19_ Sex _M_ M. or S. _S_ Height _1_
Marks _small scar R. ck. bone & fhd._
Read _Yes_ Last residence _Nogales, Son._
Destination _SPRECKELS SUGAR Co._ Employer _SPRECKELS, CALIF._
Accepted by _A. L. Knudsen_
Issued at El Paso _MAY 31 1919_, 191
Immigrant Inspector
14—1647

Name _____ No. _____
EMPLOYED BY
Name _____

ALIEN LABORER'S IDENTIFICATION CARD — No. 9121 — Triplicate
Spl. 125
U. S. DEPARTMENT OF LABOR
IMMIGRATION SERVICE
The bearer, a native and citizen of Mexico, has this day been granted the privilege of temporarily entering the United States in accordance with and under the conditions of Department Circular of June 12, 1918, as amended.
Name _Ramos, Jesus_
Age _22_ Sex _M_ M. or S. _S_ Height _5.6_
Marks _sm. mole L. chk & R. neck._
Read _Yes_ Last residence _Nogales, Son._
Destination _SPRECKELS SUGAR Co._ Employer _SPRECKELS, CALIF._
Accepted by _A. L. Knudsen_
Issued at El Paso _MAY 31 1919_, 191
Immigrant Inspector
14—1647

Name _____ No. _____
EMPLOYED BY
Name _____

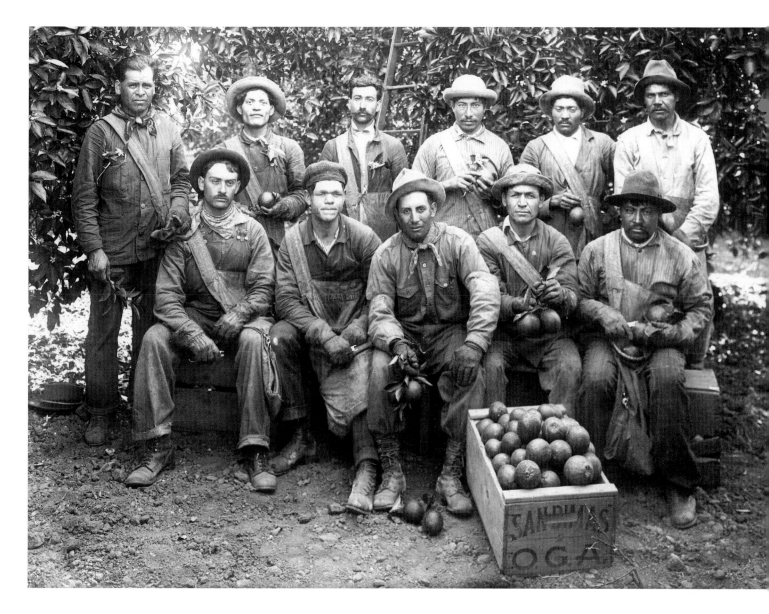

(*above*) Capturing the grit and grime of ladder work, these Mexican orange pickers of the San Dimas Citrus Association posed for an unknown photographer during their morning break in the winter of 1929. Courtesy of the Pomona Public Library.

(*left*) Brought in to work for the Spreckels Sugar Company on May 31 and June 2, 1919, these Mexican field hands were photographed by the U.S. Department of Labor and their mug shots placed on identification cards. Courtesy of the California History Section, California State Library.

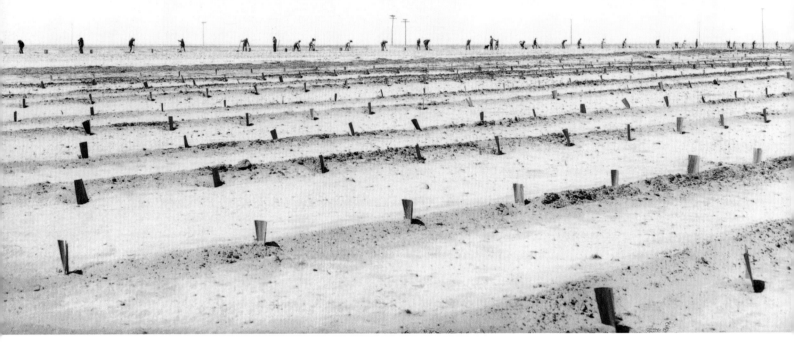

In this 1926 image of Mexican field hands planting young grapevines, Merced photographer Frank Day Robinson adopts a perspective emphasizing their insignificance in the vast, wide-open landscape. Courtesy of Stephen Johnson.

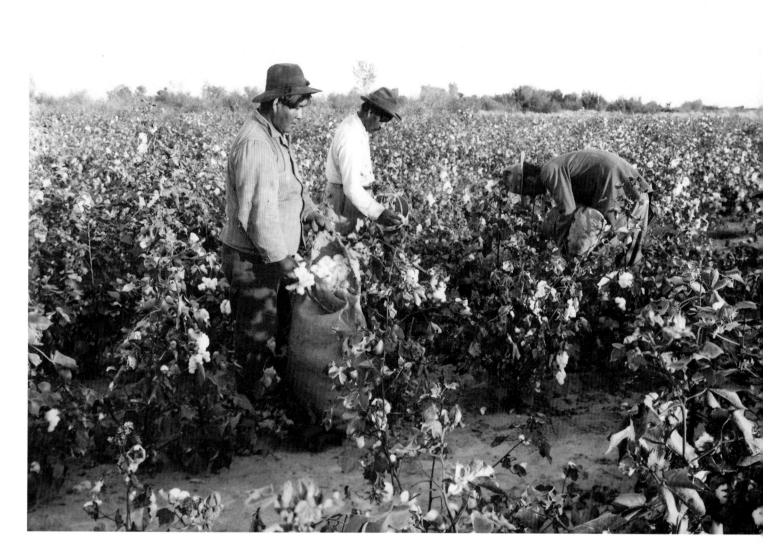

When the Indians moved into the fields to pick cotton near Fresno in 1929, an unknown photographer thought them newsworthy enough to record on a large-format glass-plate negative. Courtesy of the Seaver Center for Western History, Los Angeles County Museum of Natural History.

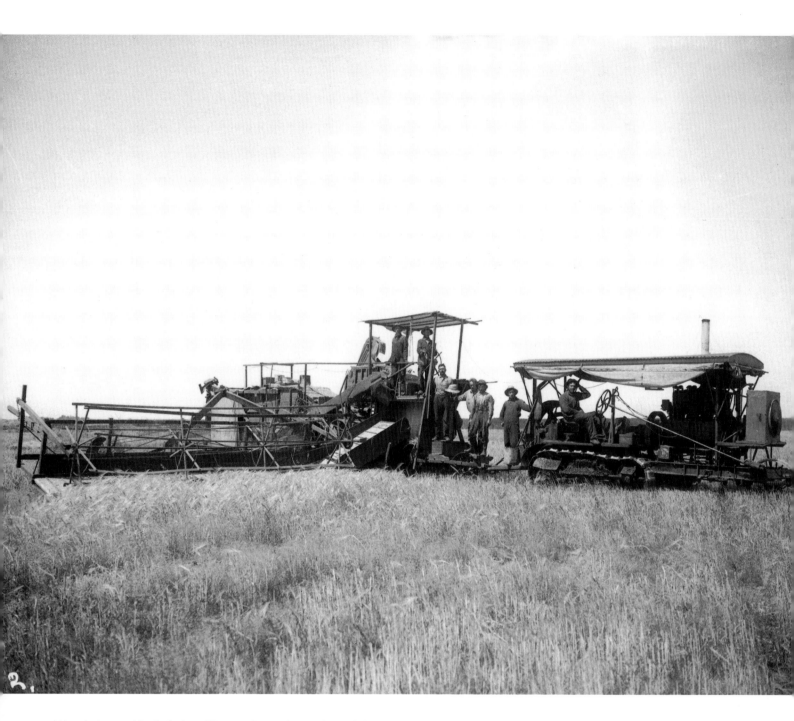

Although photographing in the late 1920s, an unknown photographer took the time to record this crew, with its gasoline-powered combine, on an obsolete but razor sharp, large-format glass-plate negative. Courtesy of the Huntington Library, San Marino, California.

x

90

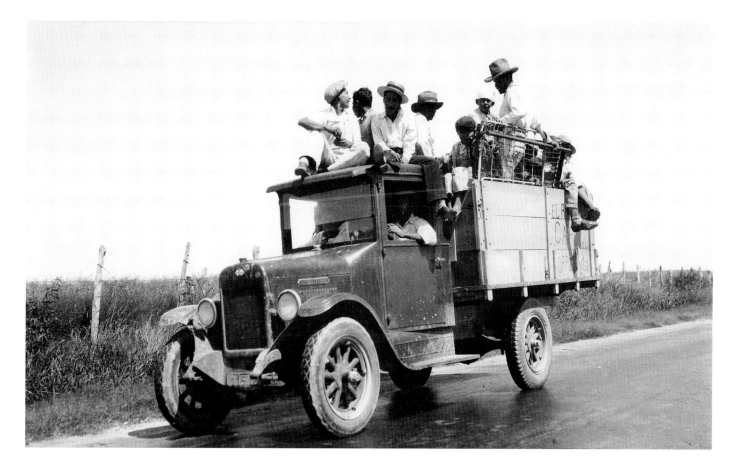

While completing his multivolume study of Mexican labor in the United States, University of California economics professor Paul S. Taylor packed a camera as a means of visual shorthand. This rare image of Mexicans revealed how rapidly they had adopted the automobile as a means of extending the range of migration in search of work. Courtesy of Paul S. Taylor.

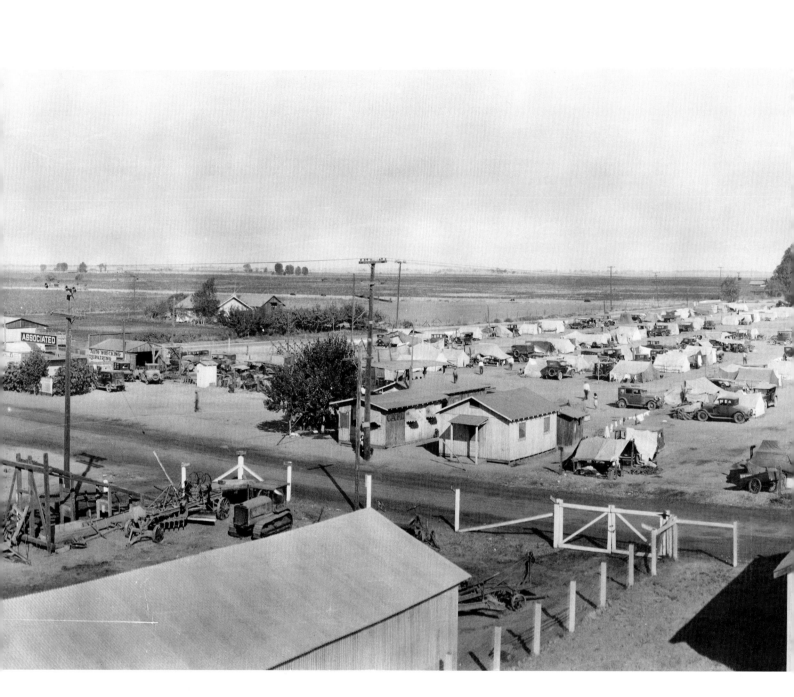

To make this panorama of the Corcoran cotton pickers' camp in October 1933, Hanford photographer Ralph H. Powell climbed to the top of a water tower with a Cirkut camera. Courtesy of Ralph H. Powell.

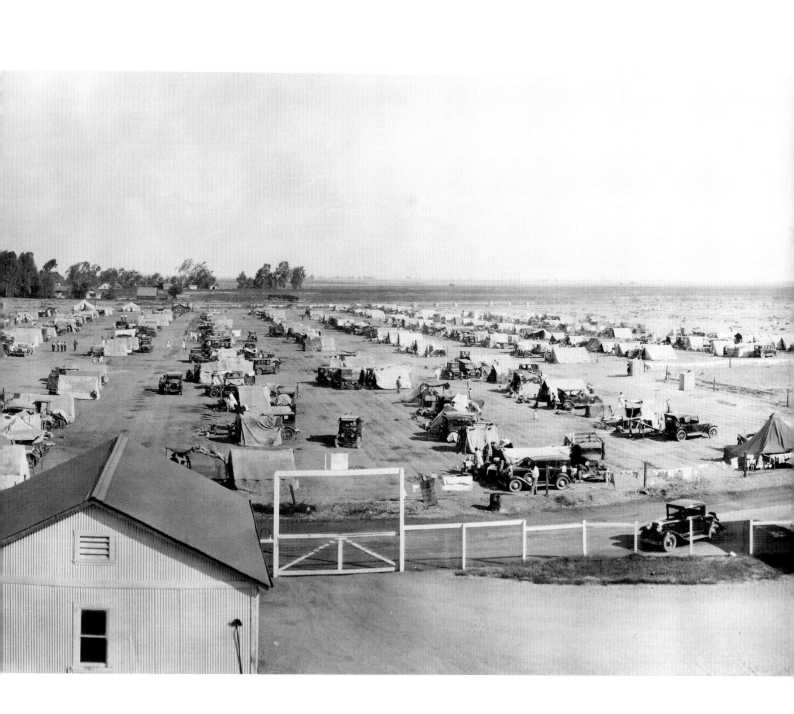

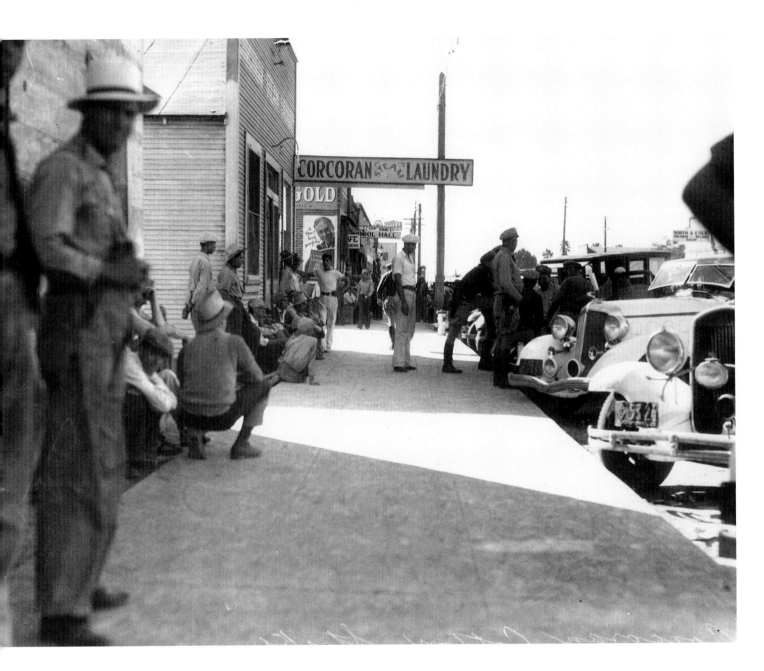

During the 1933 Corcoran cotton pickers' strike, *San Francisco Examiner* photographer Harold Ellwood made this image of strikers and highway patrolmen in the downtown area on October 24, 1933. Courtesy of the *San Francisco Examiner*.

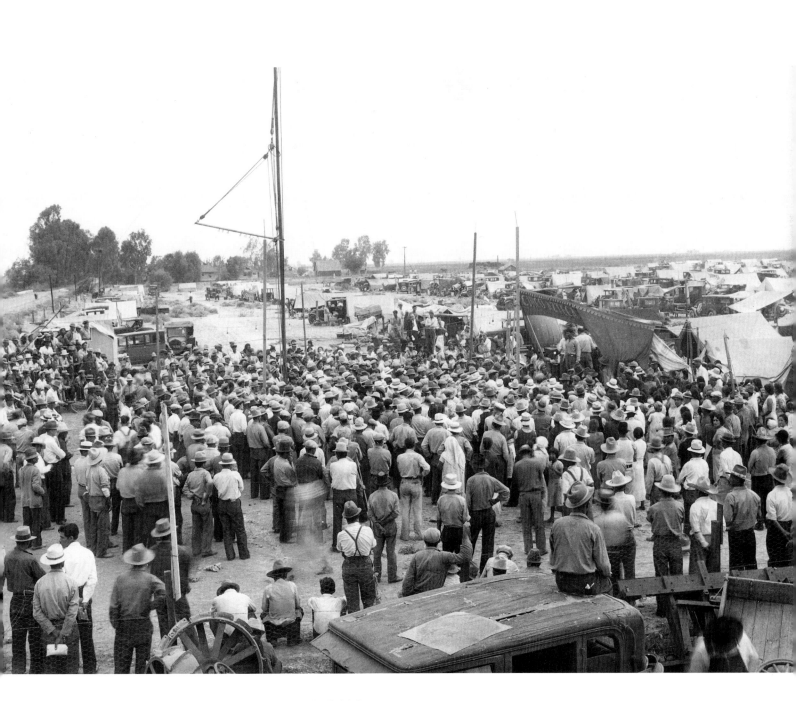

Climbing onto a shed on October 9, 1933, Hanford photographer Ralph H. Powell placed his camera on a tripod and shot at one-third of a second to record the Azteca Theater as it entertained striking cotton pickers in the Corcoran cotton camp. His slow exposure produced several blurred figures, bottom right and center. Courtesy of Ralph H. Powell.

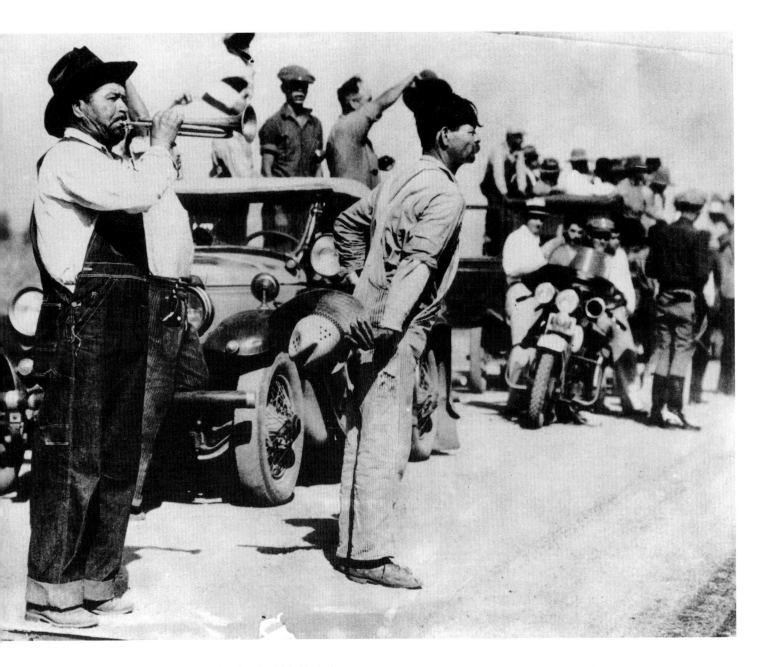

Following caravans of striking cotton pickers into the fields, Hanford
photographer Ralph H. Powell made this classic shot of picketers calling
workers out of the fields on October 9, 1933. Courtesy of Ralph H. Powell.

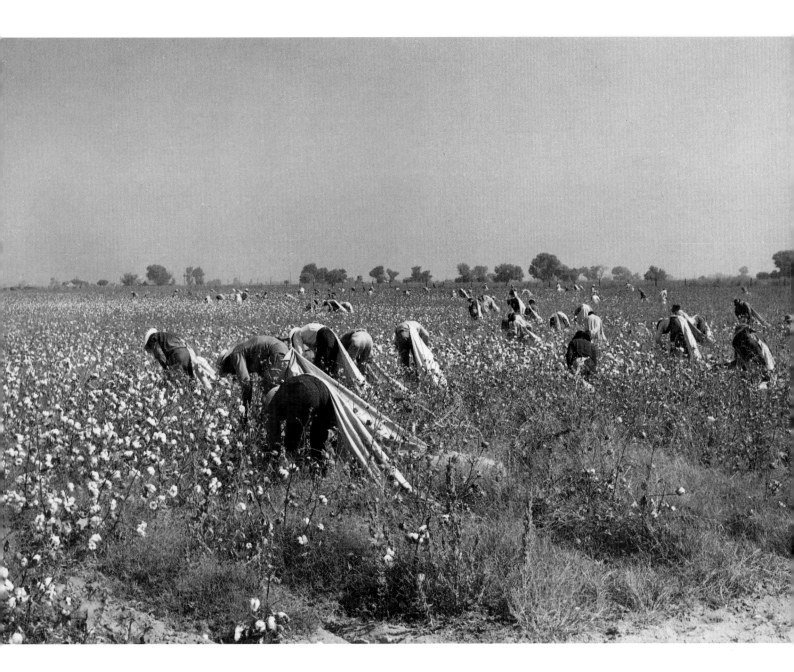

Stooped over and pulling their long sacks through the fields, these cotton pickers near Fresno captured the attention of an unknown photographer sometime in 1930. Courtesy of the California Historical Society.

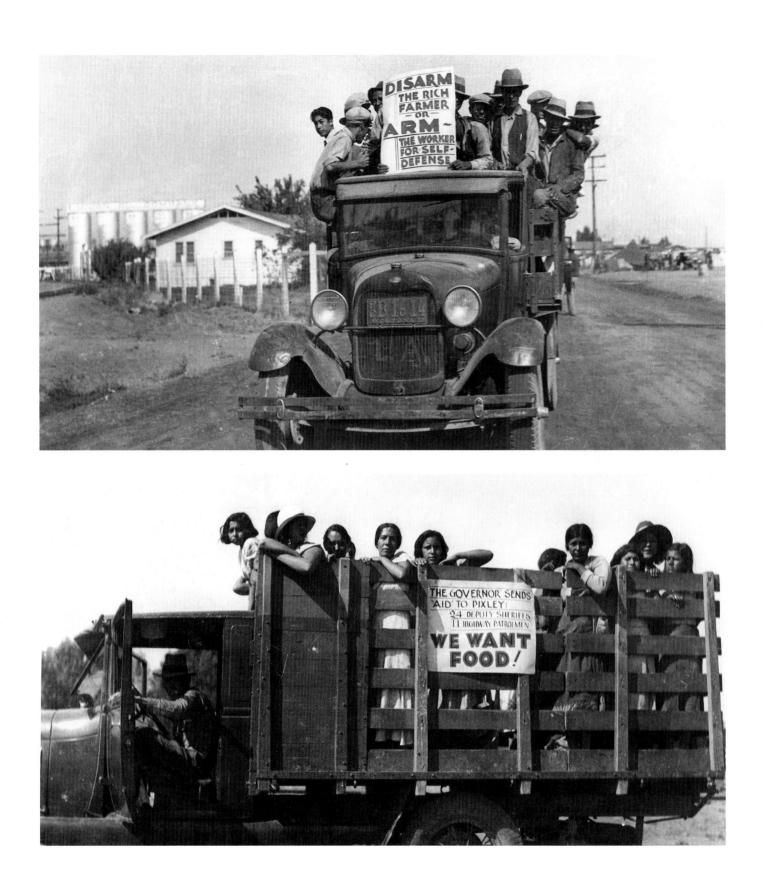

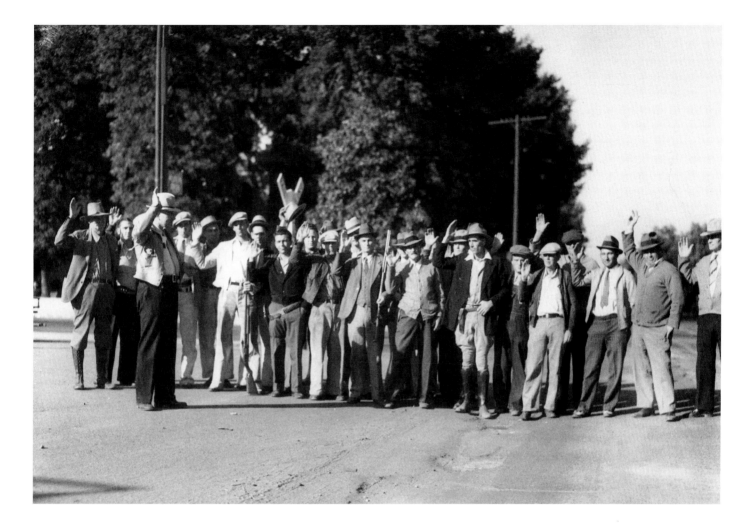

(*above*) *San Francisco Examiner* photographer Harold Ellwood made this photograph of Sheriff R. Hill swearing in deputies on October 25, 1933. Courtesy of the *San Francisco Examiner.*

(*left, top*) After Ralph H. Powell made this and the following image of roving bands of picketers, University of California economics professor Paul S. Taylor obtained copies that he placed in the Library of Congress and used during the La Follette Civil Liberties Committee investigation into industrialized agriculture. Courtesy of Ralph H. Powell.

(*left, bottom*) Ralph H. Powell's image of striking women cotton pickers crying out for relief would become one of the most well-known and widely published images of the 1933 cotton strike. Although the image would grace the cover of at least one book, Powell would never receive a byline or proper credit. Courtesy of Ralph H. Powell.

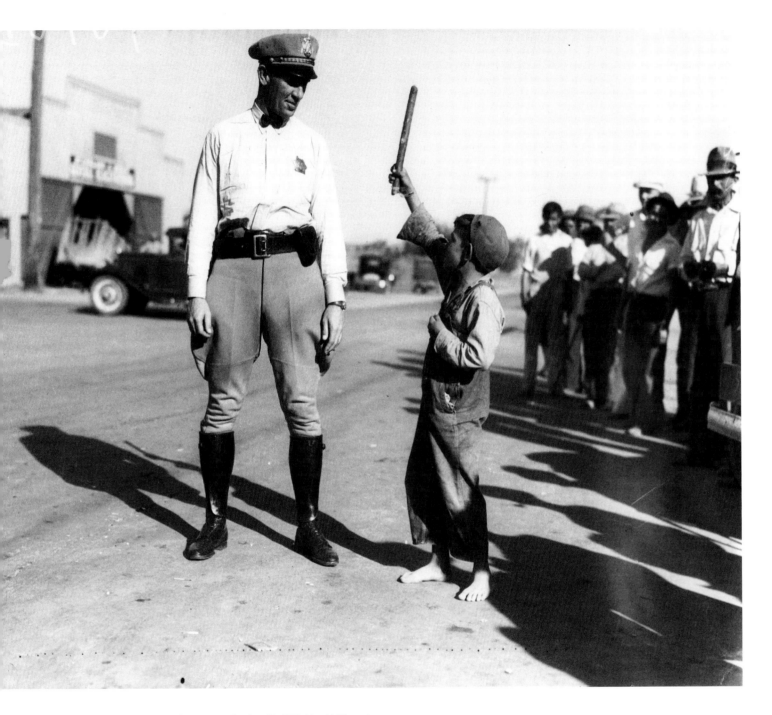

While working the streets in Corcoran on October 25, 1933, Harold Ellwood captured this image of the child of striking cotton pickers confronting a highway patrolman. Courtesy of the *San Francisco Examiner*.

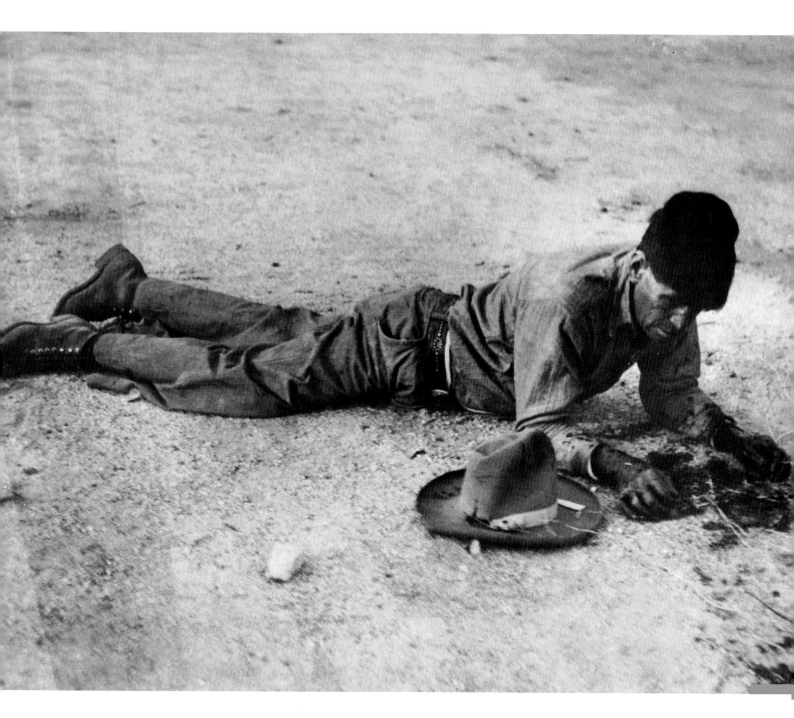

On assignment for the *San Francisco Chronicle*, Fred Smith came upon a
mortally wounded Mexican cotton picker trying to rise while lying in a pool
of blood after being shot by vigilantes in Pixley on October 10, 1933. It was one
of many photographs of the strike later collected by University of California
economics professor Paul S. Taylor. Courtesy of the Bancroft Library, University
of California, Berkeley.

Paul Taylor and Dorothea Lange

Toward the end of the summer of 1934, while attending an exhibit at photographer Willard Van Dyke's Oakland studio, Paul Taylor noticed the work of one photographer in particular—Dorothea Lange. Awestruck by Lange's image of an organizer addressing a crowd, he asked Van Dyke to put him in touch with the photographer. "I asked her, could the photograph be used as an illustration to accompany the article on the San Francisco general strike?" Lange said yes, and a collaboration began. Looking back on that encounter, Taylor recalled it as a turning point in his life and in the relationship between photographers and farmworkers in California. He had met the person who, more than any other, would influence the image of farmworkers. Lange inspired a more creative, socially oriented photography and set the standard by which documentary photography was measured. She would become his partner in an unusually productive union of social science and photography.

Married in 1920 to painter Maynard Dixon, Lange pursued a career as a studio photographer, producing safe, conventional portraits. But as her portrait business began to wane, Lange grew restless. She moved outside her studio and began doing street photography, looking at the dispossessed and photographing them in unusual and beautiful ways. While photographing the May Day protest rallies and the San Francisco general strike in 1934, Lange found her special gift as a photographer, or, as she put it, she "grabbed a hunk of lightning." This was the work that inspired Van Dyke to invite her to exhibit at his gallery, which in turn led to her subsequent encounter with Taylor.

About mid-January 1935, when Taylor was asked to head the research program of the Division of Rural Rehabilitation of the California State Emergency Relief Administration (SERA), the state arm of Harry Hopkins's Federal Emergency Relief Administration, he requested funds to hire a photographer who would bring from the field the visual evidence that would accompany his textual reports. This was important because the people who would read his reports and were responsible for making decisions had to see the actual

conditions. There was no authority to hire a photographer, and the situation seemed at an impasse until office manager Lawrence Hewes, a Dartmouth graduate whose career in stocks and bonds had been terminated by the Wall Street debacle, stretched the rules and hired Lange as a clerk-typist at fifteen hundred dollars a year.

Toward the end of her life, Lange recalled her first trip with Taylor in February 1935, when they stopped at a gas station and watched Dust Bowl refugees streaming over the bridge in Yuma, Arizona. Finding the newcomers packed into their cars and trucks with all their worldly possessions, Lange captured them in brave and stoic poses, in midgesture, somewhat at a distance, simultaneously admirable and vulnerable. With great stamina, Lange had no problem keeping up with the pace of work set by Taylor. Even her limp (caused by polio) seemed an asset, often disarming subjects who otherwise would have been wary of a photographer in their presence.

While returning north, Lange made one of her most famous early photographs. She encountered a couple sitting in their model-T Ford bundled against the cold somewhere along the highway near Bakersfield. They were a forlorn sight. Although the woman seemed distant and relatively comfortable in her fur-lined coat with her hands tucked in her pockets, the driver was clearly anguished. With his long face, sturdy nose, and wide eyes, he stared past his wife at Lange as she opened the door and looked inside. By world standards, they were well-off, well dressed, well clothed, with transportation. After photographing them, Lange later made several prints. She cropped out the woman and enlarged the portion of the photograph that centered on the driver. As a result, the image—entitled "Ditched, Stalled, and Stranded"—became a different picture.

As she worked, Lange quickly developed a way of enveloping herself in what she later called her "cloak of invisibility"—which was simply a way of photographing among strangers without attracting attention. Another aspect of Lange's working technique, for which she would become fa-

mous, also developed at this time. Carrying a small notebook, she began jotting down notes. Seldom comprehensive, these informal "notes from the field" or "field notes" became a distinguishing characteristic of Lange's photographic presence.

Taylor and Lange were in the process of compiling an illustrated presentation. Taylor already had the typed text laying out the background, presenting statistics or estimates and recommending certain solutions. Completed on March 15 and soon shown to members of the SERA, the fifty-four page report contained fifteen pages of text, with fifty-seven of Lange's photographs, some dated as recently as March 2. Members voted immediately to provide funds for the construction of twenty sanitary camps for migrant workers. "After that," Taylor recalled, "no question was raised about why I wanted a photographer. It worked."

Lange and Taylor's collaboration was the first extended teaming of a social scientist and photographer. With their reports, Taylor and Lange moved into a new area of communication, that of the illustrated book, a venture far more pathbreaking than they realized.

At the end of August, Lange transferred from the SERA to the regional office of the newly created Resettlement Administration (RA). Needing good publicity for its programs, the RA created a photographic unit. Called the historical section, it was headed by Roy Stryker. Seeking to round out a staff of photographers that would at various points include Arthur Rothstein, Carl Mydans, Walker Evans, Ben Shahn, John Collier, Jack Delano, Russell Lee, and Marion Post Wolcott, Stryker hired Lange because she had been doing on her own in California exactly what he intended to do for the United States.

At that time, there was no term for an independent and probing photographic consciousness, although soon it would be called "documentary." Lange disliked the term, as did the preeminent photographic historian of the time, Beaumont Newhall. When she was praised as one of the founders of documentary photography, Lange always replied, "That's

nonsense," citing the earlier work of Lewis Hine and Jacob Riis. Her ambivalence in formulating a terminology, and the dilemma of others seeking definitions, came from the realization that, to some extent, every photograph documents something. Whatever the labels, her work was far more complicated than she could explain, or than anyone has ever been able to put into words.

Much to the consternation of her friends, Lange divorced Maynard Dixon in October 1935. Early in December, Taylor and his wife divorced. On December 6, while in Albuquerque, Taylor and Lange married. That afternoon, she went out and photographed. They would remain married through the next thirty eventful years, until Lange's death from cancer of the esophagus in 1965.

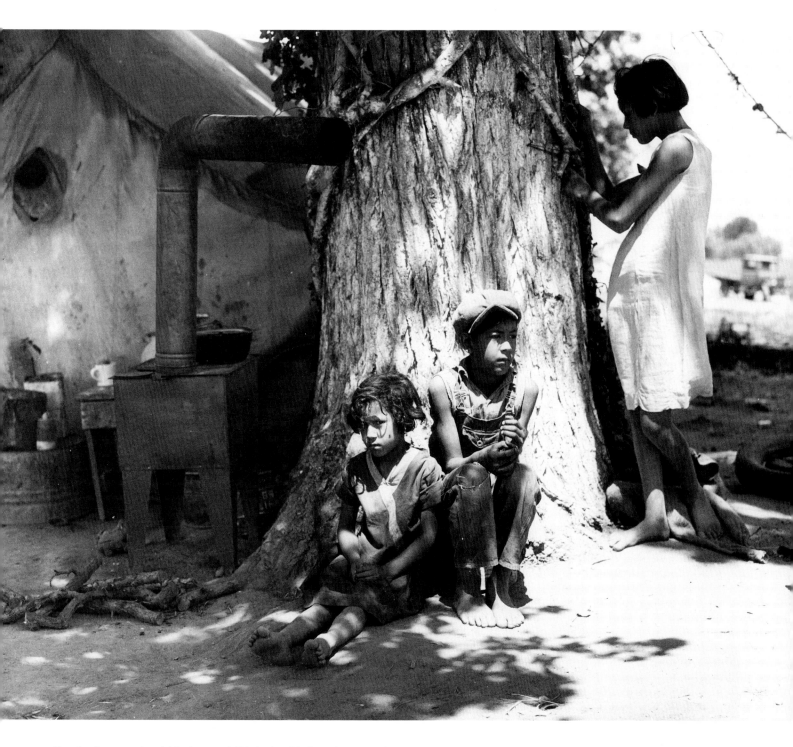

Dorothea Lange captioned this photograph "Motherless Mexican migrant children who work in the cotton in California, June 1935." Courtesy of the FSA/OWI Collection, Library of Congress.

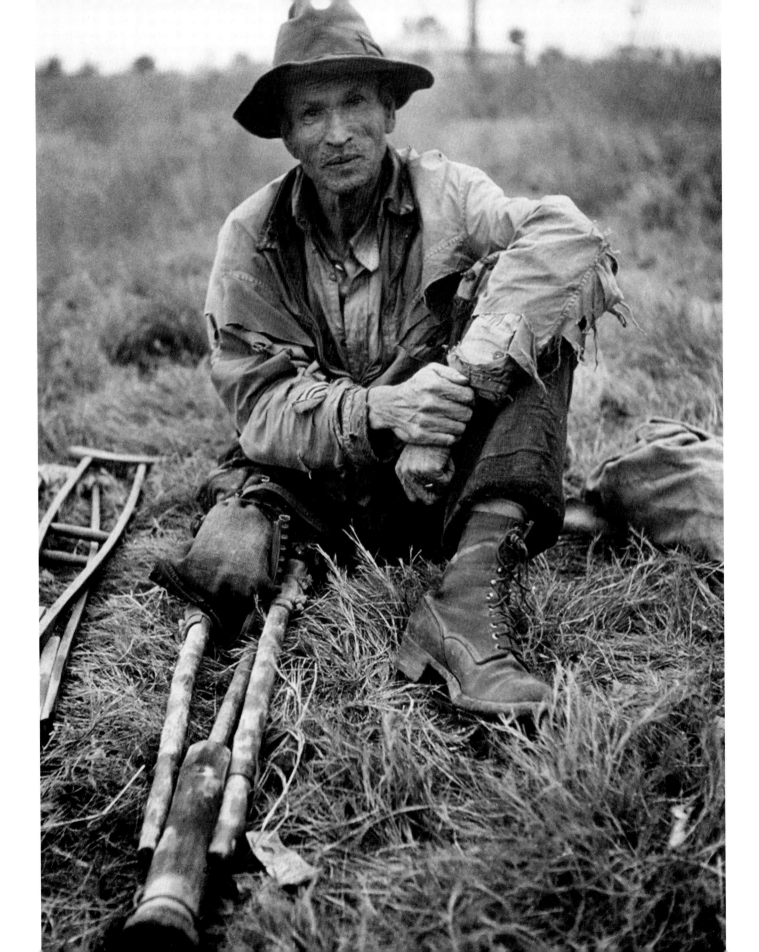

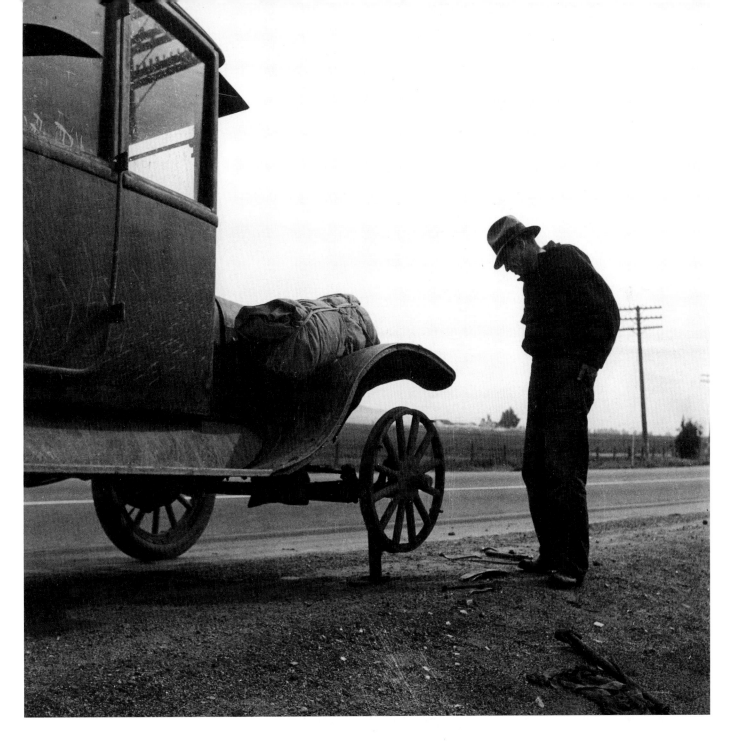

(*left*) While photographing on the west side of the San Joaquin Valley in 1934, Otto Hagel happened upon Francisco Martinez, also known as "Salty Wooden Leg." His caption, reminiscent of a Dorothea Lange field note, read: "Coming off the field upon the highway, a car sideswiped him and left him where he fell. In the morning the Highway Patrol found him and a hospital discharged him early without a prosthesis or medicine. Crutches he begged. Wooden leg he made from scrap he found by the side of the road and was now making his way picking cotton." Courtesy of the Collection of Otto and Hansel Mieth Hagel, Center for Creative Photography, University of Arizona, Tucson.

(*above*) Capturing one of the perils of the Okie migration west, Dorothea Lange made this image of a Dust Bowl refugee contemplating his front wheel after removing the tire to make repairs along Highway 99 somewhere in the San Joaquin Valley in 1935. Courtesy of the Dorothea Lange Collection, Oakland Museum of California. Gift of Paul S. Taylor.

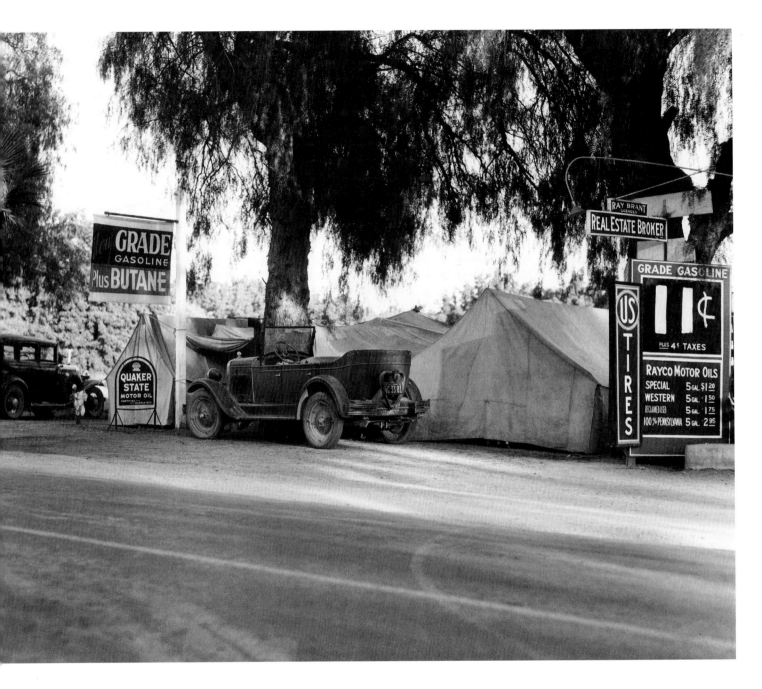

Following migrant workers in the Coachella Valley in 1935, Dorothea Lange documented this roadside camp, conveniently located at the last water and gasoline station for twenty miles. Courtesy of the Dorothea Lange Collection, Oakland Museum of California. Gift of Paul S. Taylor.

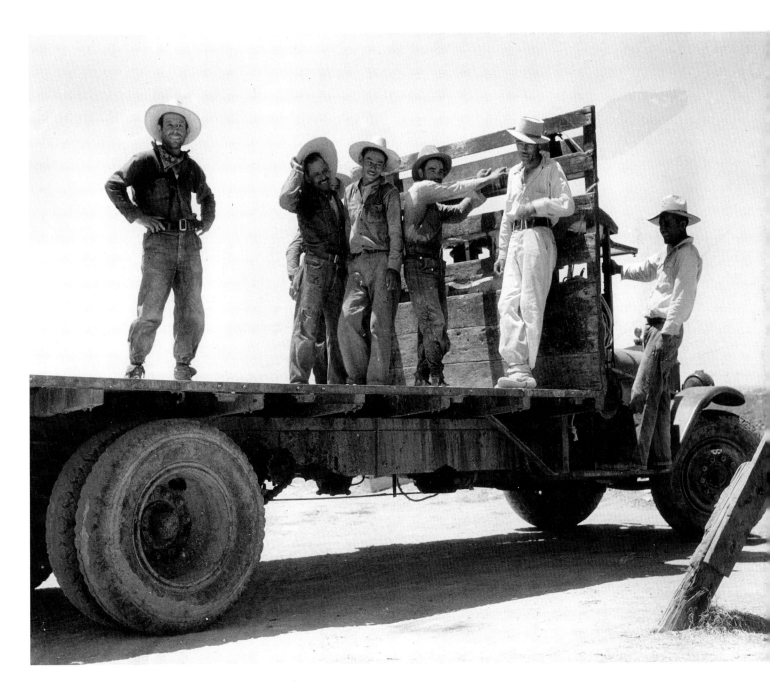

A portrait artist at heart, Dorothea Lange excelled at getting these melon pickers to hold for a candid pose as they headed to the fields in the Imperial Valley in June 1935. Courtesy of the Farm Security Administration/Office of War Information (FSA/OWI) Collection, Library of Congress.

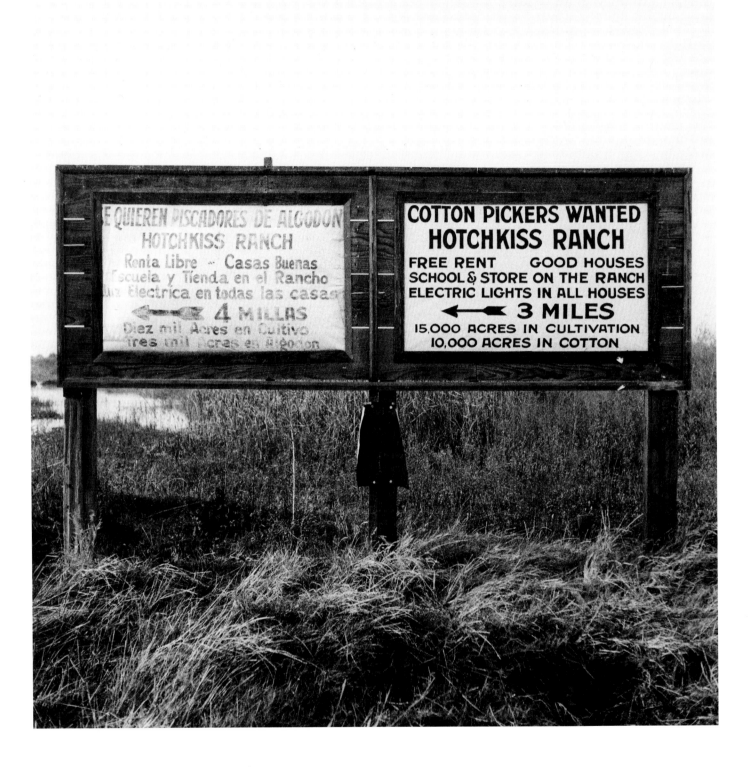

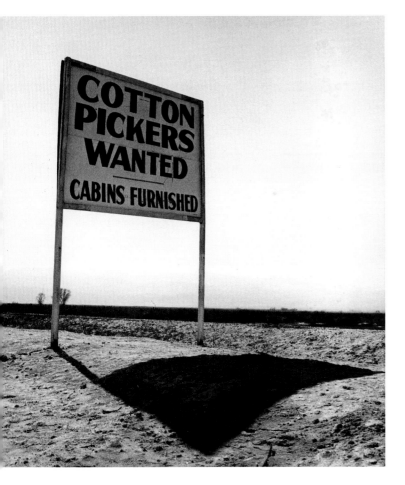

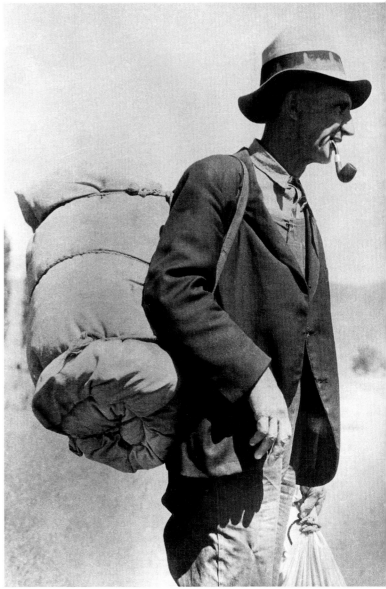

(*above*) One of hundreds of such signs Dorothea Lange photographed along the route traveled by migrants, this one beckoned cotton pickers to a ranch near Pixley in the southern San Joaquin Valley in the fall of 1935. Courtesy of the FSA/OWI Collection, Library of Congress.

(*right*) Although it is often said that Dorothea Lange never photographed the truly down-and-out, she made many portraits of bindlemen (so named because they traveled with their belongings wrapped in a blanket or "bindle") such as this individual, whom she encountered hiking between jobs in the Central Valley in 1935. Courtesy of the Dorothea Lange Collection, Oakland Museum of California. Gift of Paul S. Taylor.

(*left*) Always attentive to signs along the way, Dorothea Lange noticed this billboard soliciting cotton pickers in both English and Spanish and promising good houses and free rent to travelers along Highway 99 near Fresno in October 1935. Courtesy of the Dorothea Lange Collection, Oakland Museum of California. Gift of Paul S. Taylor.

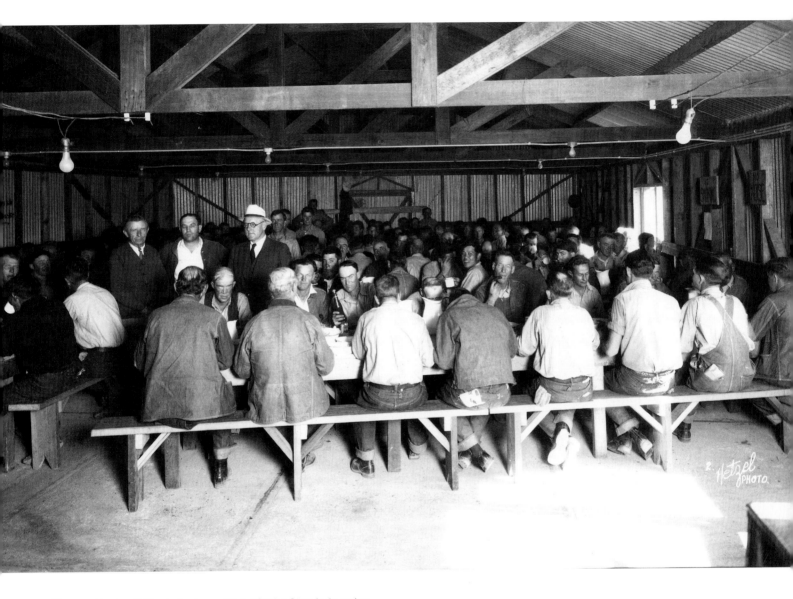

Photographing in a California Employment Relief Station Camp in the spring of 1934, Imperial Valley commercial photographer Leo Hetzel documented hundreds of luckless people stranded in the valley while seeking work in the fields and on various canal construction projects. Courtesy of the Imperial County Historical Society/Pioneers' Museum.

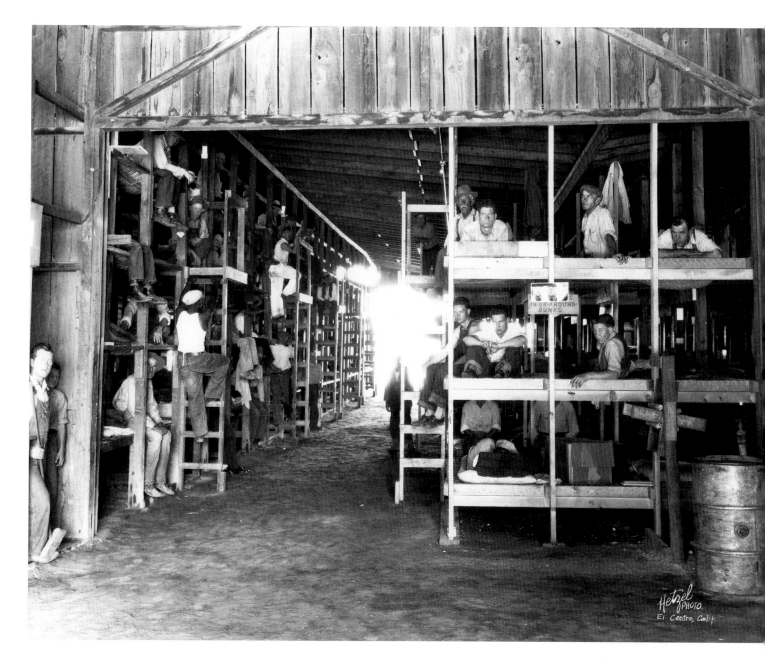

Leo Hetzel could not pass up this picture of field hands, drifters, and down-and-outs crammed into a work camp in the spring of 1934 in bunks three tiers high and three deep. Courtesy of the Imperial County Historical Society/Pioneers' Museum.

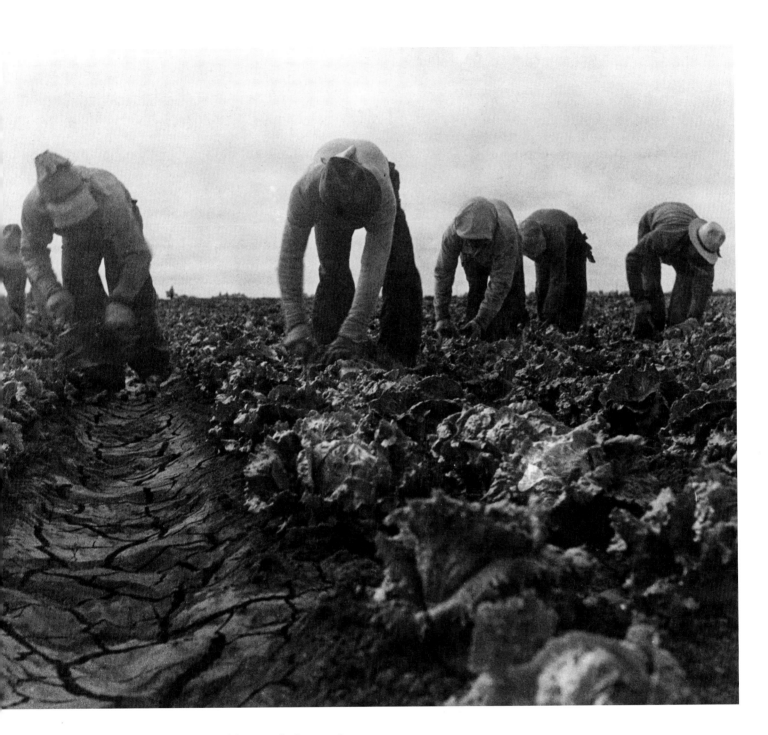

Unsurpassed in the way it captures stoop laborers cutting lettuce under lowering skies, this image by Dorothea Lange depicts Filipinos in the Salinas Valley in June 1935. Courtesy of the FSA/OWI Collection, Library of Congress.

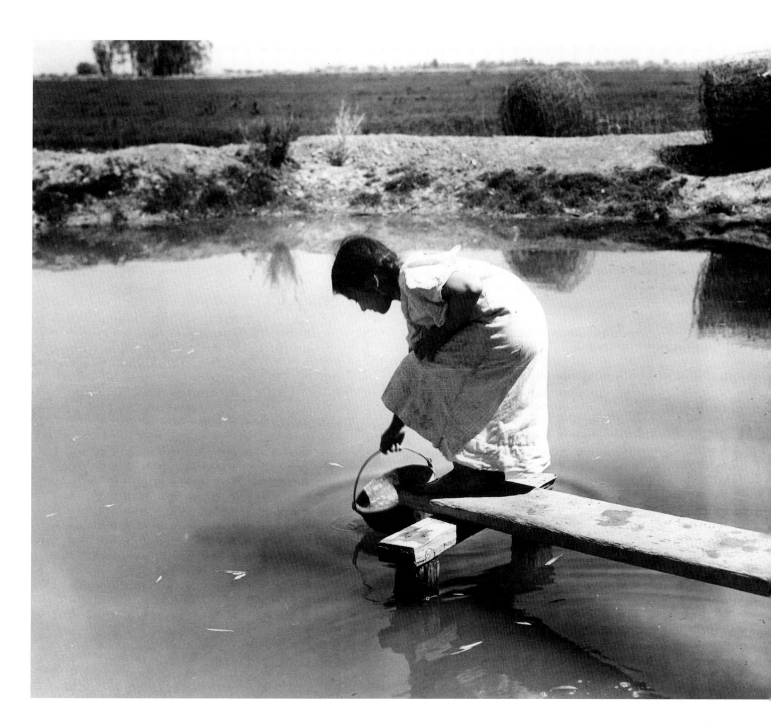

Near El Centro, in the summer of 1935, Dorothea Lange photographed this young girl scooping drinking water out of a canal. Just before taking this image, Lange had characteristically recorded an "establishing image" of the improvised shack the family had constructed beside the water supply. She would return to this scene and record it from different angles, in different ways, over several days. Courtesy of the FSA/OWI Collection, Library of Congress.

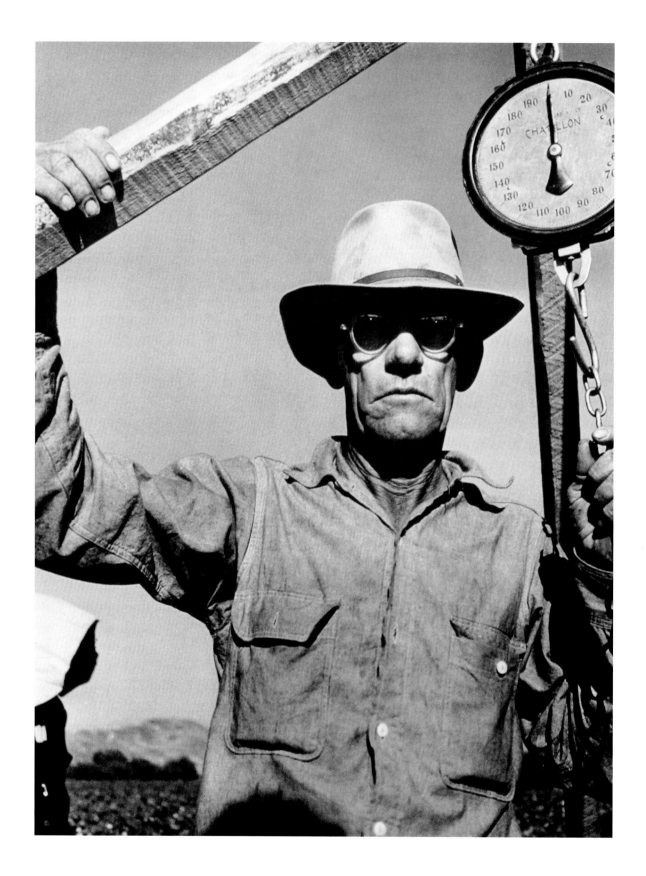

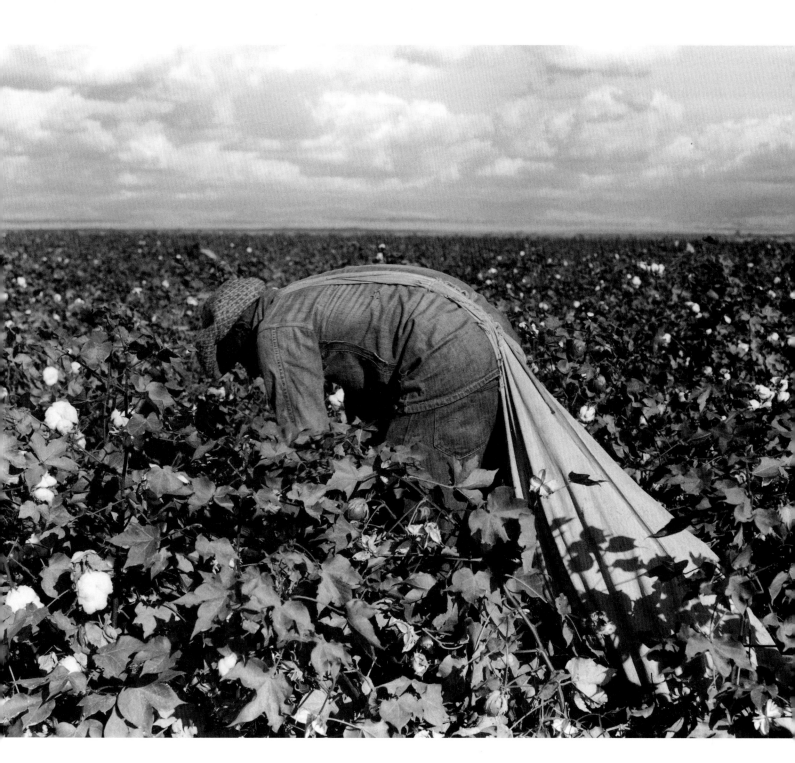

(*left*) After photographing this foreman supervising cotton picking in the San Joaquin Valley in 1934, Otto and Hansel Mieth Hagel captioned their image, "The weigh master awaits." Courtesy of the Otto and Hansel Mieth Hagel Collection, Center for Creative Photography, University of Arizona, Tucson.

(*above*) While covering the San Joaquin Valley cotton strike of 1938, Dorothea Lange made this close-up emphasizing the toll exerted on one's back while hunched over dragging a sack through the fields while picking cotton on a piece rate basis for ten hours each day. Courtesy of the FSA/OWI Collection, Library of Congress.

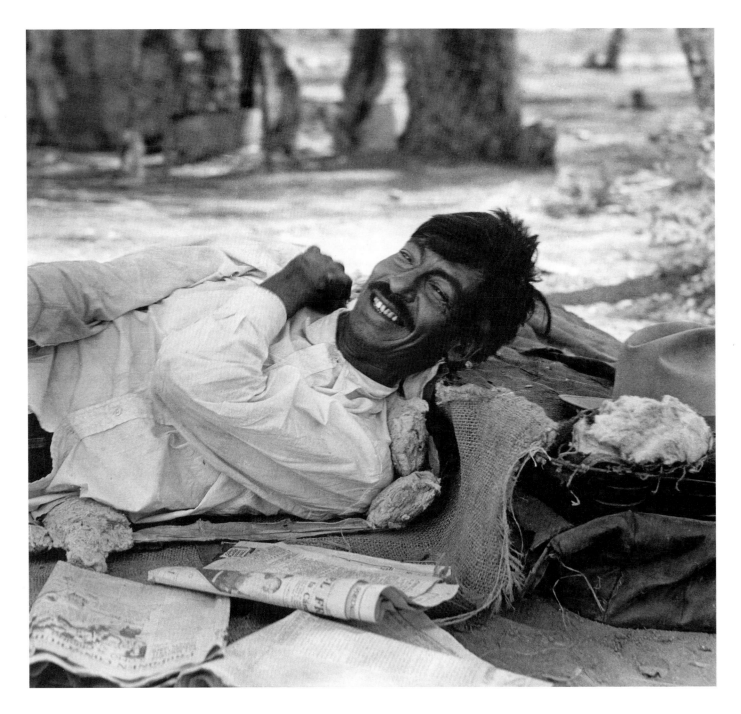

(*above*) Dorothea Lange photographed this Mexican worker in an Imperial Valley squatters' camp as he was reading newspapers and relaxing in the shade after a day in the fields in the summer of 1935. Courtesy of the Dorothea Lange Collection, Oakland Museum of California. Gift of Paul S. Taylor.

(*right*) Epitomizing the term "ditch bank camp," Dorothea Lange's 1935 photograph of a settlement in the San Joaquin Valley well captures the way field hands congregated along any shady place near water. Courtesy of the FSA/OWI Collection, Library of Congress.

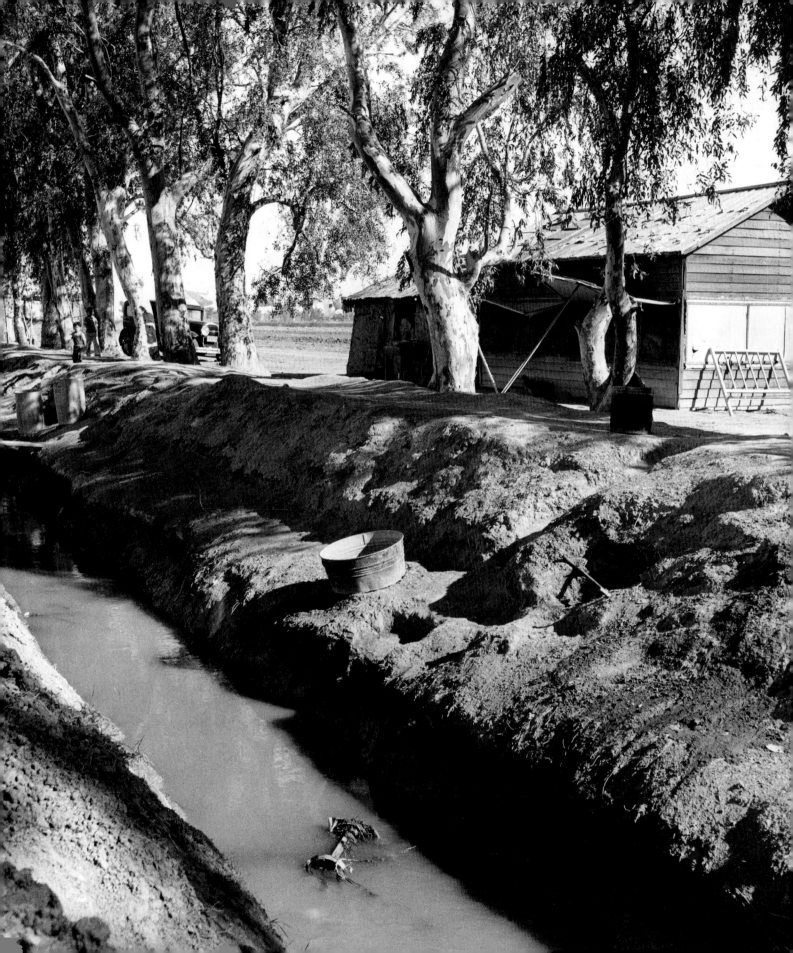

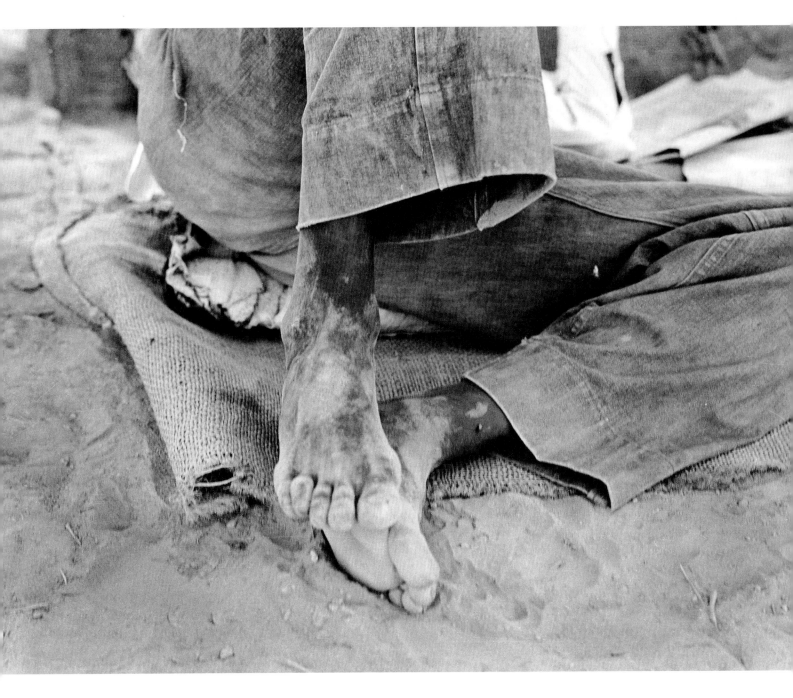

(*above*) Always attentive to the salient detail, Dorothea Lange trained her lens on the feet of this Mexican field hand as he sat on some burlap in the dust of an Imperial Valley squatters' camp in the summer of 1935. This may be the same individual earlier pictured reading a newspaper. Courtesy of the Dorothea Lange Collection, Oakland Museum of California. Gift of Paul S. Taylor.

(*right*) A typical Sunday afternoon camp scene, this photograph, taken in an Imperial Valley squatters' camp in the summer of 1935, captures a woman washing clothes and hanging them out to dry. Courtesy of the Dorothea Lange Collection, Oakland Museum of California. Gift of Paul S. Taylor.

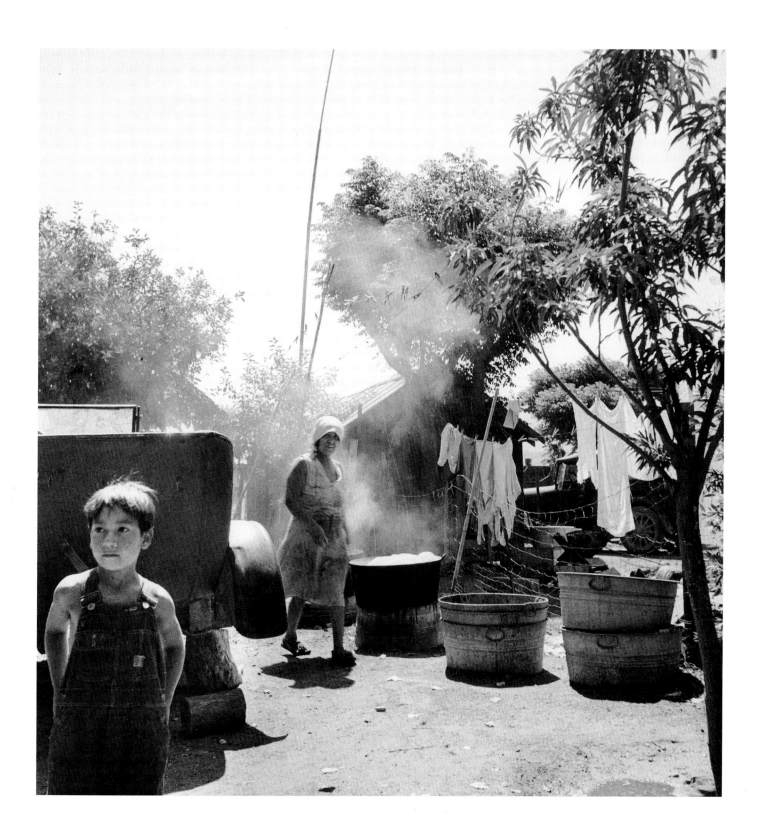

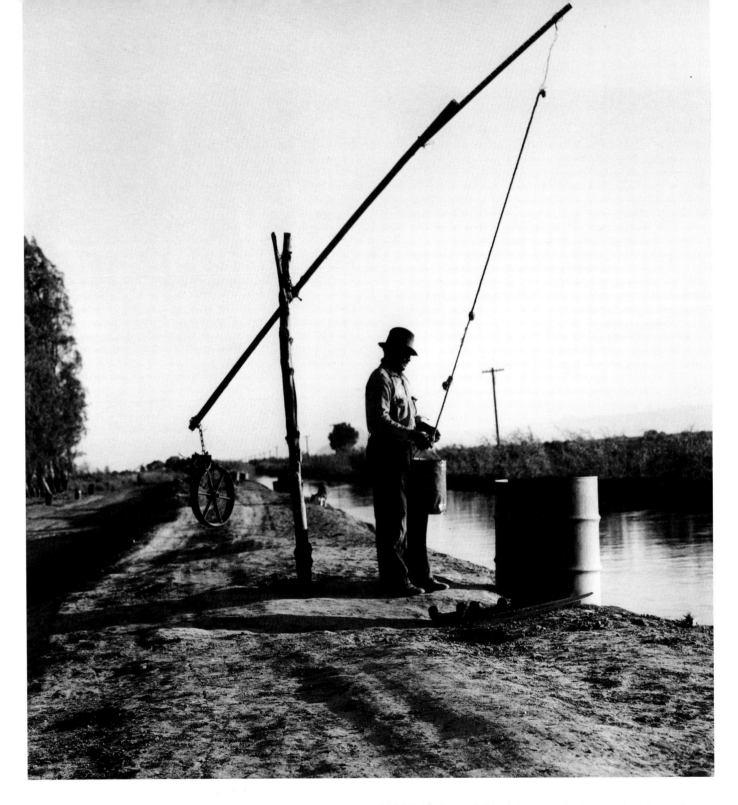

(*above*) Interested in this improvised water lifting device, with its balance weight from a discarded tractor wheel, Dorothea Lange photographed a Mexican field hand as he hauled a five-gallon can of water from an irrigation canal on the west side of the San Joaquin Valley in 1935. Courtesy of the FSA/OWI Collection, Library of Congress.

(*right*) Having been in California long enough to have purchased a new license plate, this refugee from the Dust Bowl poses for Dorothea Lange beside the stovepipe to his family's cook tent around sunrise somewhere in the San Joaquin Valley in the summer of 1935. Courtesy of the FSA/OWI Collection, Library of Congress.

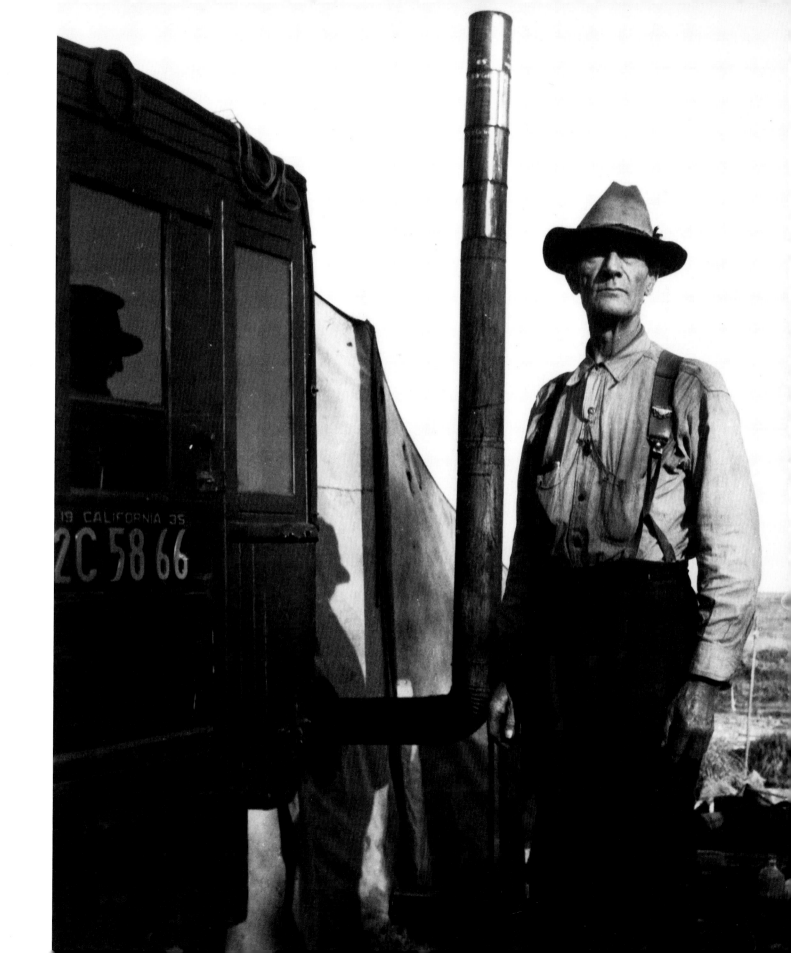

Government Photographer, American Icon, and Blood on the Lettuce

On March 7, 1936, Dorothea Lange was returning home from a monthlong trip photographing farmworkers in Southern California when around nine A.M., while passing through Nipomo, she barely noticed a crude wooden sign with an arrow pointing west. "PEA-PICKERS CAMP," it read. She did not stop.

Twenty miles later, Lange made a U-turn on the empty highway, drove back, pulled into that miserable, soggy camp, and parked her car "like a homing pigeon." Sensing something newsworthy, she hauled out her big Graflex camera, loaded it with sheets of three-by-four-inch film, grabbed a second film magazine, and moved toward a string of dirty tents. With that decision, Lange took her first step toward producing the single most memorable, widely published, and, ultimately, most controversial photograph of the depression years, the central icon of the California farmworker experience, one of the greatest American photographs.

Spending no more than fifteen minutes at Nipomo, Lange focused on a gaunt, sunburned, apparently destitute mother and her four children. In Lange's last photograph, the woman held her baby and comforted two children as she brought her right hand to her face. Staring off-camera, she seemed to wonder what she was going to do. Few photographs in American history resonated with such highly charged emotional urgency and power or conjured up such a powerful variation on a favorite symbol of Western religion—the nursing Madonna.

With little rest after the long drive home, Lange developed her negatives, made prints, and took the ferry boat from Berkeley across San Francisco Bay, arriving at the *San Francisco News* office with—as she later recalled—"the prints hardly dry." Upon seeing them, Taylor's childhood friend, managing editor George West, informed United Press wire service of the situation at Nipomo. He then ran a page-three story headlined: "Ragged, Hungry, Broke, Harvest Workers Live in Squalor." Illustrated with two photographs from Lange's Nipomo series, the story went on to describe how twenty-five hundred men, women, and children, emaciated by

hunger, were rescued after weeks of suffering "by the chance visit of a government photographer" to a pea-picker's camp in San Luis Obispo County. The next day, the last of Lange's images, a vertical composition of the young mother that would become known as "Migrant Mother," accompanied an editorial by George West.

For more than a half-century after Lange photographed "Migrant Mother," no one ever questioned the authenticity of her work. Accepted as an accurate representation of California farmworkers in dire circumstances, the photograph derived most of its documentary value from the facts Lange herself supplied in her captions and field notes. But as these facts came under scrutiny, scholars pointed out that Lange's information was either vague or demonstrably inaccurate.

Perhaps because Lange was tired after her long photographic sojourn and intent on reaching home, she did not follow her usual technique of banter, photography, and diligent note taking. Had she done so, Lange might have discovered that Florence Thompson was not one of the migrant workers at the camp, most of whom were Mexicans, or that she was not a typical Dust Bowl refugee. Of mixed American Indian and European ancestry, she had fled to California from the drought-stricken plains of the Midwest.

Lange's photographic methods were anything but objective and far more complicated than she admitted. What is surprising was the extent to which Lange, having assumed that Thompson and her children were starving farmworkers, orchestrated and designed scenes, possibly coached her subjects in what amounted to a portrait session in the field, employed all of her photographic talents, and otherwise went to great lengths in order to create an image that elicited sympathy, influenced public opinion, advanced political goals, and transformed a mother who at that time was not a field hand into a pea picker caught in dire circumstances.

"Migrant Mother" was not the most controversial, dramatic, or important photograph of California farmworkers in 1936. It was soon surpassed by the work of a half-dozen San Francisco Bay Area press photographers who, on September 10, rushed south to cover the Salinas Valley lettuce packers' strike. What happened in the weeks following severely tested their journalistic abilities. Caught up in the action, news photographers became casualties of the violence. But repression did not prevent them from doing their jobs. Photographers recorded images of armed lettuce trucks running the gauntlet between crowds of angry strikers, pickets facing off against sheriff's deputies, and Filipinos harvesting under the watchful eye of gun-toting deputies.

Of all the images, one in particular epitomized the battle of Salinas. *San Francisco Examiner*'s Harold Ellwood captured the scene at the corner of Main and East Gabilan Streets on Wednesday, September 16, moments after Henry "Hank" Strobel, a local grower and president of the Monterey Associated Farmers had been knocked to the ground and kicked. Strobel stood defiantly at the intersection with a club in one hand, bleeding from the nose, with his shirt torn open.

Nothing like these pictures had ever been made in rural California. Whereas Lange's "Migrant Mother" had evoked feelings of pity and discomfort and Fred Smith's photograph of a murdered farmworker at the 1933 cotton strike had elicited a sense of horror and injustice, the Salinas Valley lettuce packers' strike photographs captured violence as it was unfolding.

There was another unusual aspect to the photographic coverage. For the first time in the history of California farmworker photography and California press photography as well, a photographer—Otto Hagel—documented a farm labor strike using the new 35-millimeter-camera technology. Hagel took considerable risks just being in Salinas. Without proper immigration papers, he could have been arrested and deported back to Nazi Germany. But Hagel managed to photograph unobtrusively. Climbing on top of cars and drifting in and out of police and picket lines, he followed the ebb and flow of battles, firing off strings of pictures from differ-

ent perspectives and using his rapid film advance mechanism to capture a sequence of action pictures impossible to obtain with bulky press cameras.

Hagel's darkroom technique also contributed substantially to his success. Closely examining the individual frames of his contact sheets, he obtained some of his best published images from as little as 20 percent of an individual frame. Appearing along with photographs by Ellwood and other press photographers, Hagel's pictures filled the September 16 and 17 editions of San Francisco Bay Area newspapers. "PHOTO EYE ON SALINAS," promised the *Chronicle*. No farm labor photographs appearing in Bay Area newspapers before, or since, filled so much space and so thoroughly broadcast violent struggles in the agricultural districts.

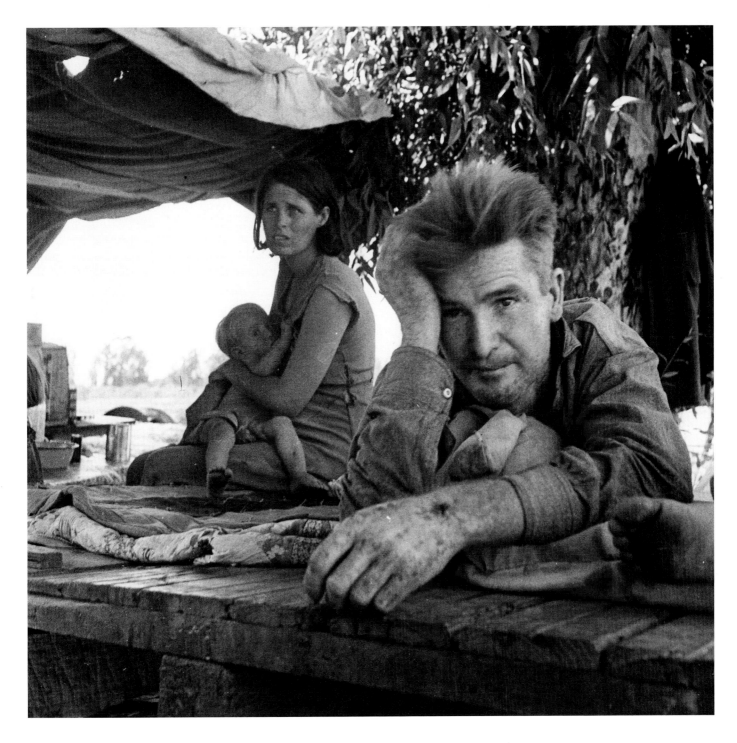

Dorothea Lange made two photographs of this family camped on the roadside near Blythe, California, in August, 1936. The second image, taken several feet to the left of this one and excluding the woman's husband, would be widely published. Courtesy of the FSA/OWI Collection, Library of Congress.

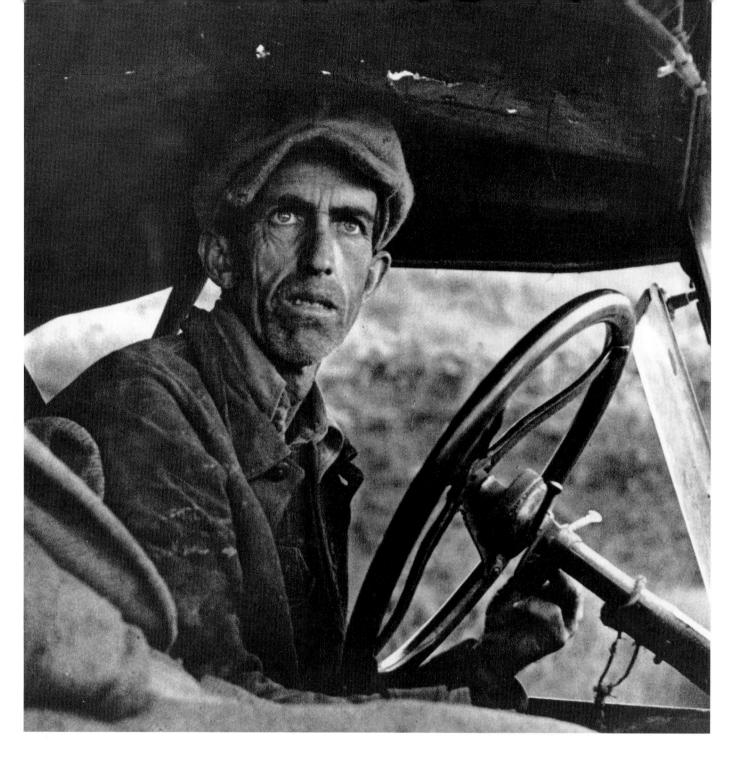

(*above*) Encountering this man and his wife along Highway 99 in the San Joaquin Valley in February 1935, Dorothea Lange discovered that he had once been a Missouri farmer but now worked in the fields up and down the Pacific Coast. Projecting a sense of desperation, the cropped version of the photograph, "Ditched, Stalled, and Stranded," is quite different from the uncropped version, in which the man's wife is seen looking rather comfortable in a nice coat. Courtesy of the FSA/OWI Collection, Library of Congress.

(*right*) At Nipomo in February 1936, Dorothea Lange found these Oklahoma refugees stranded in their cars on the edge of a muddy pea field. Courtesy of the FSA/OWI Collection, Library of Congress.

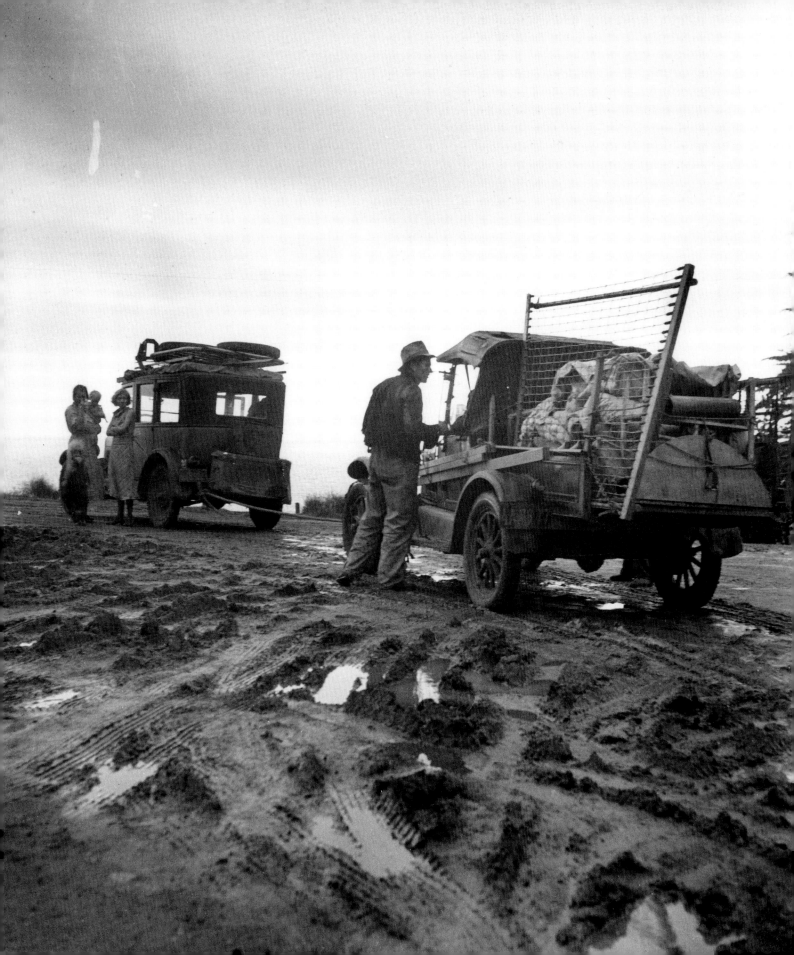

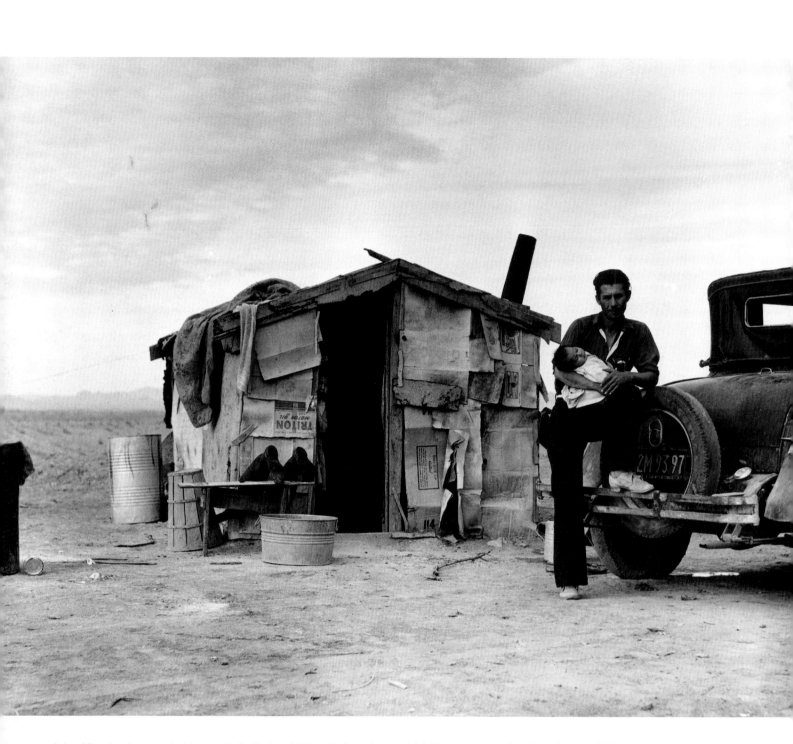

(*above*) Dorothea Lange made this portrait of a Mexican field hand in front of his home on the edge of a pea field in the Imperial Valley in March 1937. The pea crop had frozen, and he was waiting for work. Courtesy of the FSA/OWI Collection, Library of Congress.

(*right*) Returning north after six weeks in the field, Dorothea Lange again stopped at Nipomo. On March 7, 1936, she made this photograph of Florence Thompson cradling her baby and two young children. Known as "Migrant Mother," it later became the most famous and controversial image of the Great Depression. Courtesy of the FSA/OWI Collection, Library of Congress.

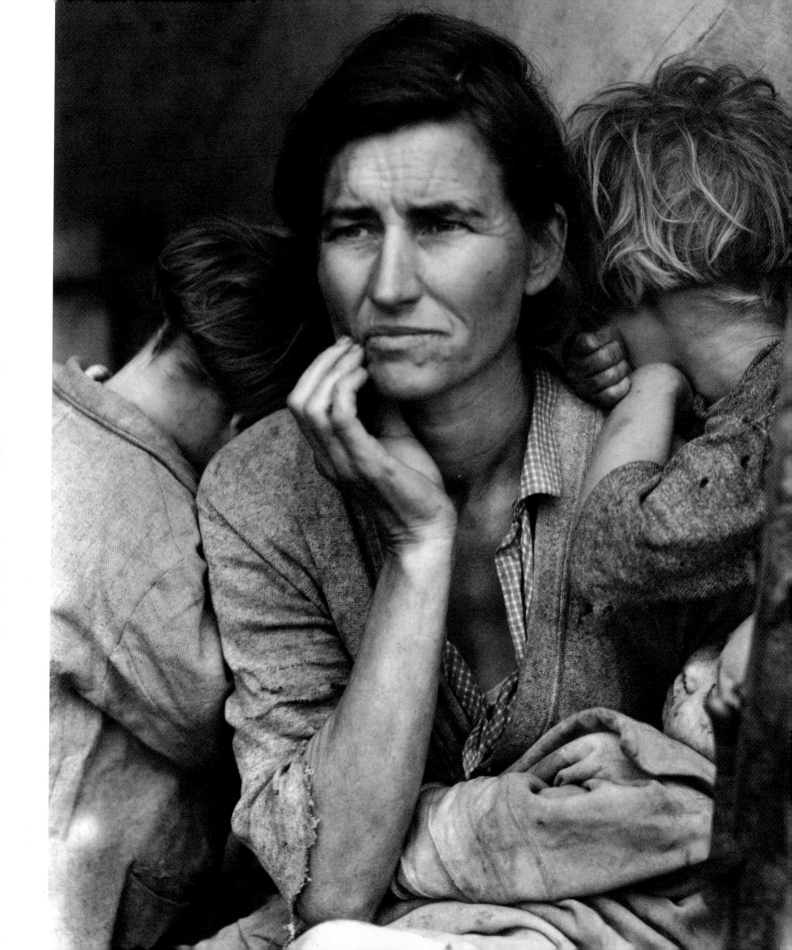

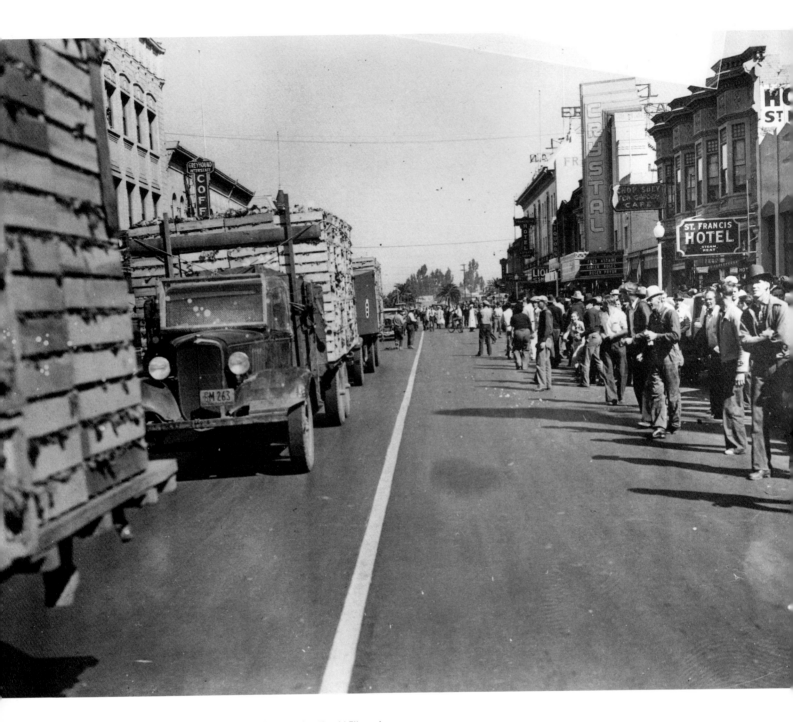

On September 15, 1936, *San Francisco Examiner* photographer Harold Ellwood took this picture of the first truckloads of "hot lettuce" rolling past angry, jeering pickets (right) who lined Main Street in downtown Salinas. Shortly after Ellwood took this photograph, strikers stopped the trucks. As they began throwing lettuce crates onto the ground, guards attacked them and a riot ensued. Courtesy of the *San Francisco Examiner*.

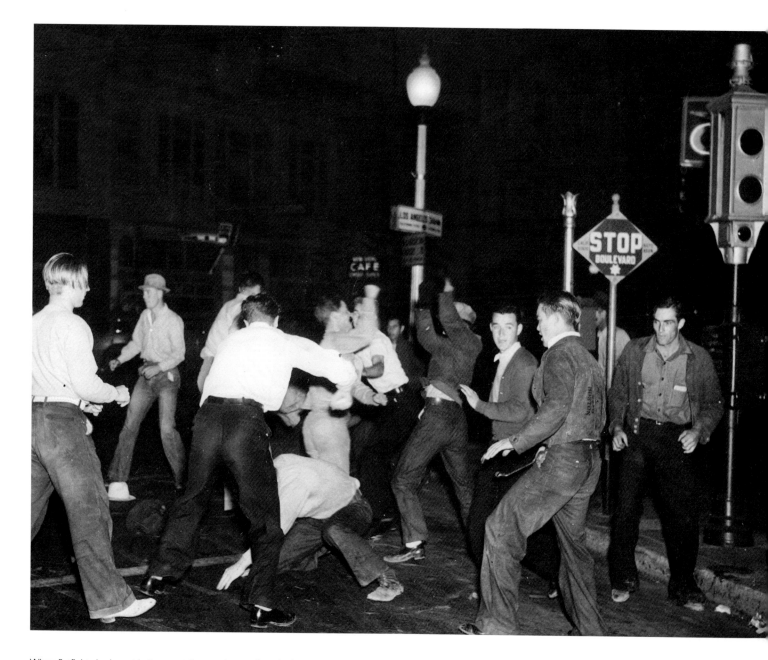

When fistfights broke out between strikers and nonstrikers in downtown Salinas on the evening of October 5, 1936, Harold Ellwood caught the action with this flash-lit photograph. The second man from the right holds a large monkey wrench and is about to use it on a fallen opponent. The published version of this image has an arrow pointing to the wrench. Courtesy of the *San Francisco Examiner*.

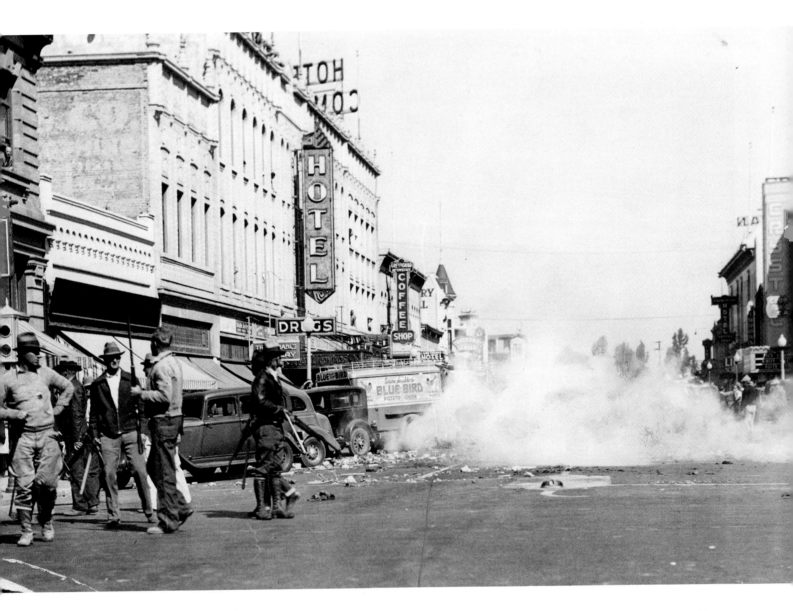

(*above*) The *San Francisco Examiner* caption accompanying this image from September 17, 1936, reads: "The above photograph was taken just as a barrage of gas grenades and shells had routed a crowd of lettuce pickets in a pitched battle on the main street of Salinas. The retreating force cannot be seen because of the wall of gas vapor that has risen from the many grenades hurled at the strikers." Harold Ellwood photograph. Courtesy of the *San Francisco Examiner*.

(*right*) These images from Otto Hagel's 35-millimeter contact sheets of the 1936 Salinas lettuce packers' strike reveal how Hagel employed his Leica to move about and photograph more rapidly than other press photographers. Courtesy of the Dorothea Lange Collection, Oakland Museum of California. Gift of Paul S. Taylor.

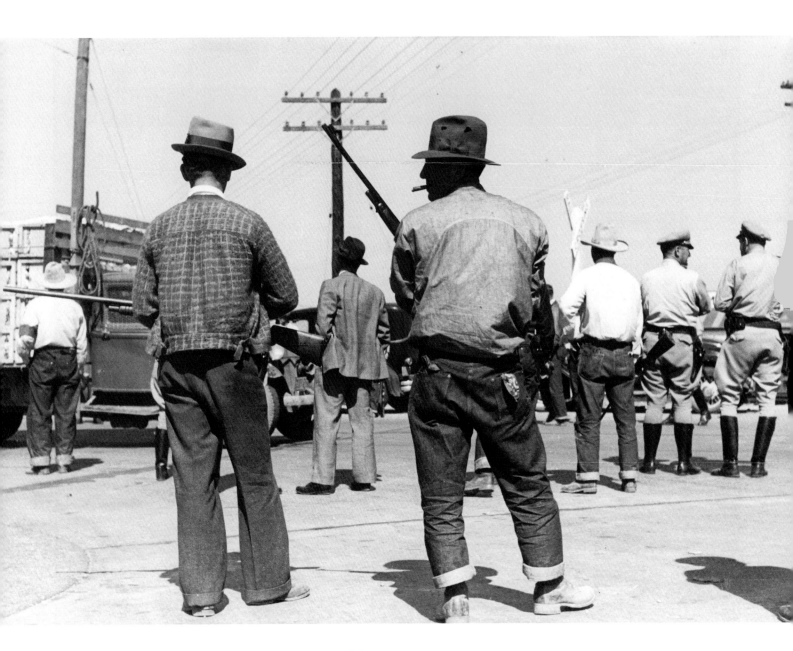

Otto Hagel's image of the sheriff, deputies, and their rifles at the 1936 Salinas lettuce packers' strike comes from a frame on the left of the contact sheet on the previous page. It reveals how easily he was able to work in a dangerous situation. Courtesy of the Dorothea Lange Collection, Oakland Museum of California. Gift of Paul S. Taylor.

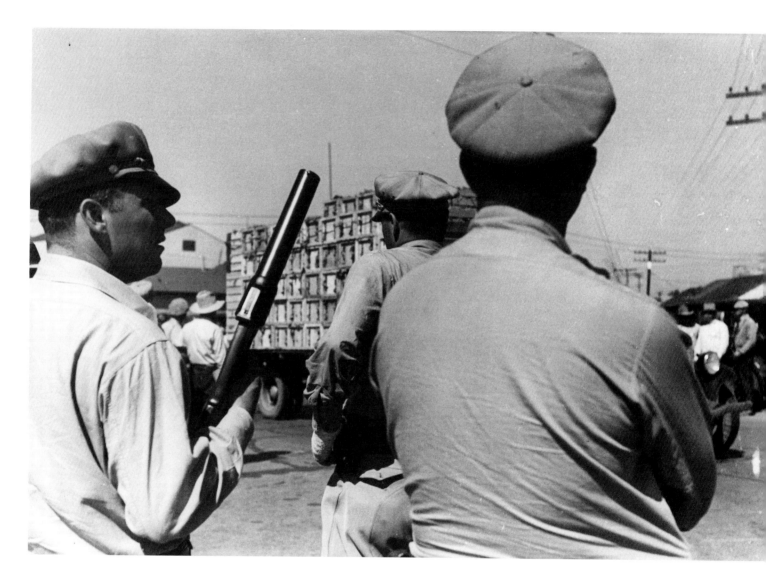

This Otto Hagel image of deputies and their tear gas guns is from the lower left of his contact sheet. Courtesy of the Dorothea Lange Collection, Oakland Museum of California. Gift of Paul S. Taylor.

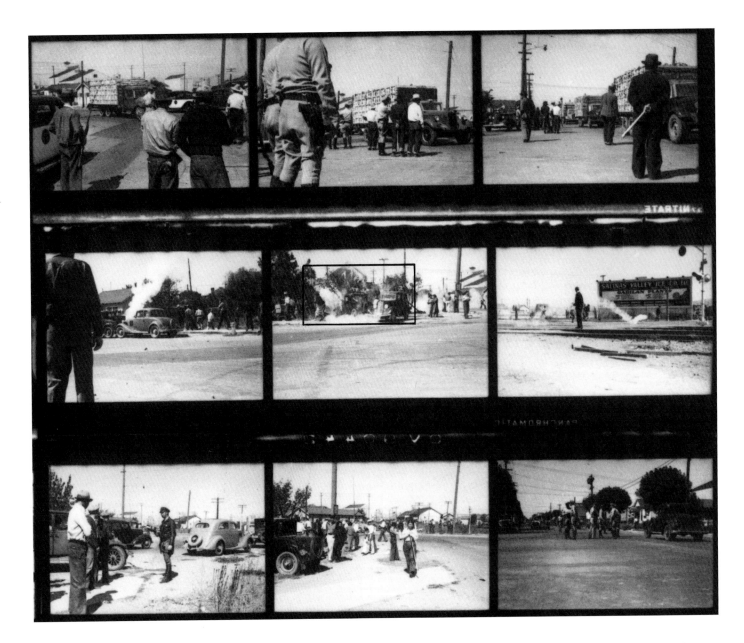

(*above*) The outlined area in this enlargement of nine frames from one of Otto Hagel's 35-millimeter contact sheets from the Salinas lettuce packers' strike indicates that portion of his negative that he used for a photograph that ran on the cover of several San Francisco Bay Area newspapers. The printed image is about 25 percent of the frame. Courtesy of the Dorothea Lange Collection, Oakland Museum of California. Gift of Paul S. Taylor.

(*right*) Front page of the *San Francisco News*, September 16, 1936, with the lead pictures from the Salinas lettuce packers' strike. The bottom image is taken from the enlarged portion of the center frame on the previous contact sheet.

SPECIAL POLICE MOBILIZED IN SALINAS; 2 SHOT IN RIOT

URPHY WINS N MICHIGAN; COUZENS OUT

Curley Takes Massachusetts Senatorial Nomination

ES LOSES IN MAINE

illette Sweeps Wisconsin; New York Passes Up Independents

he 14-year senatorial caf James Couzens, wealndependent Republican upported President elt, was ended in Michlay. Philip F. La Folwas given a large vote of ere in Wisconsin, and followers suffered es in the final primaries e 1936 campaign year. ights of the results in five

GAN—Frank Murphy, ret his post of high comor of the Philippines to camthe New Deal, won the ntic gubernatorial nominaGeorge W. Welsh. gular" Republican candsenator, former Gov. Wilber ichter, rolled up a 5 to 3 lead enator Couzens, who conducts o active campaign but merely s brief statement that the res of President Roosevelt was aid objective this year. ents were elated by the vicf Mr. Murphy, the avowed nt candidate for the Demomination for governor. He ie than a one and one-half lead over Mr. Welsh. Mr. will face Gov. Frank D. Fitzthe Republican nominee, in

CHUSETTS — Gov. James ed, campaigning as "the origvelt man in Massachuthe Democratic senatorial

HAMPSHIRE—Gov. Henry won the Republican senamination over former Senar H. Moses. NSIN—Gov. Philip F. La supposed for renomination f Progressives, a pro-Roosevelt in within 7000 votes of the Republican vote total. The only party to oppose the old line parties total. YORK—Congressional can of the old line parties independents running un Townsend and Coughlin

ONT BEATS DISCOVERY UCKET, R. I., Sept. 16.— er Farms' Rosemont de G. Vanderbilt's handicap by a head in a thrillch chief in the $25,000 added mont special here today.

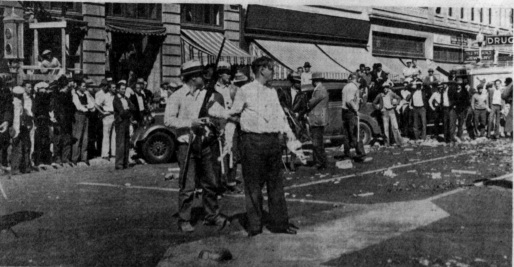

After the battle at Main and East Gabilan-sts, Salinas, today—In the center, battered but still defiant, stands Henry Strobel, who was the center of fighting when he led a group of deputy sheriffs through the heart of Salinas, attempting to clear the streets after strikers and sympathizers had attacked a fleet of lettuce trucks. Surrounding Strobel are deputy sheriffs who also participated in the clash. A few minutes later Sheriff Carl Abbott called upon "all able-bodied citizens" to report to the City Hall "for emergency."

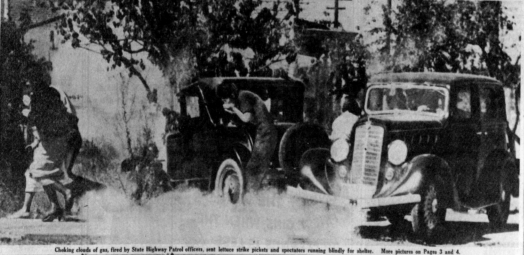

Choking clouds of gas, fired by State Highway Patrol officers, sent lettuce strike pickets and spectators running blindly for shelter. More pictures on Pages 3 and 4.

SHERIFF ASKS MERRIAM TO SEND MILITIA

30 Special Deputies With Guns Rushed by Crowd of Workers

'GET BACK OR WE SHOOT!

Legion Assembly Order Can celed; 'All Able-Bodied Men' Summoned

BY ADOLPH MULLER
The News Staff Correspondent

SALINAS, Sept. 16.—An emergency call to every ablebodied citizen to mobilize fo police duty was issued her today, after a morning of fight ing between striking lettuce workers, deputy sheriffs and state highway police in th heart of the city's business district.

At the same time Sheriff Carl Abbott, who issued the mobilization call, requested Gov. Frank F. Merriam to order the National Guard into the strike area. It was understood here that Gov. Merriam refused the request.

Two men, one a San Francisco were shot, several injured and man strikers were gassed in the riotin which broke out when truckle after truckload of lettuce wa brought from nearby fields to th barricaded packing sheds.

Expressing the hope that 1000 cit izens would volunteer, Sheriff Abbo announced he planned to arm all th "citizen police."

Will Use Pick Handles

As citizens were lining up at th City Hall to be sworn in as specia deputies, and as a truckload of pic handles was being unloaded, a ne barrage of tear gas was laid dow by state police a few blocks away.

Twenty-two more trucks came i from the lettuce fields. As the ounded the corner of Monterey an East Gabilan-sts, deputy sheriff atop some of the trucks fired thei shotguns into the air. The crowd o pickets, which had done nothin more than jeer up to this poin drew back and half a dozen rock were hurled.

This was the signal for half dozen state police cars to dri alongside the trucks, officers hurlin gas bombs into the crowd. Scor fied, gasping and weeping.

How About Pay?

By 3 o'clock about 300 specia deputies had been sworn in at th City Hall. A dispute then arose a to whether they would be paid. I was pointed out that the Board o Supervisors would have to vote an funds for such a purpose.

By 3 o'clock 500 men had bee

(Turn to Page 8, Column 7)

LAST MINUTE NEWS

NEW VIOLENCE IN SALINAS

SALINAS, Sept. 16.—Disturbance broke anew in the fight on strikers in Salinas late today when state highway patrolmen streets around the loading sheds. Newly deputized citizens, shouting, "We'll drive 'em out of town," followed, clubbing The streets were deserted, with a few persons hurt and d. The march of 75 newly-made deputies on the Monterey sent strikers fleeing. Police Chief George Griffin ordered tions aides "to use clubs to disperse strikers." (Earlier details in 8.)

SPORT FLASHES

CARDS IN TRIPLE PLAY
PHILADELPHIA, Sept. 16.— Muffing a chance to narrow the Giants' lead, the St. Louis Cardinals split a double header with Philadelphia today. Walters held the Redbirds to seven hits in the first game, winning 7 to 3. The Cards completed a triple play in the first game.

CUBS WIN TWO GAMES
BOSTON, Sept. 16.—Sweeping

U. S. NAVY TO KEEP WARSHIPS IN EUROPE

By United Press
WASHINGTON, Sept. 16.—The U. S. Navy has decided to establish a "temporary" European squadron, it was revealed today.

The squadron will have the Raleigh as flagship, the destroyers Kane and Hatfield and the Coast Guard cutter Cayuga. The latter vessels have been in Spain to evacuate Americans from the civil war zone, but were recently ordered to leave actual Spanish waters and steam to nearby European ports.

(The danger of war in Europe is

Insurance Firms Refute Knox, Say Conditions Are Improving

BY THOMAS L. STOKES
Scripps-Howard Staff Writer

WASHINGTON, Sept. 16.—Out of the mouths of big insurance company executives President Roosevelt had an answer today to the "fright" issue raised originally by Frank Knox, Republican vice-presidential candidate, who declared in a campaign speech that "Today no life insurance policy is secure; no savings account safe."

Eight insurance company heads, all Republicans, joined in a statement in which they reported an increase of three billion combined assets of life insurance companies since Jan. 1, 1933, the total now being $23,915,000,000; two million

has been backed by Republican National Chairman John Hamilton and the Republican National Committee.

Reporting on the meeting, President Roosevelt explained that the

(Turn to Page 5, Column 1)

1500 ATTEND RITES OF IRVING THALBERG

By United Press
HOLLYWOOD, Sept. 16.—Funeral services for Irving Thalberg, the "boy wonder" who grew to be the dominant figure in the motion picture industry, were held here today with 1500 of his friends paying respects in the Temple B'nai B'rith.

Mr. Thalberg's widow, Norma Shearer, film star who was guided to the heights by Mr. Thalberg's genius as a producer, received thousands of messages of condolence. Shortly before services started she received a message of sympathy from

10 KNOWN HURT IN CLASHES IN LETTUCE ROW

SALINAS, Sept. 16.—The followin are known to have been injured i clashes here:

J. A. Baird, 32, San Francisco, spe tator. Bullet wound in right le Treated at Salinas Valley Hospital.

Woodrow Jones, striker. Bull wound in right hip. Treated at Sa linas County Hospital.

John Bunn, special deputy. Frac tured jaw. Treated at Salinas Valle Hospital.

A. McDowell, deputy sherif Caused by backfire of gas gun.

Henry Strobel, leader of deputie Face cut and bruised. Treated Salinas Valley Hospital.

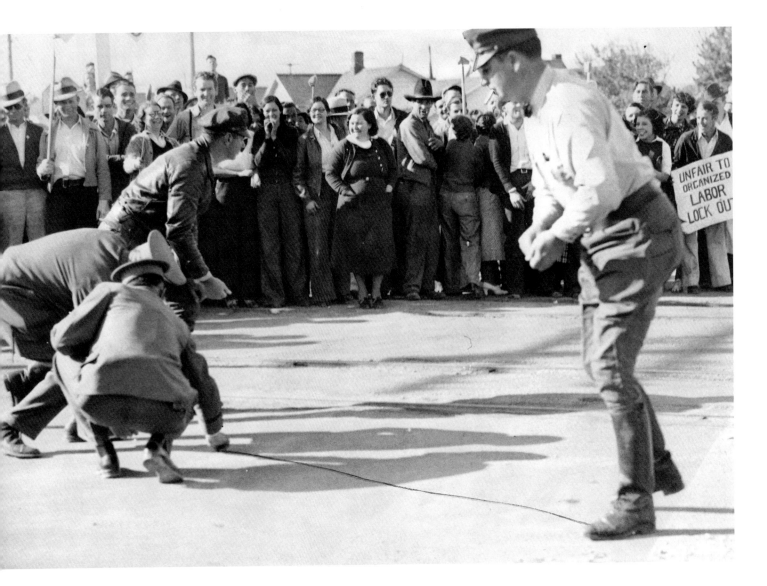

The *San Francisco Examiner* caption to this September 15, 1936, Harold Ellwood photograph reads: "They mean business—State highway patrolmen, shown holding at bay a band of picketers in the strike-torn Salinas area, have set up a deadline—beyond which strikers are forbidden to pass. The pitched battles fought earlier in the day have evidently convinced the picketers that to defy officers would be foolhardy." Courtesy of the *San Francisco Examiner*.

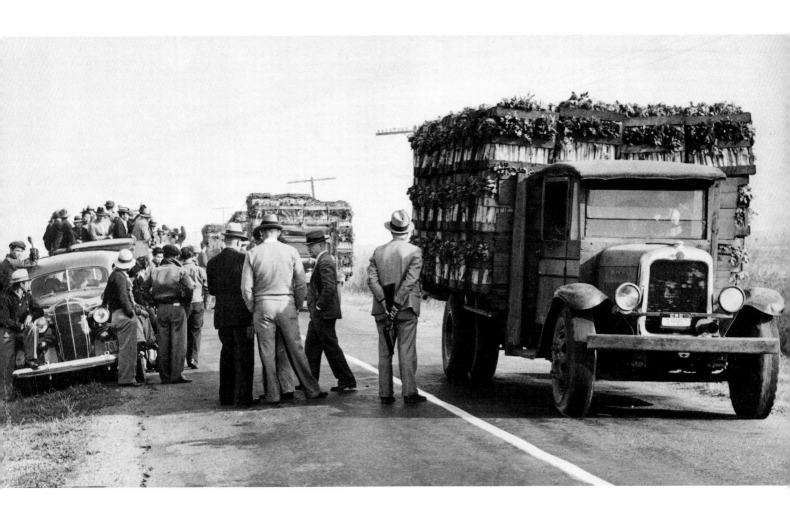

Dispatched to Salinas on November 26, 1936, to cover a strike by celery workers, Joe Rosenthal, working for the International News Service and the *San Francisco Examiner*, photographed deputies armed with tear gas guns eyeing strikers on the left as trucks loaded with celery head out of Terminus for market. Courtesy of the *San Francisco Examiner*.

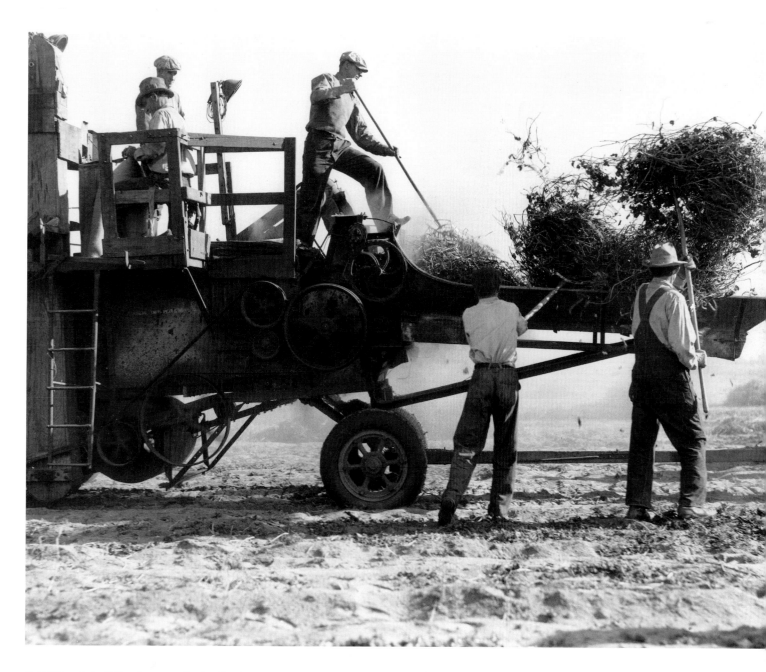

(*left*) Although the Salinas lettuce packers' strike of 1936 occurred within a short drive from his home in Carmel, it did not attract the attention of renowned photographer Edward Weston. Preferring to photograph the pristine environment, he made this 1937 photograph in a tomato field less than twenty miles west of Salinas. Courtesy of the Edward Weston Collection, Center for Creative Photography, University of Arizona, Tucson.

(*above*) While photographing between Merced and Turlock in November 1936, Dorothea Lange turned her camera on mechanized agriculture and photographed this bean threshing operation. Courtesy of the FSA/OWI Collection, Library of Congress.

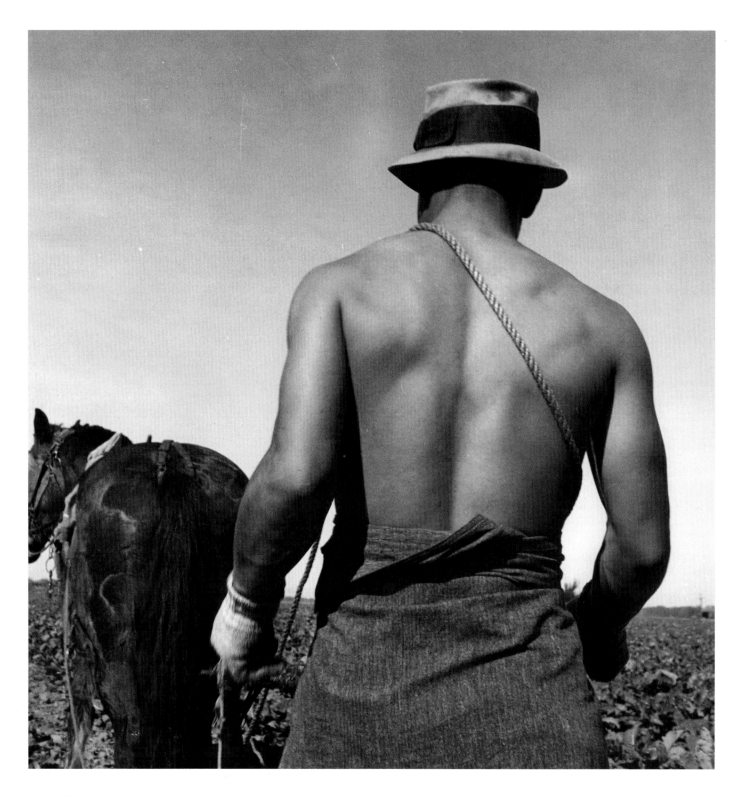

(*above*) Often photographing people from the back, Dorothea Lange made this image of an African American man plowing cauliflower fields in Guadalupe near Santa Maria in the spring of 1937. Courtesy of the FSA/OWI Collection, Library of Congress.

(*right*) Dorothea Lange photographed this family of Dust Bowl refugees as they rested at a desert hot spring in the Imperial Valley in 1937. Courtesy of the FSA/OWI Collection, Library of Congress.

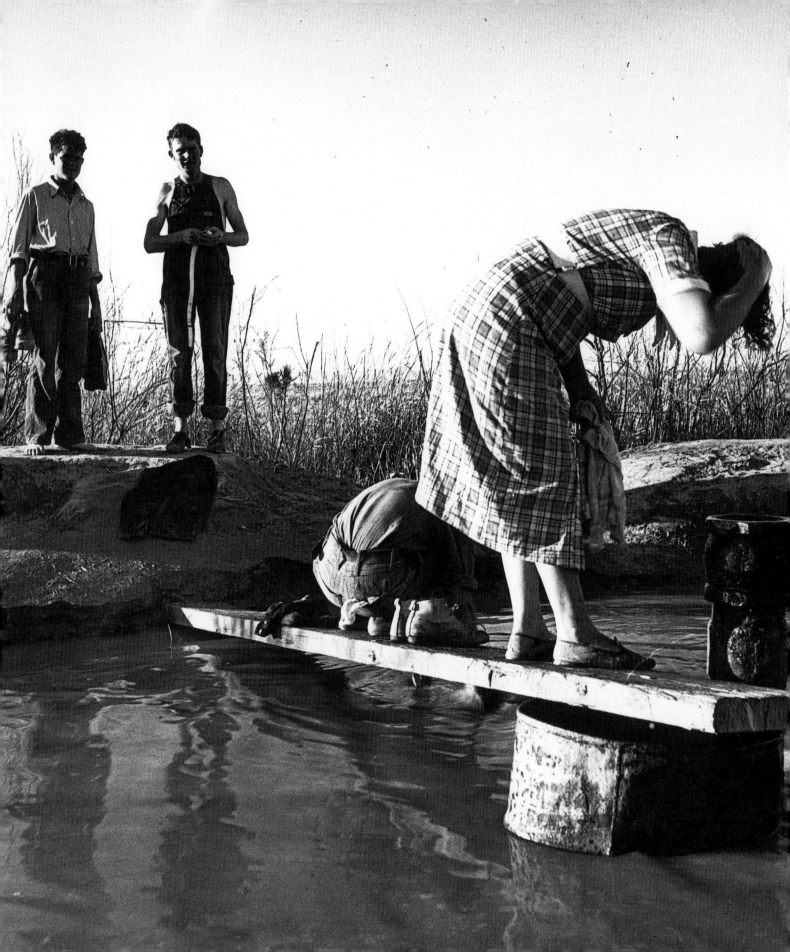

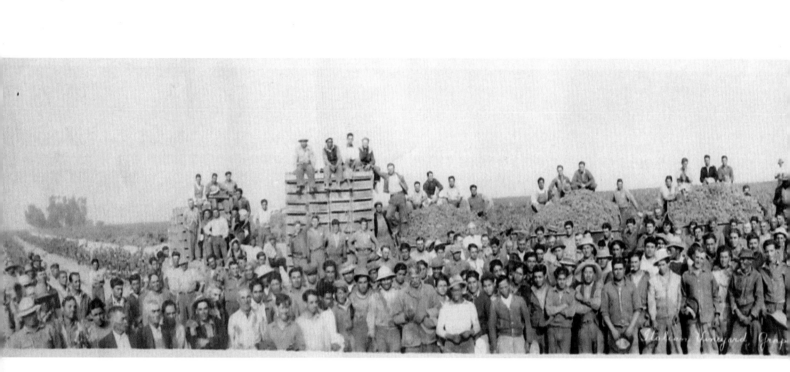

Every fall from 1935 to 1938, Colton photographer C. N. Jackson traveled
to Guasti Vineyards near Ontario to make a panoramic portrait as the wine
grape harvest began. Pictured here is the panorama from the 1937 harvest.
Author's collection.

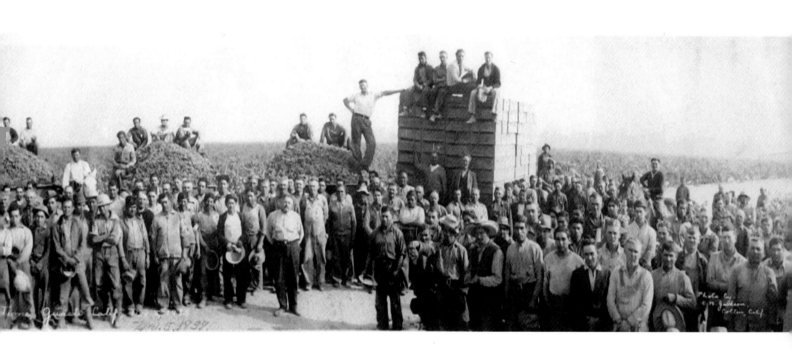

CHAPTER 7

Facts Behind Fiction and Food for Victory

After 1938, Dorothea Lange was laid off and rehired several times. Roy Stryker, her boss in the historical section of the Farm Security Administration (FSA, successor to the RA), eventually fired her on the grounds that she was the most troublesome and least technically proficient member of the FSA staff. Lange had certainly been independent, rebellious, even uncooperative. She had an independent streak that had been a constant irritant to Stryker, making her hard to handle, expensive to maintain in the field, and less the apprentice that Stryker could control than an energetic equal who could not be treated as one of the boys. Ironically, at the moment that Stryker fired Lange, he was striving mightily to exploit public excitement generated by *The Grapes of Wrath*, a book whose characters so closely resembled the people captured in Lange's images that when a magazine ran movie stills next to Lange's images the two were indistinguishable from one another.

Of all the many disputes leading to her termination, the most significant was over her retouching of the "Migrant Mother" photograph. When Lange had made her final image, Florence Thompson—so the story goes—had reached out with her left hand to grasp a tent post or hold back a flap. As a result, the blurred image of her thumb had intruded into the lower right corner of the picture. Dissatisfied with this glaring defect, Lange had withheld the image from circulation, preferring to publish other images from the sequence. Borrowing the negative under the pretense that she needed it to make accurate prints for an exhibition, Lange then hired "the best retoucher on the Pacific Coast" and directed him to eliminate the blurred thumb. This infuriated Stryker, who considered the retouching a major breach of the photographer's code of objectivity and of the FSA's general commitment to truthful documentation. He called it "dirtying the negative."

Before she was fired, Lange completed two important projects. One was a book, *An American Exodus*. Although interrupted many times by family matters and various assignments, Lange worked on her book continually after 1938. Sorting and resorting her pictures throughout the fall of

1939 and pausing only for a few days to cover the pea, lettuce, and carrot harvests, Lange rejected what she termed a "museum wall" approach. Instead she created a "human document" that integrated Taylor's research and writing with her images in a presentation that was an amalgamation of theoretical, visual, and oral information around the theme of "human erosion"—a concept that she and Taylor had been thinking about for several years. Published in January 1940, *An American Exodus* was largely ignored. Although it was a highly original work of contemporary history and photography, the book was seen as an attempt to capitalize on the popularity of John Steinbeck's novel *The Grapes of Wrath*. Ironically, Steinbeck himself had found inspiration for his characters in the fieldwork and images compiled over the past five years by Lange and Taylor. Further complicating matters, Carey McWilliams published *Factories in the Field: The Story of Migratory Farm Labor in California* (1939), a journalistic exposé of the industrializing tendency in agriculture and its consequences, which also quickly became a best seller. Like Steinbeck, McWilliams had employed Lange and Taylor's fieldwork extensively in writing his book, quoted Taylor frequently, published some of Lange's photographs, and had followed Taylor and Lange's field research methodology while writing a series of articles for *Pacific Spectator* under the title "Factories in the Fields."

The other important project centered on strikes in the cotton fields. Having missed the Salinas Valley lettuce packers' strike of 1936, Lange spent most of October 1938 with Rondal Partridge (photographer Imogen Cunningham's son) photographing a cotton strike by four thousand cotton pickers in the southern San Joaquin Valley. While attending a secret nighttime union meeting in Bakersfield, she and Partridge used an off-camera flash light to photograph an Oklahoma refugee addressing a group of strikers, perhaps the first time that she had employed a flash to advance her documentary work. At another nighttime strike meeting in the "Mexican town" outside of Shafter, Lange and Partridge made a second flash shot of organizing activity. A few days later, Lange pulled into a Madera gas station advertising free air, noticed a sign propped against the pump, and made one of her most famous shots. "THIS IS YOUR COUNTRY," the sign shouted in bold capital letters, "DON'T LET THE BIG MEN TAKE IT AWAY FROM YOU."

After she was fired, Lange certainly drew some compensation from her accomplishments. Largely on her own, she had undertaken one of the most significant photographic projects in American history, and in doing so, helped establish documentary photography. Together with Taylor, she had produced one of the last great "problem books" of the Great Depression, a fitting climax to her career with the FSA. Lange and Taylor had established the parameters for debate over the nature of rural society, and forged a unique marriage that amalgamated photography and social science in a partnership of creative intimacy.

Although Lange could have returned to portrait work, studio and commercial photography, or most likely of all, accepted a staff position at *Life* magazine or one of the other big newsmagazines, she hardly considered these options. Through a variety of different assignments for the Bureau of Agricultural Economics and subsequently while covering the relocation of Japanese Americans for the War Relocation Authority, Lange continued her farmworker photography over the next three years. She probably did her best work at Manzanar War Relocation Camp in the Owens Valley. Recording crews bent over and swinging hoes while moving through the cornfields in the blazing July heat, her work contrasted starkly with that of Ansel Adams, whose images of field hands working on the North Farm in the early morning light beneath the snow-capped Sierra Nevada were essentially landscapes with people in them and seemed to suggest a sublime vision of an agricultural utopia, not workers imprisoned against their will.

Hired by the Office of War Information, Lange photographed farmworkers for the last time under government contract on September 6, 1942, when she documented five hundred braceros arriving at the Sacramento railroad sta-

tion. Bordering on public relations, her photographs of happy newcomers arranging their fingers in "V"-for-victory signs lent an upbeat tone to the bracero program, barely hinting at the hardships and unequal wages that the men would endure. The adulatory images marked a strange departure for a photographer who had spent seven years exploring the plight of migrant laborers. Ironically, her work documenting braceros was far surpassed by a freelance agricultural journalist of lesser talent and entirely different values. F. Hal Higgins, who had once shot flattering photographs of armed vigilantes at the Salinas Valley lettuce strike, photographed virtually side by side with Lange at the Sacramento railroad station. But while Lange ended her work at the tracks, Higgins did not. Employed by the agricultural press, Higgins followed the braceros out into the countryside, creating a highly original essay on the vanguard of a labor program that would eventually entice one out of every nine Mexican men north.

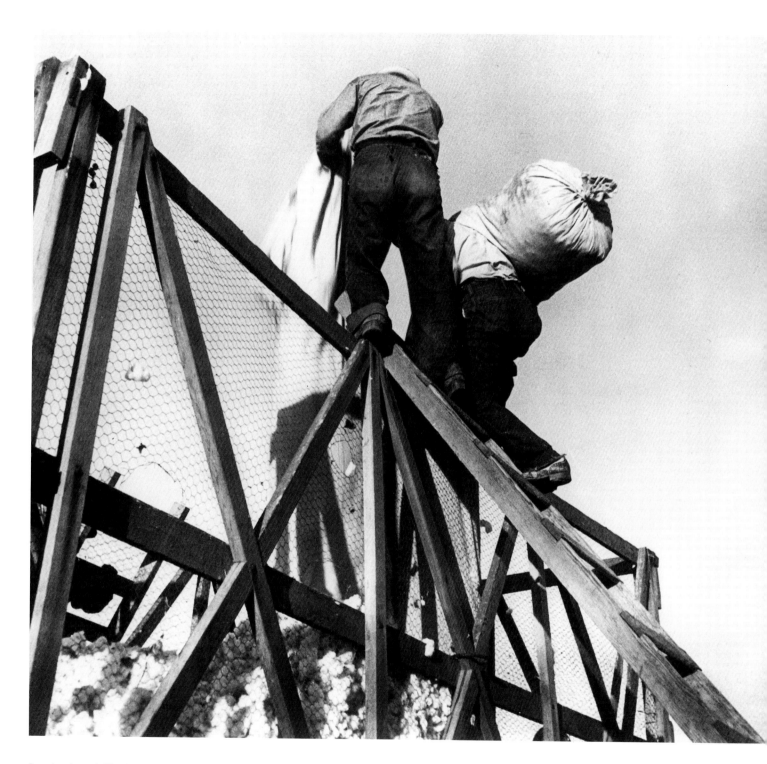

Dorothea Lange's identifying caption for this image reads "Pickers and Cotton Wagon near Corcoran, October, 1937." Courtesy of the Dorothea Lange Collection, Oakland Museum of California. Gift of Paul S. Taylor.

(*above*) Also at the Calipatria relief office in February 1937, these former tenant farmers express a mood of despair as they wait for their checks. Courtesy of the FSA/OWI Collection, Library of Congress.

(*left*) One of a dozen photographs Dorothea Lange made in Calipatria in February 1937, this one depicts men biding their time as they wait for relief checks. Courtesy of the FSA/OWI Collection, Library of Congress.

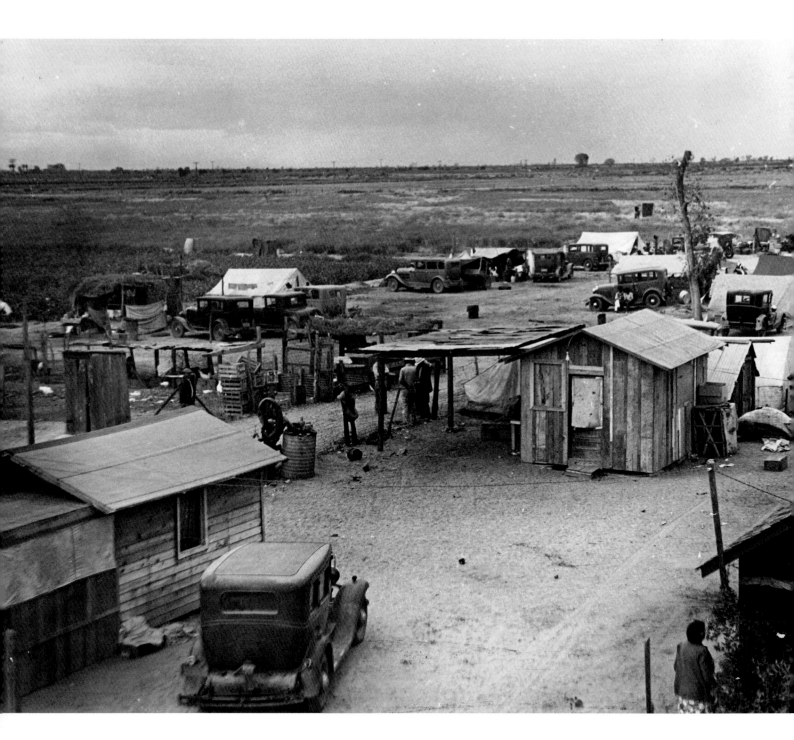

Having missed both the 1933 cotton pickers' strike and the 1936 lettuce packers' strike, Dorothea Lange was determined to cover the San Joaquin Valley cotton pickers' strike in October 1938. To make this picture, she climbed to the top of a shack to provide perspective to her photograph of a portion of the Corcoran camp. Courtesy Paul S. Taylor.

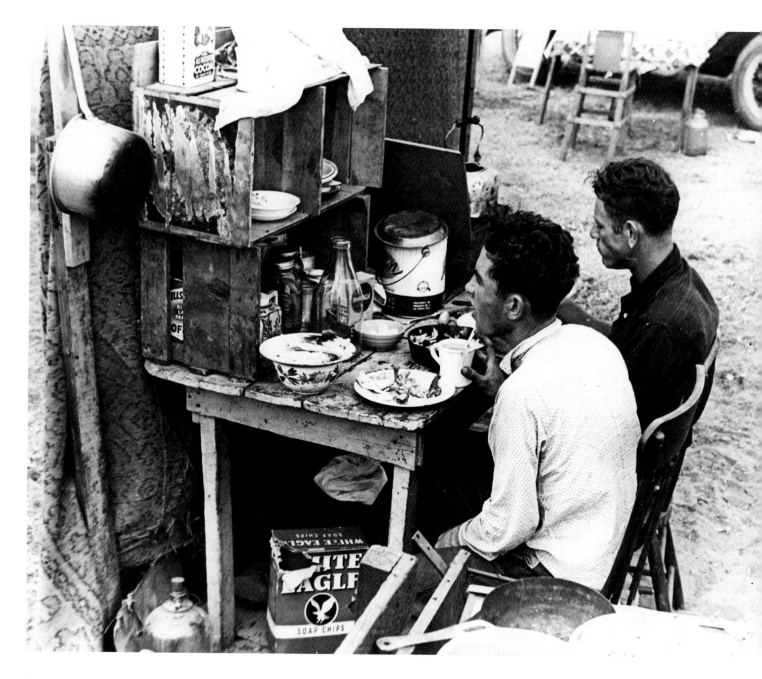

Dorothea Lange's handwritten caption on the back of this October 1938 photograph reads, "Dinner hour in strikers' camp, Corcoran." Courtesy of Paul S. Taylor.

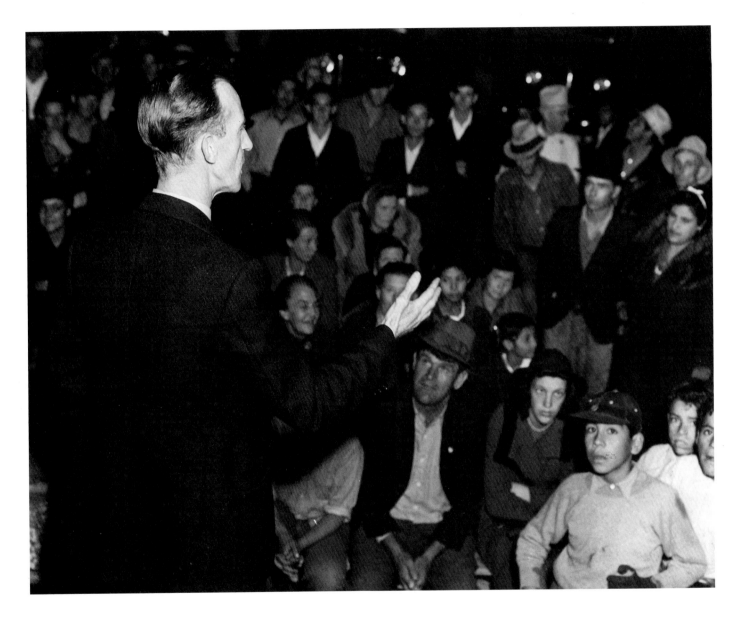

Working late into the night, Lange used a strobe light to make this image of a UCAPAWA (United Cannery, Agricultural, Packing, and Allied Workers of America) organizer addressing a mixed crowd meeting clandestinely in the Mexican section of Shafter in October 1938. In her caption notes, Lange observed that twenty-nine years earlier, Imperial Valley growers had solicited labor to work for one dollar per hundred pounds of cotton but in 1938 were only paying seventy-five cents. Courtesy of the FSA/OWI Collection, Library of Congress.

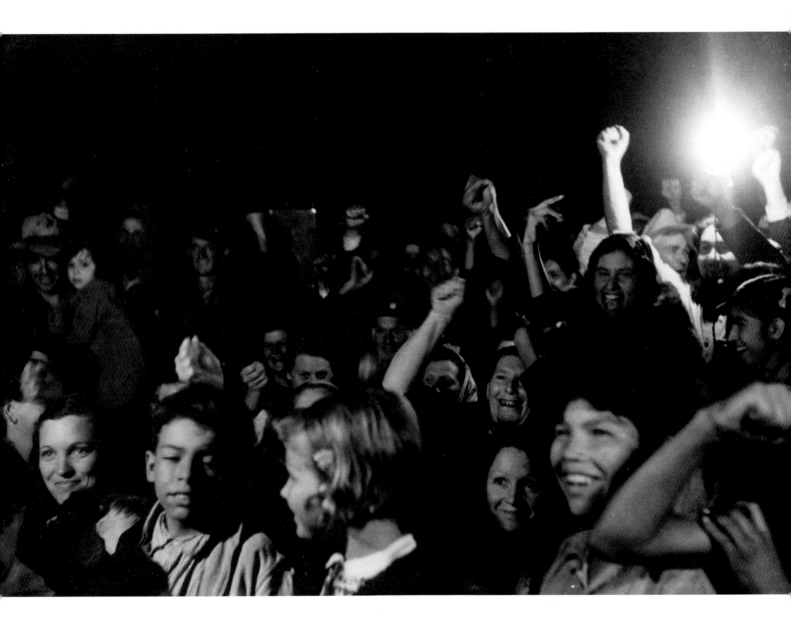

Accompanying Dorothea Lange to the 1938 San Joaquin Valley cotton pickers' strike, Rondal Partridge made a number of his own images, including this one of a strikers' meeting illuminated by a single, handheld strobe light. Courtesy of Rondal Partridge.

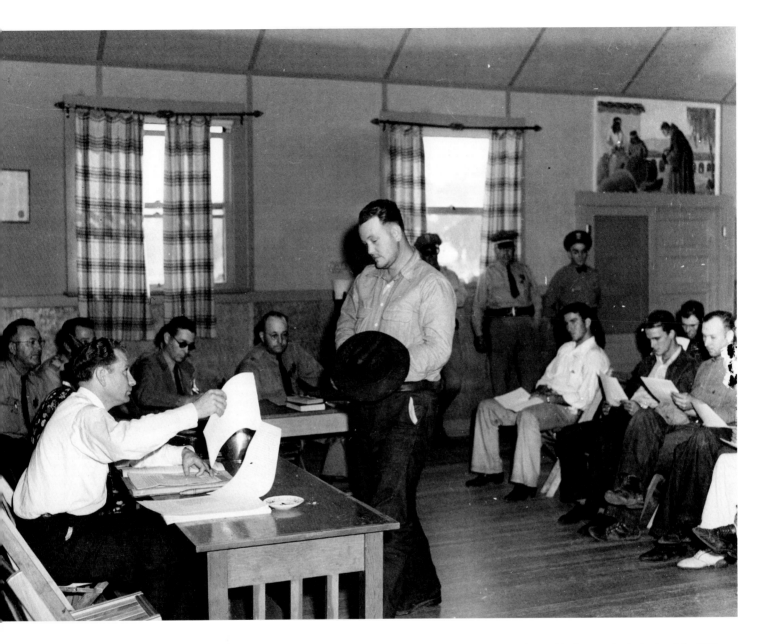

(*above*) When another cotton pickers' strike broke out in Arvin in November 1939, an unknown Bakersfield photographer used a large-format camera to document the mass arrest and trial of the strikers, seen here receiving their sentences in the Kern County Courthouse. Courtesy of the Kern County Museum.

(*right*) Dorothea Lange's caption to this photograph of a leader of the 1938 San Joaquin Valley cotton pickers' strike (posed in front of a Culbert Olson for Governor poster a month before the election) reads: "He came from an Oklahoma farm in April 1938. Became a migratory farm worker in California; joined the United [Cannery] Agricultural, Packing and Allied Workers of America (CIO) at the beginning of the cotton strike of October 1938 and became a leader of the 'Flying Squadron' which attempted to picket the large fields of corporation farms by automobile caravan. He drove the first car." Courtesy of the FSA/OWI Collection, Library of Congress.

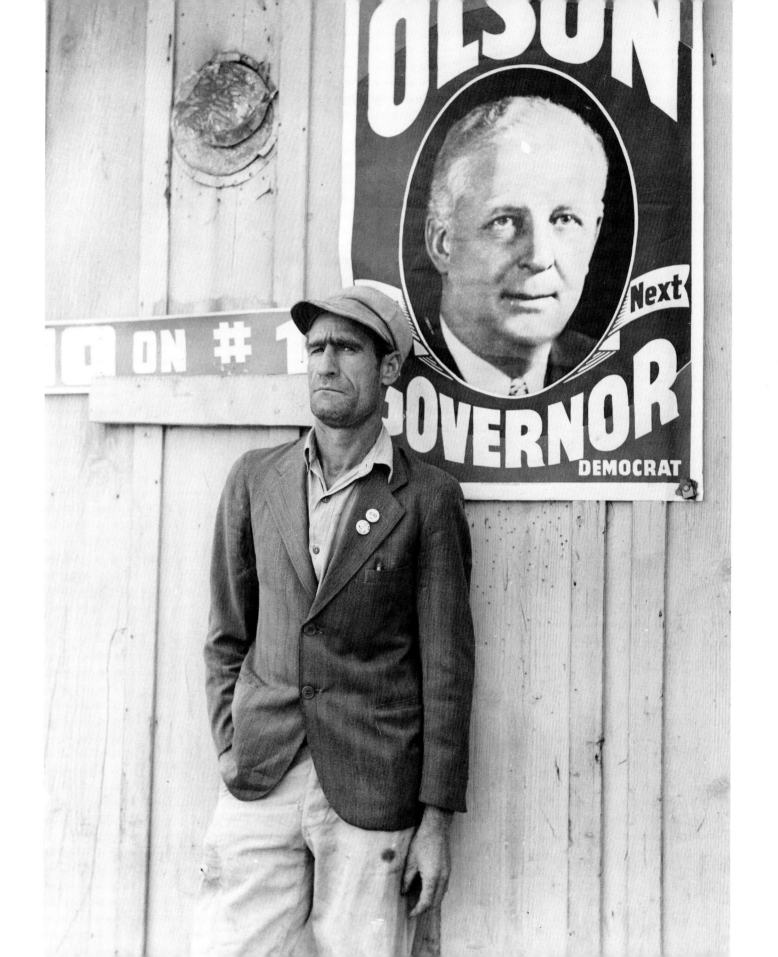

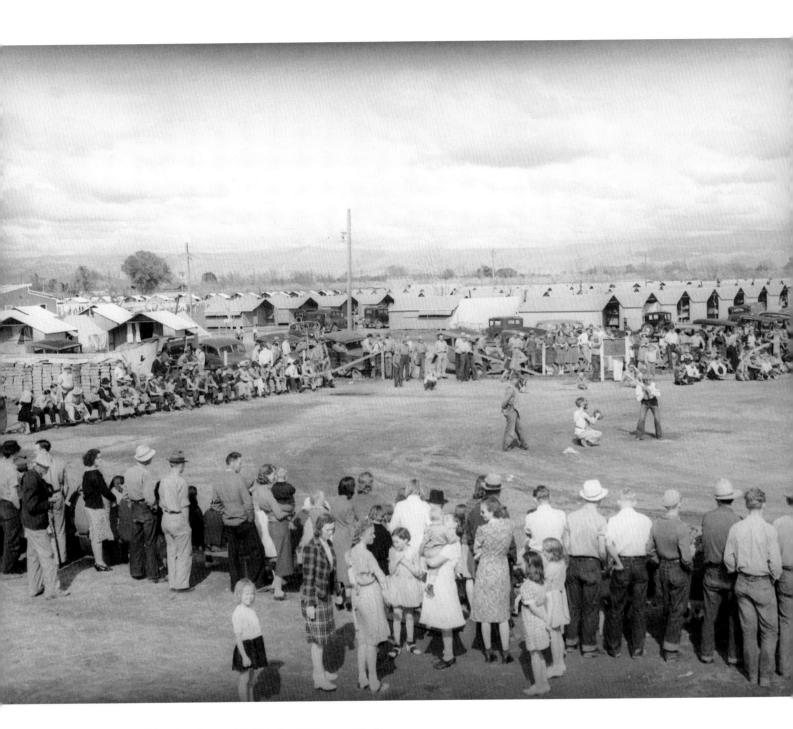

Photographing at the Tulare Farm Security Administration (FSA) camp at Visalia in March 1940, Arthur Rothstein produced an essay on all aspects of this baseball game, from the spectators and players to the camp members and physical environment. Courtesy of the FSA/OWI Collection, Library of Congress.

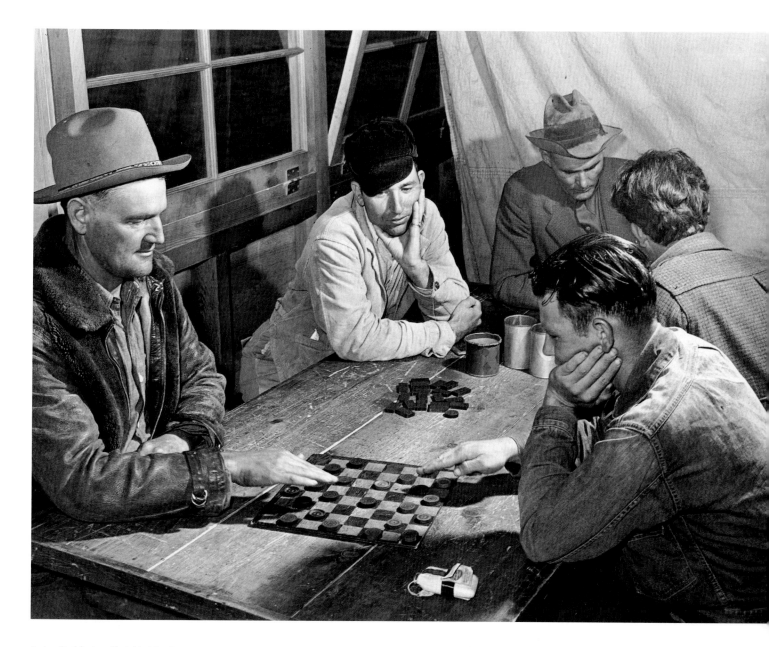

Arthur Rothstein called this March 1940 photograph from the Visalia FSA camp "In the Recreation Room." While he found community life in the Visalia camp a vast improvement over the squatters' camps that dotted the countryside, Rothstein discovered that many camp residents disliked the controlling and communal tendencies they encountered and were soon on their way. Courtesy of the FSA/OWI Collection, Library of Congress.

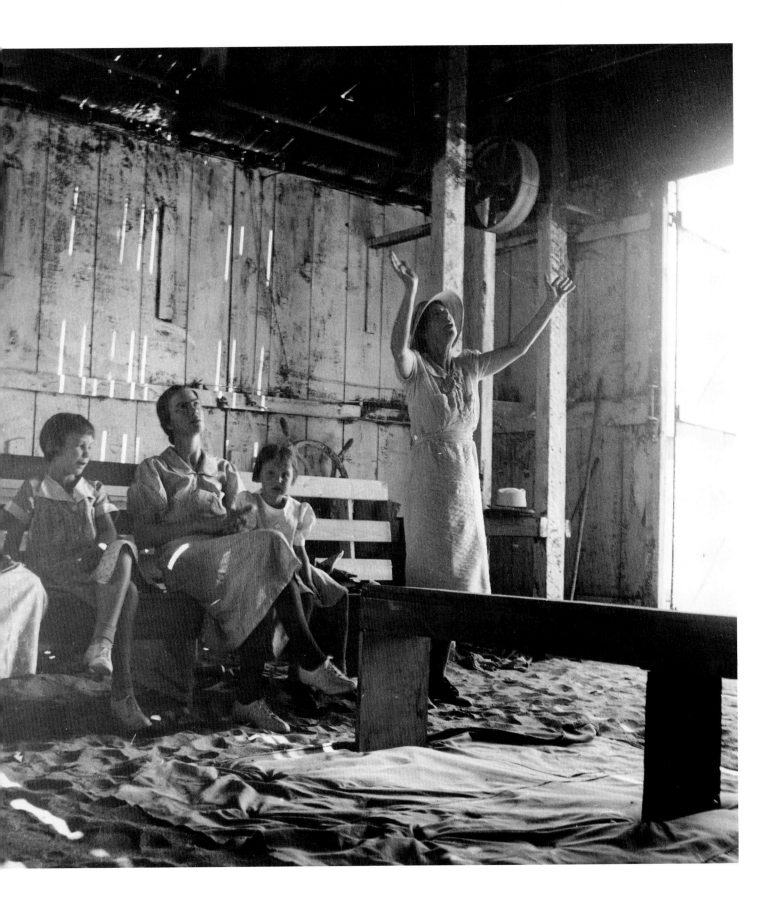

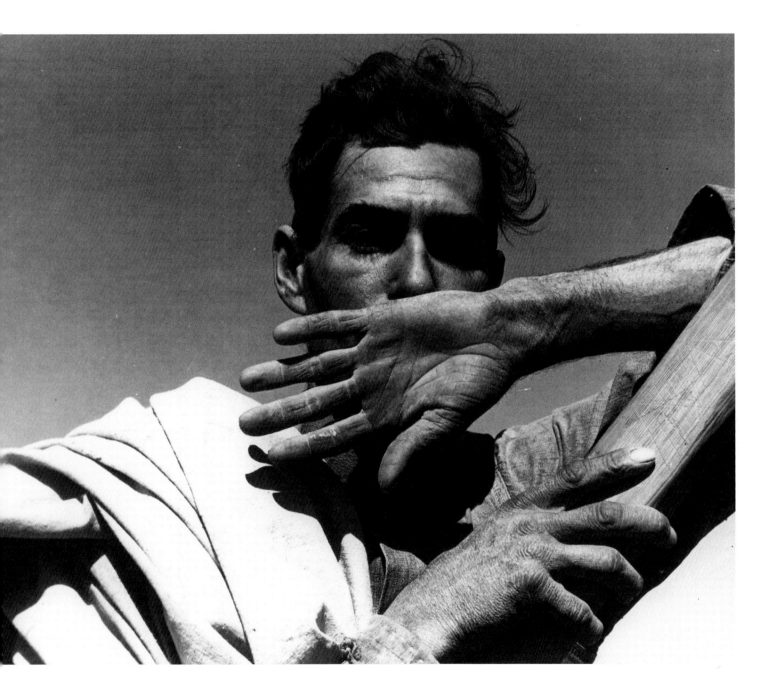

(*above*) While employed by the Bureau of Agricultural Economics in 1940, Dorothea Lange photographed this cotton picker on his way to California from Eloy, Arizona. Her caption reads: "Resting at a cotton wagon before returning to work in the field. He has been picking cotton all day. A good picker earns about two dollars a day working at this time of the year, about ten hours. This is in an area of rapidly expanding commercial cotton culture." Courtesy of the Bureau of Agricultural Economics, National Archives, Washington, D.C.

(*left*) Photographing around the San Joaquin Valley town of Dos Palos in the summer of 1938, Dorothea Lange encountered these field hands at a revival meeting in a barn. Courtesy of the FSA/OWI Collection, Library of Congress.

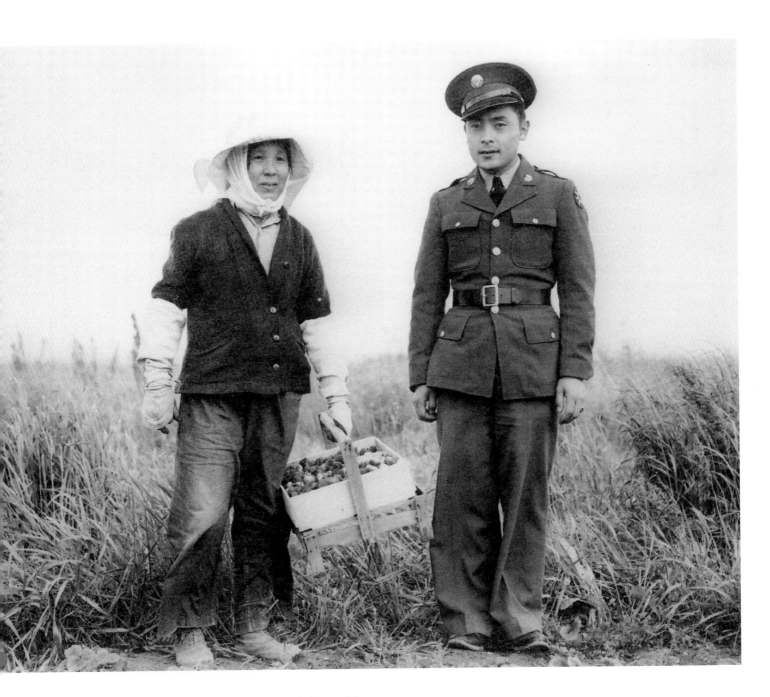

Full of irony, Dorothea Lange's caption to her May 11, 1942, photograph in
the Sacramento Valley farm town of Florin reads: "A soldier and his mother
in a strawberry field. The soldier, age 23, volunteered July 10, 1941, and is
stationed at Camp Leonard Wood, Missouri. He was furloughed to help his
mother and family prepare for evacuation. He is the youngest of six children,
two of them volunteers in the U.S. Army. The mother, now 53, came from
Japan 37 years ago." Courtesy of the War Relocation Authority Collection,
National Archives, Washington, D.C.

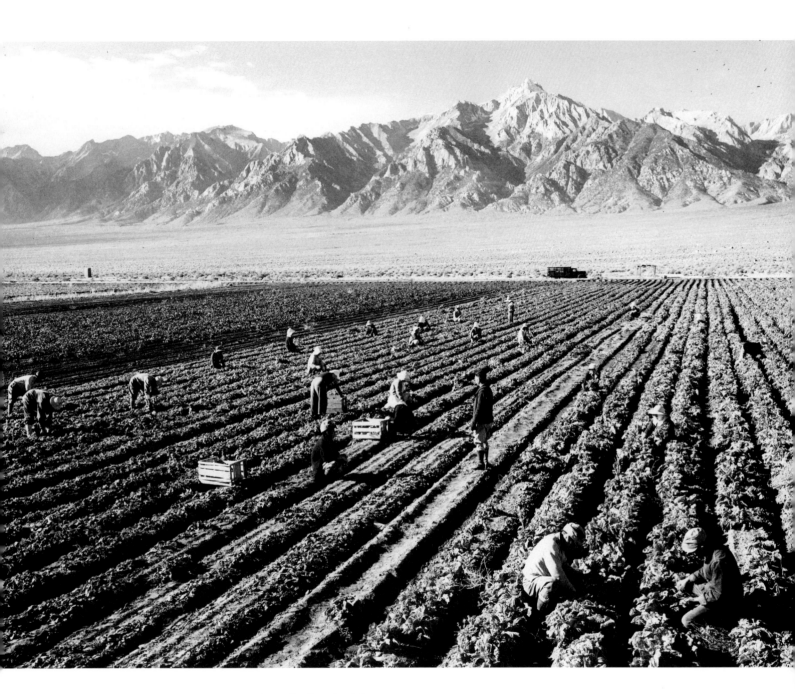

Photographing the North Farm at Manzanar War Relocation Camp in 1943,
Ansel Adams climbed to the top of his station wagon to make this beautiful
image of Japanese field hands working in the lettuce fields beneath the
snow-capped Sierra Nevada. Adams once argued that the physical beauty of
Manzanar mitigated somewhat the fact that everyone there was a prisoner.
Courtesy of the War Relocation Authority Collection, National Archives,
Washington, D.C.

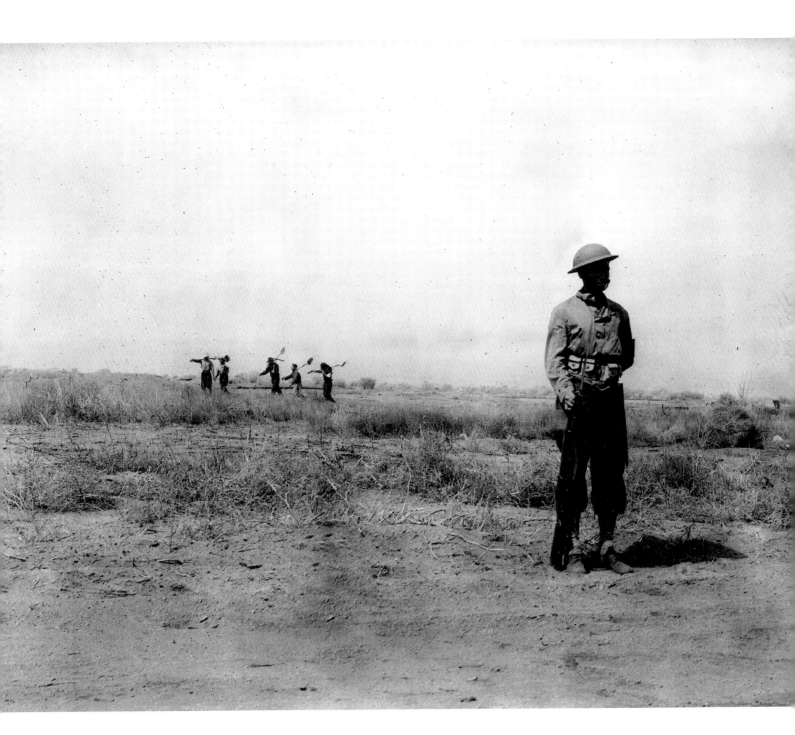

(*above*) On April 2, 1942, Clem Albers, about whom little is known, made this photograph of Japanese field hands working under armed guards at Manzanar. Courtesy of the War Relocation Authority Collection, National Archives, Washington, D.C.

(*right*) Because the shadows in this nursery suggested bars in a prison, censors briefly impounded this Dorothea Lange photograph of a Japanese field hand transplanting young seedlings at Manzanar in 1942. Courtesy of the War Relocation Authority Collection, National Archives, Washington, D.C.

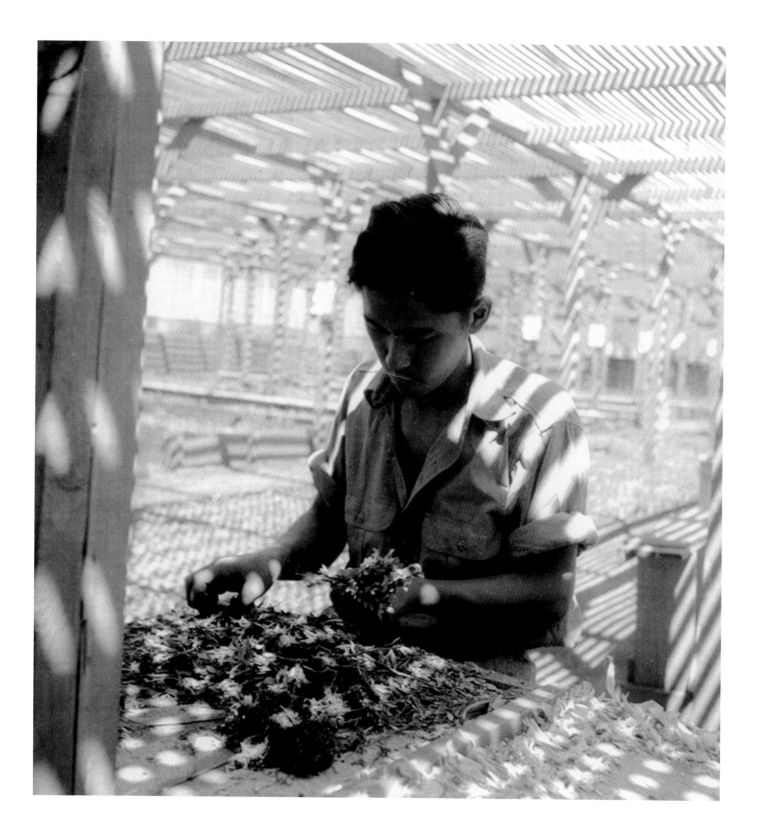

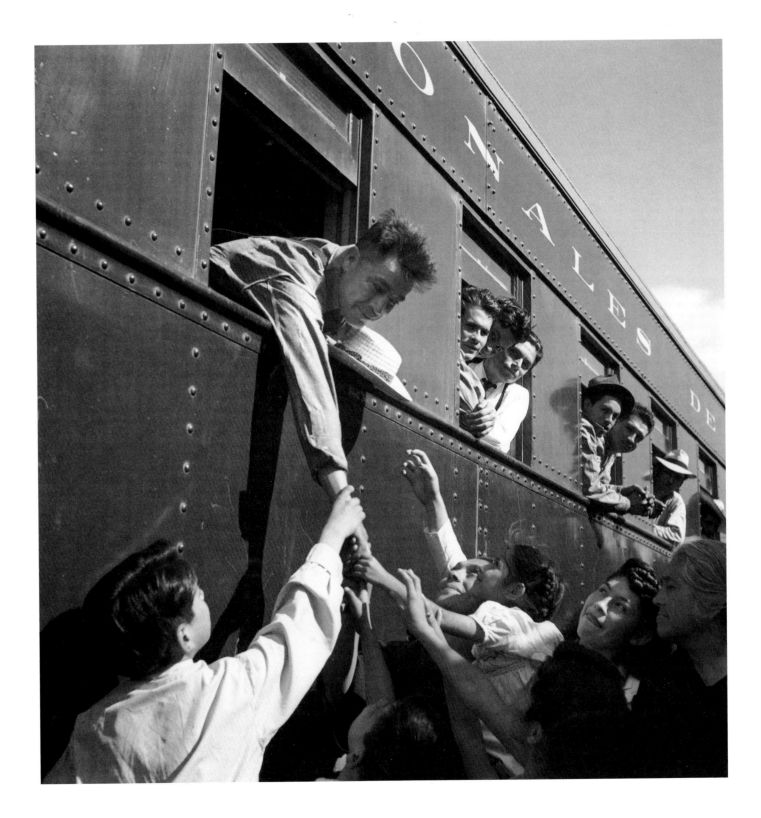

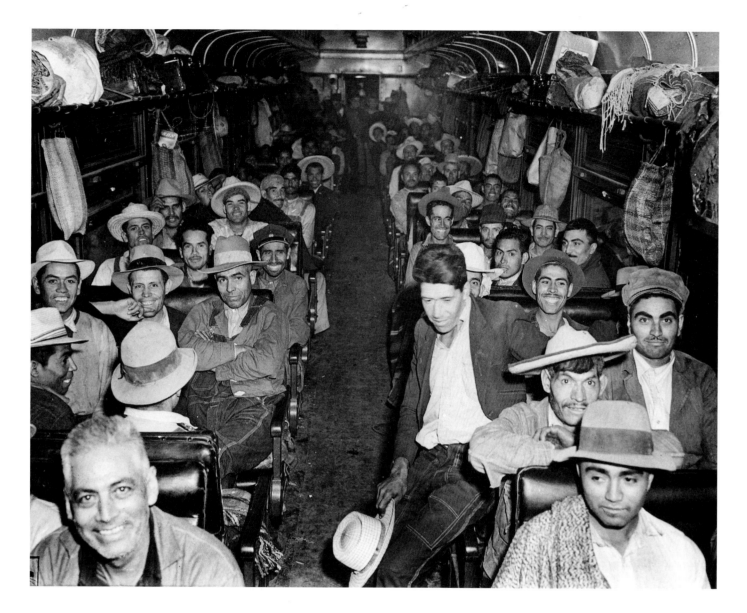

(*left*) A naturalized American citizen, German-born photographer Fritz Henle was one of only two photographers to photograph braceros at Buenavista train station in Mexico City as they departed for California in 1943. Two years later, a caption accompanied one of Henle's photographs in Wallace Stegner's *One Nation*: "And they come only as men. Women and child labor is not part of the program; the families of the braceros are left behind. These workers can afford to leave their families; they are not going to be stranded, and they can make good wages by themselves." Courtesy of the Fritz Henle Collection, Harry Ransom Humanities Research Center, University of Texas, Austin, and the estate of Fritz Henle/Maria Henle.

(*above*) Moving inside one of the passenger cars carrying the braceros north, this photographer—possibly Dorothea Lange—used a flash light to capture a feeling of joy and anticipation that pervaded the cramped quarters at the end of the five-day journey north. Shortly after arriving at Stockton and Sacramento in September 1942, the men piled out of their Southern Pacific railcars and filed into orderly, methodical groupings while shouting, "Viva Mexico, Viva Estados Unidos." Courtesy of the FSA/OWI Collection, Library of Congress.

Of all the photographers covering the arrival of braceros during 1942 and 1943, no American photographer shot more images and covered the newcomers in greater depth than F. Hal Higgins. He followed the braceros from the train stations at Stockton, Tracy, Woodland, and Salinas out to the various camps and photographed them parading through town behind a police escort, being greeted as they arrived at the Roberts Island camp in the Sacramento Delta, relaxing in their barracks, attending church on Sundays, and at work in the fields. This image documents braceros being hauled away from the Salinas train station on October 3, 1942. His caption reads: "They were peons of a soft, lazy, Latin land, made hard-working heroes by the exigencies of an international crisis." Courtesy of the F. Hal Higgins Collection, Department of Archives and Special Collections, University of California, Davis.

On October 3, 1942, F. Hal Higgins photographed these newly arrived braceros enjoying "hot Mexican dishes the workers love" in the dining hall of a sugar beet camp near Pleasanton. Courtesy of the F. Hal Higgins Collection, Department of Archives and Special Collections, University of California, Davis.

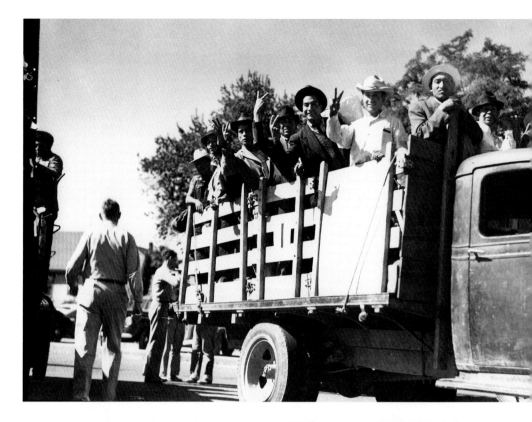

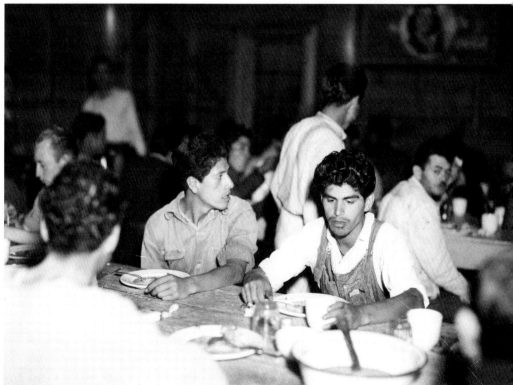

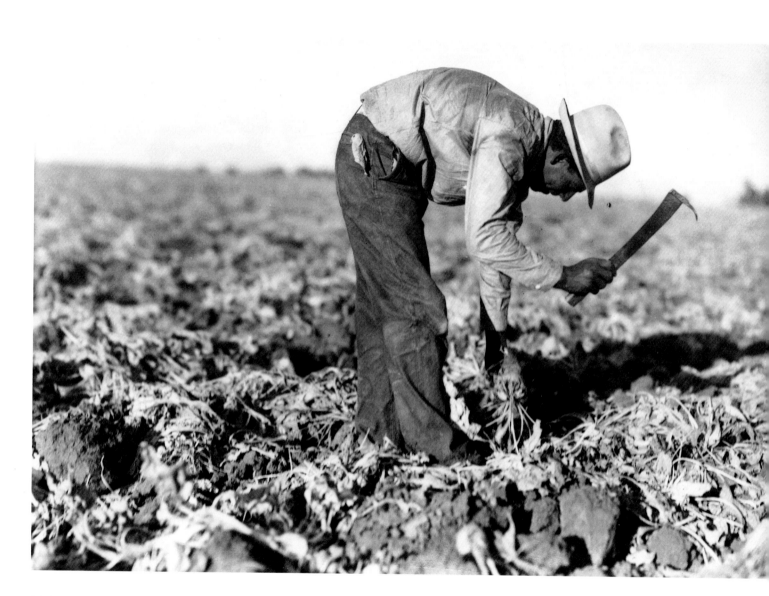

Of all the photographs of braceros brought in to work in the sugar beet fields during World War II, none surpassed this October 4, 1942, F. Hal Higgins image of a field hand stooped over while topping beets with a razor sharp beet knife on the Otto Mueller ranch near Stockton. Courtesy of the F. Hal Higgins Collection, Department of Archives and Special Collections, University of California, Davis.

The Decline and Fall of Documentary Photography

World War II virtually ended serious photographic coverage of California farmworkers. During the war years, only a few Department of Agriculture photographers remained active in the fields. Their role was to document how good life was for farmworkers, which they accomplished with propaganda shots of happy field hands holding up gigantic sugar beets and smiling as they washed up after work. Typical of their approach was the lavishly illustrated *A Report of the Emergency Farm Labor Project of the Agricultural Extension Service, 1943–1945*. Published by the University of California in conjunction with the Department of Agriculture, the *Emergency Farm Labor Project* was filled with beautiful portraits of "girl volunteers" packing fruit, happy milkers in Los Angeles County, prisoners of war pruning fruit trees in Sonoma County, Jamaicans picking citrus around Riverside, Mexican American families harvesting prunes in the Santa Clara Valley, and soldiers picking onions on three-day passes. The largest and most important photographs, filling a half-page, depicted county extension agents holding meetings with Farm Labor staffs and various committees discussing current labor issues in front of huge graphs depicting the labor requirements for various crops on a monthly basis. So scarce was serious photographic coverage during the war years that it could be said to have been nonexistent.

After the end of World War II, when photographers returning from military service trained their cameras on farmworkers, they did not do so with the same intensity and sense of purpose that had inspired Dorothea Lange and other documentary photographers during the Great Depression. Few, if any, photographers even photographed farmworkers for explicitly documentary reasons. It was not because they lacked talent or ideals. Whether they had served with the Combat Camera Unit of the air force or in Edward Steichen's Combat Photography Section of the navy, or in any of several other military photographic operations, returning veterans were among the bravest and most talented of their profession. Nor were they insensitive, lacking in values, or overly

concerned with commercial success. Deeply affected by what they had seen and endured, returning veterans like Loomis Dean, Pirkle Jones, Wayne Miller, Joe Munroe, and Max Yavno all aspired to do good work. And they were determined to discover their own vision rather than follow any particular tradition.

But for most, earning a living took precedence. Working for photo agencies and *Life* magazine, or as educators and commercial photographers, they covered farmworkers on their own, as part of some personal project, or while completing an assignment on agriculture, wine, water, land, community life, or race relations. Producing many outstanding individual images, these photographers never had the opportunity to photograph in the fields for more than a few weeks or produce anything resembling a photo essay. Oddly, the one photographer who was constantly in the fields, Joe Munroe, worked for an agricultural publication that, while uninterested in documenting life and labor in the fields, assigned him to photograph what turned out to be the first, last, and only photo essay on a farm labor organizer.

Photojournalists did not do much better. Other than the occasional newspaper photograph of farmworkers killed in a horrible bus crash or an organizer wounded in a drive-by shooting, daily press photography during these fifteen years largely skirted the issues. As a consequence, such important matters as field sanitation and housing received little coverage and the bracero farm labor program, which brought hundreds of thousands of Mexican nationals north to work in the fields and exerted a huge impact on both sides of the border, remained largely undocumented in any meaningful way.

When serious documentary photography finally returned in 1958, it was largely due to the work of a single individual—worldly, handsome, silver-haired Leonard Nadel. Well established as a corporate photographer, Nadel had an adventurous bent and social values that always steered him toward the less fortunate members of society. An avid reader who thoroughly researched subjects before photographing

them, Nadel in 1957 became fascinated by a small book written by farm labor organizer Ernesto Galarza. Entitled *Strangers in Our Fields* (1956), it was a devastating indictment of the bracero program and it inspired Nadel to produce the first comprehensive photo essay on braceros in California agriculture.

Setting aside his commercial work, Nadel obtained a grant from the Fund for the Republic and devoted most of 1958 to creating a visual counterpart to *Strangers in Our Fields*. Often living with the men in their camps, he photographed filthy quarters, overcrowded conditions, inadequate sanitary and eating facilities, dangerous transportation methods, and substandard medical provisions. Moving into the fields, he then captured men at work. To understand why and how workers migrated north, Nadel traveled deep into Mexico, photographing the men in their home villages. From there he followed them to the Mexico City recruitment and assembly centers and on to Monterrey, Mexico, where five thousand men were processed each day. He then boarded railroad cars, each packed with seventy men, and rode north to border reception areas.

At the border processing centers, Nadel captured images that were so strong and disturbing that they could not achieve wider circulation. One of the most distressing images documented braceros lined up and being fumigated with DDT. Another caught a group of one hundred braceros stripped naked and lined up against the cinder block walls of a border processing center while being examined by a doctor. Without an identifying caption, the photograph, if slightly blurred, could easily have been mistaken for a group of prisoners awaiting execution in a Nazi death camp. Yet another image caught federal police with rubber truncheons herding men behind barbed wire fences.

At the end of his sojourn, Nadel had shot nearly two thousand pictures. Having traveled five thousand miles, he was no longer a neutral observer. As he submerged into the world of braceros, he concluded that they were essentially

modern slaves. Kept in line by the fear of being sent home if they complained, they were caught between two worlds. Determined to convey this view and make his work available to as many people as possible, Nadel carefully organized his images, aggressively lobbied editors, and eventually created two classic photo essays, which he published in *Jubilee* and *Pageant* magazines. Taken together, Nadel's photographs were a devastating indictment of the bracero program. But Nadel could not sustain his effort and eventually returned to the commercial photography that paid his bills. He would never again photograph braceros or any other group of farmworkers.

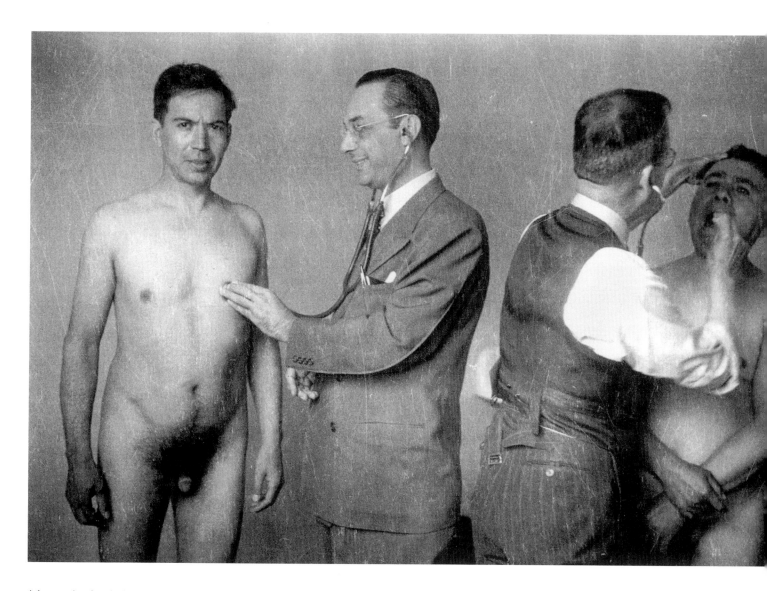

A few weeks after the beginning of the bracero labor program, a photographic collective known as Hermanos Mayo began photographing braceros in Mexico preparing for their journey north. Five Spanish republicans who had fled to Mexico after the Spanish Civil War, the Hermanos Mayo (May-Day Brothers) were especially concerned with documenting social struggles that others would or could not cover. Breaking with the dominant perspective on Mexico as seen through foreign eyes, they spent eight years photographing all aspects of the bracero program. Here they have documented naked *aspirantes* being probed, prodded, tested, X-rayed, and vaccinated against smallpox during a series of medical examinations at La Ciudadela, an old fortress in the center of Mexico City, in August, 1942. Courtesy of the Archivo General de la Nación in Mexico City and John Mraz.

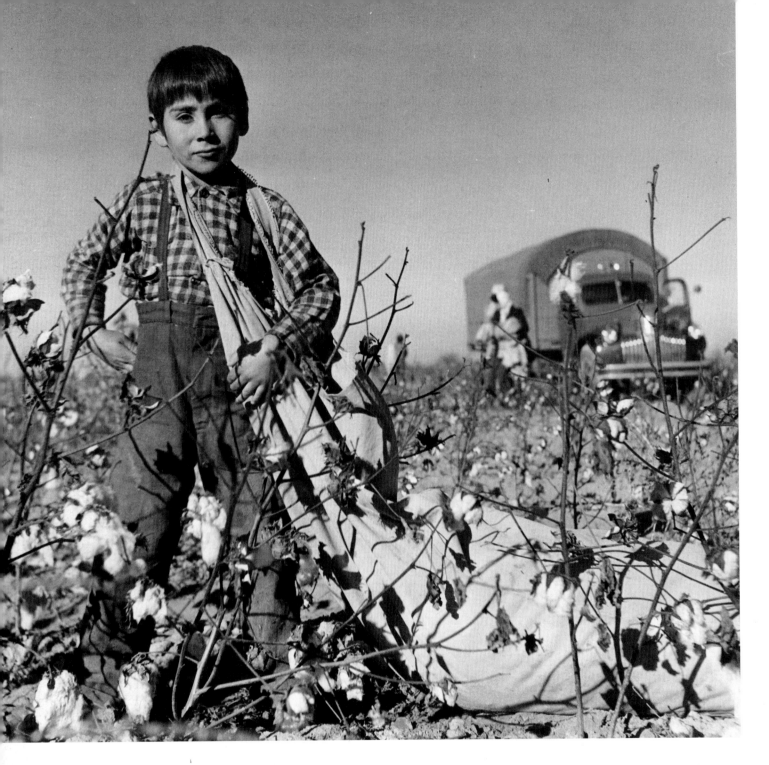

(*above*) Shaped by his World War II experiences as a member of Edward Steichen's Naval Photography Unit and deeply troubled by the sight of Hiroshima after it was destroyed by the atomic bomb, Wayne Miller returned to the United States determined to "document the things that make the human race a family." In 1949, *Ebony* magazine, the leading African American publication in the United States, assigned Miller to photograph a story about "the South moving to California." Near Fresno, Miller made this photograph of six-year-old Pete Gonzales, who claimed that he picked cotton only after school. Courtesy of Wayne Miller.

(*right*) While photographing his essay on African American cotton pickers, Wayne Miller met Alice Mack, who told him that she had been a cotton picker in Arkansas and had come to California in 1946. She earned six hundred dollars the first year, but only four hundred dollars in 1948. Within two years, virtually the entire California cotton crop would be harvested by machine, eliminating the need for more than ten thousand cotton pickers. Courtesy of Wayne Miller.

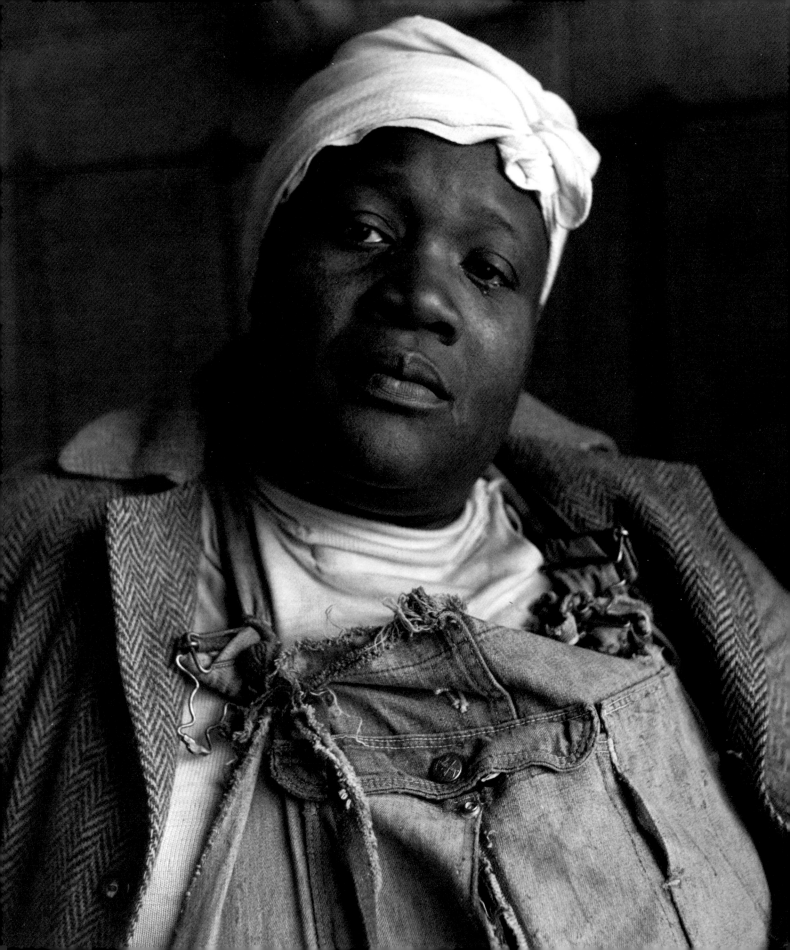

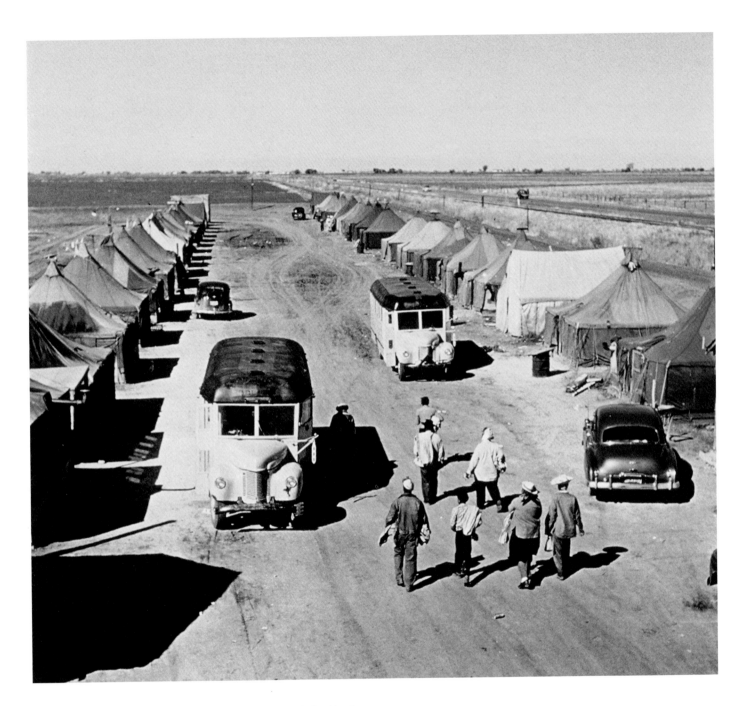

Completing various farm-related stories for *Life* magazine in 1950, Otto Hagel become fascinated by Huron. A small farmworker community on the west side of the San Joaquin Valley, Huron underwent a remarkable transformation in October and November when ten thousand migrants packed in for the cotton harvest. While concentrating on one camp, Hagel first photographed people outside of their cabins and then climbed to the top of a labor bus and made a series of shots of men arriving and departing from the fields. His caption reads: "Livingston Camp, for black people only." Courtesy of the Otto and Hansel Mieth Hagel Collection, Center for Creative Photography, University of Arizona, Tucson.

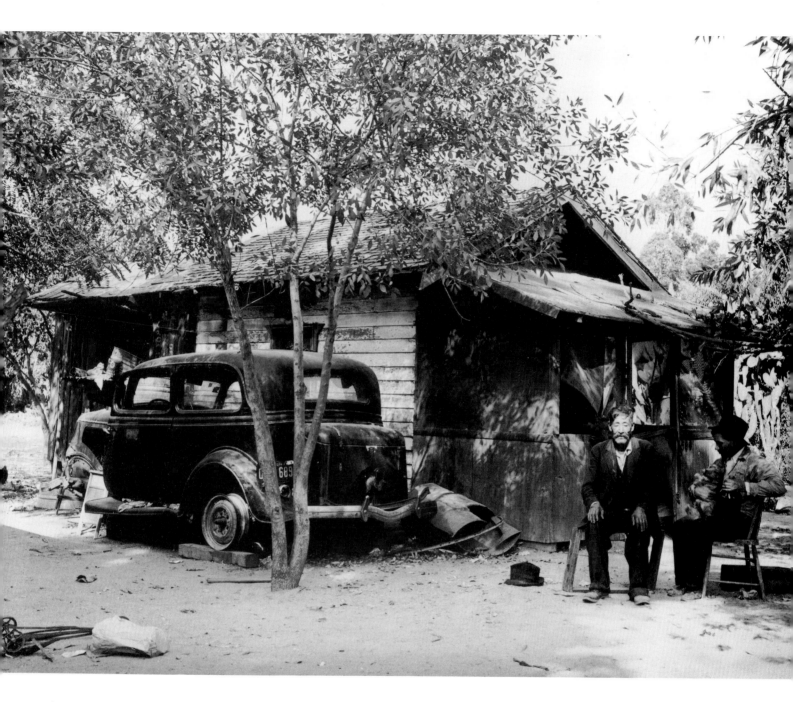

A prematurely bald photographer who settled in Los Angeles following service in the Army Signal Corps, Max Yavno began documenting the Los Angeles area. Accepting conditions as he found them, Yavno delighted in discovering the sort of situations that Lange probably would have passed up—family members arguing over some trifling disagreement or the ugly graffiti on the wall of a labor camp. In this 1946 image, Yavno has photographed two old paisanos sitting in the dappled shade having a great time drinking homemade wine. Courtesy of the Max Yavno Collection, Center for Creative Photography, University of Arizona, Tucson.

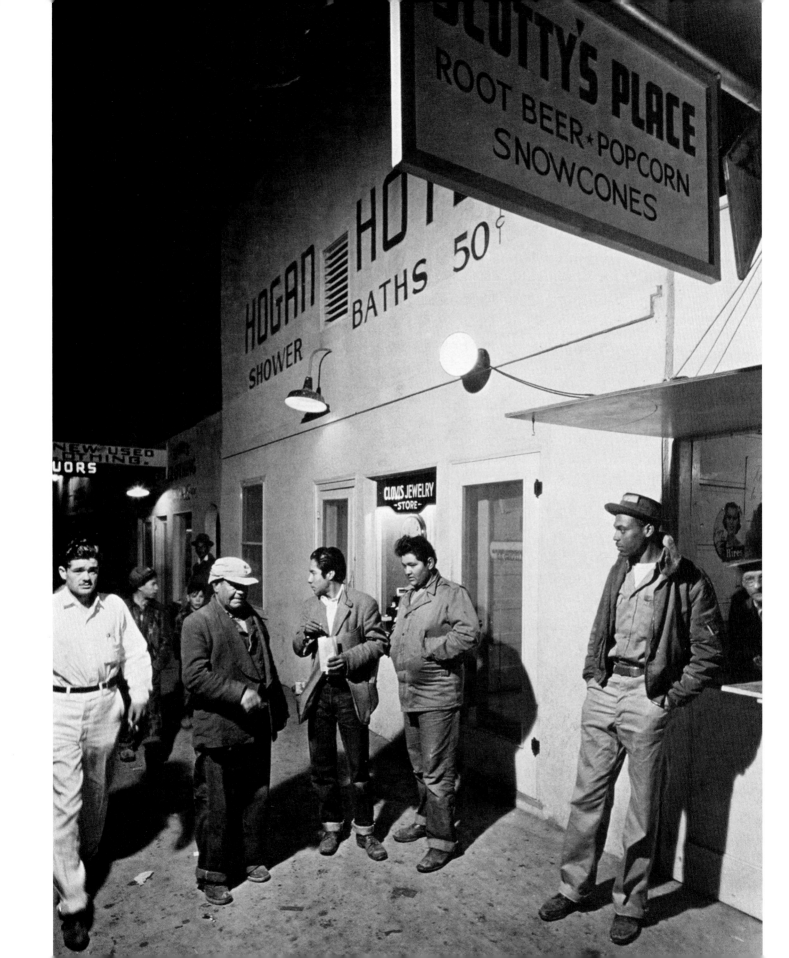

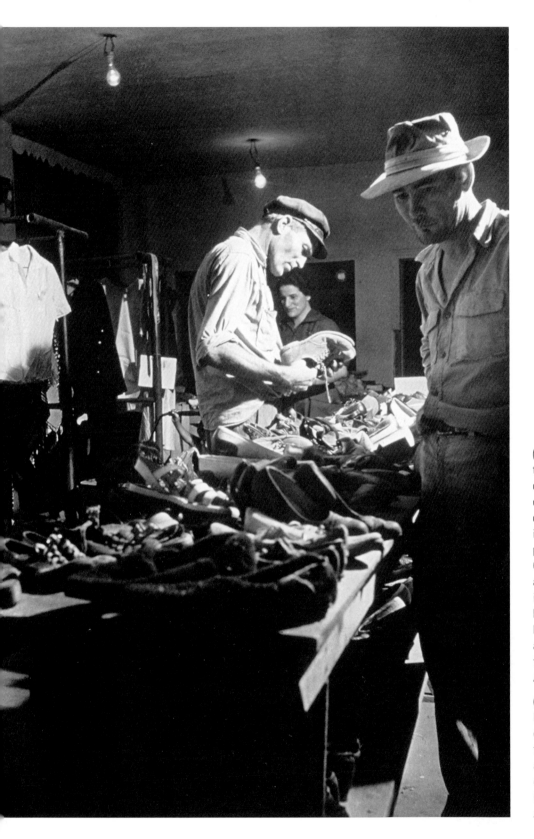

(*opposite*) In Huron, Otto Hagel focused on the town's cluttered sidewalks and made a number of highly innovative photographs of men waiting outside hiring offices, searching through surplus clothes in the Salvation Army stores, and moving in and out of bathhouses. Resembling the street photography of Bruce Davidson in New York City, these shots—many of them made with an off-camera flash—captured farmworkers in unposed moments as they went about their business, largely unaware of the camera. Photograph circa 1950. Courtesy of the Otto and Hansel Mieth Hagel Collection, Center for Creative Photography, University of Arizona, Tucson.

(*left*) Moving inside the Salvation Army store in Huron, Hagel continued to use his remote flash to overcome the dark interior lighting and document field hands picking through piles of shoes, tools, and clothing. Photograph circa 1950. Courtesy of the Otto and Hansel Mieth Hagel Collection, Center for Creative Photography, University of Arizona, Tucson.

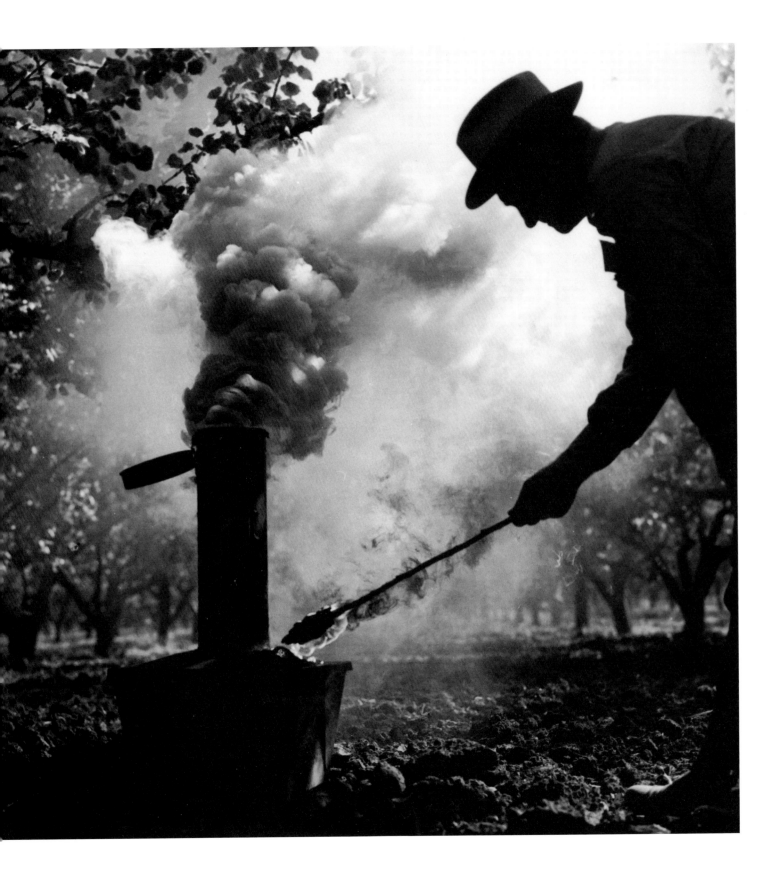

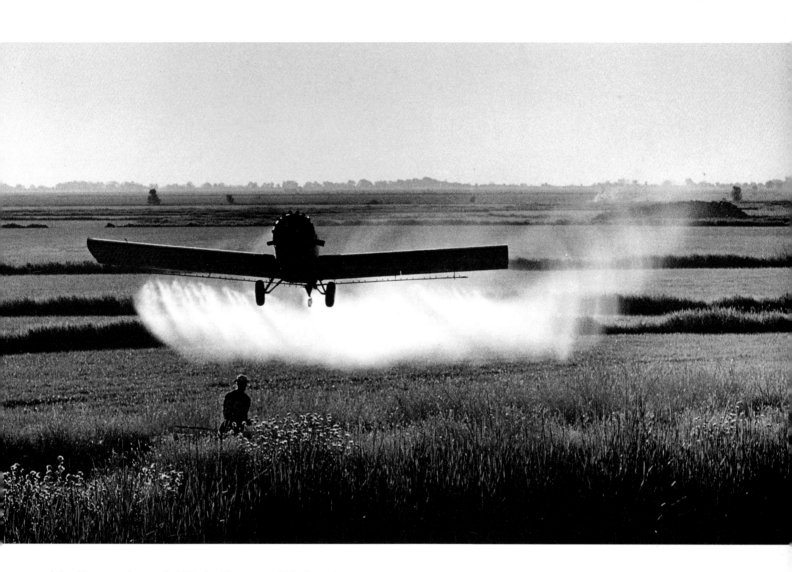

(*above*) Late one afternoon in 1959, Joe Munroe was driving home from an assignment in the rice growing districts around Colusa in the northern Sacramento Valley. The sun was low on the horizon and off in the distance a crop duster was at work spraying herbicides, directed by a flagger who marked the location of each pass. Munroe stopped his car, climbed onto the roof, and began shooting with a 300-millimeter telephoto lens. Compressing the perspective in the scene so that it appeared as if the flagger was about to be drenched in poison, when in fact he was a safe distance away, Munroe created a memorable image, one that instantly conveyed the danger and omnipresence of pesticides. Courtesy of Joe Munroe.

(*left*) As a commercial photographer specializing in agriculture, Joe Munroe photographed extensively in the Napa Valley, where he made this classic shot of a field hand lighting a smudge pot during a freeze in the winter of 1959. Courtesy of Joe Munroe.

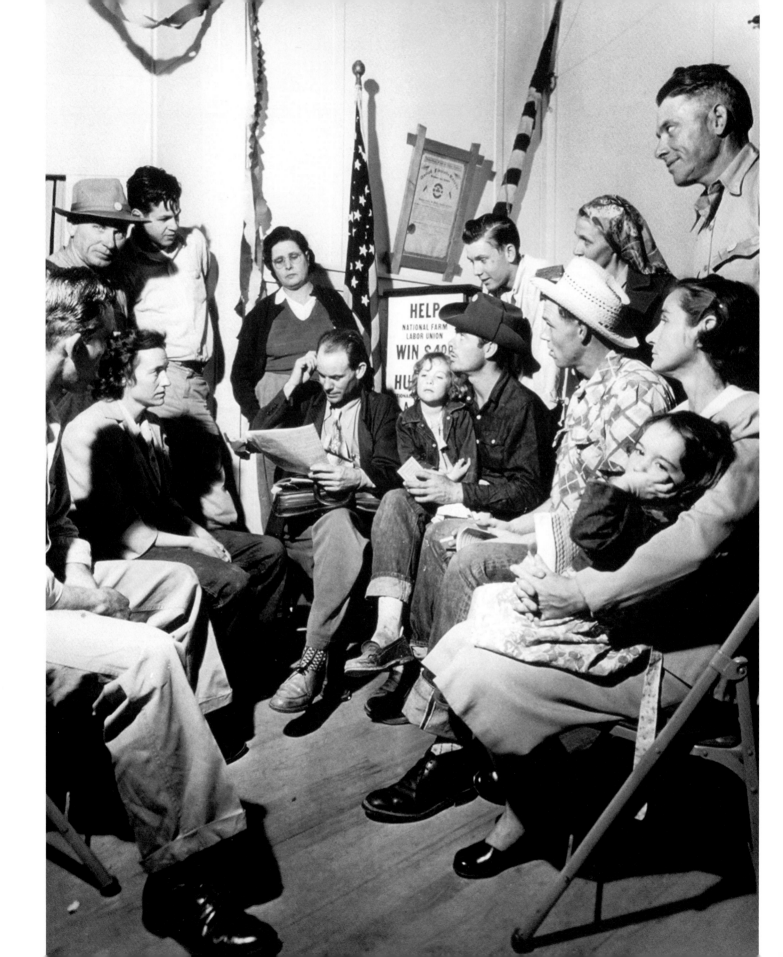

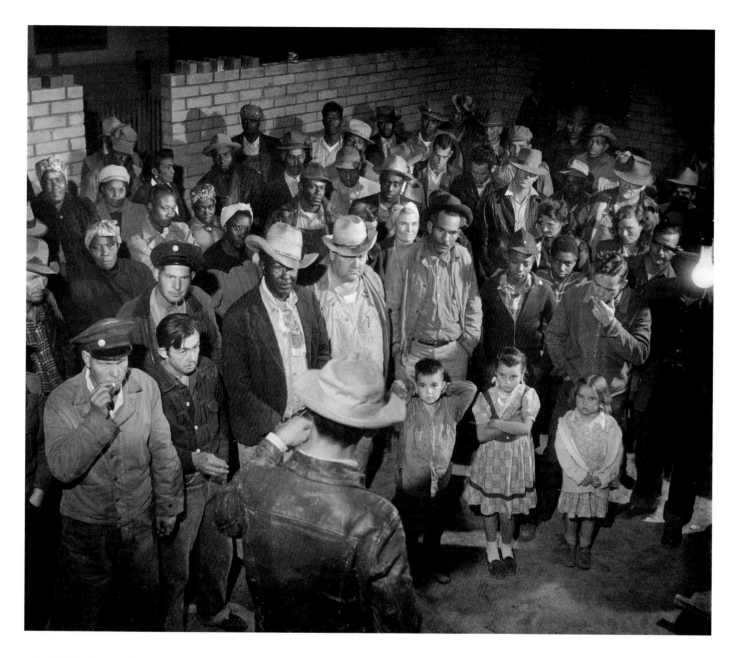

(*above*) While photographing his essay on African American cotton pickers, Wayne Miller met an organizer for the National Farm Labor Union and used an off-camera flash to record this clandestine meeting in a partially constructed building with half-walls and no roof in the middle of a big field on a cold and windy night. Photograph October 1949. Courtesy of Wayne Miller.

(*left*) In 1949 or 1950, Otto Hagel recorded former Dust Bowl refugees meeting with a National Farm Labor Union organizer to discuss the union's activities around Huron. Courtesy of the Otto and Hansel Mieth Hagel Collection, Center for Creative Photography, University of Arizona, Tucson.

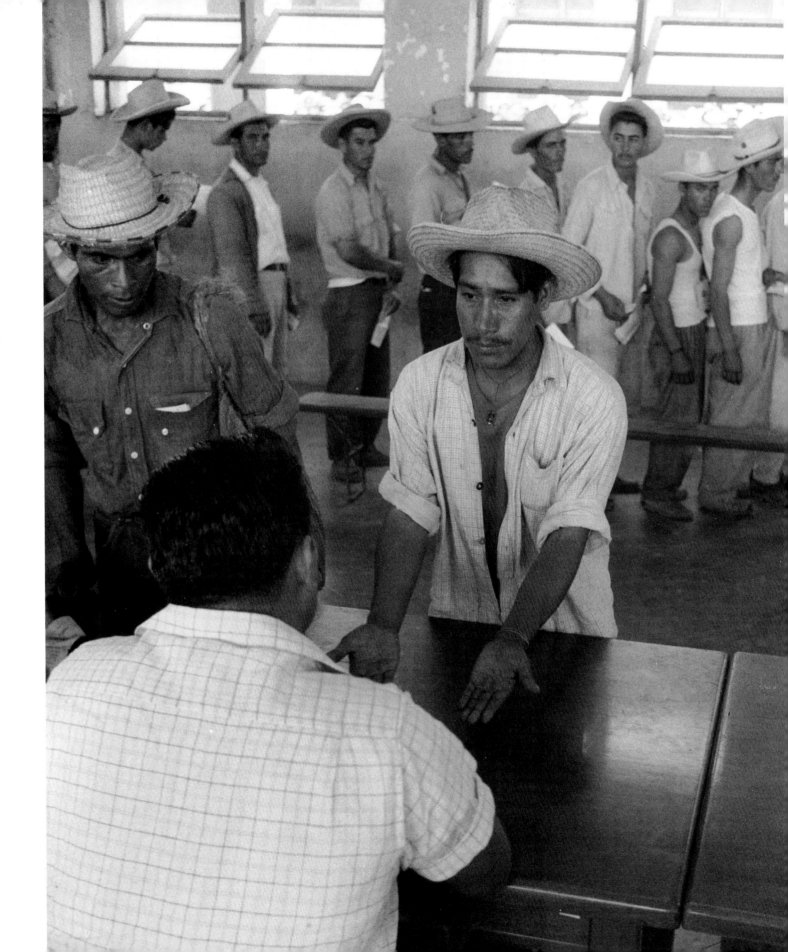

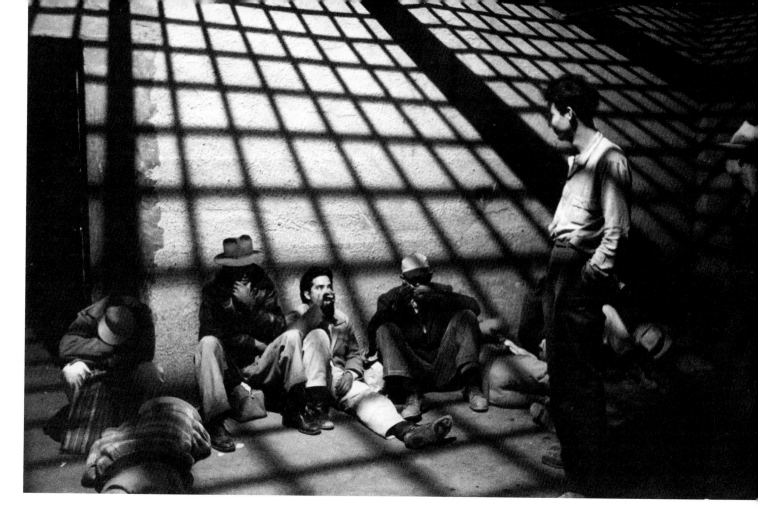

(*above*) When in 1951 national attention shifted to the 127,000 "wetbacks" arrested while trying to cross illegally into the United States, mainly to work on farms in California and the Southwest, *Life* magazine assigned Loomis Dean to photograph the story. A photographer with the air force during World War II, Dean was a jack-of-all-trades photographer who, after going to work for *Life* in 1948, handled everything from celebrities and breaking news to bat caves and maritime disasters. Well known for a series of stories on "checkbook farmers" and wealthy ranchers, Dean traveled to the Imperial Valley in May 1951 to cover the Border Patrol's massive campaign to arrest, detain, and deport thousands of undocumented Mexican laborers. Working night and day over a period of several weeks, Dean thoroughly documented the story, shooting what amounted to the first extended photo essay on undocumented farmworkers in California agriculture. After the Border Patrol arrested one group of men, Dean followed them south to the Calexico jail and, while visiting them in their cell, noticed the way a single lightbulb cast dramatic shadows from the jail cell bars across the room where the men were held. Using a Leica camera with a 28-millimeter wide-angle lens, he leaned against the cell bars and overcame the low light with a series of exposures at one-half or one-tenth of a second. Courtesy of *Life Magazine* and *Time* Inc.

(*left*) "One of the primary requirements for employment of braceros in the United States is that the laborers must have farming experience," wrote Leonard Nadel, in his caption to this 1958 photograph. "During processing at the Mexican Contract Center in Monterrey, Mexico, a United States inspector examines the calluses of a prospective laborer and decides that he is not eligible." Courtesy of Evelyn DeWolfe Nadel.

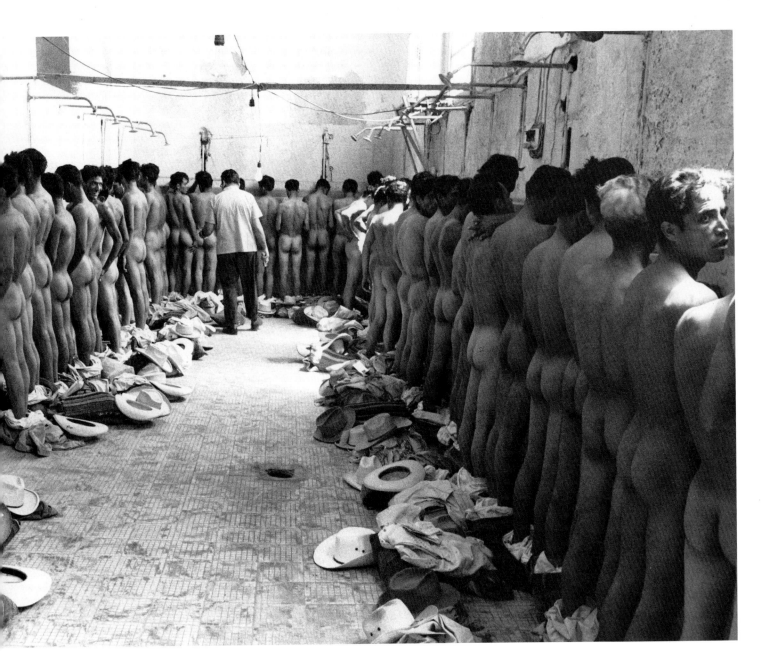

Leonard Nadel's caption to his 1958 photograph of braceros stripped naked while undergoing a medical examination reads: "Men told to strip and subjected to a complete body search for drugs and contraband and to ascertain that they are robust and muscular." Courtesy of Evelyn DeWolfe Nadel.

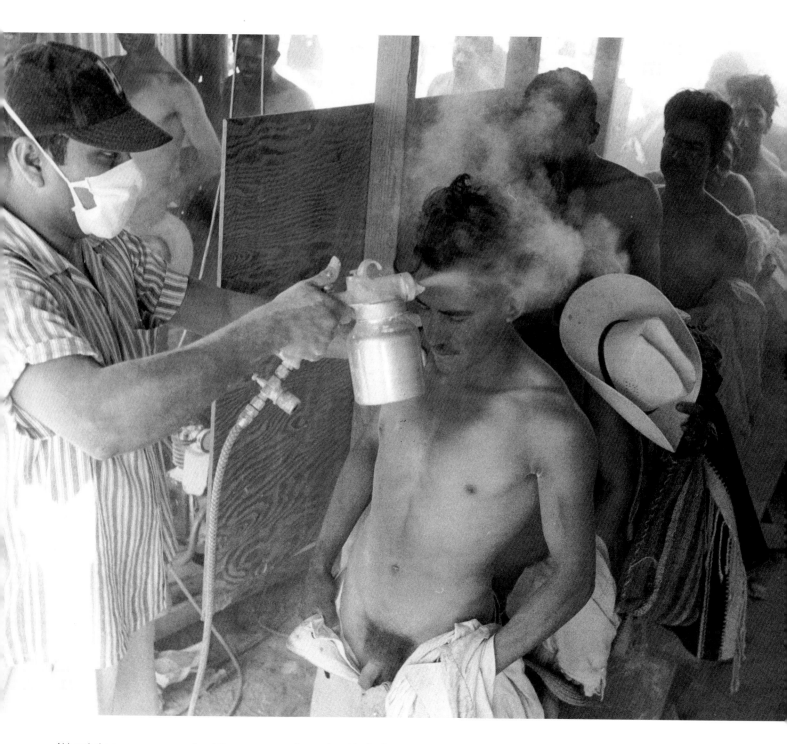

Although the sprayer wore a mask and the men were totally enveloped in clouds of DDT, Leonard Nadel did not use any protective equipment while making this 1958 photograph of braceros lining up to have their heads and genitals sprayed at a border processing center. Courtesy of Evelyn DeWolfe Nadel.

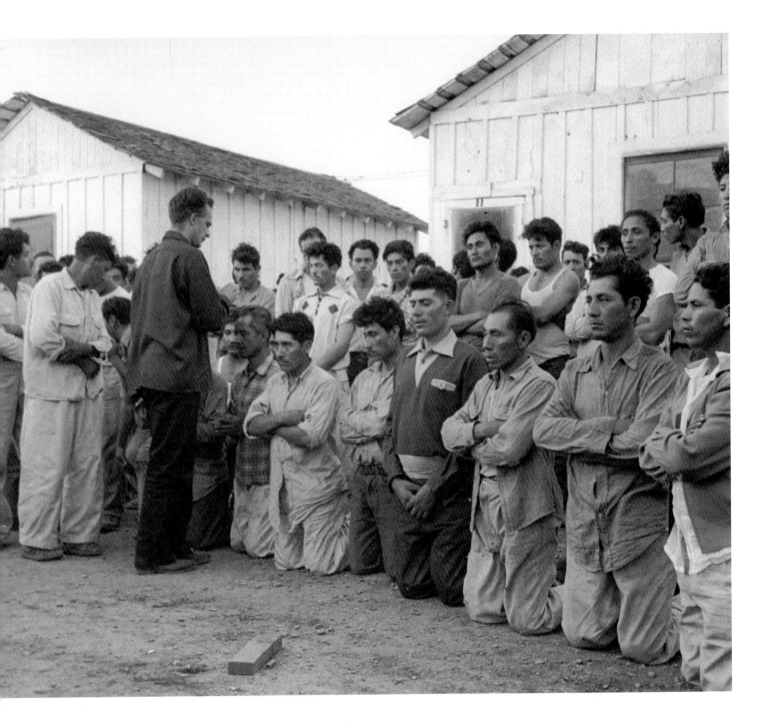

"The local parish priest brings solace to braceros who find themselves in a strange land surrounded by strangers who speak a language they cannot understand," wrote Leonard Nadel of this 1958 photograph. "Here, the deeply religious braceros gather with their companions for prayers on a Sunday morning." Courtesy of Evelyn DeWolfe Nadel.

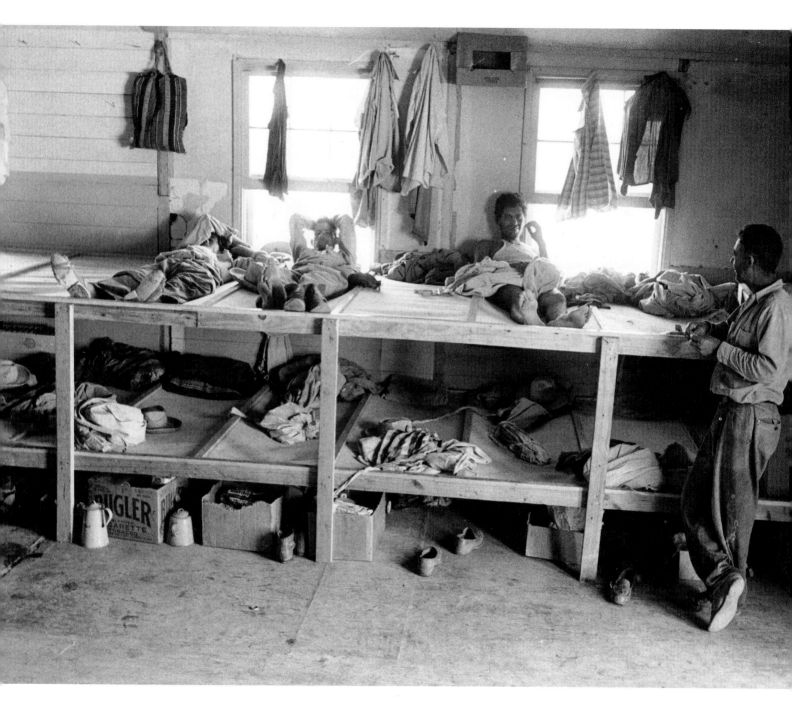

After making this 1958 photograph of braceros in their bunkhouse somewhere in the San Joaquin Valley, Leonard Nadel wrote: "After a hard day's work, there is little else for the braceros to do except rest and seek the companionship of other farm laborers. Many can not read the sometimes involved terms of their work contracts. . . . They feel stranded, helpless, and vulnerable." Courtesy of Evelyn DeWolfe Nadel.

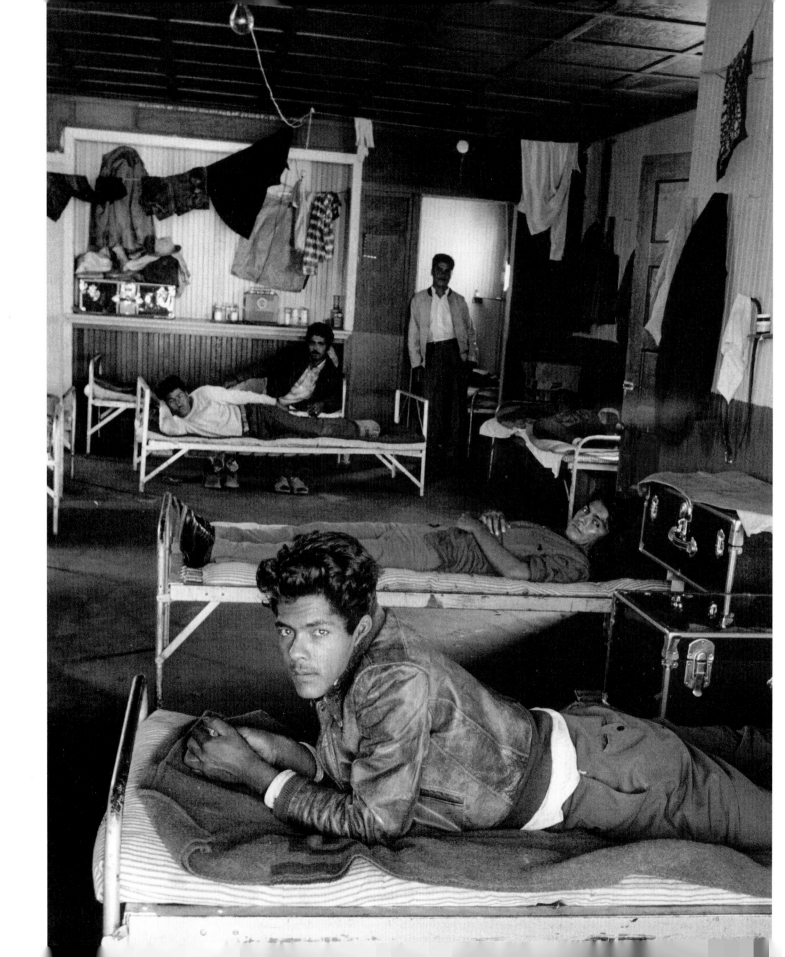

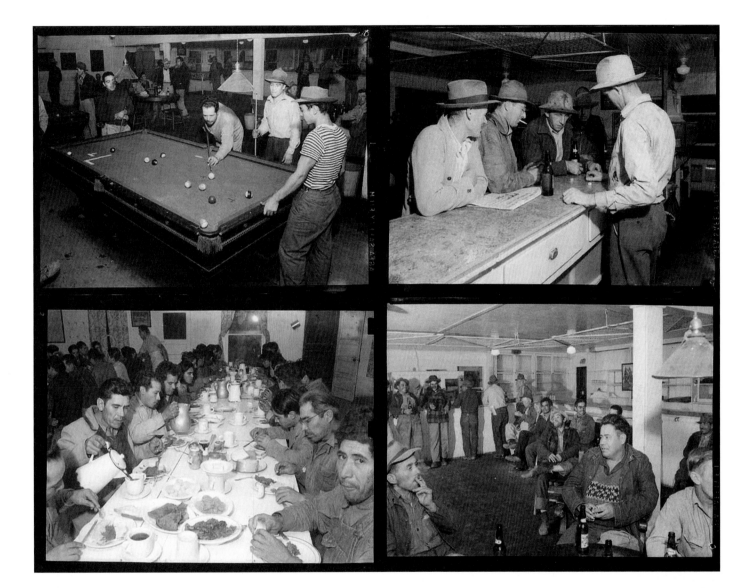

(*above*) As part of a commercial assignment at the El Solyo Ranch in the mid-1950s, Ansel Adams photographed permanent field hands and braceros in the ranch pool hall, bar, and dining hall. The pictures were radically different from Leonard Nadel's images of braceros and a marked departure from the photographs normally associated with Adams. Courtesy of the Ansel Adams Collection, Center for Creative Photography, University of Arizona, Tucson. Used by permission of the Trustees of the Ansel Adams Publishing Rights Trust. All Rights Reserved.

(*left*) Reflecting on his photograph of living conditions for braceros on one farm in 1958, Leonard Nadel later wrote: "A drafty barn in Stockton, California, was hastily converted into housing facilities for these workers. Only a piece of canvas to lay on and one toilet were supplied for sleeping comfort." Courtesy of Evelyn DeWolfe Nadel.

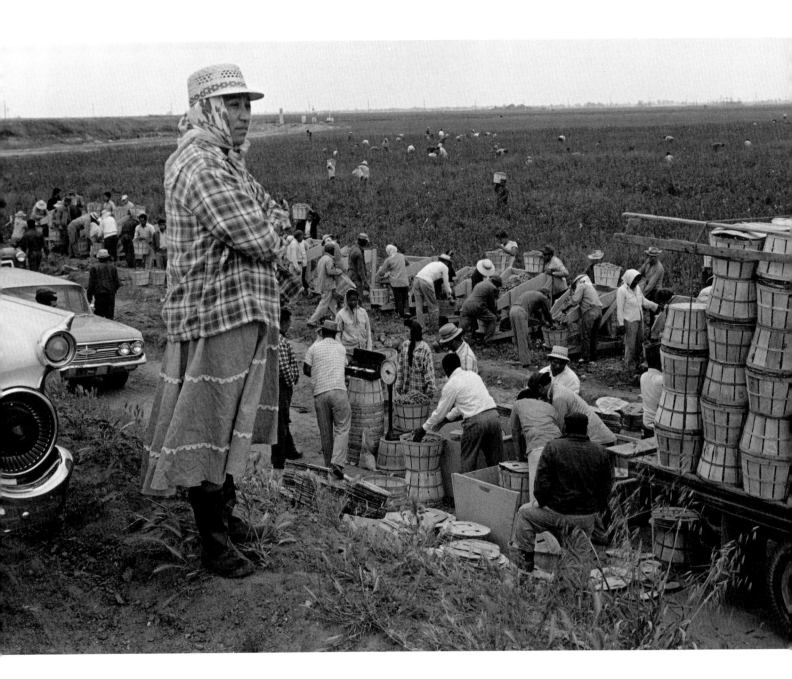

On January 1, 1961, George Ballis accompanied Agricultural Workers
Organizing Committee (AWOC) organizer María Moreno into the pea fields
around Stockton, where she spoke to workers about joining the union.
Courtesy of George Ballis/Take Stock.

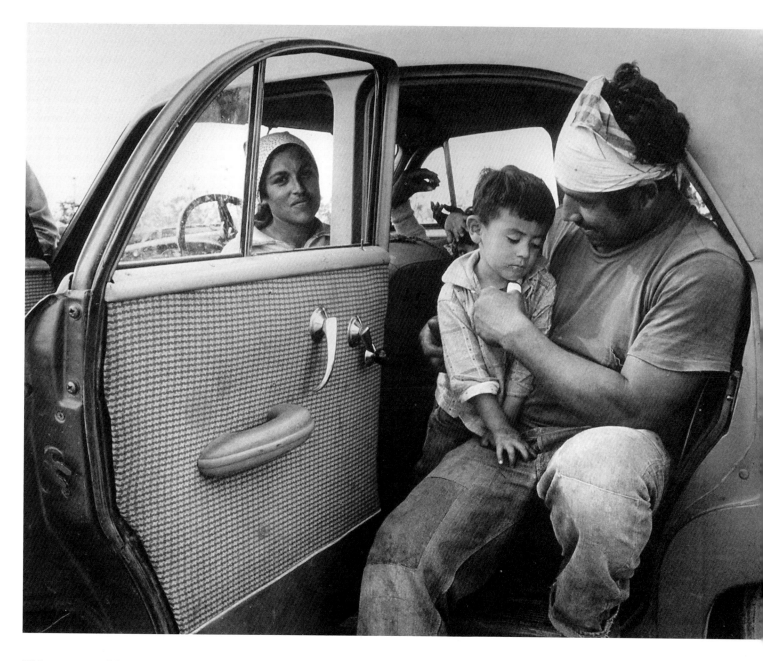

While on a commercial assignment photographing planting operations and machinery for the Kern County Land Company in 1957, Pirkle Jones saw this migrant family on the edge of the field. Copyright 1957 Pirkle Jones. Courtesy of Pirkle Jones.

Harvest of Shame

During the spring of 1961, Harvey Richards, a freelance photographer working with the Agricultural Workers Organizing Committee (AWOC), launched a photographic project unique in the annals of farmworker photography. Energized by Edward R. Murrow's CBS News documentary *Harvest of Shame* that had shocked the nation as it sat down for Thanksgiving dinner a year earlier, Richards decided to show that farmworkers lacked such basic necessities as field toilets.

Documenting the absence of something proved a challenge. A field without a portable outhouse was simply a field. Men without adequate water to wash their hands displayed no obvious or easily identifiable characteristics. Realizing these problems, Richards decided to photograph people in the act of going to the bathroom in the fields. But not everyone. Richards would exclude women and children from his picture and focus entirely on men. Using two Nikons, Richards equipped one with a telephoto lens, mounted it on a tripod, and began looking into fields from a rooftop platform, modeled on the one used by Ansel Adams, which he constructed on top of his 1957 Chevrolet station wagon. After spending five months on the project and shooting hundreds of pictures of men urinating in the fields, using the bushes for their bathrooms, trying to hide behind tomato bins, and squatting over five-gallon buckets, Richards had compiled the first and probably the last photo essay on the subject. His work provided irrefutable evidence of the absence of toilets in the fields and demonstrated that field sanitation was a legitimate issue not only for farmworkers but consumers—a connection not lost on later organizers seeking to overcome structural impediments to organizing.

When Richards offered his photographs to editors and reporters throughout California, none would publish or even consider them. Like Leonard Nadel's photographs of naked braceros being deloused with DDT, Richards's images of farmworkers urinating in the fields were far too graphic for public consumption. Realizing their value, the United Packinghouse, Food, and Allied Workers Union used them in a pamphlet attacking the bracero program. With faces blocked

out to protect the identity of the men, the pamphlet announced, "Public Law 78 Means Filth in Your Food. Public Law 78 Must Go"; it became the center of a storm of controversy over food safety and contamination. So great was the pressure from these and similar images that within a decade every labor bus would be required to haul two toilets and provide at least one source of clean, cool drinking water to farmworkers in the fields.

Richards did not stop with his exposé. Present at AWOC strikes, demonstrations, and job actions, he followed developments throughout the state, becoming the first photographer to systematically document the introduction of pesticides on a wide scale and, by implication, their effect on farmworkers. He also photographed day-haul laborers who poured out of their cheap quarters in the slave markets of Stockton at three and four A.M. each morning, haggled with foremen who offered work, settled on a wage, piled into ancient buses and trucks, and paid one dollar for the "day haul"—the round trip to and from the fields.

By late 1961 Richards had created an activist portfolio, and a very effective one, but he did not stop there. Hardly a passive spectator to events, he and a half-dozen other activist photographers during the years 1960–65 set out not merely to criticize farm labor relations, but to force dramatic changes. Offered to anyone and everyone, their powerful photography nullified much of the agricultural industry's advertising and public relations images. But it did much more. Substituting a counterimage that eventually triumphed, photographers assumed a central position mobilizing popular sentiment. Generating an alternative discourse, they provided the visual foundation for the modern farmworker movement.

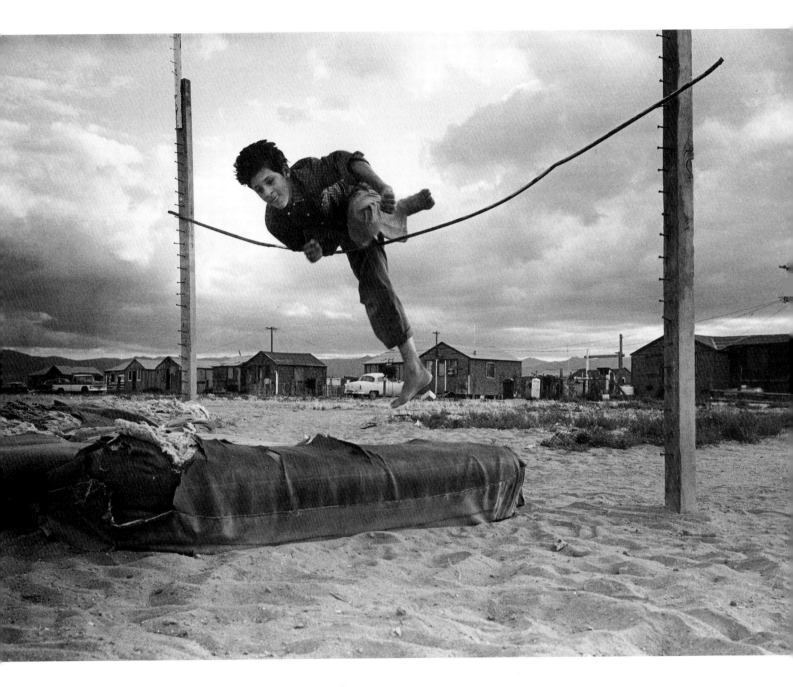

Capturing what George Ballis called "an oasis of hope," this photograph,
taken in a labor camp on the west side of Fresno County in 1958, reveals the
joy of a youngster as he clears the bar in a high-jump pit fashioned from junk.
Courtesy of George Ballis.

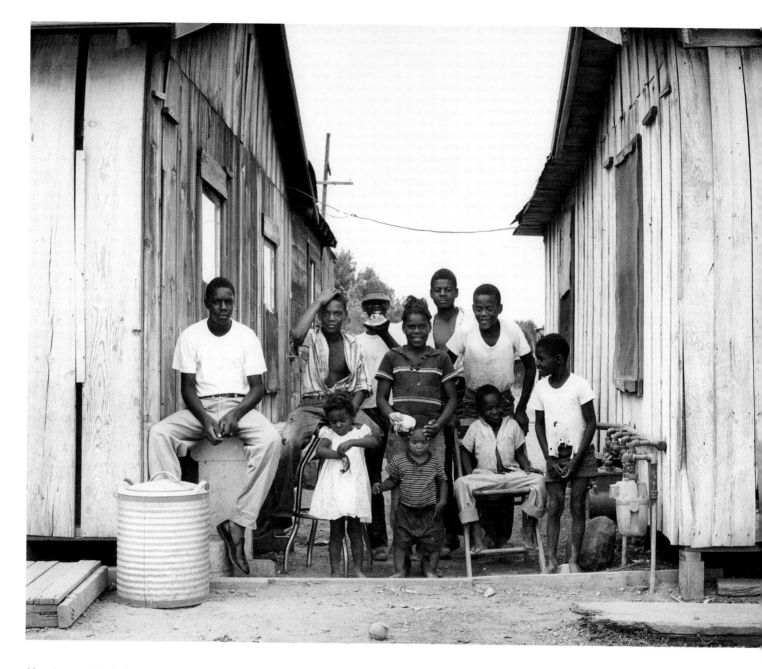

After photographing in the fields over a five-year period, Ernest Lowe in 1963 began exploring Teviston, an unincorporated African American community of trailers and shacks sprawling along the alkali flats beside Highway 99 between Pixley and Tipton. "I tried to capture a sense of their situation but I also tried to explore their industriousness and sense of community," Lowe observed of his experiences in Teviston. "Poverty created so many obstacles for them, along with race, but they kept at it." Among Lowe's favorite images is this group portrait of African American youngsters posing in the alleyway between the buildings where they lived. Courtesy of Ernest Lowe.

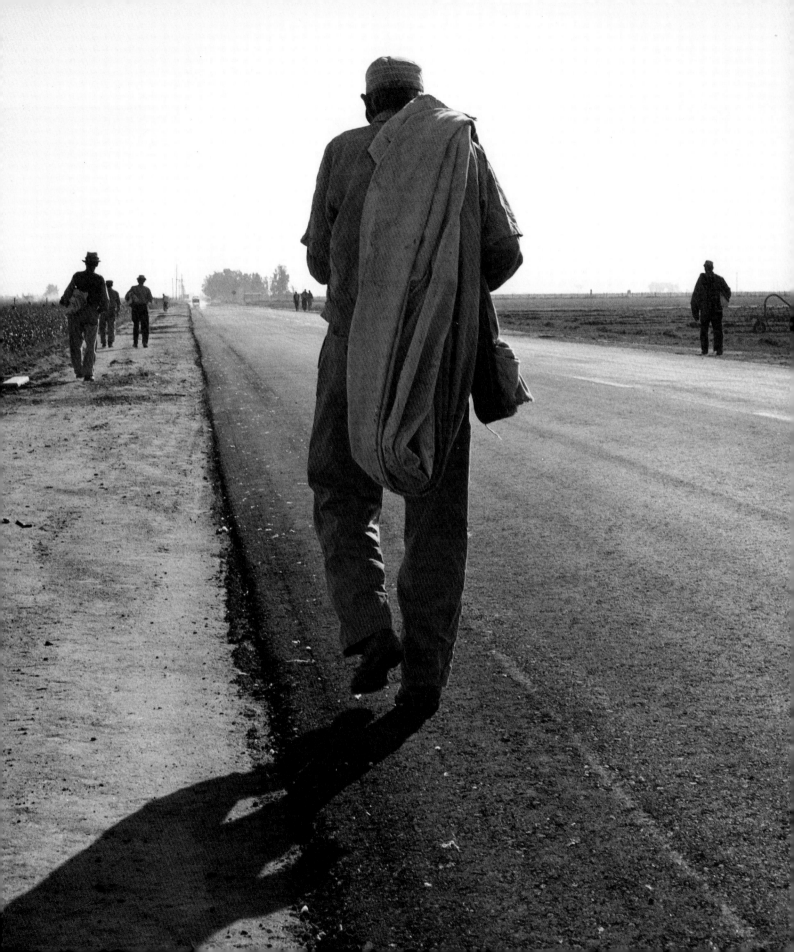

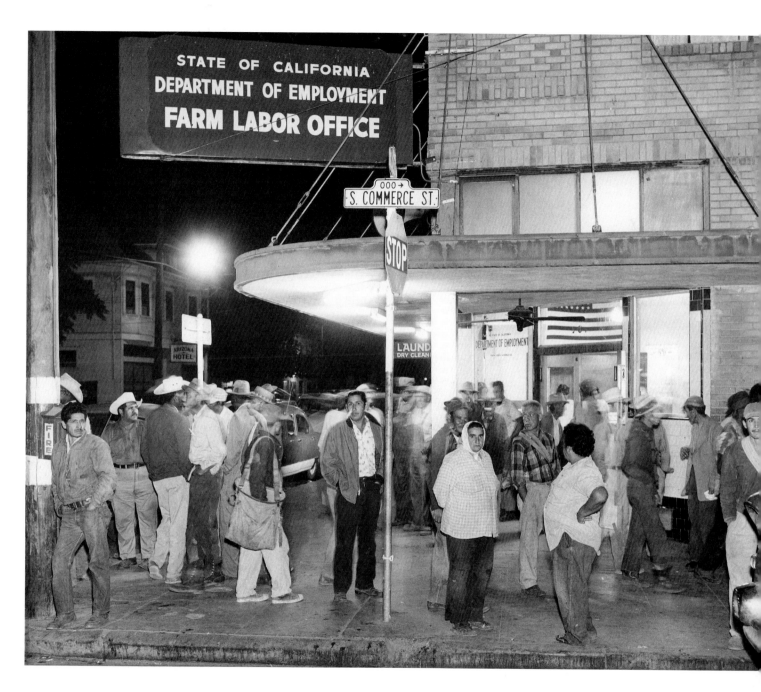

(*above*) About 4:30 A.M. on August 18, 1960, an unknown *San Francisco Examiner* photographer used a flash to document day-haul laborers of all nationalities and ethnic groups as they congregated for work outside the State Farm Labor Office at the corner of West Market and South Commerce Streets in downtown Stockton. Courtesy of the *San Francisco Examiner*.

(*left*) Although cotton picking had been almost completely mechanized ten years earlier, Ernest Lowe still found many farmworkers carrying cotton-picking bags into the fields near Tipton, in Tulare County, during the fall of 1960. Courtesy of Ernest Lowe.

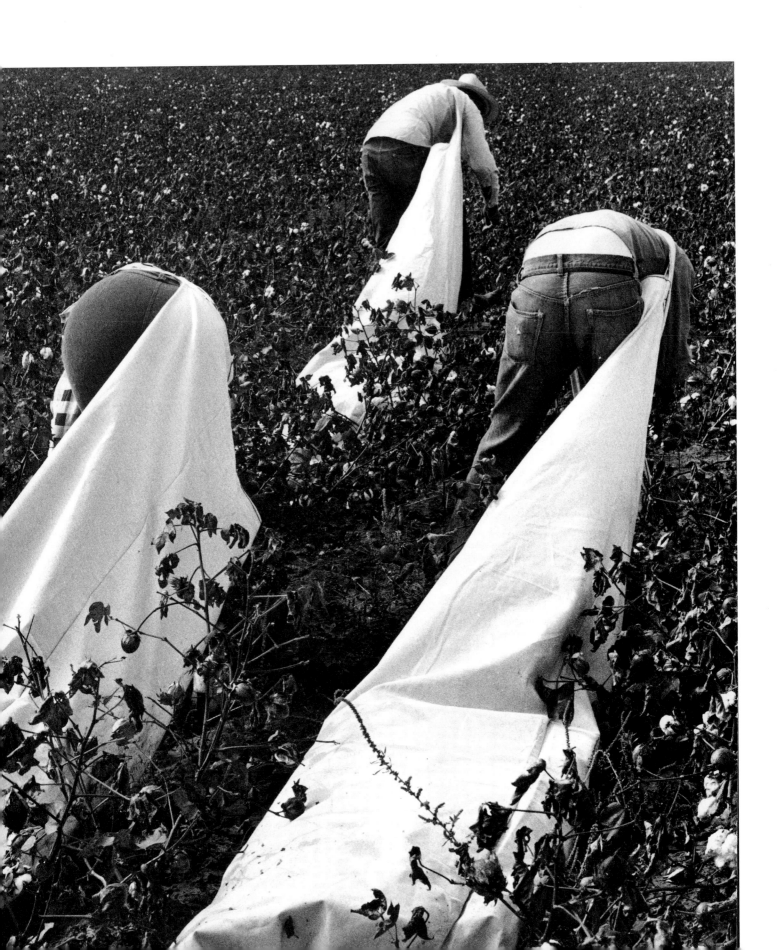

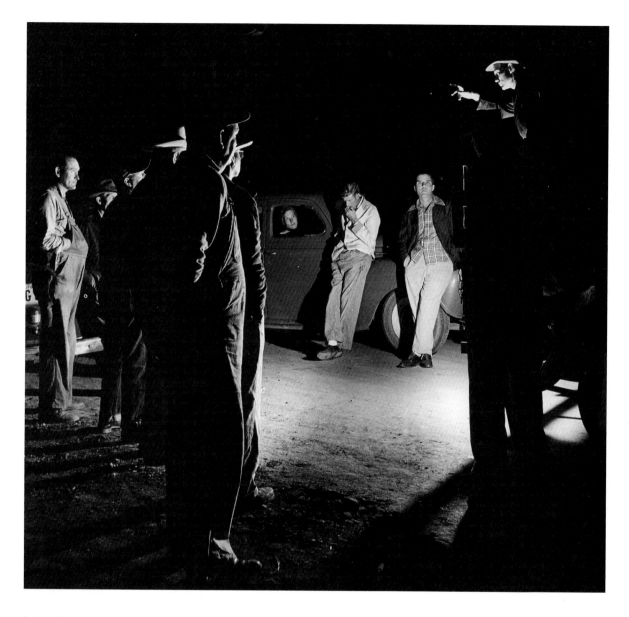

(*above*) Thirty years after he had first photographed farmworkers, Otto Hagel began following the Agricultural Workers Organizing Committee (AWOC) through the San Joaquin Valley. At an intersection of two county roads late one night in the fall of 1961, only the headlights from a parked car appeared to illuminate a meeting. Addressing the circle of men (and one woman who listened attentively through a car door window), an organizer standing in the bed of a flatbed truck leaned forward, his hand upraised in a dramatic gesture. At that moment, Hagel snapped a picture. "A second after the picture was taken," Hagel's wife Hansel recalled many years later, "they had been discovered and had to disband, at the warning shout of the lookout." Courtesy of Hansel Mieth Hagel.

(*left*) As continuing evidence of stoop labor, Ernest Lowe's classic shot of cotton pickers seems as though it is from the 1930s but was in fact taken in 1961, near Pixley. Courtesy of Ernest Lowe.

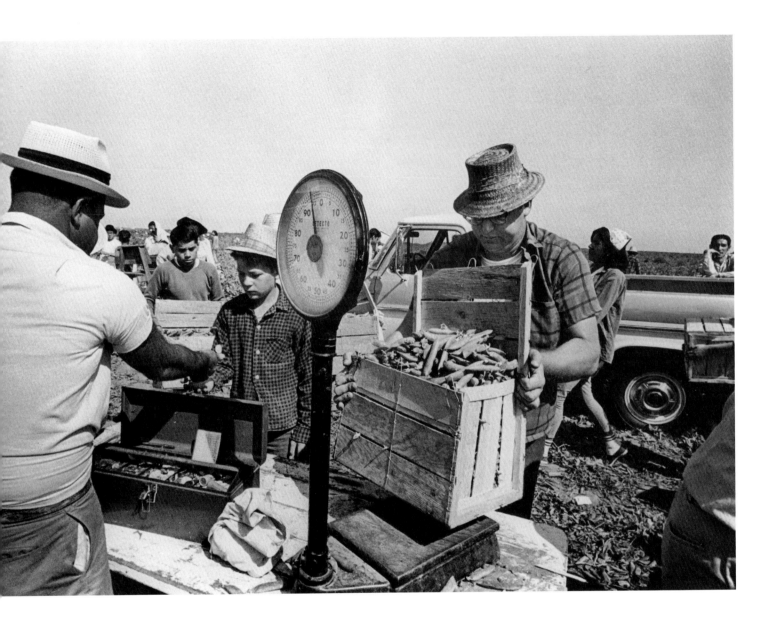

Photographing the pea harvest near Stockton on January 1, 1961, George Ballis discovered many children still working in the fields under a piece rate payment. Courtesy of Take Stock.

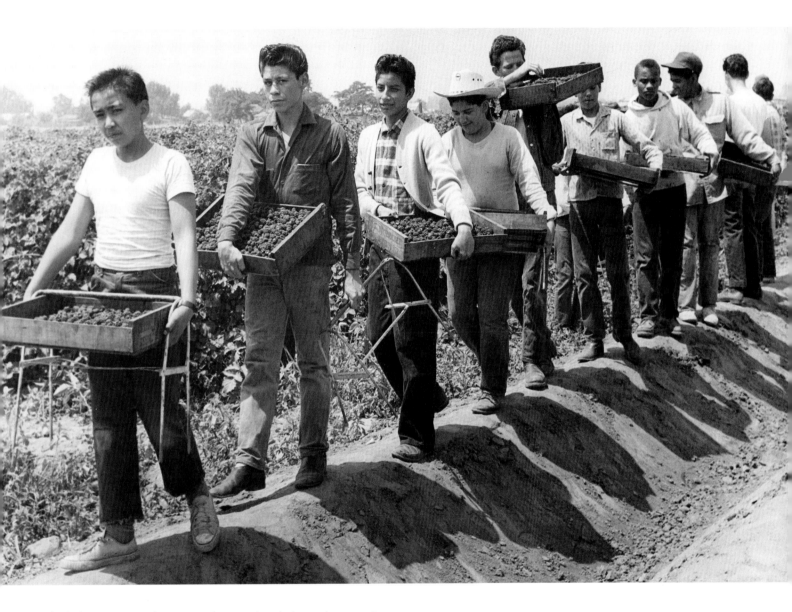

As the bracero program drew to an end, growers launched several programs to supplement the farm labor force, among them this effort to use a group of high school students to pick berries on June 17, 1963, near Tracy. Photographer unknown. Courtesy of the *San Francisco Examiner.*

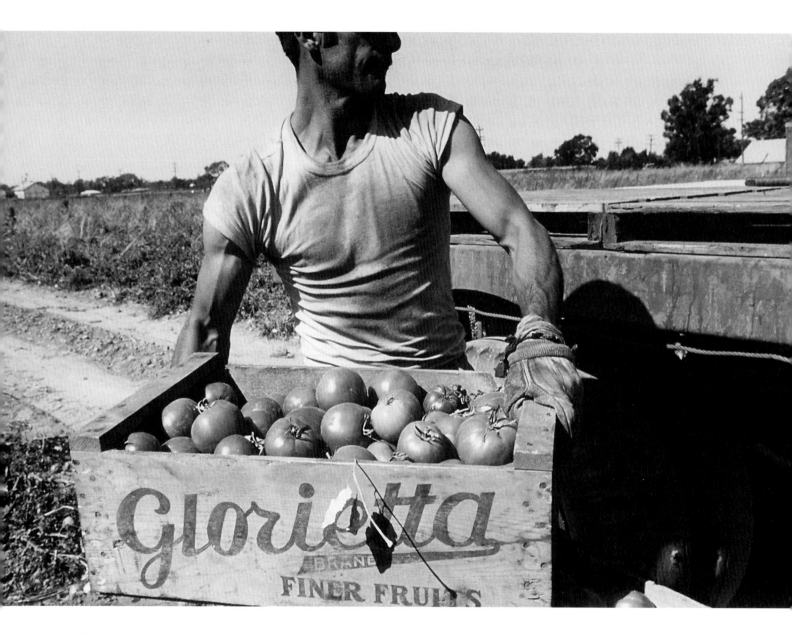

(*above*) While developing his 1961 photo essay on Walnut Grove, Pirkle Jones attempted to overcome the failure of photographers to adequately address the strains of work by focusing tightly on this tomato loader's arms as he hefted a box onto a flatbed truck. Copyright Pirkle Jones, from the series *Walnut Grove: Portrait of a Town*. Courtesy of Pirkle Jones.

(*right*) Fearing a lawsuit, the United Packinghouse, Food, and Allied Workers Union (UPWA) placed a black square over this man's face, then ran the photograph on the cover of a pamphlet attacking the bracero labor program for perpetuating a work environment devoid of minimal water and toilet facilities. Photograph circa 1961. Courtesy of Harvey Richards.

206

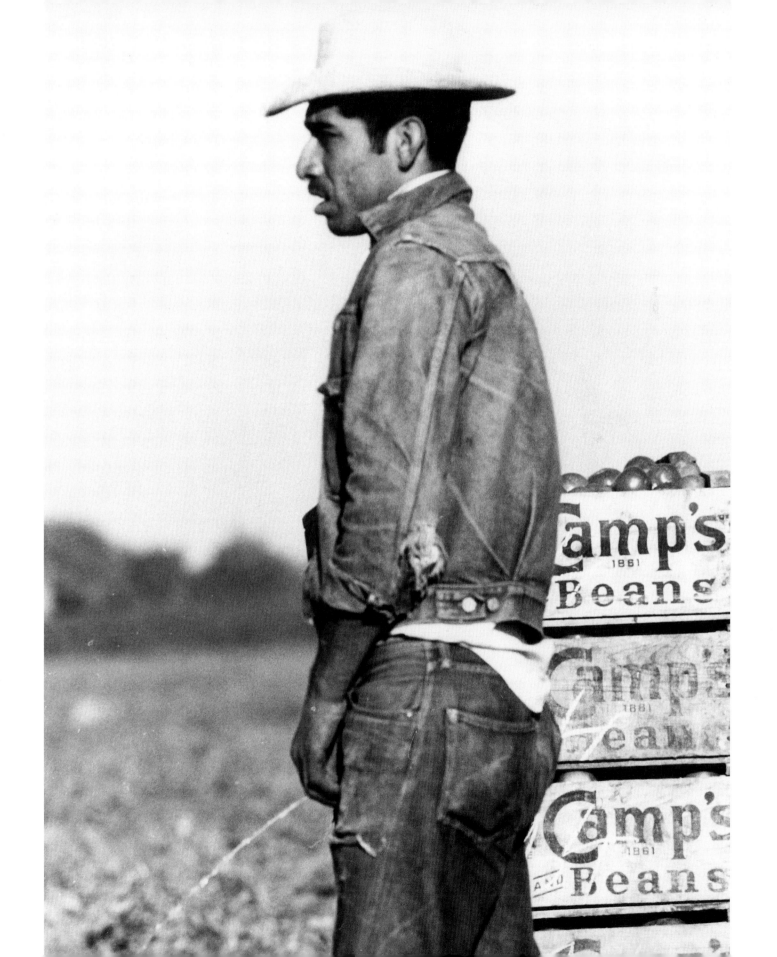

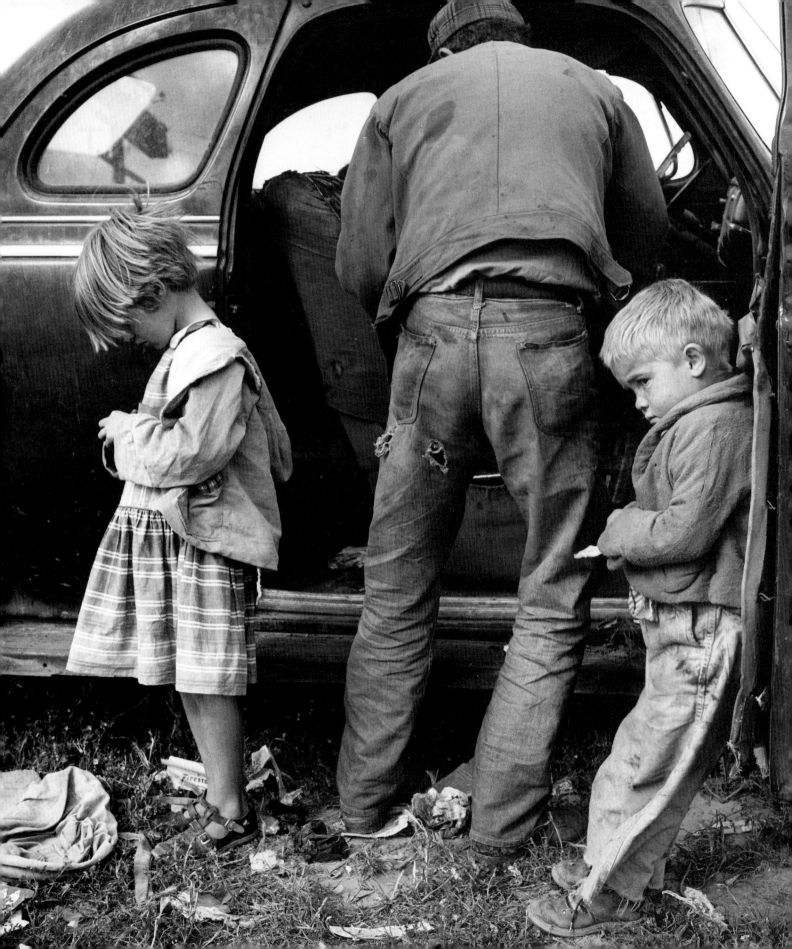

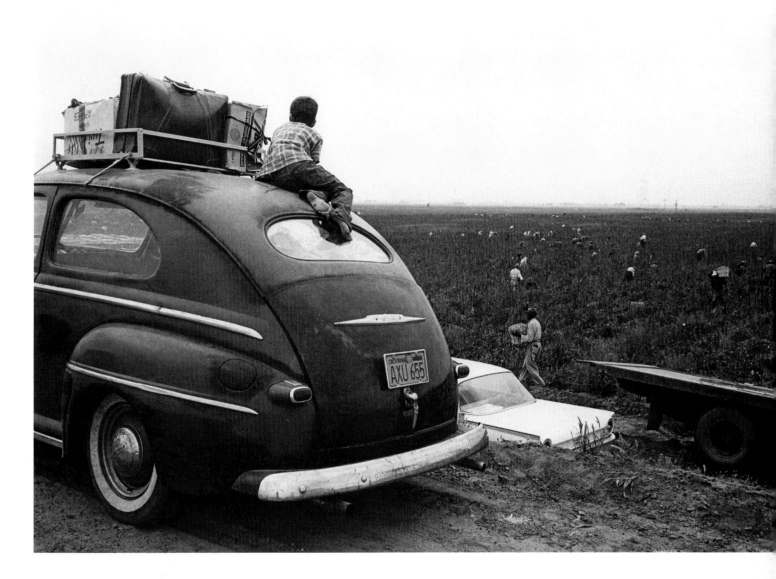

(*above*) To illustrate the pressures that migratory labor placed on family life, George Ballis made this photograph about 1962 of a child on top of the family's fully loaded automobile, gazing across the San Joaquin Valley pea field where his parents had been hard at work since arriving early that morning. Courtesy of George Ballis.

(*left*) Ernest Lowe ran into this full-time farmworker and his two children as the man was irrigating a field on the west side of Fresno County in the spring of 1960. Courtesy of Ernest Lowe.

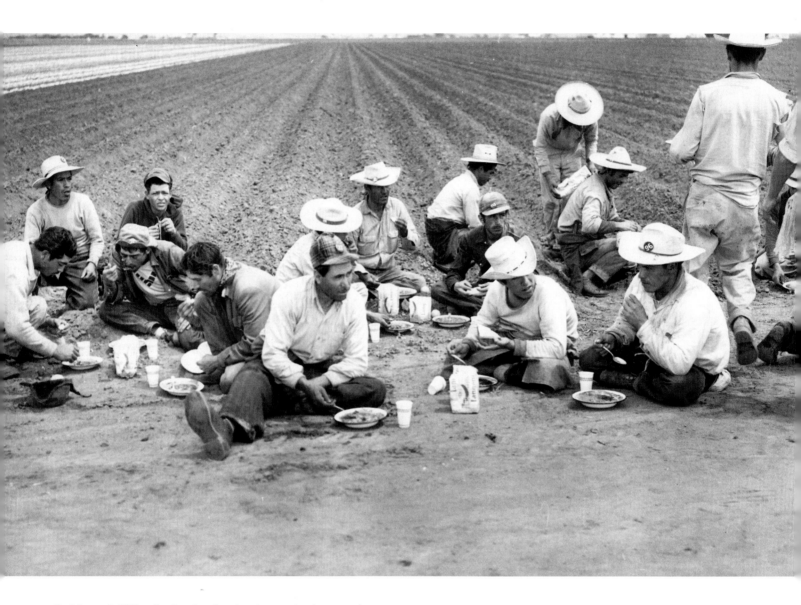

On February 9, 1959, a *San Francisco Examiner* photographer documented these braceros eating their hot lunches on the ground beside the Salinas Valley fields where they were cutting lettuce. Courtesy of the *San Francisco Examiner*.

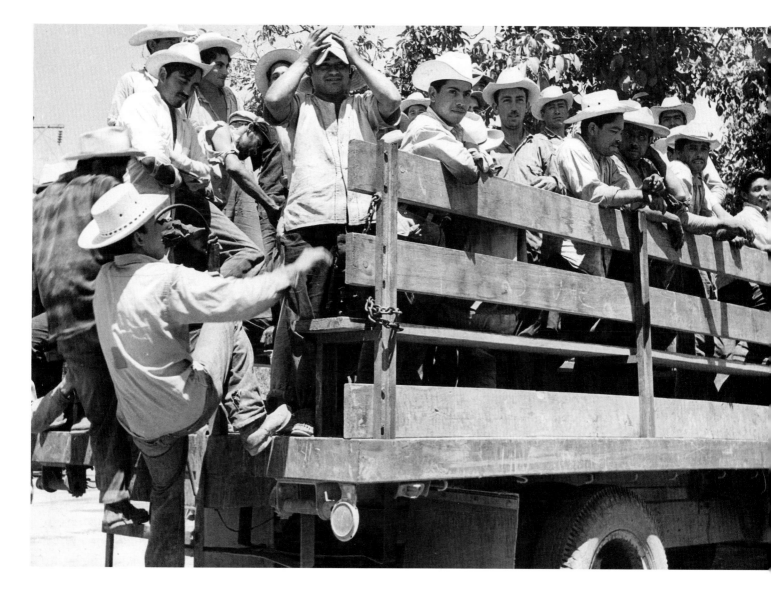

Near Tracy on August 19, 1959, an unidentified *San Francisco Examiner* photographer recorded braceros piling into an open truck for the trip to the fields. Even then, the dangers of such farm labor transportation were apparent to many. Courtesy of the *San Francisco Examiner*.

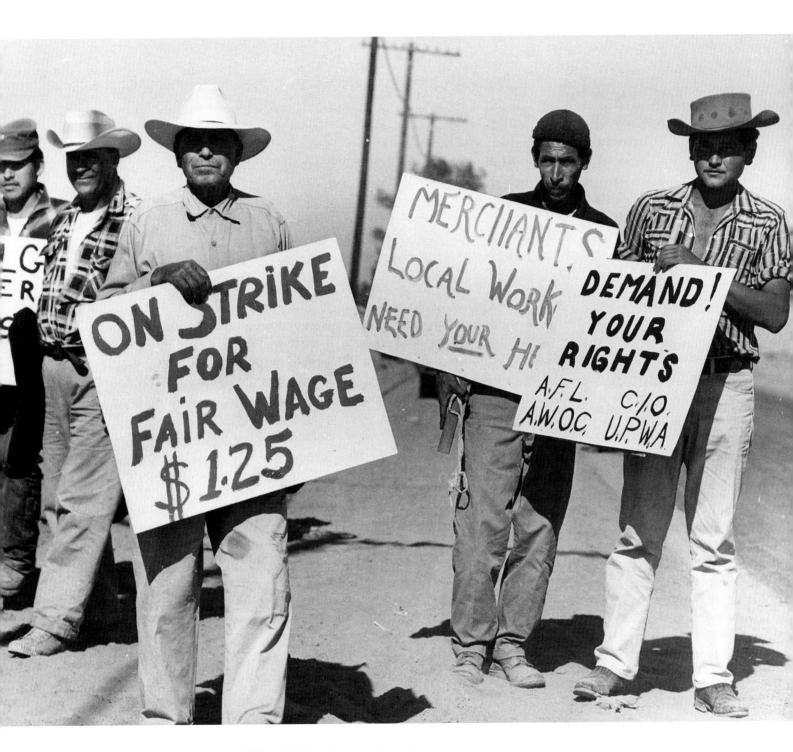

During the January 1961 joint campaign by AWOC and UPWA against the employment of braceros in the Imperial Valley, Arthur Dubinsky made this photograph as union members picketed a field near El Centro. Their signs said it all. Author's collection.

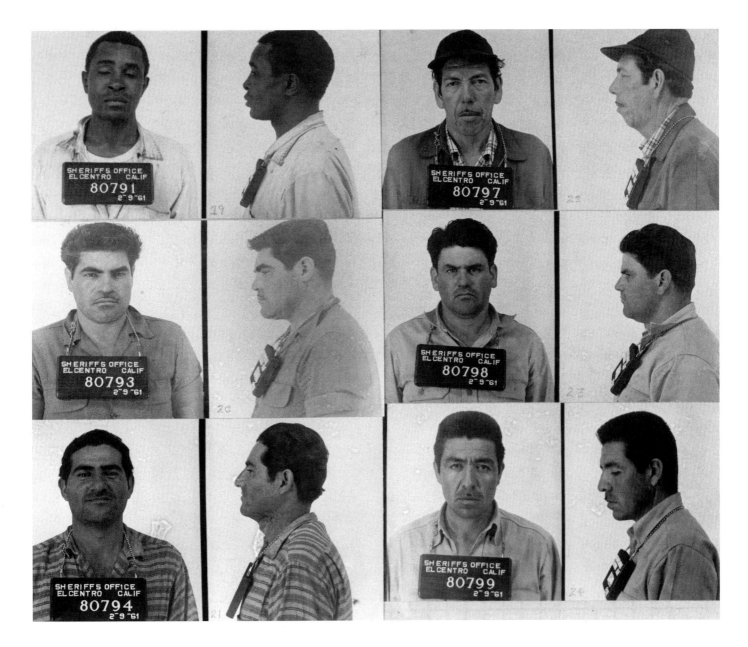

Early in February 1961, AWOC and UPWA staged a sit-in at the Danny Danenberg Green Barn Labor Camp near the rail yard in El Centro. Between 250 and 300 union members were involved in what they claimed was an attempt to dramatize the imprisonment of braceros inside the camp, but their show of force was broken up by about one hundred armed deputies who arrested and then photographed dozens of union activists. Top to bottom, left to right: Oroville Belfour; Salvador Ortega; Gregorio Leon; Rafael Placencia; Jose Gutierrez; Carlos Jimenez. Photographer unknown. Author's collection.

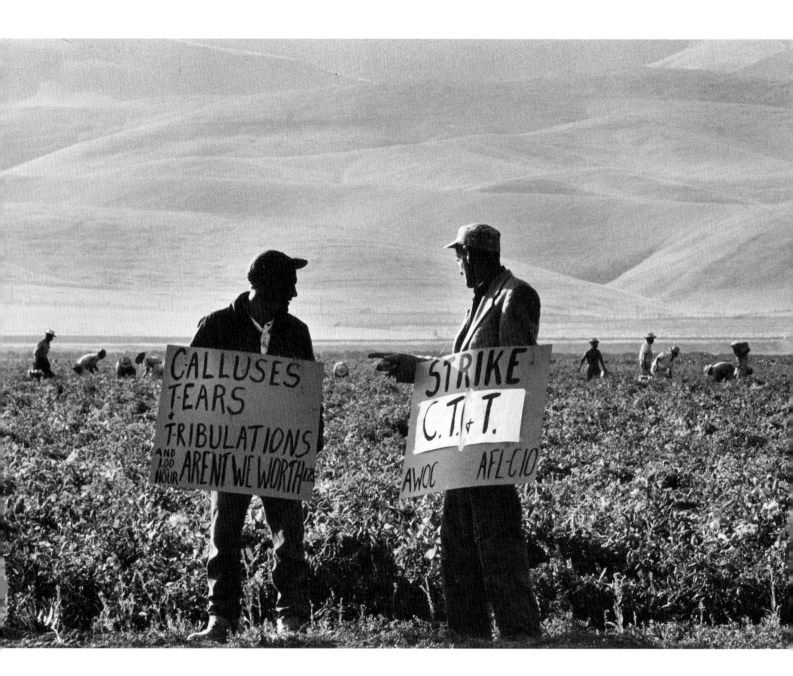

(*above*) Searching for an image encapsulating the difficulty of organizing farmworkers, Joe Munroe found exactly such a picture in September 1961, near Tracy, where field hands employed by the Cochran Company walked out demanding higher wages. Picketing a field while carrying signs stating "Calluses, Tears, Tribulations, and $1.00 an Hour, Aren't We Worth $1.25," the pickets were a pathetic sight, and Munroe underscored their plight by standing far back from the action and using a telephoto lens to record the field hands as small, almost insignificant figures in the rural environment. Courtesy of Joe Munroe.

(*right*) On September 25, 1965, Harvey Richards caused a huge uproar when he photographed strike leader Dolores Huerta standing on top of an old automobile holding a large sign exclaiming, *Huelga* (Strike). Published on the cover of the October 2 issue of *People's World*, and subsequently republished in many other newspapers and magazines, including the *San Francisco Examiner*, the image soon caught the attention of an anonymous informant. On the basis of the informant's request, FBI Director J. Edgar Hoover initiated an investigation of Richards, opened an ongoing file on César Chávez, and spied on the farmworker movement for the next ten years. Courtesy of the Harvey Richards Film Collection/Estuary Press.

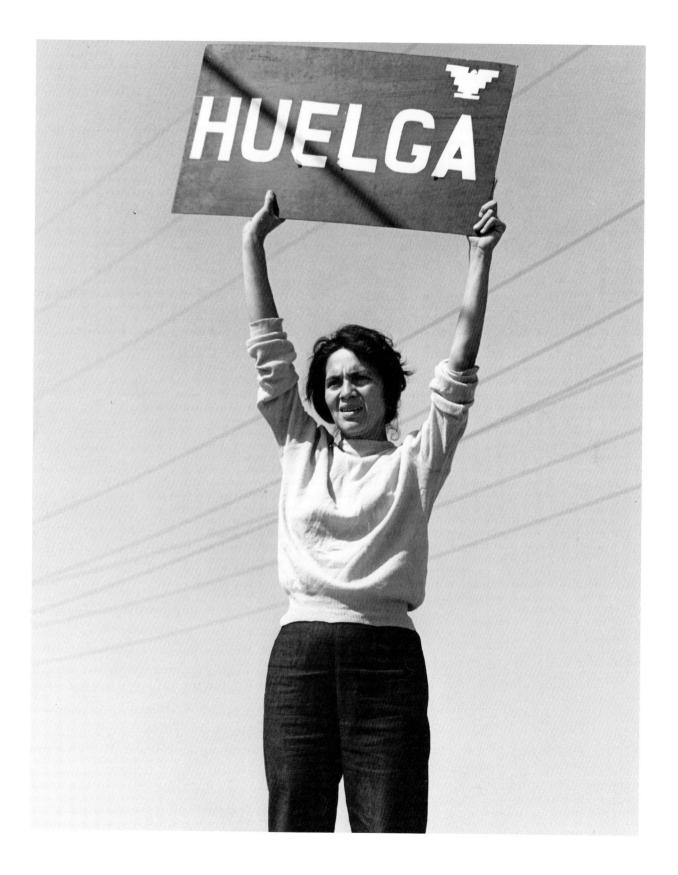

The Delano Grape Strike and Boycott

On September 16, 1965, César Chávez and the newly formed National Farm Workers Association (NFWA) joined with the Agricultural Workers Organizing Committee and launched a strike against the entire table grape industry. Attracted to a David-versus-Goliath confrontation pitting an upstart farmworker movement against the huge and powerful table grape industry, a steady stream of photographers from *Time*, *Life*, the *Saturday Evening Post*, and a variety of other magazines arrived in Delano. But few ever remained for more than a few days.

Most of the extended coverage and most of the good photographs came from a small cadre of talented and fanatically dedicated freelance news photographers. An entirely different breed from commercial photographers and even photojournalists, freelancers threw themselves into the fray. Trading job security for the opportunity to study a subject in depth, many sacrificed personal relationships, left their families, borrowed money, endured financial insecurity, jeopardized their health, took great risks in pursuit of their craft, and in several cases, expended so much energy that their careers suffered—all just to stay in Delano long enough to document the grape strike.

By camping out at Delano and moving in with the union, freelancers overcame the main obstacles to covering an ongoing news event—deadline pressures, lack of access, insufficient funds, and not being present when the action occurred. Proud supporters of Chávez, and distinctly hostile to agribusiness, the freelancers who descended on Delano made no secret of their decision to cross the line demarcating participant and observer. And even if they had not been sympathetic to the union when they first arrived, a few weeks in Delano was usually sufficient to cause even the most reticent freelance photographer to abandon any pretense of neutrality or objectivity. Besides photographing in a way that was highly sympathetic to the union and extremely critical of the table grape industry, freelancers supported the farmworker movement in a number of ways—by donating their photographs at union fund-raising functions and allowing the

NFWA to sell their best photographs as union posters. Most importantly, freelancers converted to the farmworker cause. "We were definitely on the union side," admitted Mike Bry, a San Francisco freelancer who took time off from compiling images for his book, *The California Feeling*, to photograph at Delano for several weeks in the fall of 1965. "All of the photographers I knew helped the union."

Of all the freelance photographers at Delano, by far the most intrepid was Jon Lewis. A Marine Corps veteran with a degree in journalism and social science from California State University, San Jose, Lewis was about to begin graduate school at California State University, San Francisco, when he visited Delano with activist Marshall Ganz and a delegation of the Student Nonviolent Coordinating Committee members in January 1966. He intended to photograph for a week, then return to school. "Once I saw what was happening," he recalled many years later, "I said, 'The hell with it. I'm sorry. I'm staying.' I stayed for nine months and shot 256 rolls of film. Like everyone, I received standard striker's wages: five dollars a week and whatever food was available."

A few weeks after arriving in Delano, Lewis headed out to the Sierra Vista Ranch. Located ten miles north of town and owned by DiGiorgio Corporation, Sierra Vista was pruning its vineyards with hundreds of strikebreakers from Texas. Fistfights and shoving matches had erupted on the picket lines, and tense and angry company personnel were not happy to see Lewis. Unable to restrain himself, DiGiorgio security guard Hershal Nuñez charged Lewis and attempted to shove his camera down his throat. Slipping away unhurt, Lewis managed to record the instant just before Nuñez's hand contacted his lens. Recalling the incident many years later, he dismissed it as insignificant. Unlike photographers covering the civil rights movement in Alabama, Lewis never felt that his life was in danger. On the other hand, he never felt safe. "Working with the union and packing a camera, you were a visible target," he explained. "Plus you are a college student, an outside agitator. You had

to be careful. You did not want to be caught in a dark alley with guys like Nuñez."

Like most union volunteers, Lewis could not afford to rent an apartment in town. To continue photographing, he flopped on the floor of what was known as the Gray House, one of two union-owned homes that served as headquarters and barracks. Crowded and noisy, with the telephones ringing constantly, the Gray House was always busy, with people repairing cars, cooking meals, and staying up all night stuffing envelopes. Day and night there was an incessant banter in both English and Spanish, with strangers tossing their bedrolls in the front yard, sleeping on the living room floor, and resting on the lawn and on every couch and unoccupied corner. Desperate for space, Lewis could only find a windowless laundry room near the garage. With $150 of borrowed funds, Lewis bought a used enlarger, built some film-processing sinks, installed a cot, and moved into his combination darkroom/bedroom. A chemical sauna in the summer, the darkroom/bedroom even lacked a fan, forcing Lewis to do most of his film processing and printing during the coolest part of the night, between one and five A.M. Many times he went straight from an all-night printing marathon out into the sunbaked fields to cover picketing.

It was the same for other freelancers. As impoverished as farmworkers, they seldom had more than pocket change. Their daily mantra, recalled by one freelancer, was "obtain more film, stay another day." Focusing not so much on the hard news of confrontation as on the soft news of everyday activities, freelance photographers were present whenever people gathered together in strike planning meetings. Often they combined the mundane work of making posters or stapling and addressing mailings with the occasional photograph (sometimes taken merely to interrupt the boredom). When union members cooked meals for picketers or held strike strategy workshops, freelance photographers were present. Operating on the edges of everyday union activities, they were thus able to capture both the day-to-day grind and the charged spirit of the movement. Because they were not work-

ing on a deadline and had an insider's view, they could document quiet moments as well as hot ones, anticipating events worthy of coverage. As they familiarized themselves with the main players and issues, they selected certain themes, sites, and personalities that they themselves—not their editors or photography supervisors—found most interesting.

With a genuine respect and affection for such photographers, NFWA leaders not only cooperated fully with them, they also assisted them by providing unobstructed access and, most important, by creating a continual stream of "photo opportunities." In the spring of 1966, Chávez stole a page from the civil rights movement, injected new life into what seemed a lost cause, and attracted massive photographic coverage with a mass march of farmworkers from Delano 250 miles north to Sacramento. Hoping to cover *la peregrinación* (the pilgrimage), even more photographers arrived in Delano, although only Lewis and San Francisco–based photographer John Kouns walked every mile, and some older photographers like Harvey Richards drove, stopping along the way to photograph from atop his station wagon roof platform.

Whether they came and went or walked the entire way, photographers covering *la peregrinación* produced images unlike any other seen before in California. Photographers captured marchers out in the countryside carrying statues of the Virgin of Guadalupe, a large cross, and the Mexican, American, and NFWA flags waving in the spring breeze. The images could easily have been mistaken for photographs of civil rights marchers moving through the American South. Photographers also found a rich reservoir of subjects in the barrios and *colonias* where farmworkers stopped each night along the way, in the masses celebrated at each layover, in the police presence everywhere, and in the Brecht-like performances of El Teatro Campesino, the irreverent guerrilla theater group, founded by Luis Valdéz, that entertained farmworkers in city parks and on stages improvised on flatbed trucks. But more than anything else, photographers focused on Chávez, documenting his every grimace, especially his nightly ritual of massaging his aching feet and applying bandages over lanced blisters.

Photographers from all of the major Bay Area newspapers joined the march when it reached Tracy, and marchers rested in the parks, received Holy Communion, or attended mass. A day before the marchers reached Sacramento, George Ballis made what many regard as the single most memorable photograph of *la peregrinación*. When two marchers carrying a ten-foot-high cross fell behind late in the afternoon, Ballis photographed them alone on the road struggling to carry their burden. So obviously did they emulate Christ on his way to the Crucifixion that the image was attacked as sacrilegious. But it also drew attention to the sacrifices that farmworkers were making as they fasted and limped along the road and further confirmed a picture of Chávez and his followers as the Mexican American counterparts to the civil rights marchers in the South.

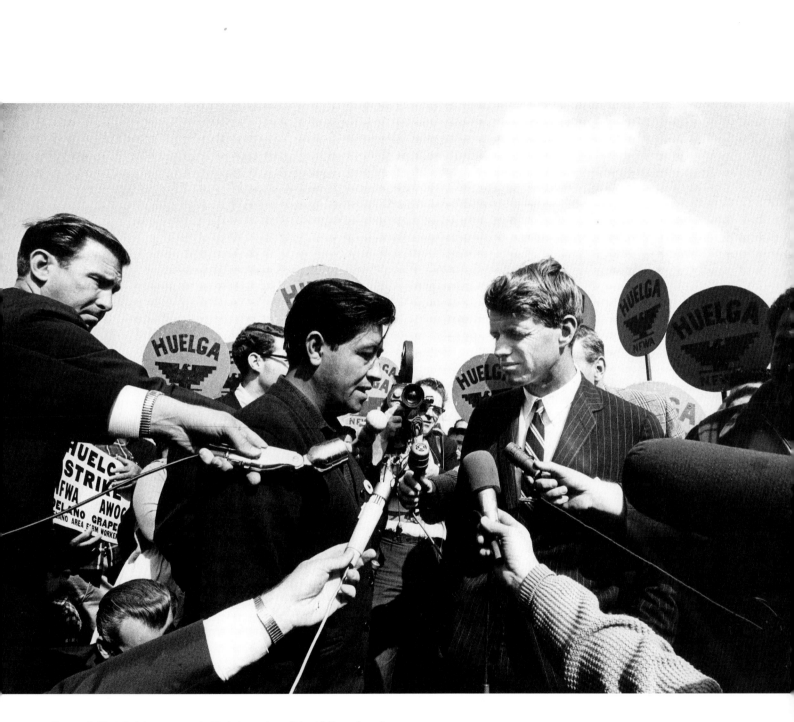

Surrounded by television crews and still photographers, Robert F. Kennedy and César Chávez meet in Delano in March of 1966. Photograph by George Ballis. Courtesy of George Ballis.

(*above*) Without the kind of government sponsorship that Dorothea Lange had exploited, Max Yavno was forced to set aside his early documentary efforts among farmworkers and concentrate on commercial photography. But over the next two decades, while photographing numerous assignments on the California wine industry, he continued to produce surprisingly beautiful, quasi-documentary images of farmworkers. Typical of this approach was an image he shot for *The Story of Wine in California* (1962). Focusing on a grape picker's hands and the hooked knife he used to cut grapes, Yavno created a tightly cropped and beautifully composed image that amalgamated aesthetics with the documentary tradition in what was essentially an abstract photograph in the style of Aaron Siskind. Photograph circa 1960. Courtesy of the Max Yavno Collection, Center for Creative Photography, University of Arizona, Tucson.

(*left*) For Visalia photographer Richard Hammond, the sight of winter fog lifting from recently pruned grapevines near Modesto in 1978 calls forth memories of the Delano grape strike. "A lot of people can still hardly look each other in the face after so much suspicion and violence," he wrote in a caption to this photograph. "It drew sharp lines. And it carries a bitterness that doesn't pass." From the series *The San Joaquin Valley*, 1979. Courtesy of Richard Hammond.

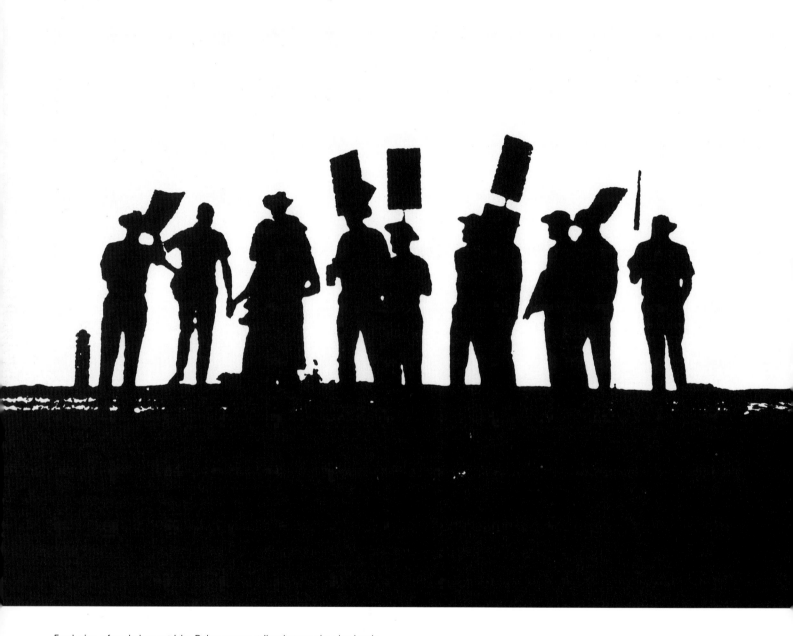

Employing a few darkroom tricks, Delano grape strike photographer Jon Lewis
made this high-contrast print of farmworkers picketing a vineyard at sunrise in
the spring of 1966. Courtesy of Jon Lewis.

At 4:30 A.M. on March 20, 1965, George Ballis recorded this scene from the predawn shape-up in downtown Stockton, where Agricultural Workers Organizing Committee (AWOC) concentrated most of its early organizing activity. Copyright George Ballis 1976. Courtesy of Take Stock.

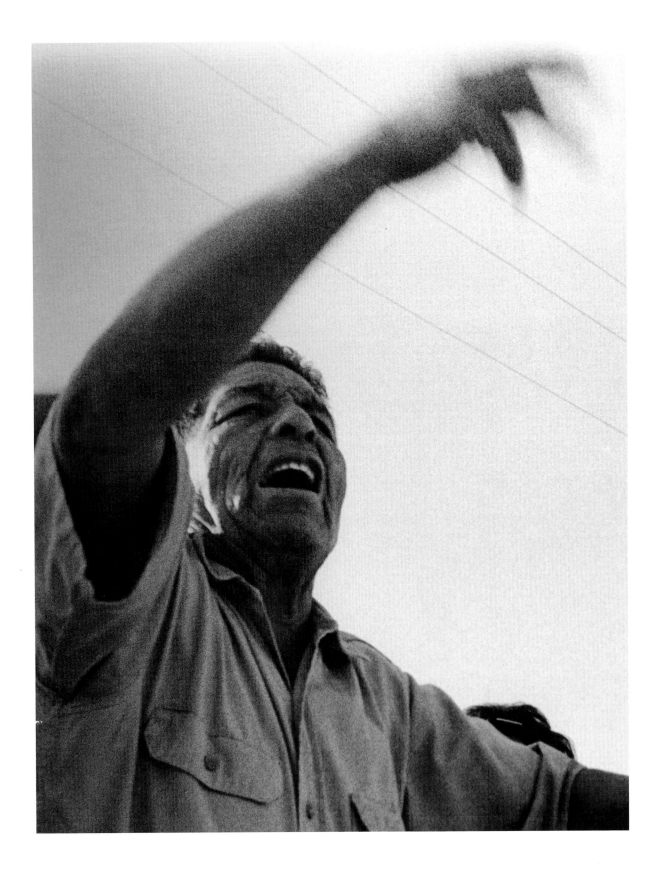

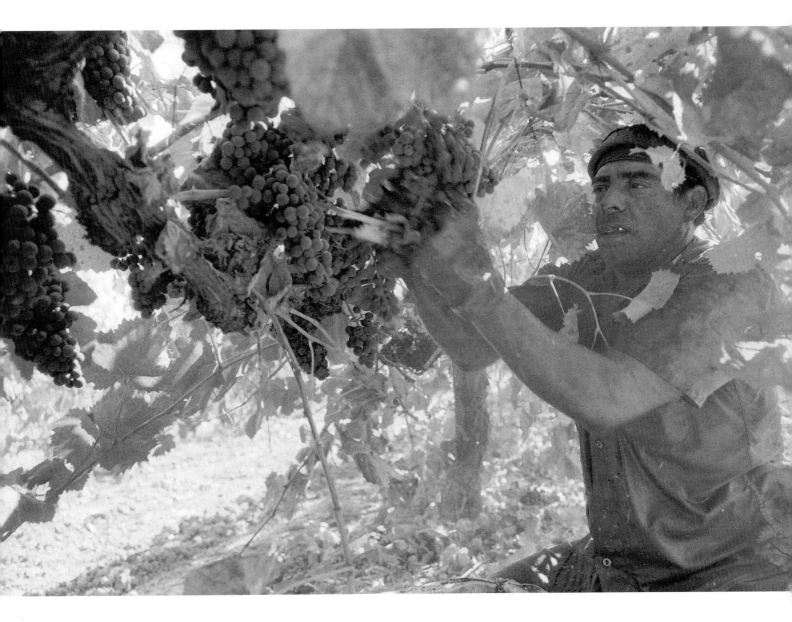

(*above*) Rejecting standard commercial photographs of vineyards seen from an elevated perspective at sunrise or sunset, Magnum photographer Paul Fusco crawled under the vine canopy to discover a grape harvester's perspective as the man sweated in the midday heat. From the series *La Causa*, 1968. Courtesy of Magnum Photos.

(*left*) Early in the Delano grape strike, Jon Lewis shot a sequence capturing this picketer's efforts to entice strikebreakers out of the vineyards. Arranging them in sequence, he produced an almost cinematic appreciation of a common picket line gesture. This is one image from a series of four. Photograph 1966. Courtesy of Jon Lewis.

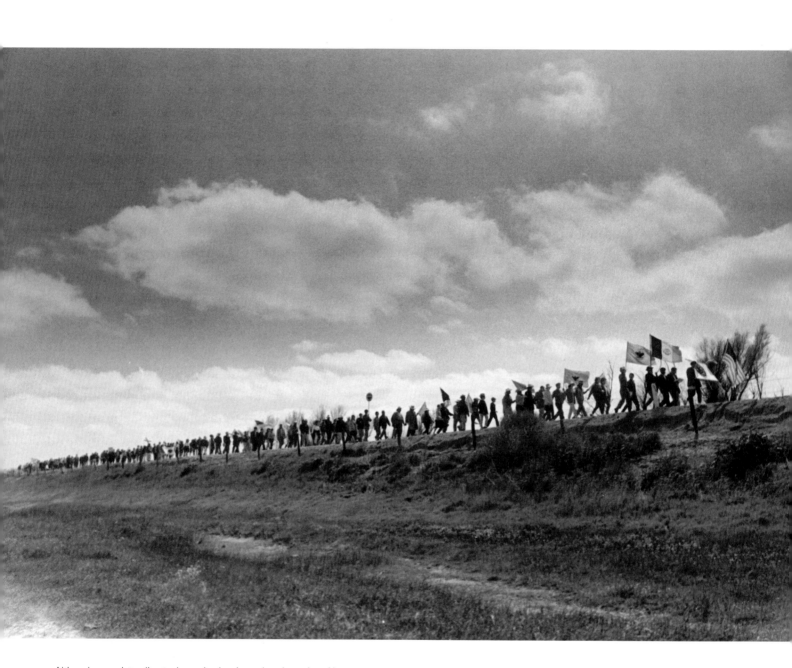

Although never intending to do so, Jon Lewis produced a series of images of *la peregrinación* that were nearly identical to those made by civil rights photographers covering events in Georgia and Alabama several years earlier. This photograph captures marchers moving through the Central Valley north toward Sacramento in March 1966. Courtesy of Jon Lewis.

226

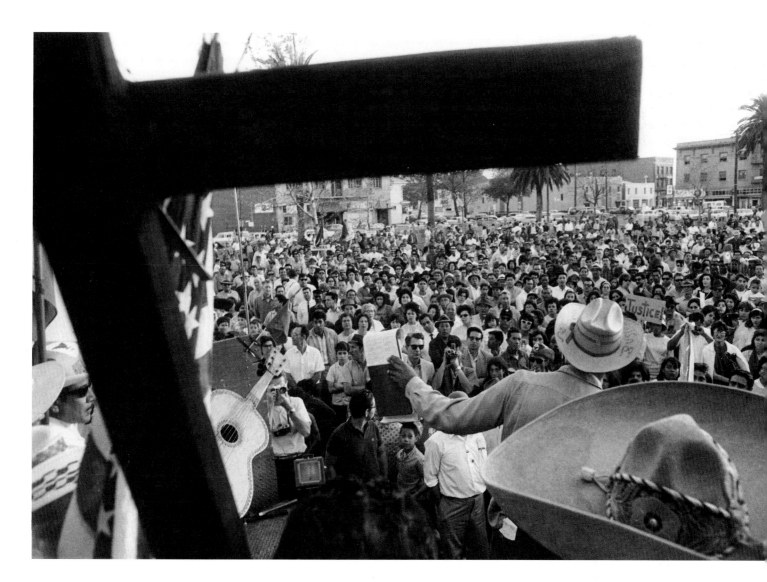

Standing behind the speaker's podium at the conclusion of *la peregrinación* on Easter Sunday, 1966, Jon Lewis framed the scene with the huge cross that farmworkers had carried all the way from Delano. Courtesy of Jon Lewis.

227

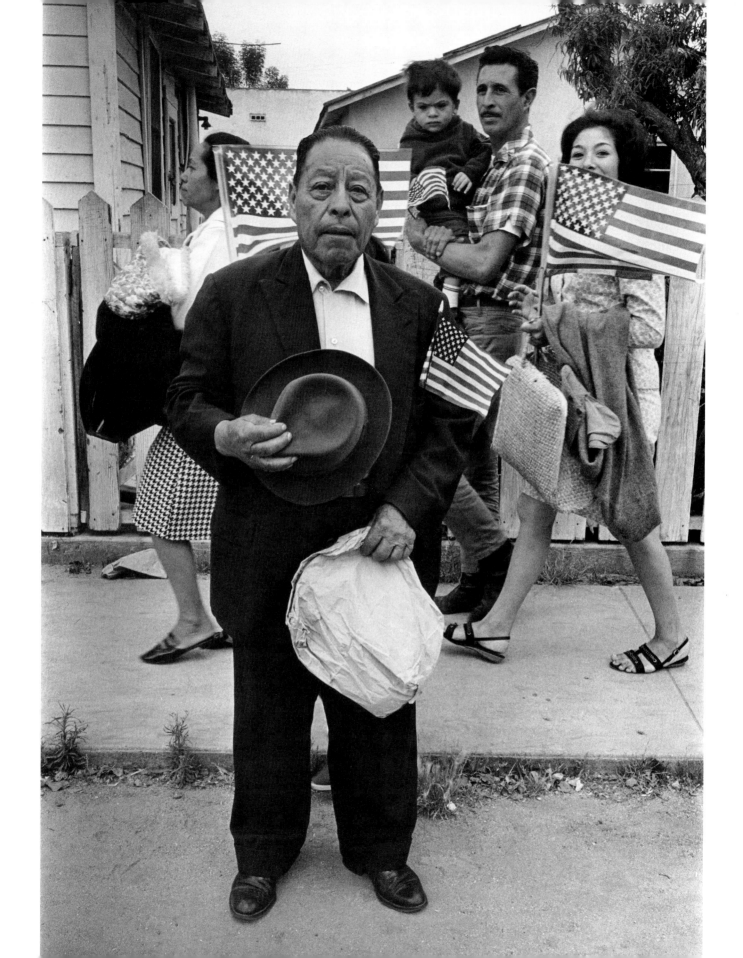

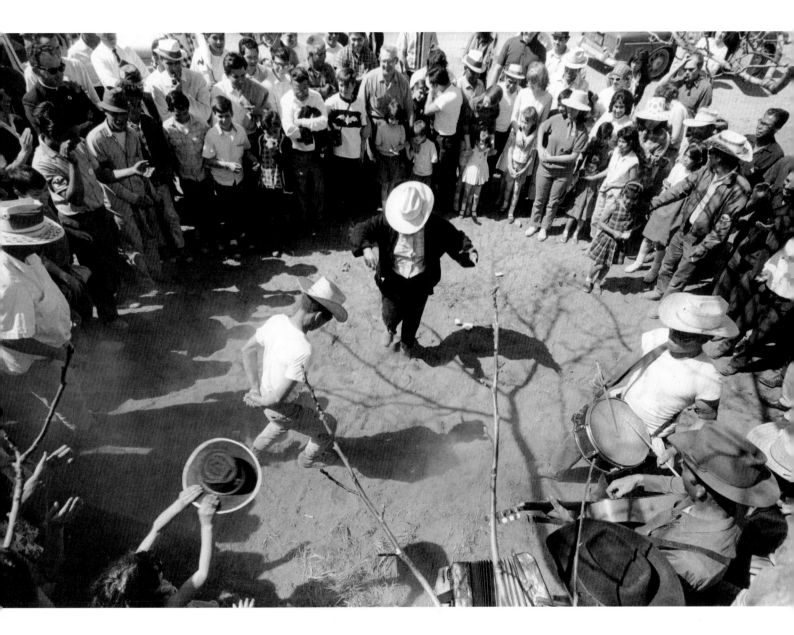

(*above*) At a rest stop midway through *la peregrinación*, George Ballis photographed marchers and supporters joining with members of the local community in song and dance. Photograph March 1966. Copyright 1976 George Ballis. Courtesy of Take Stock.

(*left*) Alert to the people who watched *la peregrinación* as it passed through their communities, George Ballis photographed this elderly Mexican American who has dressed up and brought out an American flag to wave. Photograph March 1966. Copyright 1976 George Ballis. Courtesy of Take Stock.

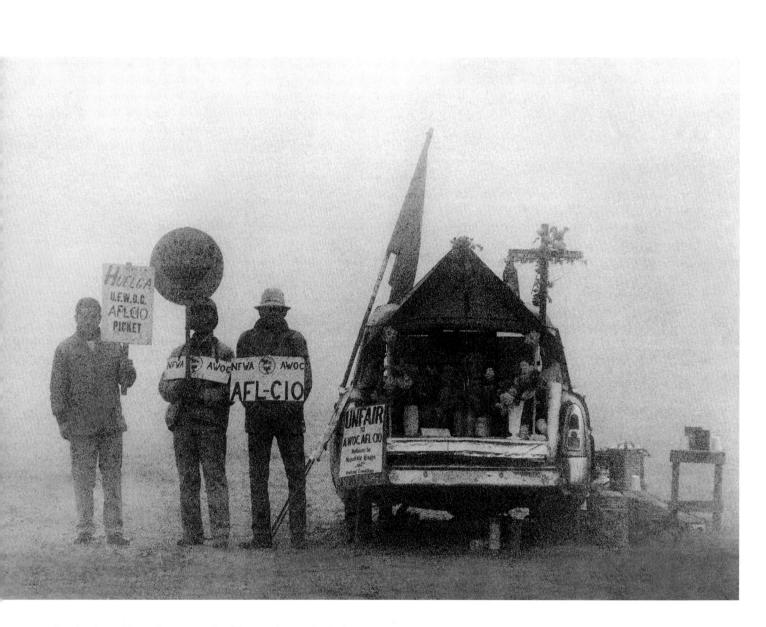

Spotting these picketers late one evening, Magnum photographer Paul
Fusco rolled out of bed early the next morning, returned to the scene, and
photographed the cold and lonely vigil across a highway with a medium
telephoto lens mounted on a tripod. From the series *La Causa*, 1968.
Courtesy of Magnum Photos.

As the Delano grape strike dragged into its second winter, Magnum photographer Paul Fusco recorded the image of pickets reflected in a puddle of water that had accumulated on the edge of a muddy vineyard. From the series *La Causa*, 1968. Courtesy of Magnum Photos.

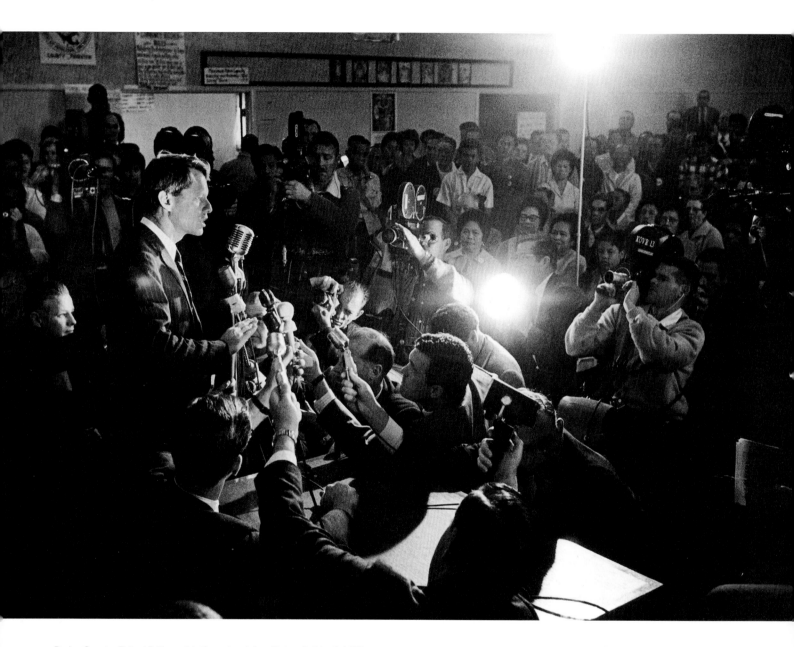

During Senator Robert F. Kennedy's three-day visit to Delano in March 1966, George Ballis recorded him giving this impromptu press conference in an AWOC hall just after questioning various law enforcement authorities about their handling of the strike. Copyright 1976 George Ballis. Courtesy of Take Stock.

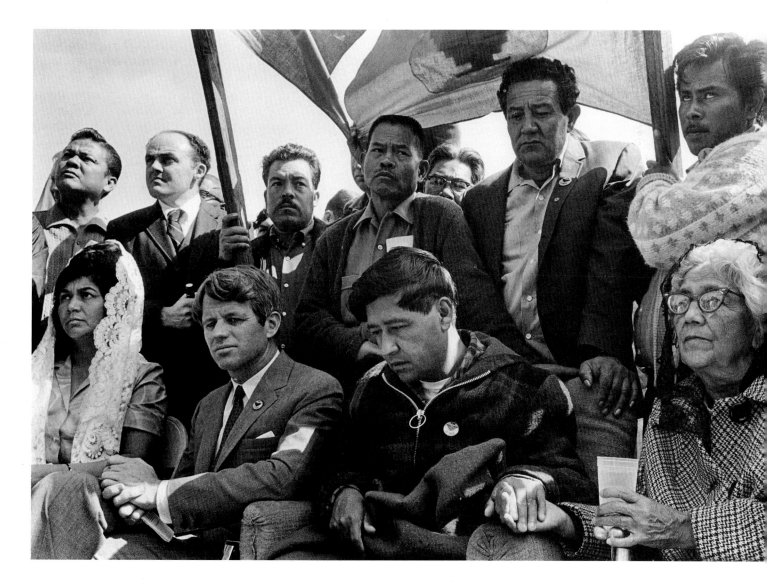

With photographers George Ballis to his left and Jon Lewis to his right, John Kouns wedged into the crowd surrounding Senator Robert F. Kennedy and César Chávez to record the moment on March 11, 1968, when Chávez ended his twenty-six-day fast. Courtesy of John Kouns.

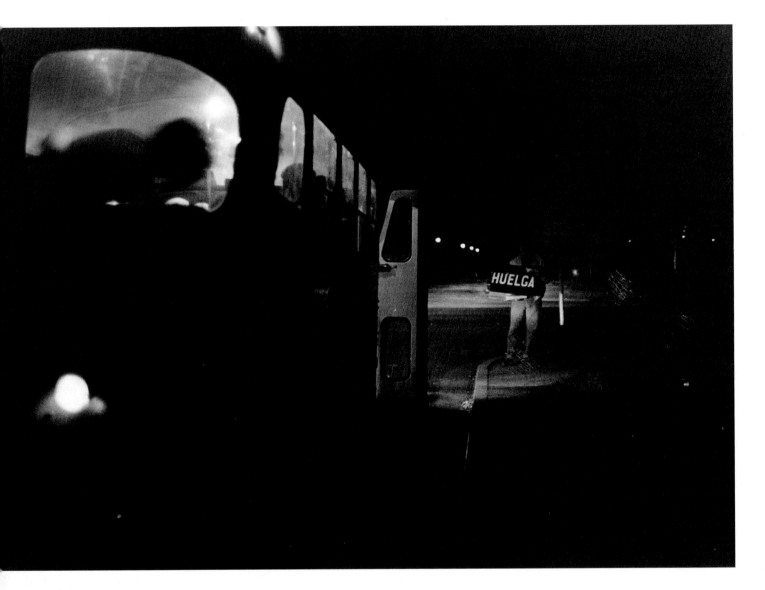

In the fall of 1967, George Ballis recorded picketing activity along Tulare and
F streets in downtown Fresno where labor contractors picked up workers in
the early morning hours. Copyright 1976 George Ballis. Courtesy of Take Stock.

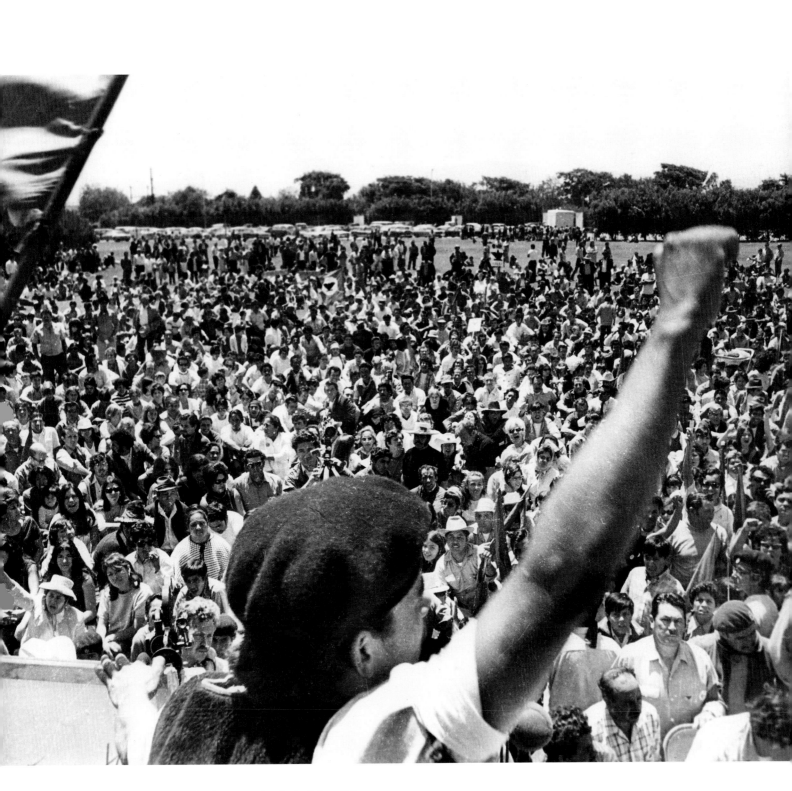

When César Chávez began organizing lettuce workers in the Salinas Valley early in 1970, *Salinas Californian* photographer Clay Peterson stood behind a speaker at a rally attended by thousands of farmworkers and recorded this dramatic gesture. Courtesy of Clay Peterson/the *Salinas Californian*.

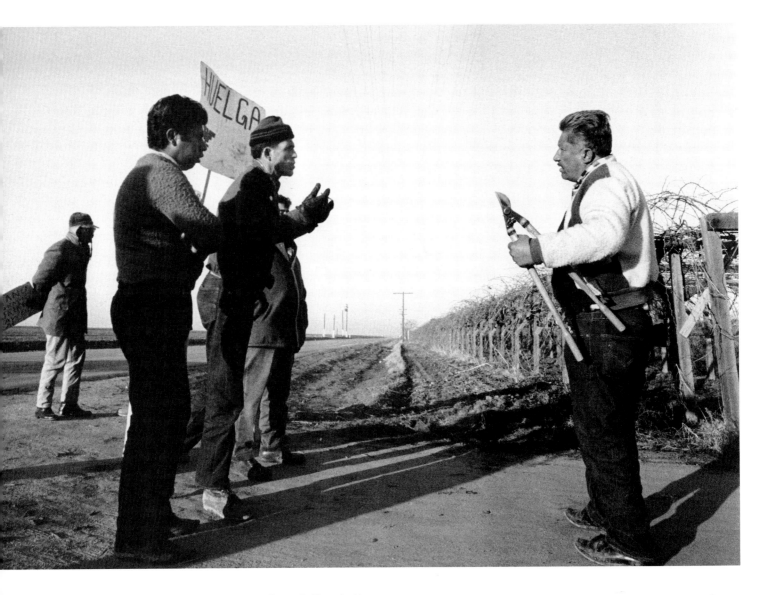

When grapevine pruning began in December 1966, George Ballis made this classic photograph of strikers unsuccessfully trying to persuade pruners to leave the fields near Delano. Copyright 1976 George Ballis. Courtesy of Take Stock.

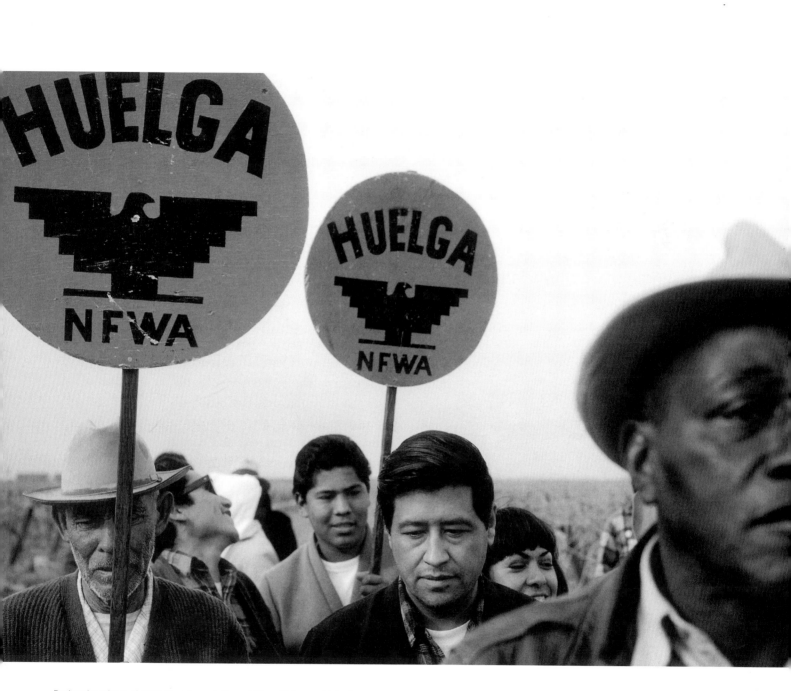

During the winter of 1966, Paul Fusco followed César Chávez out into the vineyards and photographed him parading with pickets. Original photograph in color. Courtesy of Magnum Photos.

The Struggle to Organize Farmworkers

Of all the photographers scrutinizing the Delano grape strike at this time, by far the most famous and influential, if not legendary, was Paul Fusco. A *Look* magazine photographer, Fusco had been shooting a series of portraits of influential Californians in the summer of 1968 when he learned of the grape strike and used some free time to spend three weeks photographing in Delano. Fusco shot most of his *Look* assignment working close-up and using wide-angle lenses. But he made one of his most memorable images with a telephoto lens during a second trip to Delano in the winter of 1968.

Out scouting for pictures late one foggy evening, Fusco encountered a few farmworker pickets maintaining a round-the-clock vigil on the edge of a vineyard. Nearby was an old automobile that César Chávez had once used but was no longer in running condition. The strikers had transformed it into a shrine to the Virgin of Guadalupe, patron saint of farmworkers. Early the next morning, Fusco rolled out of a dingy motel room long before sunrise and drove through the fog out to the shrine. Realizing that the fog would reduce the contrast in his picture, Fusco isolated the scene and compressed the distance, taking advantage of the diffuse light and emphasizing the austere winter conditions. Walking across the two-lane road into a bordering field, he used his 180-millimeter lens to compress the scene. Emphasizing the gray morning light, Fusco created a timeless symbol of quiet and determined farmworkers manning an isolated and silent outpost in the freezing fog.

Searching out such unforgettable imagery, Fusco and countless other photographers dramatically reshaped public opinion toward Chávez and extended the grape strike far beyond the vineyards into the larger public arena, allowing farmworkers to disrupt the American conscience as much as any striking group of coal miners or autoworkers. As important to the farmworker cause as politicians, picket captains, labor leaders, reporters, and the usual array of volunteers and sympathetic bystanders, photographers like Fusco took their place in the strike. With the exception of the civil rights movement, few other struggles were so strongly impacted by pho-

tographers and photography. Just as scenes of police billy clubs and fire hoses unleashed against peaceful civil rights protesters in the American South seemed incredible to many citizens, scenes of mass marches, fasts, arrests, picket lines, impoverished workers, and nonviolent protests had a similar galvanizing effect on public attitudes toward the farmworker struggle in California and throughout the United States. Without such imagery, Chávez could not have succeeded in mounting the boycotts, sustaining the organizing drives, forging the alliances, raising the funds, and building political alliances.

Newspapers and magazines began publishing photographs of farmworkers being arrested, beaten, and attacked, igniting an explosion of protests throughout California and across the nation. Raising the temperature of confrontation to a boiling point, the photographs—with their freeze-frames of white deputies hauling dark-skinned Mexican farmworkers, old women, teenagers, priests, and nuns off to jail—placed the questions of race, class, justice, and nonviolent protest before the public far more effectively than had all of Chávez's speeches. They also brought the farmworker struggle to the attention of people who might not normally have been concerned. The images seemed barbarous, even vicious: the frightened face of a teenage girl, the blood-stained shirt of a middle-aged woman, an older man forced to his knees by three deputies, children in handcuffs, and old women battling armed deputies. As with photographs of aggression during the civil rights struggle in the South, these images depicted the overwhelming violence unleashed against people unable to fight back. Angered by such images, the public supported César Chávez and the farmworker movement much as it had assisted Martin Luther King Jr. and the Congress of Racial Equality.

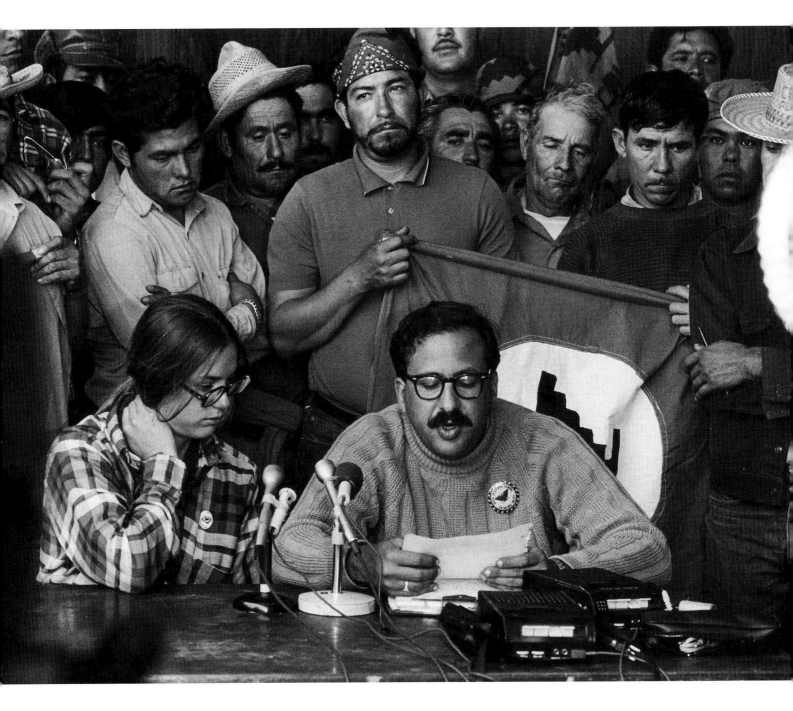

After a quirk of fate kept photographer Morrie Camhi from accompanying United Farm Workers Union (UFW) attorney Jerome Cohen and photographer/ journalist Jacques Levy into the field where they were beaten severely on August 25, 1970, Camhi the following day photographed UFW organizer Marshall Ganz conducting a news conference denouncing the violence. Commentators on this image find in the faces of the farmworkers standing behind Ganz a look seen in Dutch portrait paintings from the seventeenth century, particularly Rembrandt's *The Night Watch*. Copyright 1970, Morrie Camhi. Courtesy of Morrie Camhi.

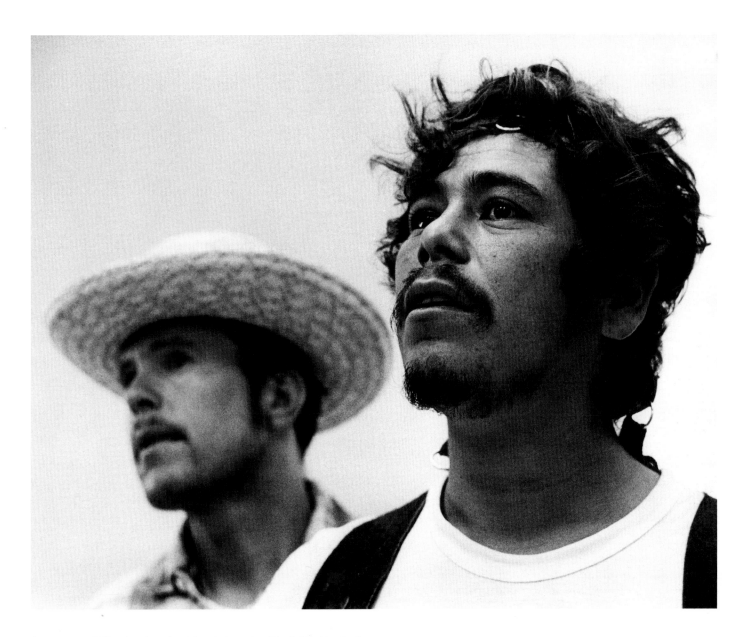

A very successful Los Angeles advertising photographer, Morrie Camhi arrived in the Salinas Valley hoping to avoid the big news events and discover what was in fact normal and ongoing about the farmworker movement. While most photographers saw only conflict and deprivation, Camhi focused on the daily rituals of life—the farmworker family ironing board, immaculate clothes hanging on the clothesline ready for Sunday church services, the father outside washing his car, the children inside studying their lessons, a husband and wife relaxing after a hard day in the fields. Complex and thoughtful, Camhi's photography—like this image of a field hand speaking in opposition to United Farm Workers Union (UFW) policies at a union meeting in the summer of 1970—was too soft and ambiguous for editors, who would not publish it and sent Camhi packing with admonitions to bring back hard news, photographs that could be easily captioned, the more outrageous the better. Copyright 1970, Morrie Camhi. Courtesy of Morrie Camhi.

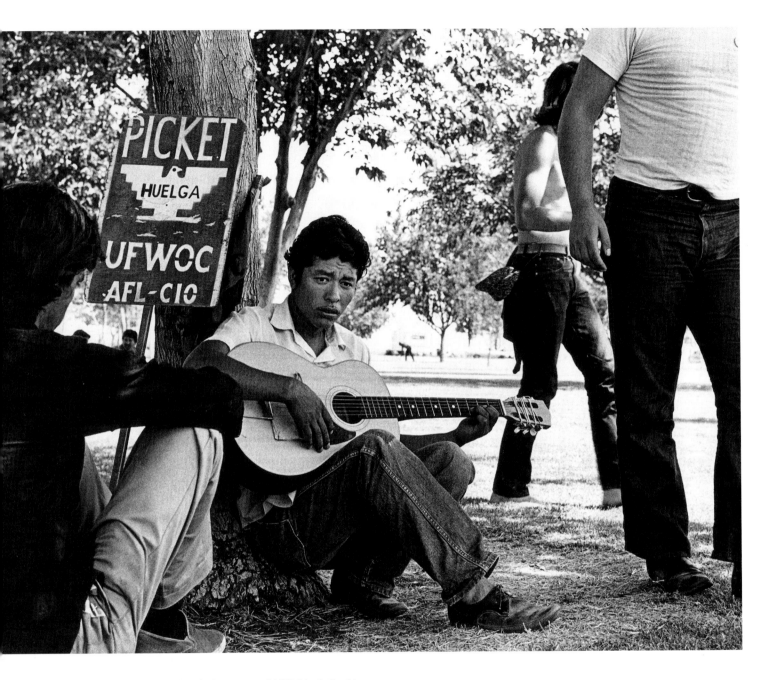

During a lull in picketing activities in the summer of 1970, Morrie Camhi captured this image of farmworkers taking a break in a Salinas park. Copyright 1970, Morrie Camhi. Courtesy of Morrie Camhi.

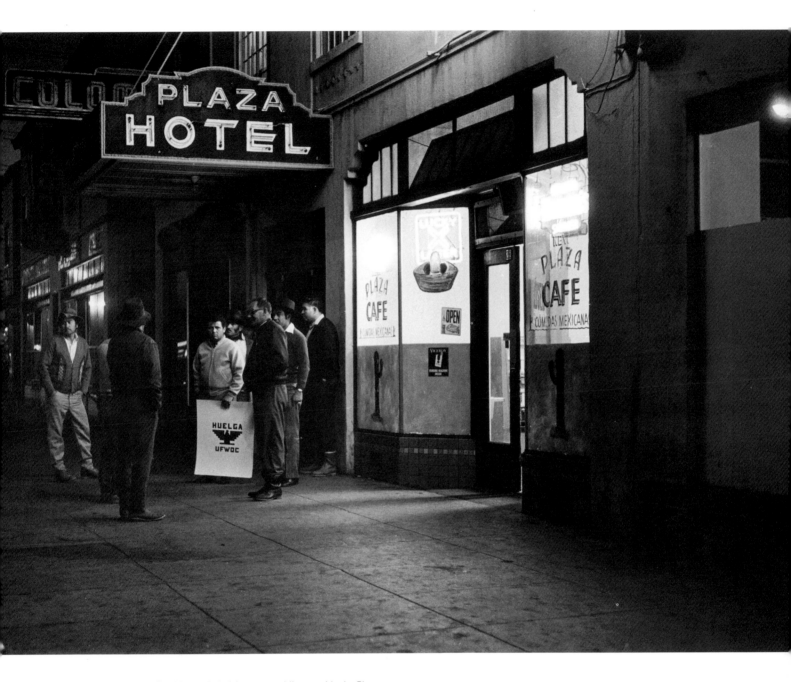

Up before dawn, Morrie Camhi recorded pickets assembling outside the Plaza
Hotel in downtown Salinas in the summer of 1970. Copyright 1970, Morrie
Camhi. Courtesy of Morrie Camhi.

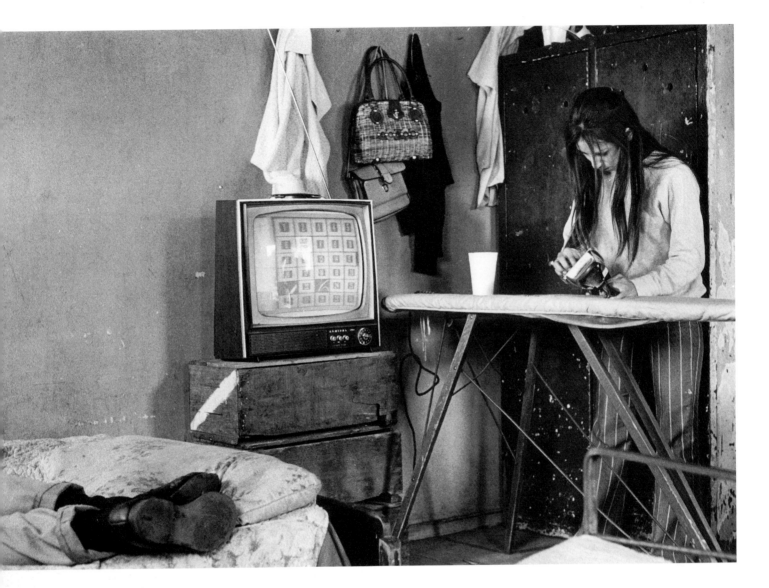

(*above*) With prices for prunes falling during the summer of 1971, farmers south of San Jose let much of the crop rot on the trees. Photographing the situation, Morrie Camhi documented these stranded prune pickers keeping occupied while they waited for work in a farm labor camp near Gilroy. Copyright 1971, Morrie Camhi. Courtesy of Morrie Camhi.

(*right*) As antidote to photographs of exploitation and confrontation, Morrie Camhi tried to focus on those aspects of the farmworker experience that were in fact normal and routine. Here he has captured the routine of a Sunday afternoon as farmworkers visit, play, and do their wash in a labor camp near Gilroy in the summer of 1970. Copyright 1970, Morrie Camhi. Courtesy of Morrie Camhi.

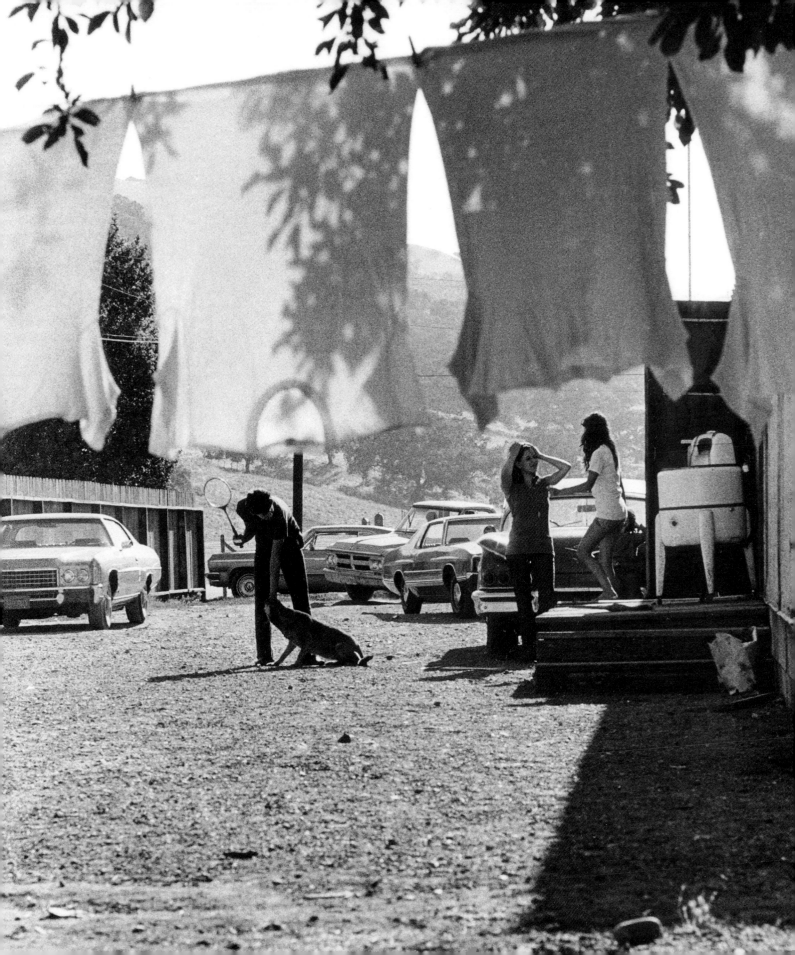

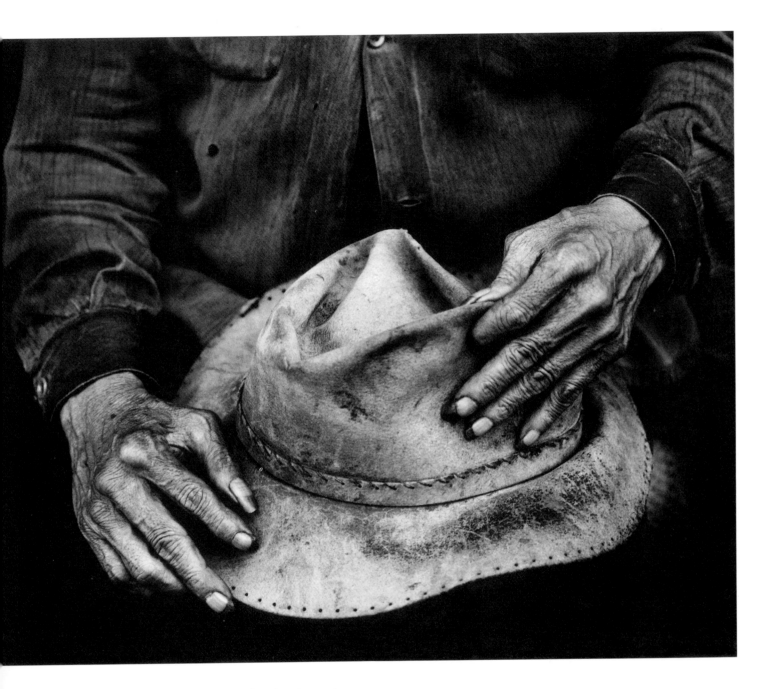

Strangely beautiful in the way it suggests a lifetime of pruning pear trees in the delta, Roger Minick's exquisite 1966 photograph "Cheng's Hands and Hat" bridges the various genres of high art, documentary photography, and photojournalism. To make the photograph, Minick placed a piece of black felt on Cheng's lap and photographed in the open shade. Copyright 1966, Roger Minick. From the series *Delta West*, 1969. Courtesy of Roger Minick.

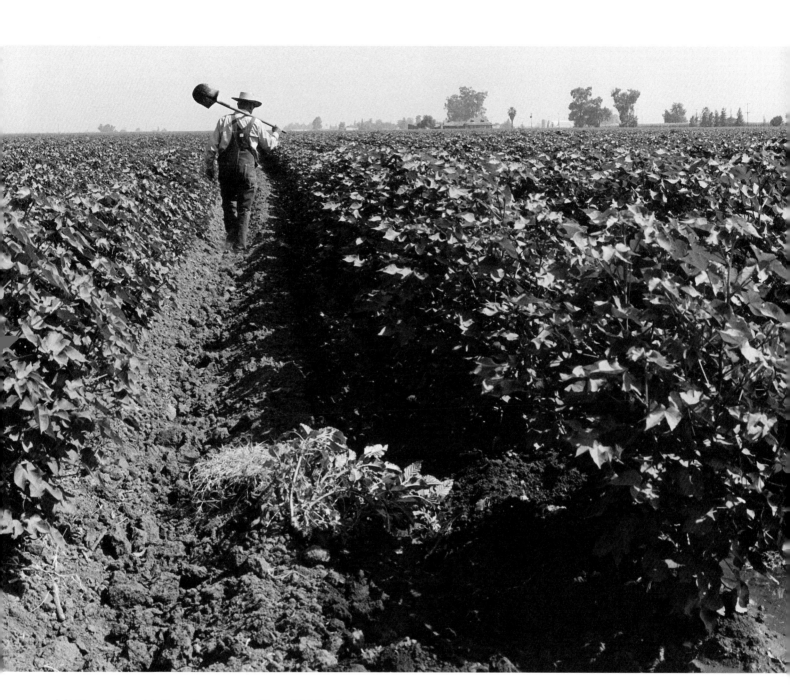

Irrigators usually work by themselves, as opposed to most field hands who are employed in gangs and crews, which is the point of this photograph, taken in the San Joaquin Valley during the spring of 1970. Copyright 1970, Morrie Camhi. Courtesy of Morrie Camhi.

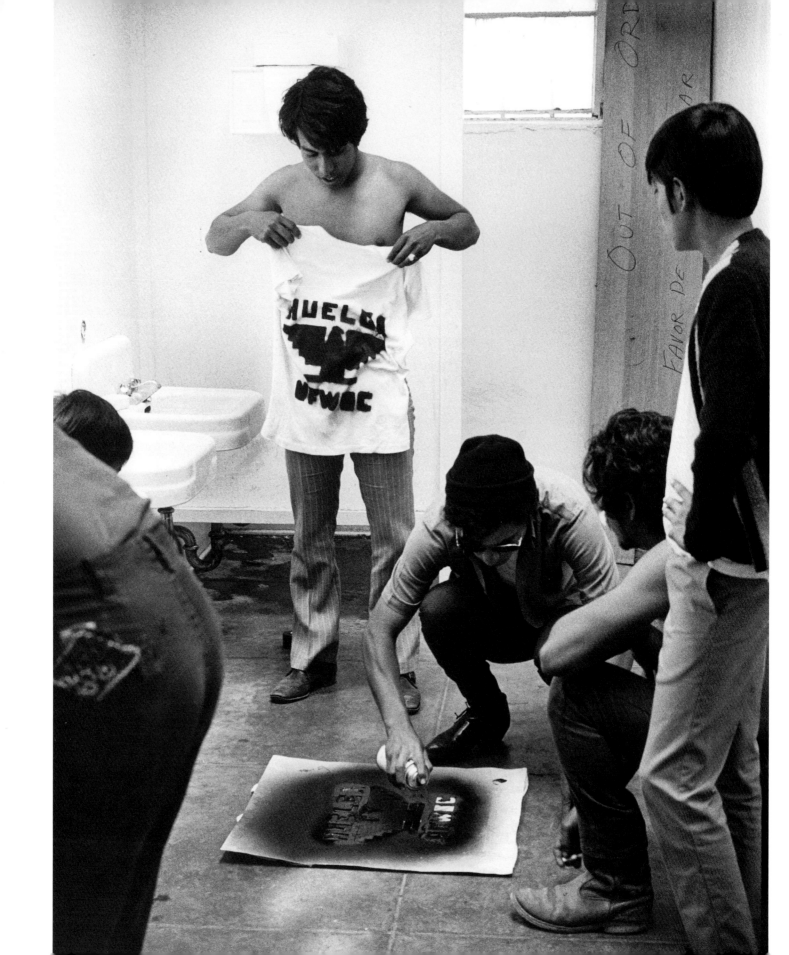

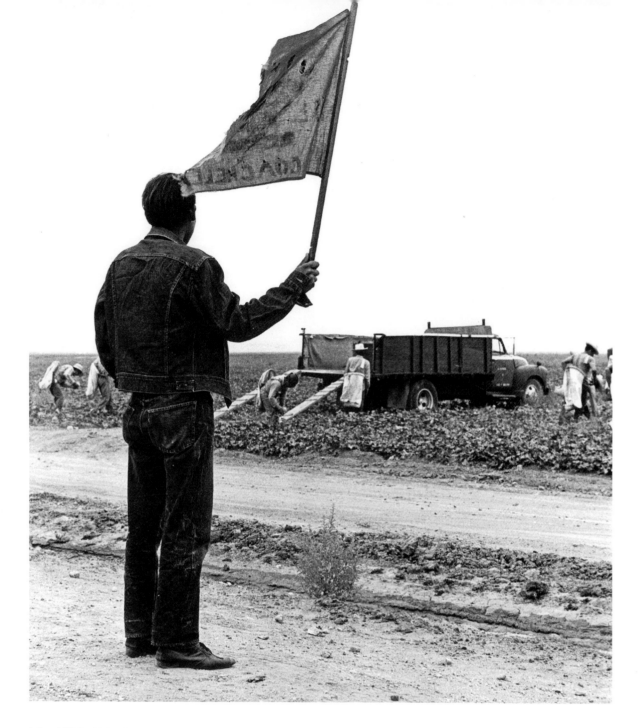

(*above*) While driving the back roads of the San Joaquin Valley in the summer of 1972, Morrie Camhi discovered dozens of solitary pickets and made a series of portraits depicting their determined but lonely vigils. This UFW member was picketing cantaloupe picking operations near Mendota. Copyright 1972, Morrie Camhi. Courtesy of Morrie Camhi.

(*left*) Documenting day-to-day activities at union headquarters in Salinas, Morrie Camhi was drawn to these local high school students. From the union hall bathroom, they created a production line that mass-produced T-shirts with the UFW logo spray-painted on the front. Copyright 1972, Morrie Camhi. Courtesy of Morrie Camhi.

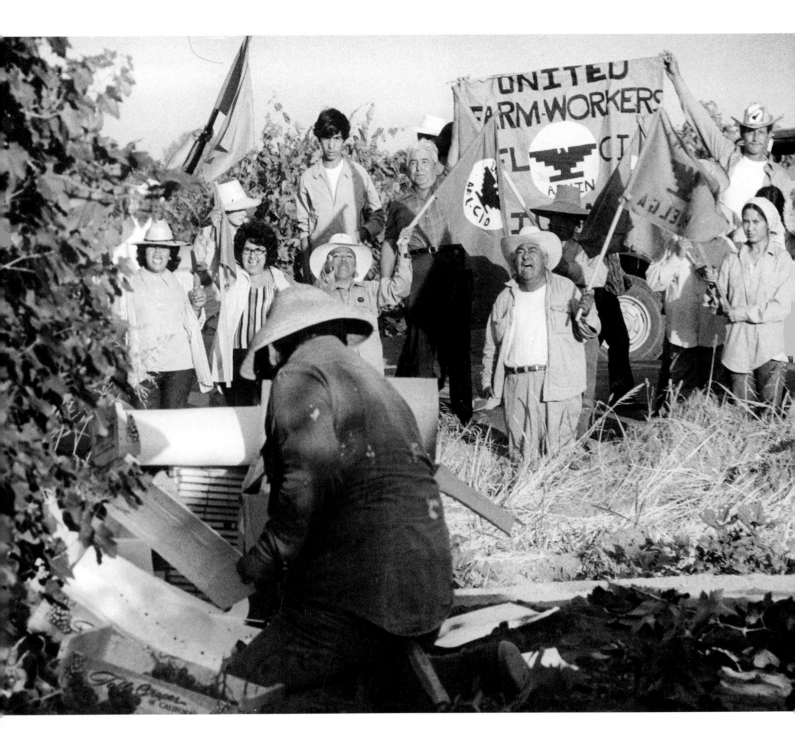

Encountering this crowd of UFW members near Lamont during the July 1973 table grape strike against Giumarra Vineyards, photographer Bob Fitch, a tall, blond ordained minister who had learned photography while covering the civil rights movement in the South, left the picket lines and photographed from the perspective of a strikebreaker. Courtesy of Bob Fitch.

250

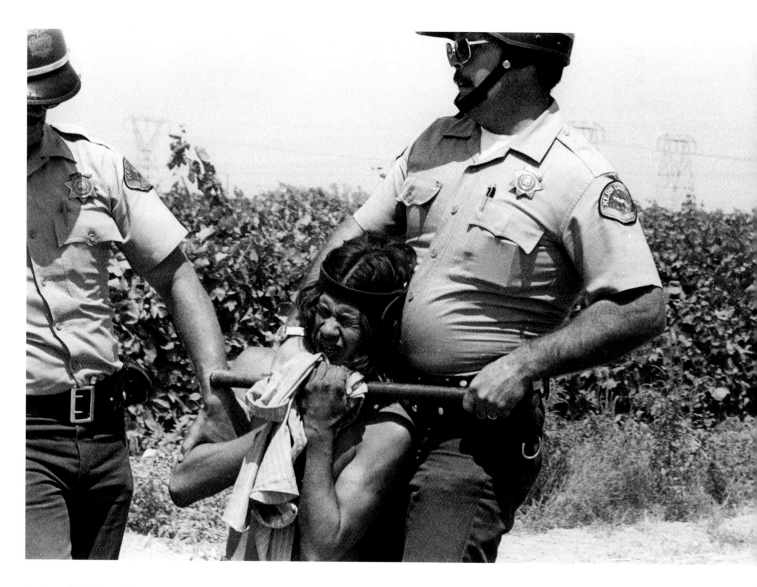

On August 7, 1973, near Lamont in the southern San Joaquin Valley, a UFW photographer (possibly Gayanne Fietinghoff) documented these Kern County deputies using choke holds to subdue and arrest UFW picketers. Courtesy of the Archives of Urban History and Labor Affairs, Wayne State University, Detroit, Michigan.

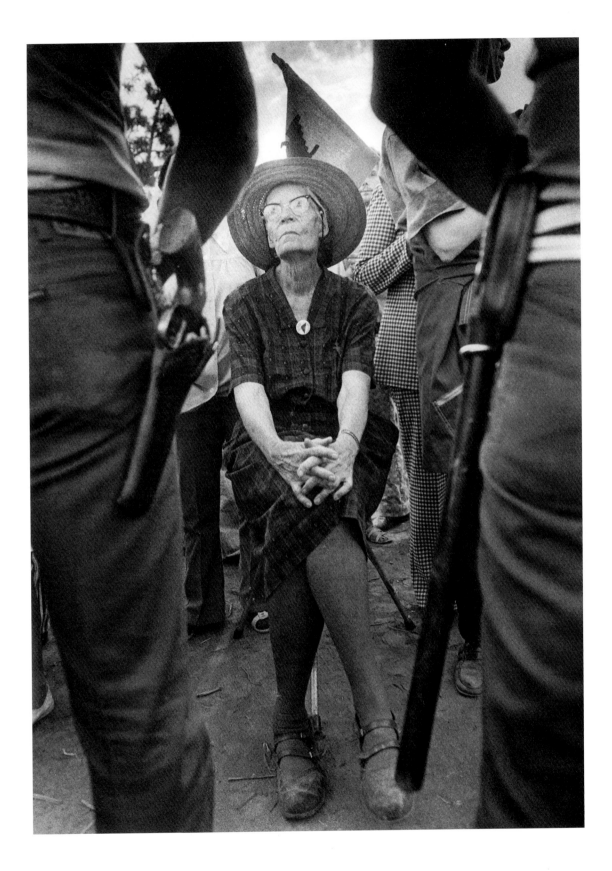

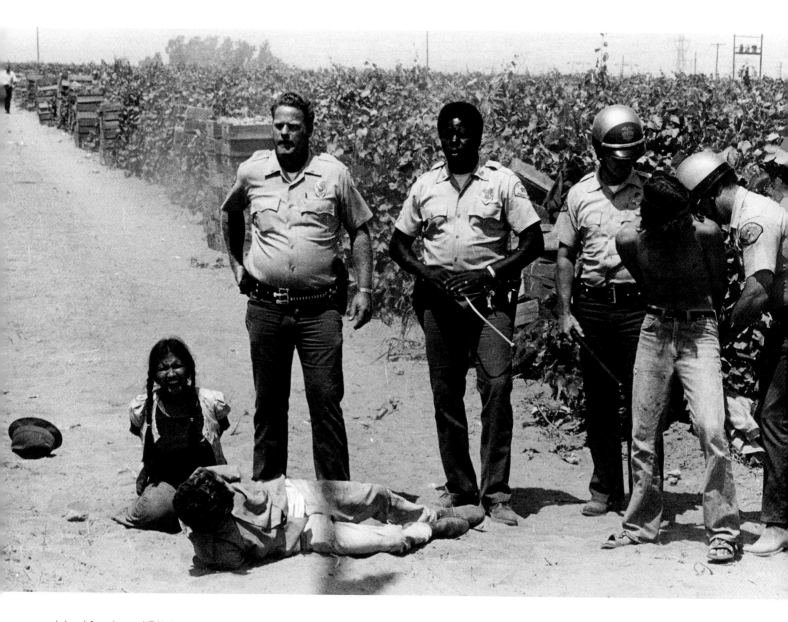

(*above*) An unknown UFW photographer took this photograph of Kern County deputies making the first of hundreds of arrests in the vineyards near Lamont on August 7, 1973. Courtesy of the Archives of Urban and Labor History, Wayne State University, Detroit, Michigan.

(*left*) One of the most well-known images from the 1973 grape strike is this Bob Fitch photograph of Dorothy Day, the seventy-five-year-old leader of the Catholic Worker movement, surrounded by armed deputies, calmly defying a ban on picketing as she waited to be arrested. "I've been in eight jails in my life," she joked as deputies led her away. "I like to see how they are." Courtesy of Bob Fitch.

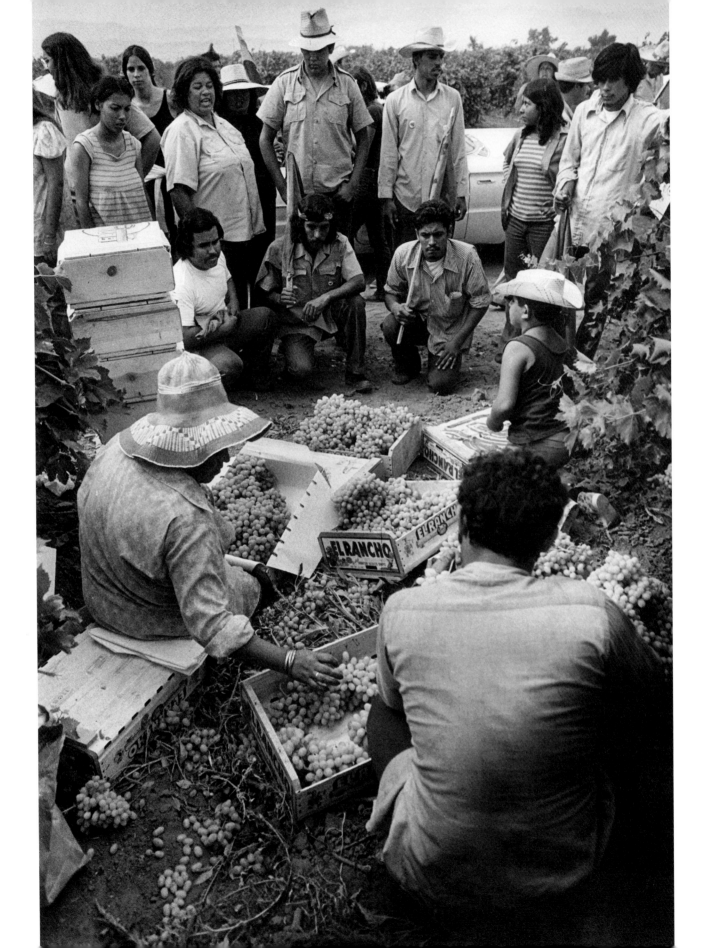

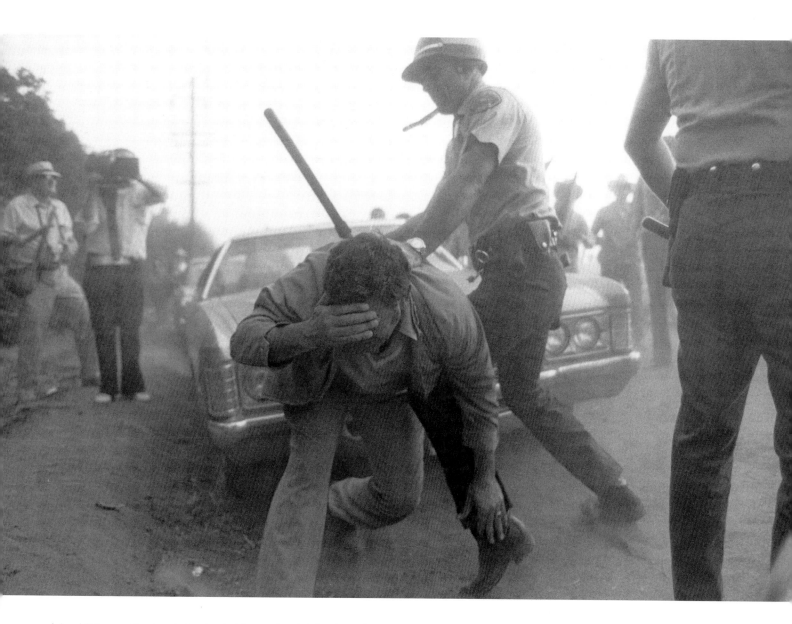

(*above*) With more than twenty-two hundred farmworkers in jail and emotions running high, Fitch on the morning of July 31, 1973, headed to the Giumarra Vineyards, just off Highway 58, near Edison. From his position near a car fender, Fitch shot two rolls of film recording what he regarded as a police riot. There was at least one other still photographer present. He can be seen to the left in this picture of Kern County deputies beating, macing, and throwing to the ground former mayor of Hollister Frank Valenzuela, who had tried to calm an agitated picketer. Frozen with fear and out of position, the photographer missed the shot. Courtesy of Take Stock.

(*left*) Convinced that the farmworker movement was not just the Mexican American counterpart to the civil rights movement, but a historical event in its own right, Bob Fitch produced the most complete record, and certainly the most unforgettable images, of the UFW at a time when it was almost continually under attack. Early in July 1973, he captured this image of UFW strikers in a vineyard near Lamont unsuccessfully pleading with strikebreakers to join their cause. Courtesy of Bob Fitch.

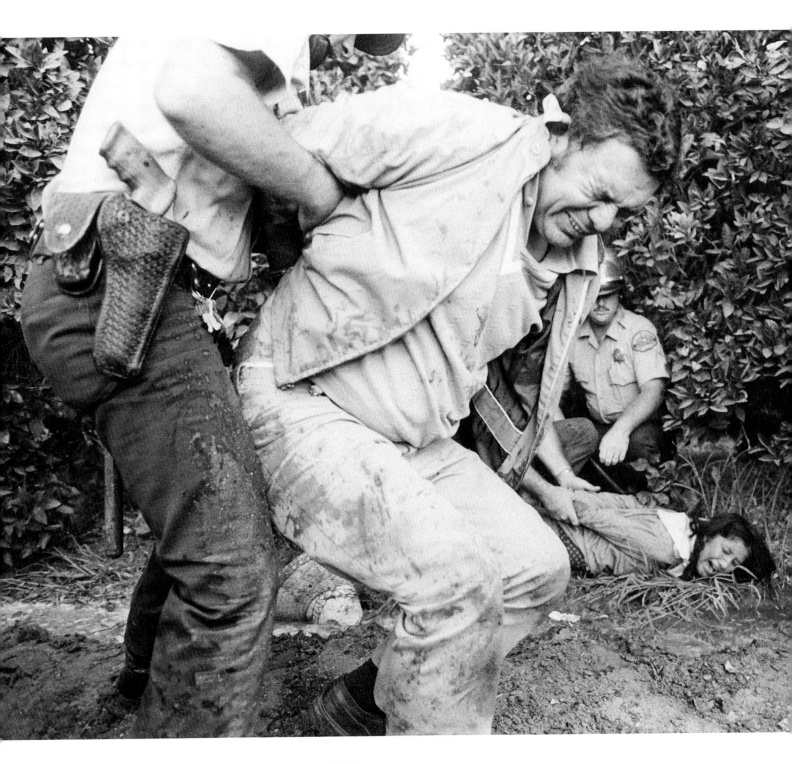

Wheeling on his heels from his protected position, Bob Fitch recorded this
photograph of Frank Valenzuela being handcuffed as sixteen-year-old picketer
Marta Rodríguez is thrown to the ground. Courtesy of Take Stock.

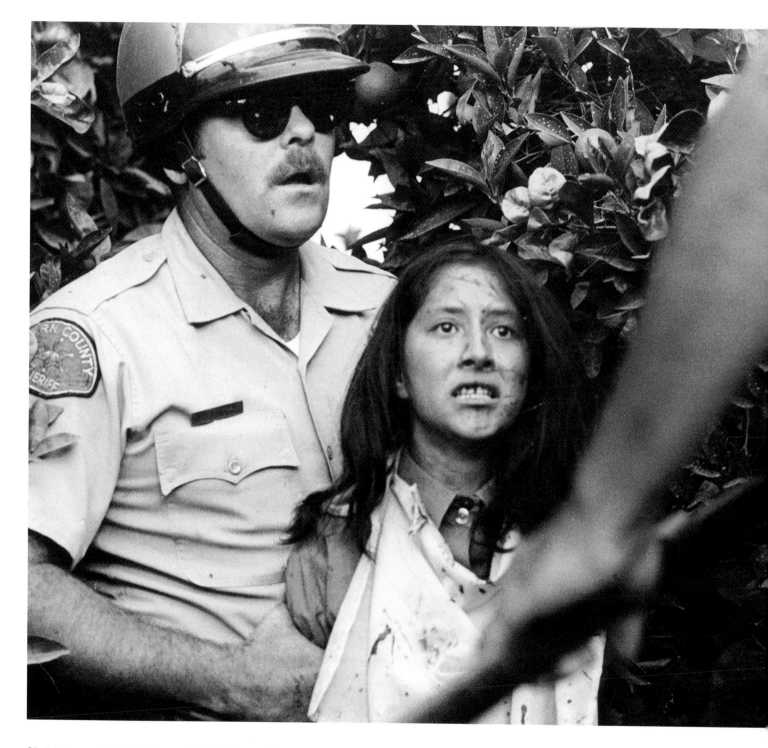

Of all the images that Bob Fitch recorded in the Giumarra Vineyards on July 31, 1973, none is more unforgettable than this picture of UFW member Marta Rodríguez. Splattered with mud and defiant, she grits her teeth in anger while being arrested along with friends and family members. Courtesy of Take Stock.

257

Violence, Art, and Justice

On August 17, 1973, Bob Fitch spent most of the day photographing the funeral of Nagi Daifullah, a twenty-four-year-old Yemeni picket captain, who had died in an altercation with a Kern County deputy sheriff outside a bar in Delano four days earlier. Difficult as that was, Fitch's task became even more challenging when, about 3:20 that afternoon, he learned that another union member, Juan de la Cruz, had been shot and killed while picketing in the Giumarra Vineyards, twenty-seven miles southeast of Bakersfield. Within a few days, Fitch would be covering that funeral as well.

To best photograph Daifullah's services, Fitch embedded himself in the funeral procession, which consisted of about three hundred Arab workers followed by thousands of United Farm Workers Union (UFW) members and supporters, many carrying small black union flags along with the flag of Yemen. Temperatures were around 105 degrees that day and Fitch later remembered how the UFW, Yemeni, and American flags lay limp in the heat. Pallbearers sweated under their heavy burden, and a single Yemeni field hand strained to carry a large portrait of Egyptian leader Gamal Abdel Nasser. Fitch's last image recorded a kind of transnational Catholic/Muslim service, where UFW members repeated the Lord's Prayer, and Daifullah's Yemeni brothers added Muslim prayers and chanted an Arabic dirge: "There is no god but Allah, and Mohammed is his prophet."

Five days later and sixty miles south, Fitch covered the second funeral. One of his last images captured the moment at the graveside when Juan's grieving widow, Maximina, her head covered in black widow's lace, sprinkled earth on her husband's coffin. In the background were César Chávez, folksinger Joan Baez, various family members, and numerous priests.

Displacing more traditional photography, images of death and violence cast a dark pall over the farmworker movement in the 1970s. One of the most horrifying of these images, taken by *Riverside Press* photographer Jeanette Hyduke, recorded the arms and legs of twenty-six dead farmworkers protruding from the windows of a labor bus that landed in a

canal near Blythe early on the morning of January 15, 1974, yet another reminder of the kinds of dangers farmworkers routinely faced. Briefly in February 1974, the UFW succeeded in creating a more positive picture. To publicize its boycott against Gallo Winery and to pressure newly elected Governor Jerry Brown into drafting a law granting farmworkers the right to hold union representation elections, Chávez lead a march from San Francisco to Modesto that rekindled the images and excitement from the march on Sacramento nine years earlier. But the following year, when photographers set out to document the grassroots organizing work associated with the UFW's campaign to win representation elections, the resulting images of community meetings and conversations over backyard fences lacked the drama sought by editors. When the election process began in September 1975, press photographers captured one image after another of foremen blocking and impeding UFW organizers and deputies arresting armed vigilantes intent on preventing organizers from entering fields to speak with workers. As in the past, such images reinforced the impression of UFW nonviolence and victimization, as did subsequent images of increasingly violent election-oriented confrontations, riots, arrests, sit-ins, fistfights. But when a labor strike erupted in the lettuce fields around Calexico and Holtville in January and February 1979, fifteen years of sympathetic coverage ended. Confronted by images of injured sheriffs and UFW members wielding fence posts and throwing tear gas canisters back at law enforcement personnel, the UFW found it difficult to defend its position. Unable to keep up with the action, *Imperial Valley Press* photographer Paul Noden photographed one riot after another. Even though farmworkers bore the brunt of the beatings and arrests, the photographic record, especially images of injured deputies, seemed to turn against the farmworker movement. Privately, Chávez admitted that photographs from the Imperial Valley strikes threatened to ruin the UFW commitment to nonviolence and unravel more than a half-century of sympathetic public support.

To counter the negative images, the UFW launched a mass march that brought ten thousand farmworkers to Salinas on August 7, 1979, and generated the kind of positive images that had once inspired massive support. Continuing unabated, the campaign to polish its tarnished image culminated on August 22, 1988, when hundreds of photographers from all over the world descended on Delano to photograph the end of yet another of Chávez's death-defying fasts. At a ceremony in a huge circus tent, surrounded by thousands of farmworkers, supporters, and prominent Hollywood personalities, Chávez celebrated mass and broke bread with Jesse Jackson, who was then campaigning for the presidency of the United States.

Herded into a bullpen with television crews and film photographers occupying an elevated platform, about seventy still photographers took up positions behind a rope barrier patrolled by Secret Service agents. For a while photographers contented themselves by remaining onstage to take a few pictures behind Jesse Jackson as he addressed the crowd. But by the time Chávez was brought in by way of a back entrance, everyone was hot, soaked in sweat, thirsty, and impatient. When a Secret Service agent walked directly in front of the bullpen, inadvertently blocking the photographers from a perfect shot of Chávez as he was led into the tent, everyone began shouting, "Get out of the way," "Move your ass," and "Move. Move." So loud and angry were the shouts, oaths, and obscenities that the Secret Service agent seemed stunned. Immediately stepping aside, he cleared a line of sight, allowing photographers to take pictures as Chávez made his way to his seat at the front of the tent. Later one agent was overheard exclaiming, "These photographers are animals. I've never experienced anything like this anywhere."

During the course of the service, photographers let loose thousands of strobe shots recording Chávez's every move. Shooting with telephoto lenses, and high-speed film, and shutter speeds of 1/250th of a second and higher, every photographer exposed several rolls of film, documenting Chávez receiving Holy Communion, meeting and greeting friends, being assisted by his son, Richard, and seeming to faint and

reawaken. When Ethel Kennedy reached over to touch Chávez and place her hand behind his head to prevent him from fainting, photographers fired off strings of shots. All around, the whir of motor drives and photographers reloading cameras continued for perhaps thirty minutes. During this time, photographers never took their eyes from their viewfinders except briefly to wipe the sweat away. Everyone was waiting for a gesture they knew would soon come—the moment when Jesse Jackson cradled Chávez and gave him a small cross made out of grapevine twigs. At that moment, a blinding wave of flashes went off. Within the space of one minute, photographers made thousands of images. They all made exactly the same picture, with the main differences resulting from their choice of lenses and position. That moment may be the single most photographed instant in the history of the farmworker movement.

On April 27, 1993, hundreds of photographers and thousands of farmworkers converged on Delano for César Chávez's funeral. During the open-casket vigil on the day before the funeral, dozens of press photographers and freelancers, including myself, waited patiently in the heat to pay their respects. Brought in by the UFW guards, they were each given two or three minutes to take the last pictures of Chávez. One day later, with some forty thousand people packing into Delano, photographers again maneuvered for shots of Jesse Jackson, Edward James Olmos, Luis Valdéz, and other pallbearers while being constantly shooed off by UFW guards. Commandeering an alfalfa loader, a group of photographers climbed to the top, had the operator raise the bundle scoop to a height of thirty feet, and proceeded to take telephoto shots of the huge funeral procession, banners backlit in the low sunlight, as it moved west through Delano. At the funeral service an hour later, photographers ringed the altar. Exploiting his contacts with the UFW, Victor Alemán arrived early and set up a motor-driven, remotely controlled Nikon on a crossbar above the altar inside the tent where the funeral service was to be held. As priests moved up and down the aisles and dignitaries and old friends filed in for the mass, photographers recorded every move, expression, tear, and gesture. At the end of the service, just before the casket was closed, Alemán triggered his camera, capturing photographs of the service as if viewed through the eyes of God. And then, just as suddenly as they had converged on Delano, the photographers went their separate ways.

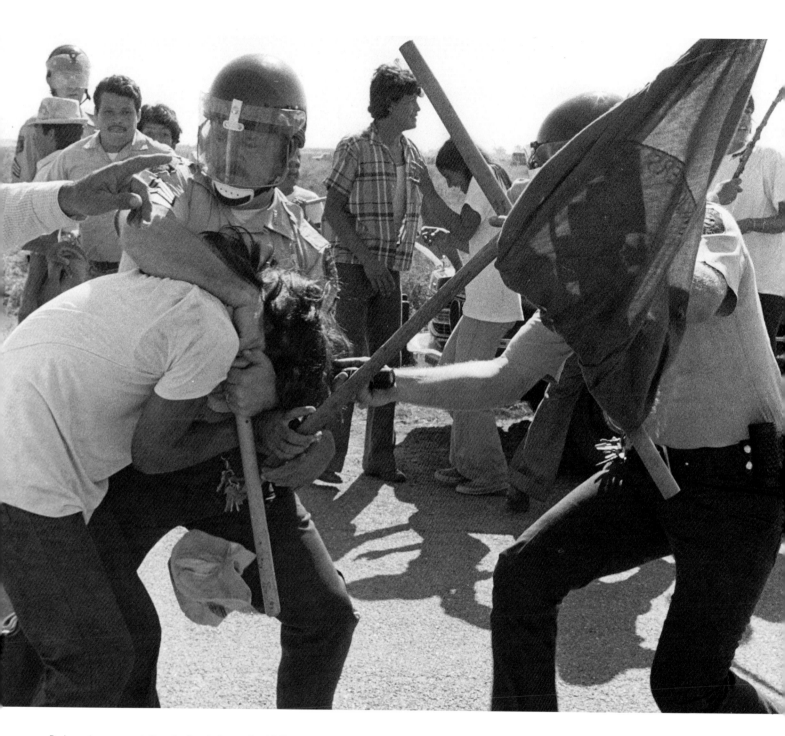

During union representation elections in September 1975, growers and labor contractors refused to allow the UFW into tomato fields north of Tracy. After dozens of union members conducted a sit-down strike and blocked a road, San Joaquin County deputy sheriffs tried to remove them. Stockton Record photographer Dave Evans snapped this picture of the confrontation. Courtesy of Dave Evans.

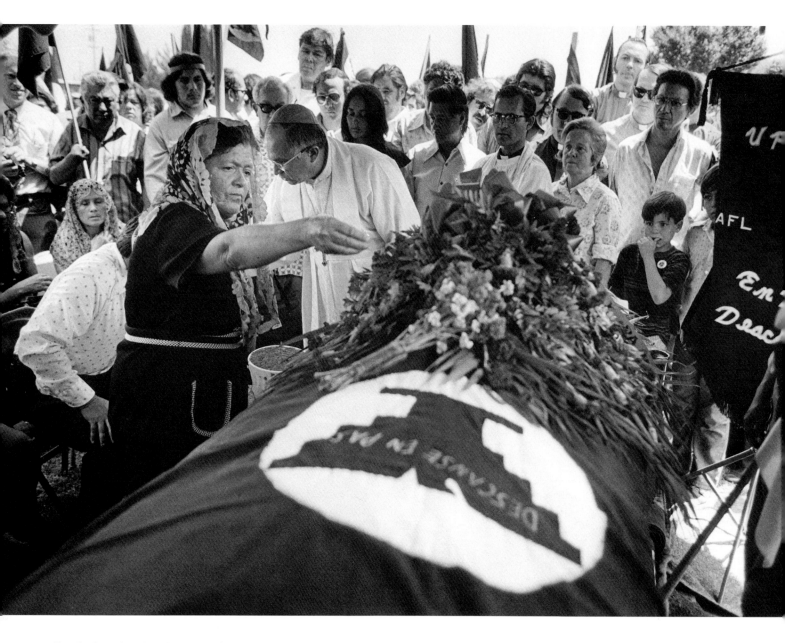

Close by the casket of murdered United Farm Workers Union (UFW) member Juan de la Cruz, Bob Fitch made this photograph on August 21, 1973, at the moment that Maximina de la Cruz sprinkled earth on the casket of her husband. Courtesy of Bob Fitch.

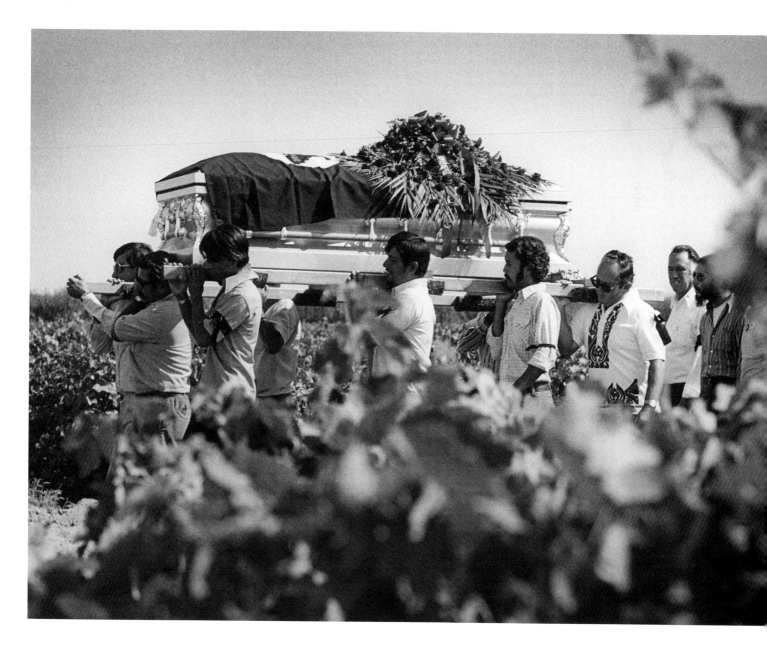

At the beginning of the funeral for Juan de la Cruz, pallbearers carried the casket though the vineyards, and Bob Fitch, seeing the obvious symbolism, framed his images to include the grapevines in the foreground and background. Photography August 21, 1973. Courtesy of the Archives of Urban and Labor History, Wayne State University, Detroit, Michigan.

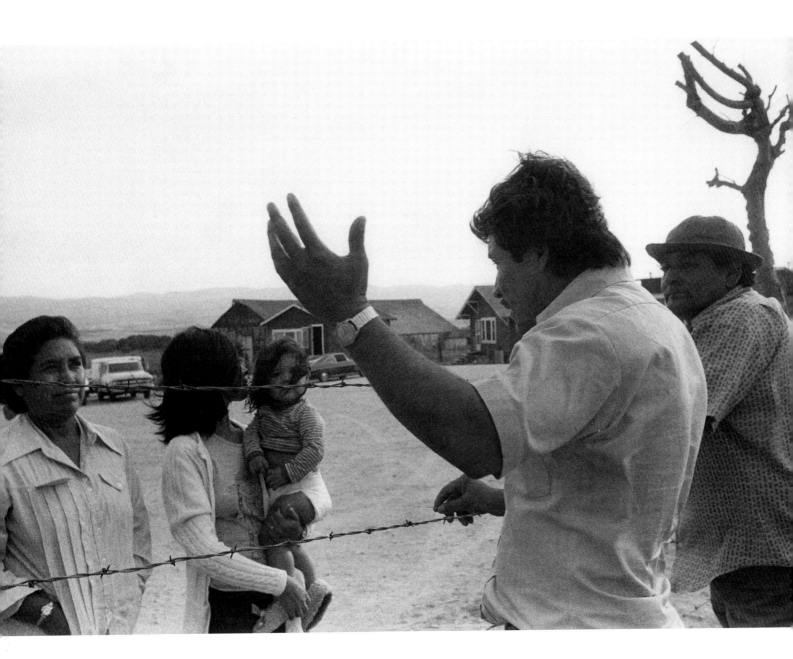

Following UFW organizer Ricardo Villapondo as he spoke to residents of a Salinas Valley labor camp about union representation elections under the new California State Agricultural Labor Relations Act of 1975, photographer Mimi Chambers recorded the hope and optimism leading many to believe that the UFW would soon organize the entire agricultural industry. Photograph summer 1975. Courtesy of Mimi Chambers-Plumb.

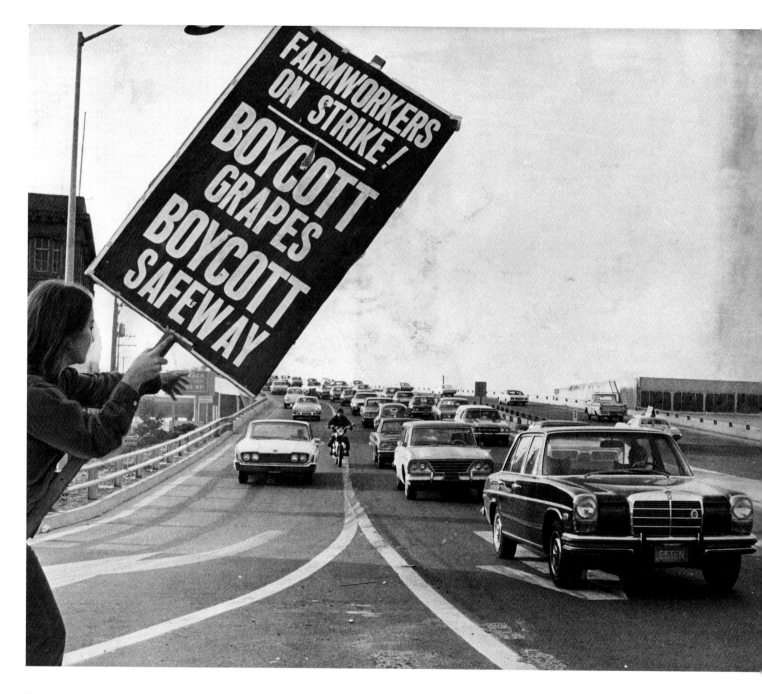

On August 20, 1973, *San Francisco Examiner* photographer Gordon Stone graphically illustrated UFW supporter Kim Crolette acting as a "human billboard" to spread word of the table grape boycott. A touch-up artist has added highlighting to Crolette's jacket and obscured some signs below her outstretched arm. Courtesy of the *San Francisco Examiner*.

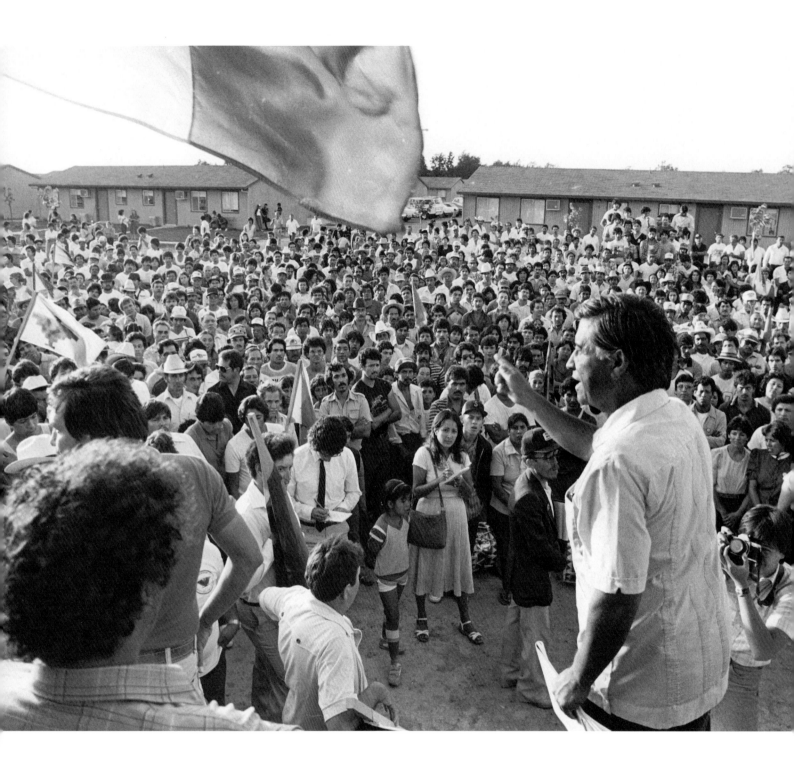

(*above*) As César Chávez toured labor camps in Stockton to drum up support for the campaign against Gallo Winery in March 1974, *Stockton Record* photographer Dave Evans caught up with him along Matthews Road, near French Camp, where he photographed him addressing a large crowd from the back of a pickup truck. Courtesy of Dave Evans.

(*right*) On September 2, 1975, when UFW members entered tomato fields around Tracy to speak with workers and petition for union representation elections, private security guards barred their way and *Stockton Record* photographer Dave Evans caught part of the action. Courtesy of Dave Evans.

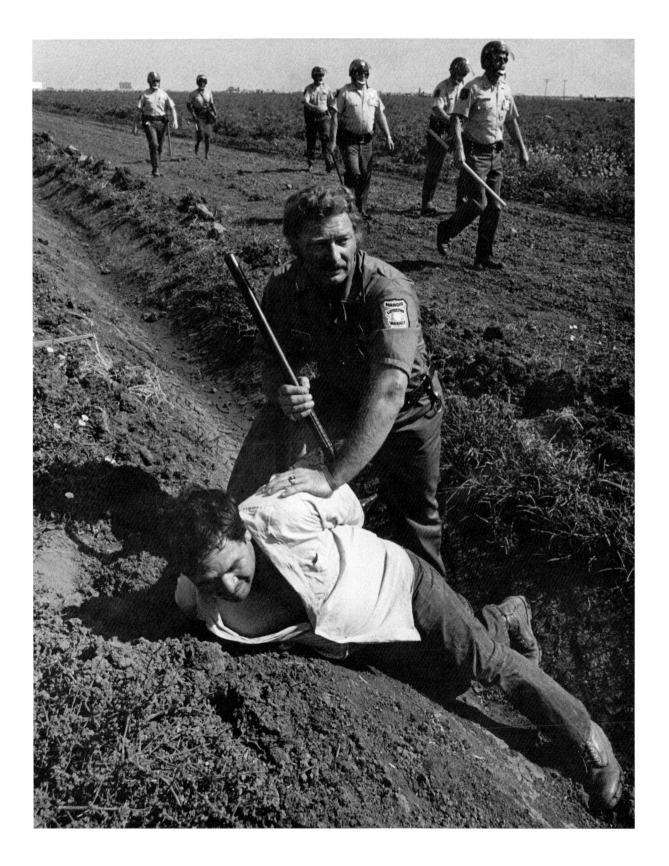

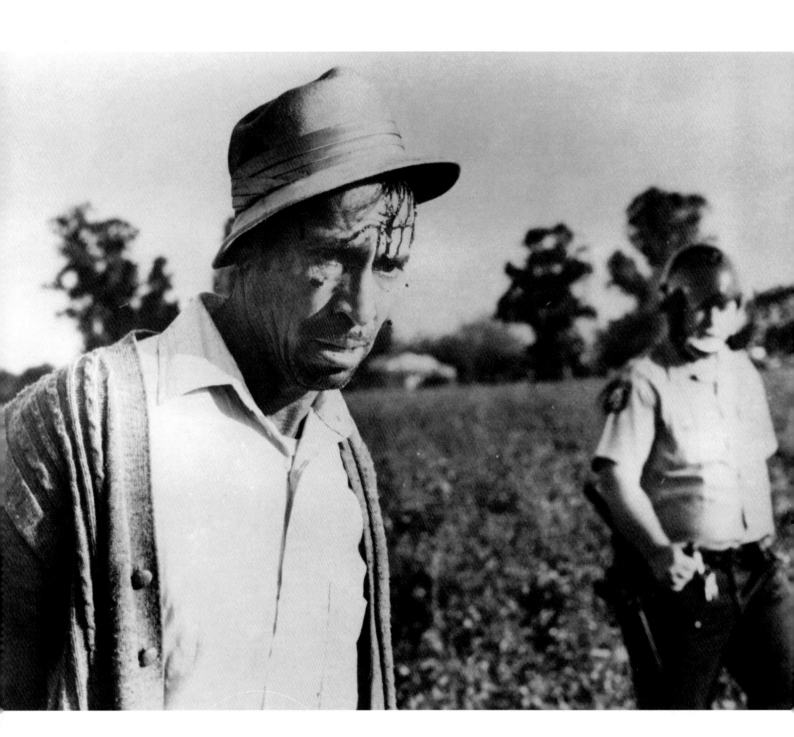

(*above*) On July 28, 1983, *Stockton Record* photographer Rich Turner photographed this bloodied individual in a tomato field near Tracy. Whacked in the head and maced by San Joaquin County deputies, he had just been arrested for threatening UFW organizers. Courtesy of Rich Turner.

(*right*) During confrontations on July 28, 1983, *Stockton Record* photographer Rich Turner captured physical confrontations between UFW members intent on entering a tomato field and the San Joaquin County sheriff's deputies intent on keeping them out. Courtesy of Rich Turner.

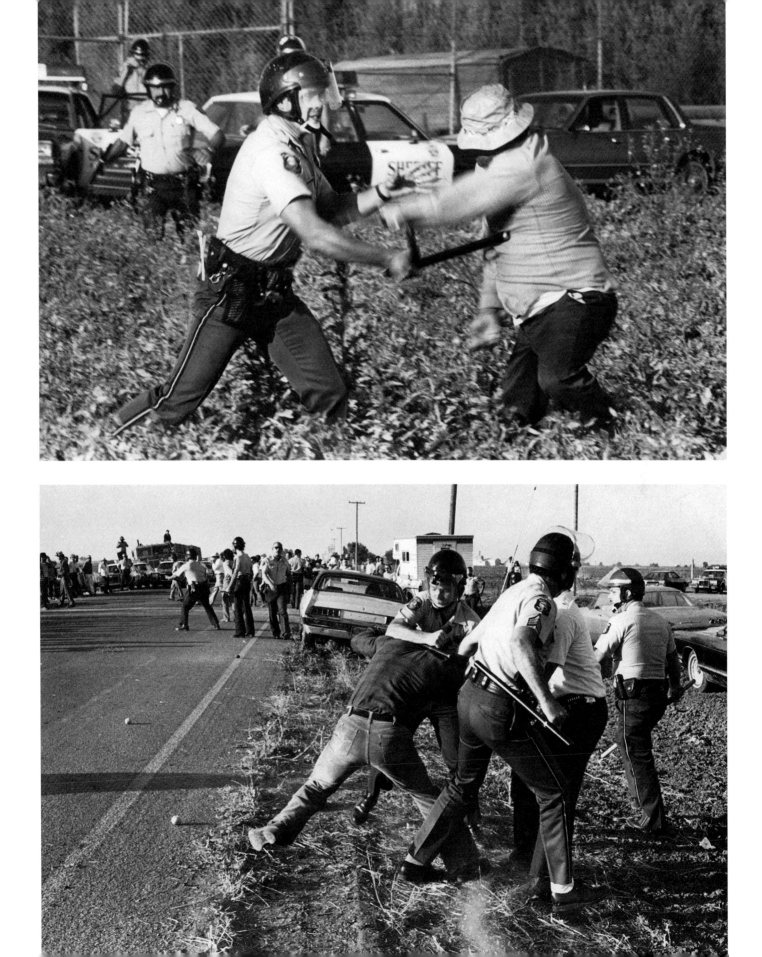

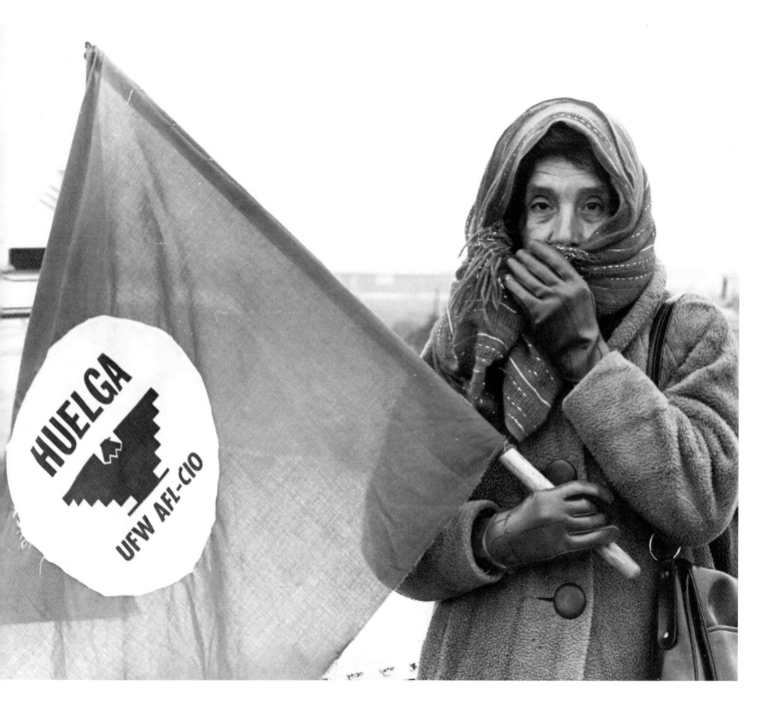

According to a caption in the UFW newspaper *El Malcriado* (The bad boy), photographer Ben Garza recorded this photograph on February 4, 1975, near the San Joaquin Valley farm town of Lamont, where fifteen to twenty union members were picketing nonunion grapevine pruners at work in the Giumarra Vineyards. However, the caption on the back of one print places it in San Luis, Arizona. One of only two photographers to come out of the farmworker ranks, Ben Garza died before the disparity could be resolved. Courtesy of the Archives of Urban and Labor History, Wayne State University, Detroit, Michigan.

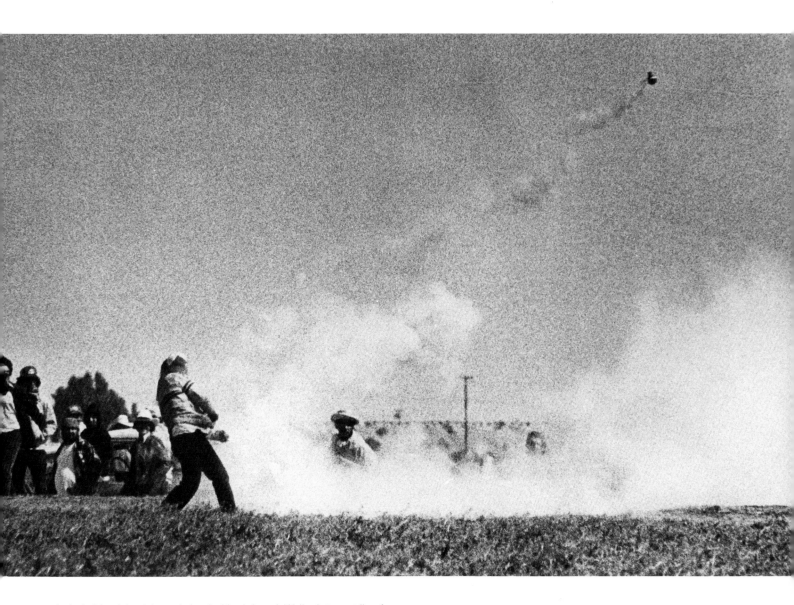

At the height of the violence during the bloody Imperial Valley lettuce strike of February 1979, *Imperial Valley Press* photographer Paul Noden captured this image of a farmworker hurling a canister of tear gas back at Imperial County deputies during a riot that erupted near El Centro on February 20. Later used as evidence in several court cases, such images severely undermined the UFW's reputation as a nonviolent organization and caused César Chávez to undertake the third of his four fasts for nonviolence. Courtesy of Paul Noden.

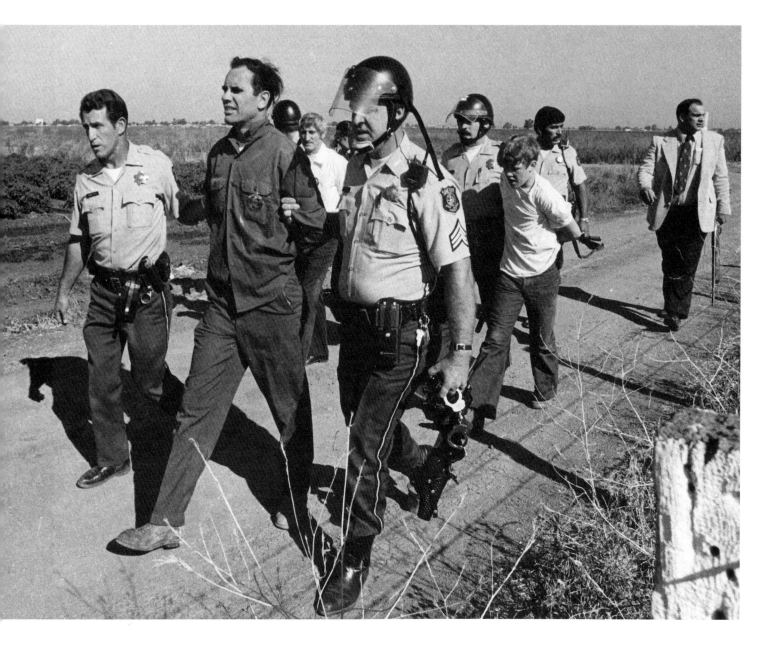

When UFW organizers entered a tomato field near Tracy on September 2, 1975, members of the Posse Comitatus (an armed citizens' group that claimed authority to make and enforce laws) threatened them with shotguns and pistols. *Stockton Record* photographer Dave Evans made this photograph as deputies led posse leader Francis Gillings and his son out of the fields. San Joaquin County Sheriff's Inspector Dan Delfatti (right) carries the shotgun fired near him. Courtesy of Dave Evans.

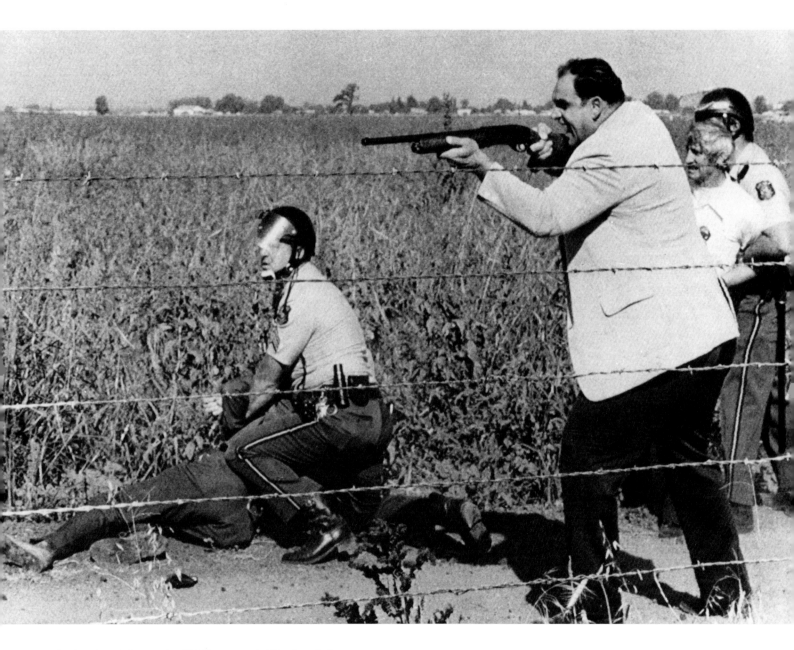

Stockton Record photographer Rich Turner recorded San Joaquin County deputies wrestling a member of the Posse Comitatus to the ground during the confrontation in a tomato field on September 2, 1975. United Press International distributed Turner's photograph nationwide. Courtesy of Rich Turner.

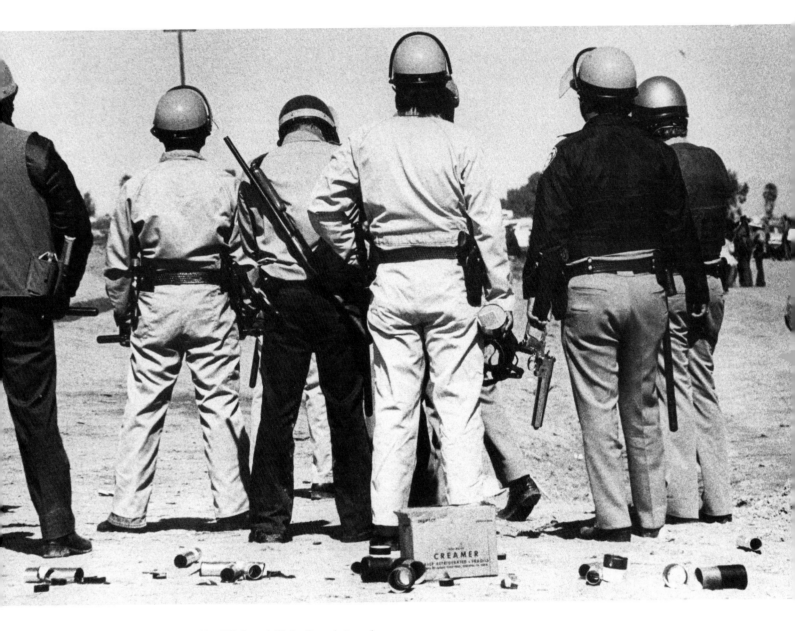

Southeast of Holtville, on February 22, 1979, *Imperial Valley Press* photographer
Paul Noden recorded the aftermath of a confrontation between Imperial County
law enforcement officers and striking members of the UFW. Five people wound
up in the hospital, two of them deputies. Although he had no way of knowing it,
Noden's photograph of this tense moment strongly resembled images taken
forty-three years earlier of tear gas–toting police at the Salinas lettuce packers'
strike. Courtesy of Paul Noden.

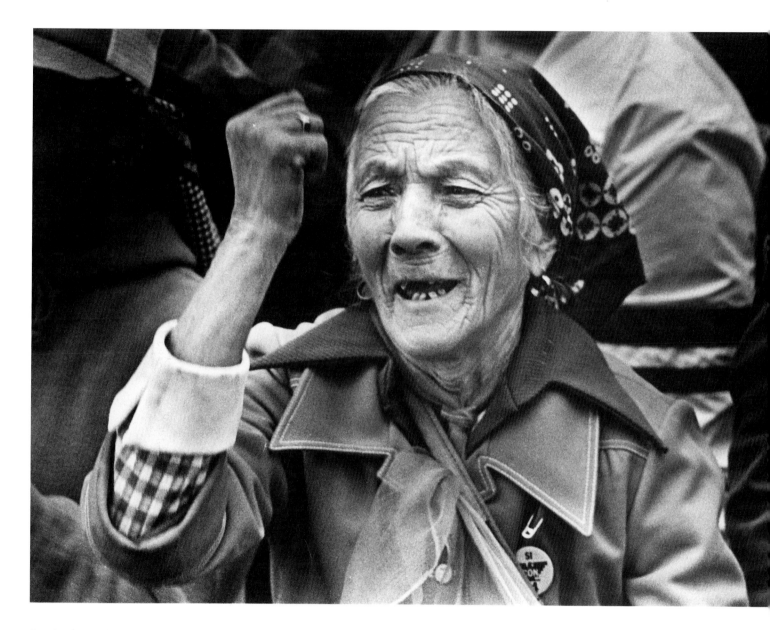

Covering the 1979 lettuce strike, Len Lahman focused his camera on the anger
expressed by this elderly picketer toward strikebreakers working in a field.
Courtesy of Len Lahman.

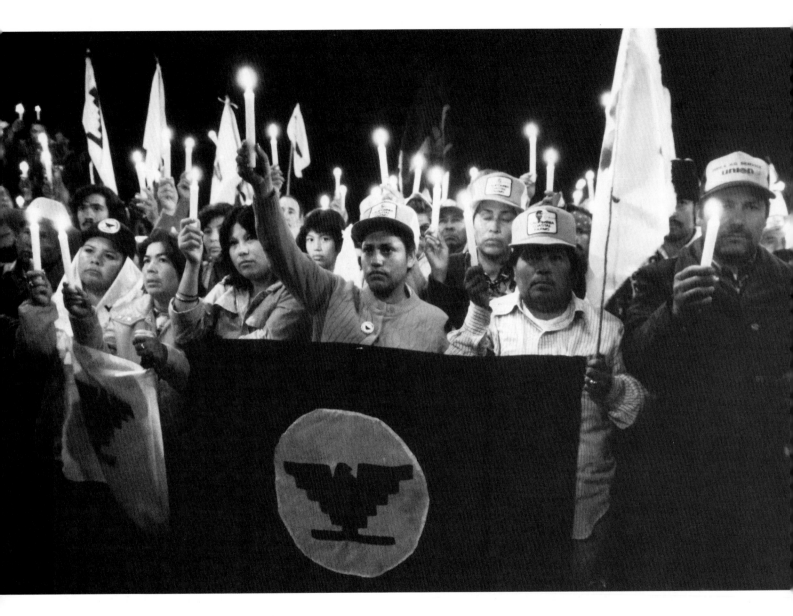

(*above*) Photographing a story for *National Geographic* in June 1980, Stephanie Maze recorded a candlelight memorial to Rufino Contreras, the UFW member shot and killed in January 1979 by strikebreakers as he entered a lettuce field to speak with them. Original in color. Courtesy of *National Geographic* magazine.

(*right*) On August 7, 1979, more than ten thousand farmworkers and their supporters converged on the town of Salinas demanding contracts and an end to violence. When César Chávez spoke to several thousand farmworkers at the annual UFW convention two days later, *Salinas Californian* photographer Richard Green photographed him at the podium beneath a huge banner of murdered farmworker Rufino Contreras. Courtesy of Richard Green/the *Salinas Californian*.

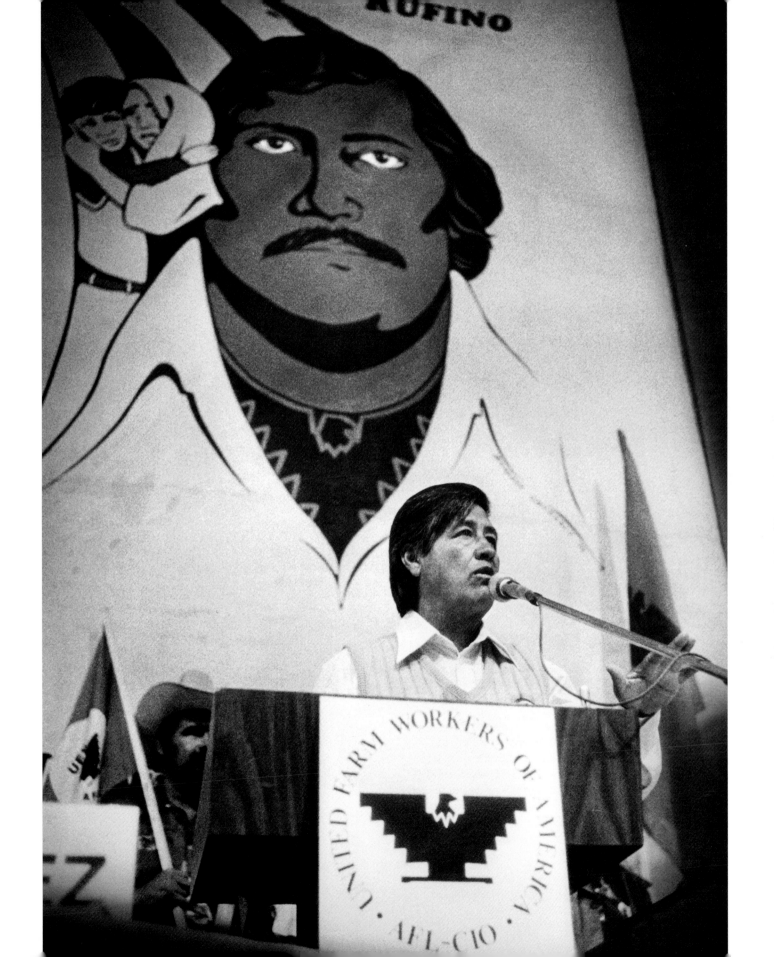

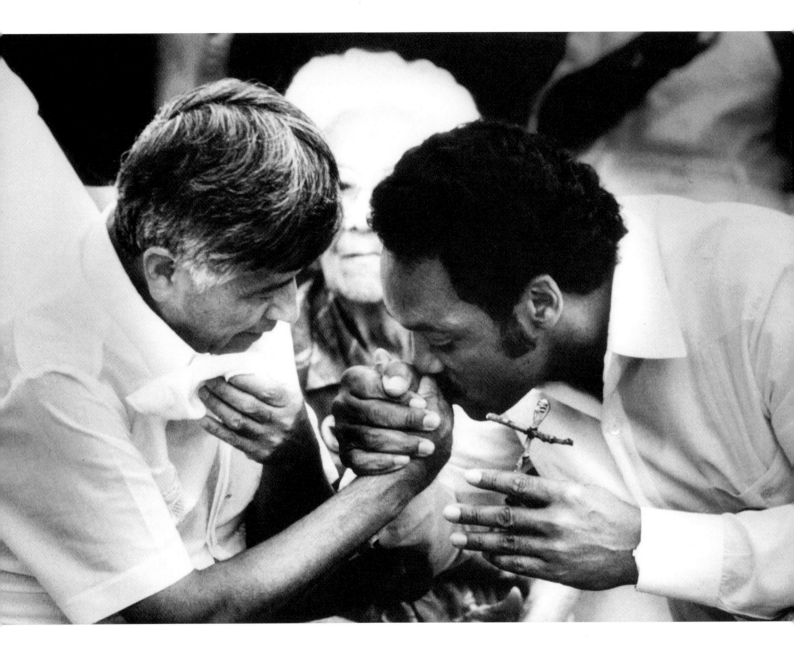

Arriving at Forty Acres (the UFW's compound on the west side of Delano) on August 22, 1988, to photograph César Chávez end his fast, dozens of photographers battled for position. When Jesse Jackson leaned over to kiss the hand of Chávez and give him a small cross made of grapevines stems, *Bakersfield Californian* photographer Felix Adamo captured the gesture. Within the space of the few seconds it took to complete the gesture, thousands of photographs were taken, and the only sound that could be heard was the whir of camera motor drives. Original in color. Courtesy of Felix Adamo/ the *Bakersfield Californian*.

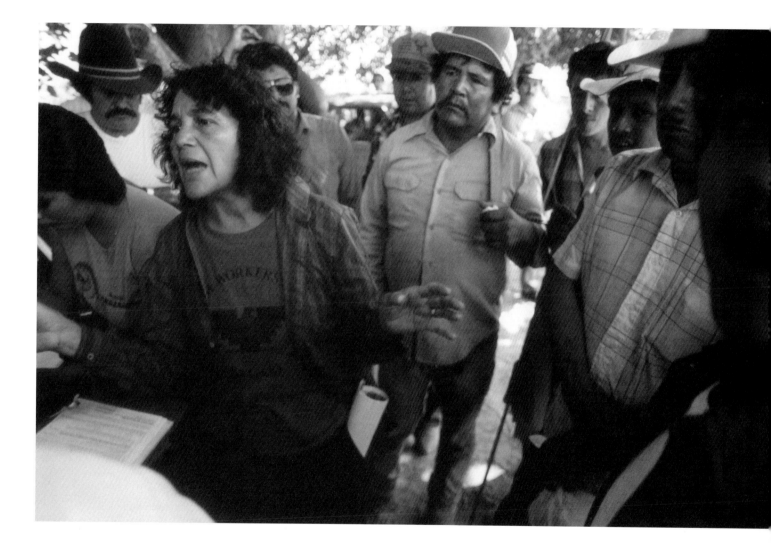

Having just completed a commercial assignment at Del Rey–based H. P. Metzler Brothers, I found myself in the middle of a peach picker's strike led by UFW founder Dolores Huerta. Threatened with arrest and thrown out of an orchard by a security guard, I returned to Metzler Brothers headquarters and asked the brothers if they were going to arrest the photographer who had just put them on the cover of *Western Fruit Grower*. Given complete access and freedom to do as I wanted, I proceeded to photograph the strike from the perspective of strikebreakers and then moved to the other side of the picket lines and made this portrait of Huerta planning the day's strategy just after sunrise on August 7, 1986. Original in color. Courtesy of Richard Steven Street/Streetshots.

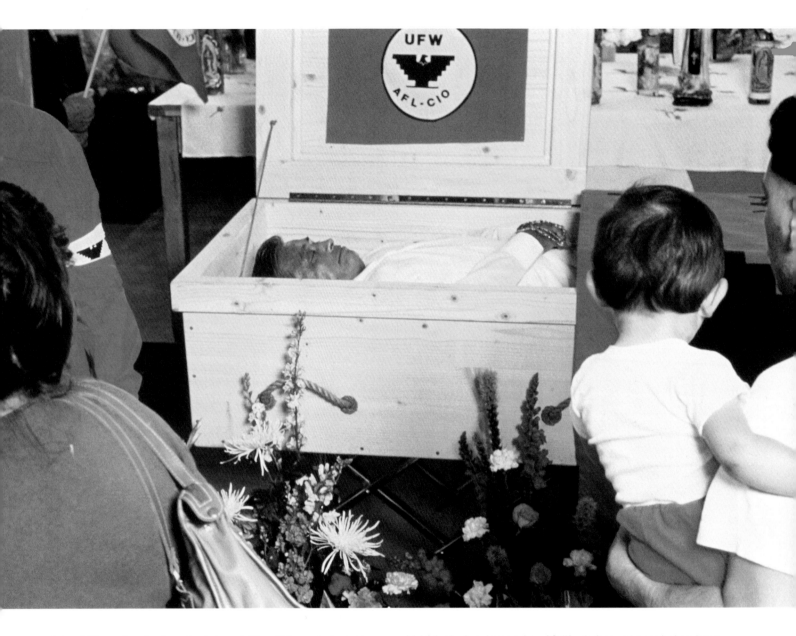

(*above*) After waiting four hours to photograph César Chávez as he lay in his casket at Forty Acres on April 28, 1993, I made the last picture of Chávez as the last mourner filed past and the unvarnished pine casket was closed. Original in color. Courtesy of Richard Steven Street/Streetshots.

(*right*) As the first photographer of California farmworkers to be born into a farmworker family, Francisco Domínguez drew on his reservoir of experiences working in the fields to broaden and deepen the portrait of California farmworkers and discover fresh perspectives on a story some now regard as having been told. In 1989, while photographing César Chávez addressing a crowd, Domínguez made what many regard as a definitive portrait. From the series *Dare to Dream*, 2000. Courtesy of Francisco Domínguez.

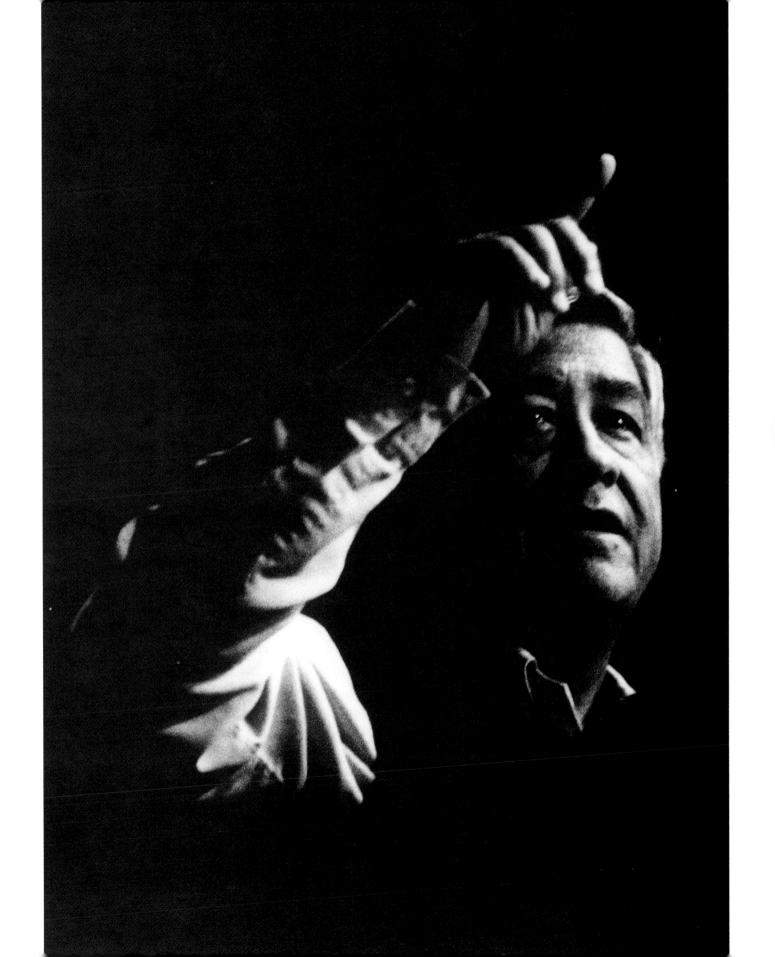

Funerals, Pesticides, and Undocumented Workers

Well before César Chávez's funeral, photographers had been steadily uncovering incredible stories about farmworkers so poor and starved for shelter that they resorted to living in holes in the ground or so uninformed and vulnerable that they were found using short-handled hoes to weed fields years after that backbreaking tool had been banned. Increasingly, such stories dominated coverage. While photojournalists employed by major newspapers accounted for some of this work, freelancers and independent photographers produced most of the best photography. Largely self-financed and lacking the kind of immediate news value that editors sought, their projects typically extended over several years and occasionally required decades to complete. Published in books and as magazine photo essays and layouts in the Sunday supplements of major newspapers, these explorations crossed all photographic genres, merging humanistic content with aesthetic concerns to provide a depth and subtlety not found in most television and daily news photography.

Two major lines of inquiry developed. One centered on the chemical dangers experienced by farmworkers on a daily basis, the devastating effects poisons were having on farmworker's children, and the sacrifices being made to care for them. To convey their message, emergency room physician Lonny Shavelson and freelance photojournalist David Wells produced essays that did not even attempt to mask their biases. At least one photographer paid a terrible price for his photographs. After Victor Alemán photographed armless and legless young Felipe Franco for the November 1986 cover of the UFW's journal *Food and Justice*, some of the union's supporters in Canada and on the East Coast enlarged the photograph to poster size and began using it in boycott activities. Enraged and feeling betrayed, Franco's family sued Alemán. Several years of court battles followed before an appeals court ruled that Mrs. Franco and other mothers had consented to the photography and that Alemán had in no way violated Felipe's privacy. Few other episodes so clearly illustrated the central importance that photographers and photography played in the farmworker movement and the

lengths to which some people would go to prevent farm-workers from employing effective visual evidence.

The other area of inquiry focused on undocumented workers and immigration, including the secret lives that immigrant farmworkers led in the shantytown communities hidden in the canyons of north San Diego County and the role they were playing in the local farming economy. In one of the first extended explorations, Len Lahman, a *Los Angeles Times* photographer, resigned from the newspaper and devoted a year to exposing the toll exacted upon undocumented workers and the journey they endured, coming north to work in the fields of California. Completing the study in 1980, Lahman's pioneering essay was rejected by *National Geographic* and countless magazines and book publishers, a fate not uncommon to those photographers producing work that was ahead of its time. Eventually, Lahman published his essay in a special sixteen-page supplement in the *Escondido Times-Advocate*. Entitled "Faces Beyond the Border" and informed by an extensive written text by journalist Sharon Myer, the essay was completed without backing from any journal, institution, agency, editor, or grant. Notable for the way it bypassed stereotypes, it suggested that undocumented workers demonstrated qualities valued by American society —self-sacrifice, hard work, and perseverance.

Although Lahman's work won the Robert F. Kennedy Journalism Award in 1984, it never received the wide expo-sure it deserved. As he moved on to new projects, other photographers picked up the story. Producing what was probably the most ambitious and comprehensive record, photojournalist Ken Light in his book *To the Promised Land* (1988) chronicled the trials and tribulations of undocumented Mexican immigrants making their way north. Focusing on ten thousand undocumented immigrants living in the ravines and canyons of north San Diego County, I explored their survival culture and efforts at self-organization. Also focusing on the San Diego side of the story, *Los Angeles Times* photographer Don Bartletti scrutinized in great detail the difficult assimilation process and the clash of cultures between the old San Diego community and the new immigrant one. Appearing episodically in the *Times* and later in a book, *Between Two Worlds: The People of the Border* (1992), Bartletti's photographs capture that ambiguous space occupied by people caught between their country of birth and a new territory, a place simultaneously foreign and familiar. One of his photographs of pedestrians running across Interstate 5 became the basis for a CalTrans highway sign alerting motorists to the presence of pedestrians and warning immigrants of the lethal dangers they might encounter. Amplifying the careful and detailed approach of those who had previously tackled the subject of undocumented field hands, Bartletti's work provided such insight that it was awarded the 2003 Pulitzer Prize.

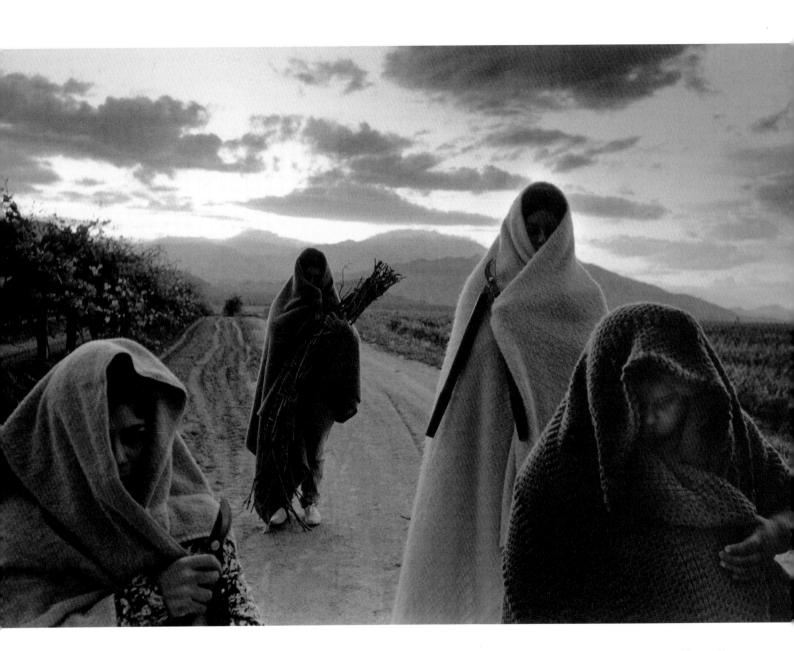

(*above*) After completing several commercial assignments for grape growers on the Mecca Slope in the Coachella Valley on December 12, 1991, I returned early one evening to document members of the Mujercitas Mexicanas surreptitiously gathering grapevines to make wreathes. From the series, *Organizing for Our Lives*, 1992. Courtesy of Richard Steven Street/Streetshots.

(*right*) While shooting a 1979 story on the artichoke industry around Castroville, *Salinas Californian* photographer Richard Green adopted an artichoke's eye view of picking. Courtesy of Richard Green/the *Salinas Californian*.

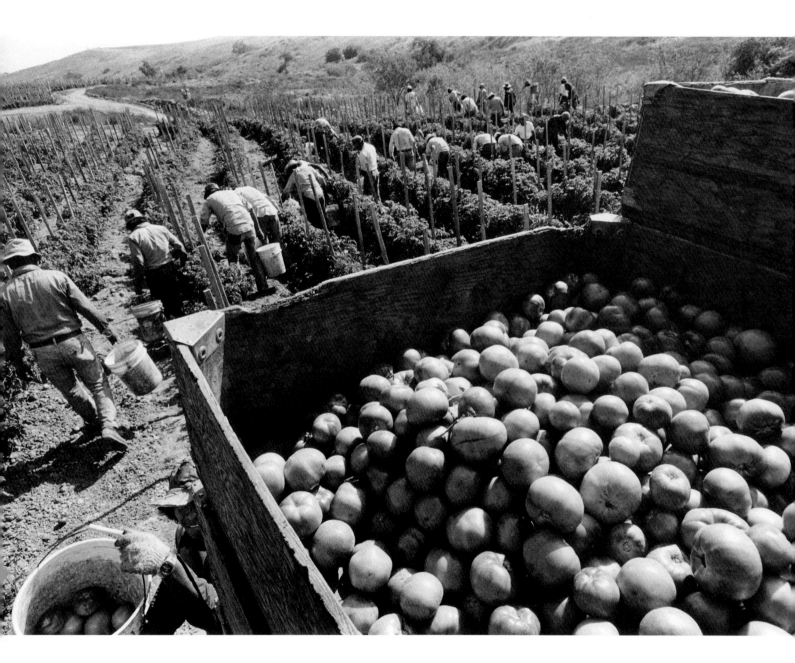

Following undocumented workers into the tomato fields near Oceanside in
north San Diego County in the summer of 1978, Roger Minick waited for all the
elements to fall in place then tripped the shutter to produce a photograph that
requires no caption. Copyright 1978, Roger Minick. Courtesy of Roger Minick.

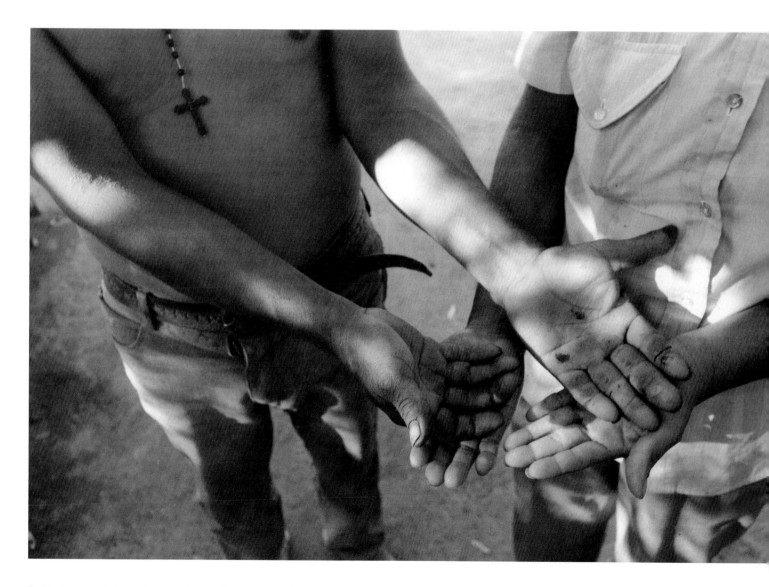

On March 19, 1991, the wife of an undocumented farmworker living in the bottom of a canyon in north San Diego County showed me the blisters on her husband's hands following a day of planting tomatoes without gloves. Courtesy of Richard Steven Street/Streetshots.

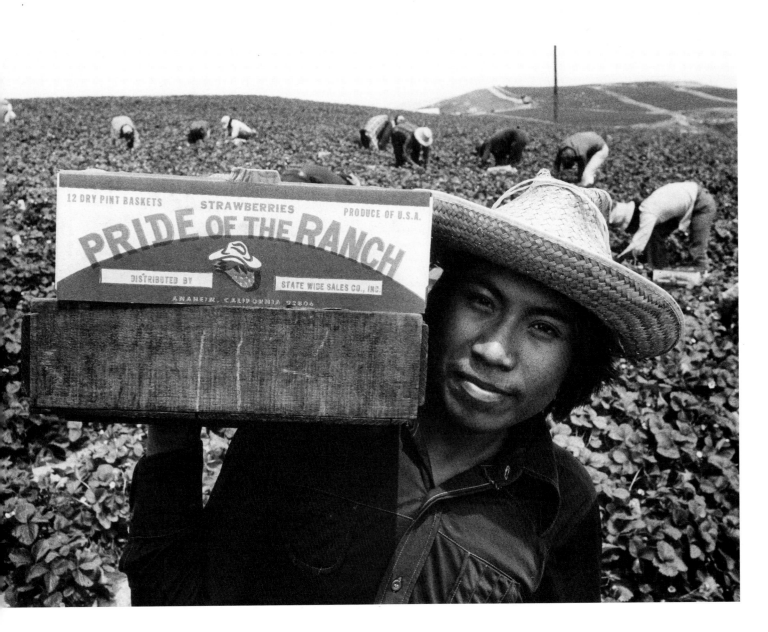

Near Oceanside in 1978, Roger Minick made this portrait of a Oaxacan field hand posing with the box of strawberries that he had just picked. Copyright 1978, Roger Minick. Courtesy of Roger Minick.

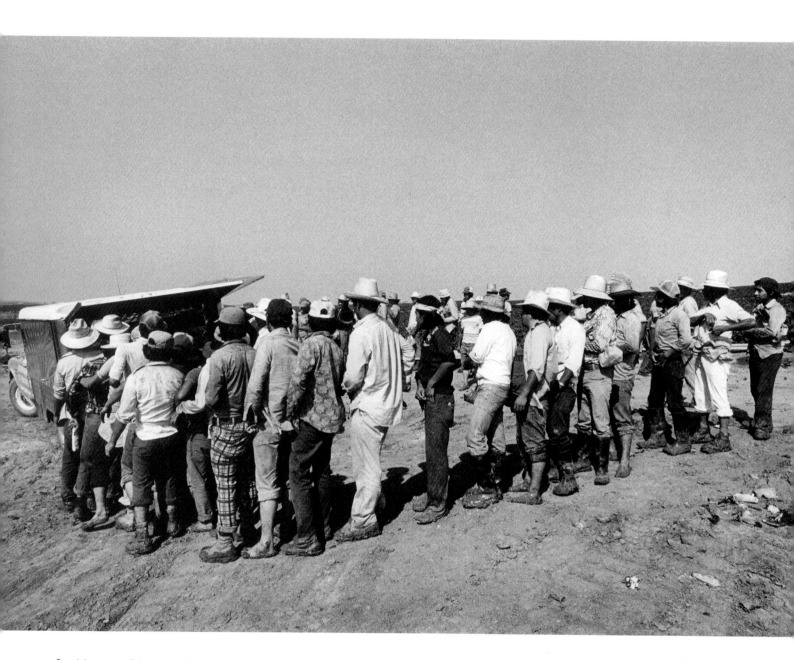

Supplying many of the needs of farmworkers in the north San Diego County strawberry fields, *fayuqueros* (catering truck drivers) deliver mail, documents, and food to workers. Roger Minick has caught the men lined up to purchase lunch. Copyright 1978, Roger Minick. Courtesy of Roger Minick.

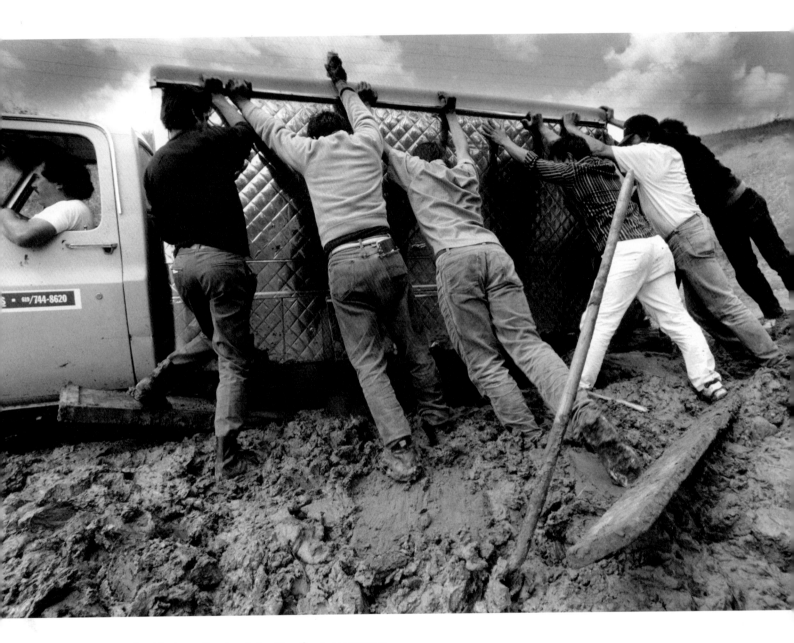

Trying to deliver mail and food to an illegal north San Diego County encampment known as Rancho de los Diablos, this *fayuquero* had become stuck in the mud and was being rocked free by field hands. Photograph 1991, from the series *Organizing for Our Lives*, 1992. Courtesy of Richard Steven Street/Streetshots.

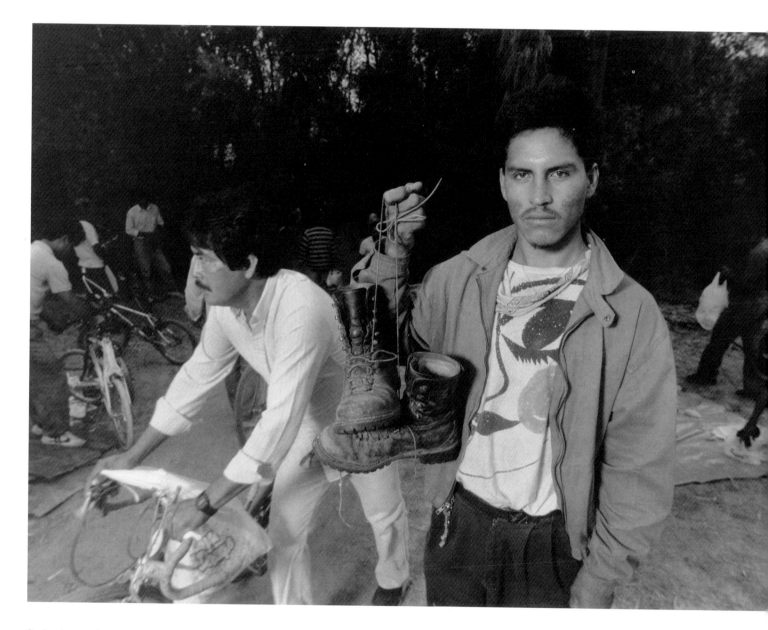

On Sunday morning, May 7, 1991, following a Catholic service under the trees in McGonigle Canyon near Del Mar, a resident of Rancho de los Diablos showed me the new boots that he had received from a Catholic Charities group. From the series *Organizing for Our Lives*, 1992. Courtesy of Richard Steven Street/Streetshots.

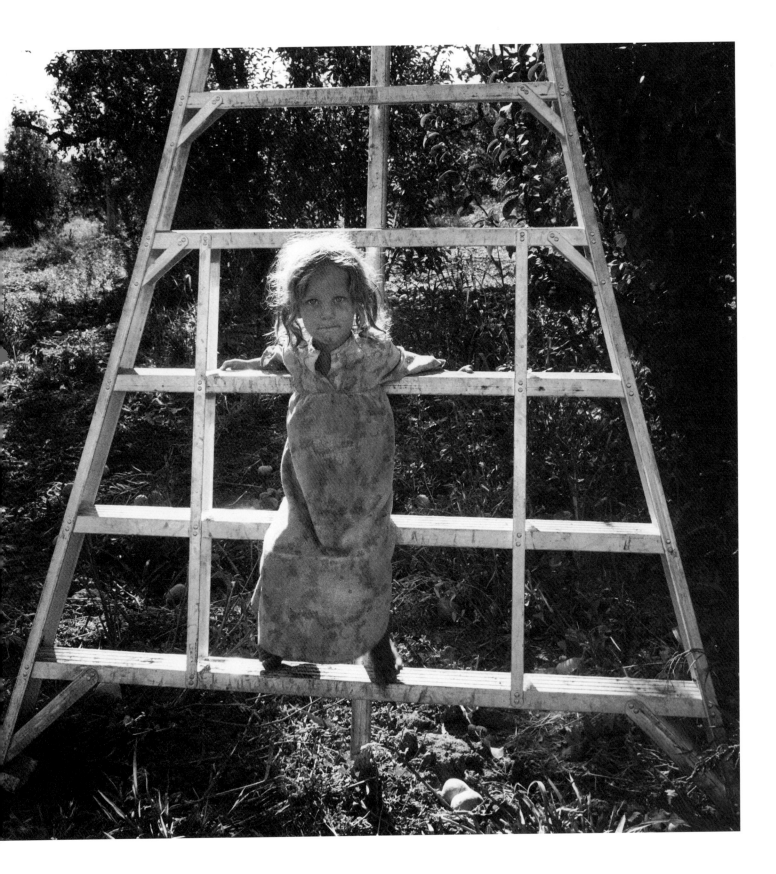

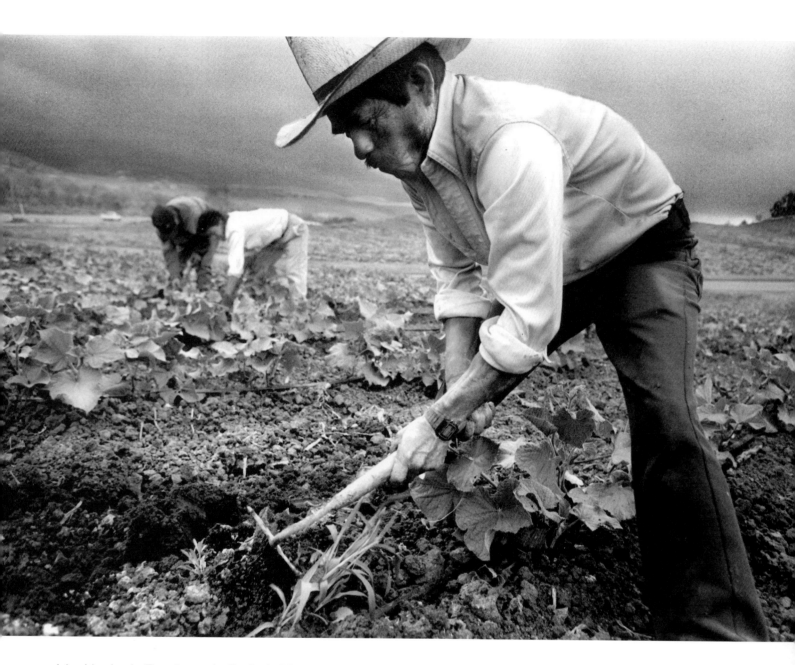

(*above*) *Los Angeles Times* photographer Don Bartletti discovered these men using short-handled hoes to weed squash in a field in the San Luis Rey area of Oceanside in May 1992. The men explained to Bartletti that they were using the banned tool voluntarily, claiming that the short handle provided more control over their work. Courtesy of Don Bartletti.

(*left*) In the fall of 1979, while completing his essay *With These Hands*, documentary photographer Ken Light found this child of a migrant pear picker playing by herself in an orchard in Lake County. Courtesy of Ken Light.

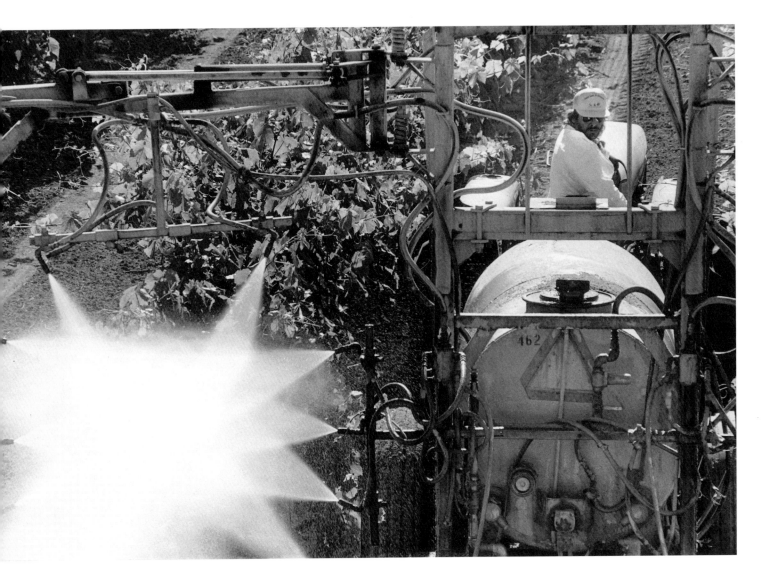

Photographing his essay on how agricultural chemicals were poisoning the
Central Valley, photographer David Wells in 1988 encountered this farmworker
operating a vineyard spray rig near Delano without benefit of protective
clothing or breathing mask. From the series *The Pesticide Poisoning of
America.* Courtesy of David Wells.

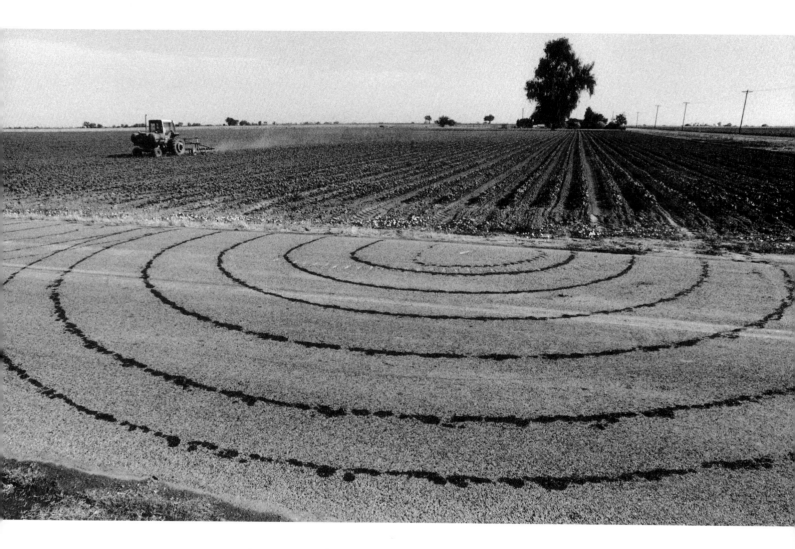

Watching this soil-injection rig operate in 1988, David Wells photographed the neat, abstract chemical patterns left behind as the driver continued applying chemicals while making his U-turns at the end of each furrow onto the county road. From the series *The Pesticide Poisoning of America*, 1988. Courtesy of David Wells.

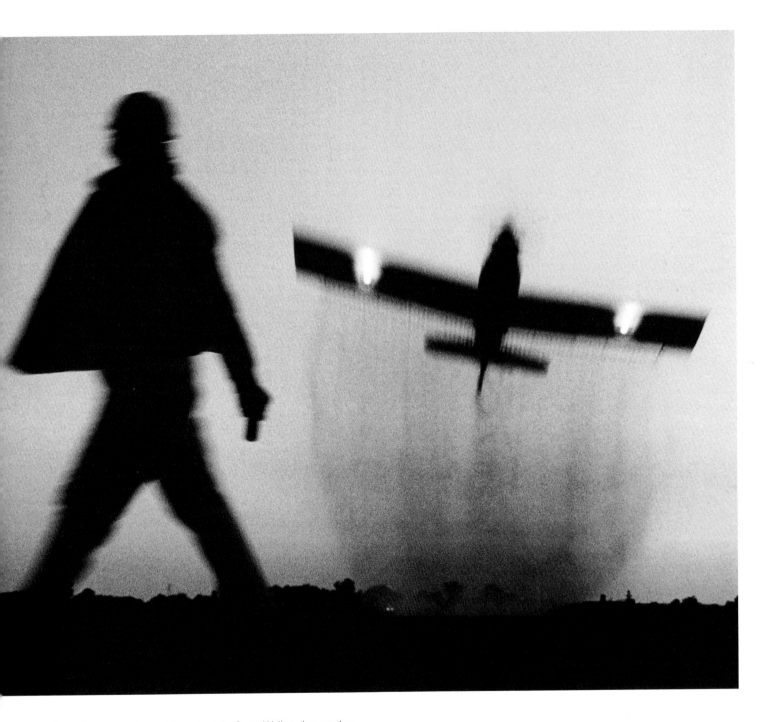

Capturing a scene observed throughout the Central Valley, photographer
David Wells documented this flagger being exposed to drifting spray as a
crop duster worked an alfalfa field west of Fresno in 1988. From the series
The Pesticide Poisoning of America, 1988. Courtesy of David Wells.

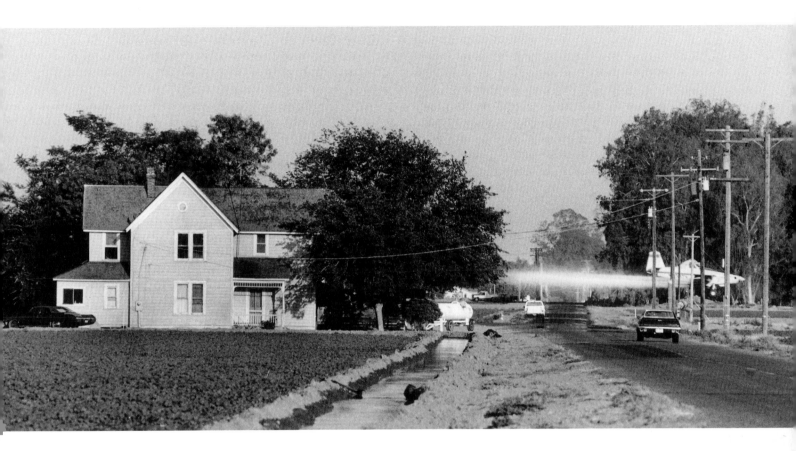

Using a powerful telephoto lens, documentary photographer David Wells compressed distance and perspective to depict the ubiquitous nature of agricultural chemicals. From the series *The Pesticide Poisoning of America*, 1988. Courtesy of David Wells.

Studying the cancer clusters in several San Joaquin Valley farm towns in 1988, David Wells discovered these children playing in a collection pond full of heavily contaminated agricultural runoff near McFarland. From the series *The Pesticide Poisoning of America*, 1988. Courtesy of David Wells.

298

In Delano, David Wells spent the day photographing Felipe Franco, age seven, who was born without arms and legs, a type of defect more common in areas with high pesticide use. The previous year seven agricultural companies had paid the family a large settlement sum without admitting liability for his condition. By photographing young Felipe, Wells tried to underscore the boy's total dependence on others. His aunt, María Torres, brushes Felipe's hair as he makes faces in the mirror. From the series *The Pesticide Poisoning of America*, 1988. Courtesy of David Wells.

Epilogue

Today photographers are a pervasive and important force shaping public perceptions of life and labor in the fields. Assuming roles played by novelist John Steinbeck, muckraking journalist Carey McWilliams, and other great narrators of the farmworker story, photographers intrude into every debate over farm labor relations, comprising their own separate subplot.

Contemporary photographers working among California farmworkers possess an extraordinary drive, courage, and craftsmanship. But what continues to give special resonance to their role is the amalgamation of six other qualities rarely found together. The first is their profound sincerity and complete dedication, coupled with what photographer Sebastian Salgado describes as a patient willingness "to put all of their life into what they . . . believed." The second is their refusal to pander to cruelty and an ability to open themselves up to the extent that, on occasion, people appear before their cameras and address them as if they are on stage before an audience. The third is their shared belief that the most interesting photography is human photography. The fourth is an easy union of aesthetics and politics, pictorial structure and content, seen in tender faces or grizzled hands, making it impossible to ignore even the subject's most gritty and disturbing circumstances. The fifth is a concern for the broad range of human experience that rejects no detail as mundane or insignificant, from the common everyday activities that comprise life's fabric—hanging laundry, cooking over a campfire, building a shelter, feeding a stranger a breakfast of liver tacos and peppers so hot that they bring sweat to one's brow—to the great themes of birth and death, marriage and sickness, love and hate, childhood and old age, as well as the transcendent emotions of grief, love, terror, and hope. The sixth is a willingness to confront reality. To reveal the essence of a moment one must see it first; and to best see it, one must walk right up to it and face it head-on. The failure to become fully integrated with a subject will render one's photographs forgettable. For some this leads quite logically to becoming more than mere observers, to participating in

the lives that they depict, and, insofar as is possible, finding ways to see with their subject's eyes.

These are, with few exceptions, "encounter and witness" photographers who regard the act of taking pictures as a variety of everyday interaction. With a vision that is compassionate and revealing, they possess that quality critics label engagement, of being able to connect with people, move them, and provoke a deep unease with an industry whose success rests on a class long excluded from the social and legal privileges enjoyed by most Americans. Diverse and eclectic, these photographers hardly constitute a unified movement. But with a shared view of the world, they are engaged in producing a massive collective portrait even though they work almost completely independently of one another. To few other groups of photographers other than the founders of Magnum, the world's foremost photographic collective, could we more truthfully apply what Cornell Capa said of his brother, Robert Capa, the great war photographer, and his colleagues: "They loved life and left behind a tradition in photography: they shared respect for humankind." What *Mother Jones* magazine photo editor Kerry Tremain called an act of "collective empathy" and Hungarian photographer André Kertész described as "writing with light" is, in all the greatest of farmworker photographers, another stage of self-discovery.

Little, if any, of their photography is objective. Much of it has salt-of-the-earth power, sometimes unintended, and carries the force of a religious icon. Deeply selective, highly fragmented, and extremely uneven, their work emphasizes certain people, places, and events at the expense of others. Although weighted toward highly critical imagery stressing the dark side, their work can also be funny and ironic, repulsive and enthralling, shocking and inspiring, and so disturbingly beautiful that it forces the viewer to realize that the line between art and politics is indeed a thin one, if it exists at all.

Much of it is being produced by intrepid freelancers who, attempting to free themselves of the newsman's deadline and achieve greater depth, become participant-observers. To take a seemingly familiar story to a more profound level, they grab a wad of cash, dash off at odd moments carved out of busy lives, and immerse themselves in their work, often following an exhausting dawn-to-dusk routine that leaves no room for partners or collaborators.

As their work becomes familiar, it has the potential for causing "compassion fatigue," that numbing effect that happens when our attention demands ever more spectacular imagery. One of the great strengths of modern farmworker photography is that while often describing people caught in desperate circumstances, leading a hand-to-mouth existence and living by their wits, it seldom strays into sensationalism. Steadily reiterating basic values and clearly delineating a world split between excess and need, it opens our minds to the pride that field hands take in doing their work, the joy they express in their families, and the general competence and industriousness they demonstrate simply to get through a day. While such photography provides no answers, it is not indifferent. It is photography with a purpose. Forcing us to pause and reflect, this photography calls our attention to farmworkers in the hope that it will somehow make things better. Conceived as an antidote to the bromides and knee-jerk affirmations of an increasingly manipulative and cowardly mass media, the very best of this photography cuts through to the human condition. Exemplifying all of the great characteristics of photographic artistry, as well as such qualities as unselfishness, diligence, and bravery, it provides us with much more than the legacy of individual portfolios. At times it is difficult to look at without recoiling in horror. But, as has been said of civil rights photography, we must look. And by doing so, answers can emerge.

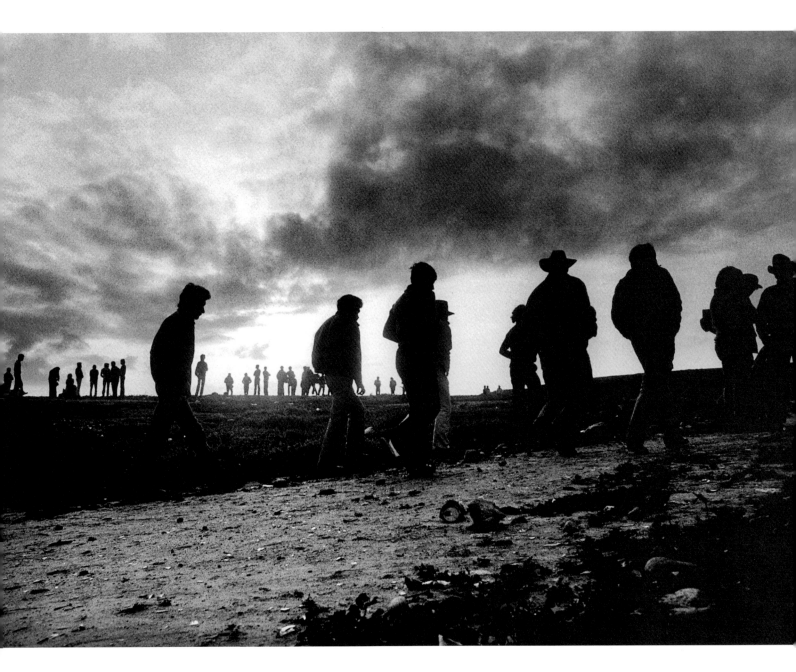

At sundown on May 21, 1983, *Los Angeles Times* photographer Don Bartletti photographed undocumented workers gathering on the soccer field, just north of the U.S.–Mexico border in Tijuana's Colonia Libertad. For a decade before the Border Patrol shut it down, the soccer field served as portal for more undocumented farmworkers than any other point of entry. Title: "Exodus," 1983. Courtesy of Don Bartletti.

Undocumented field hands, later arrested, glow an eerie green in the U.S.
Border Patrol's infrared night-vision scope on Otay Mesa on May 26, 1986.
Original in color. From the series *The Border*, 1986. Courtesy of Richard Steven
Street/Streetshots.

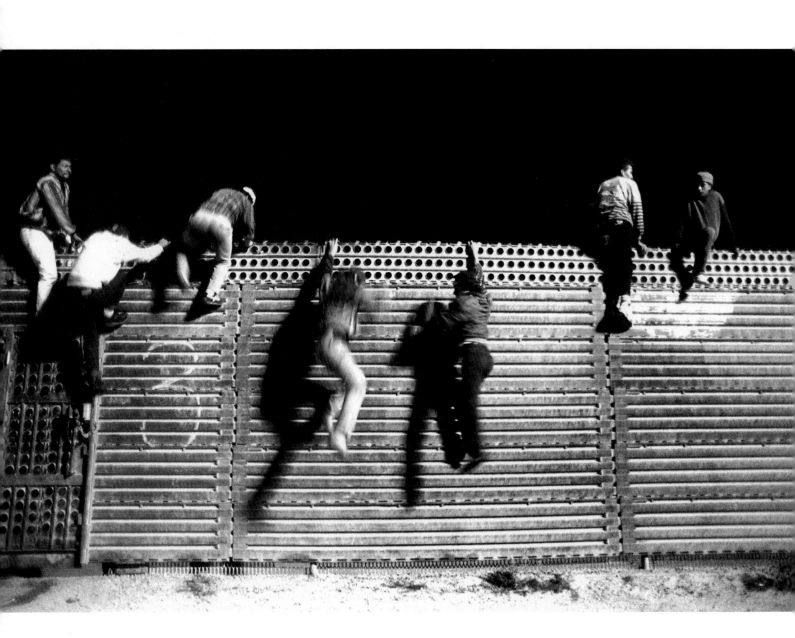

(*above*) Just as the U.S. Border Patrol made a shift change, someone signaled with a whistle and a group of young men made *el brinco* (the leap), free falling down the face of the ten-foot-high steel fence defining the border at San Ysidro. "The men ran past me without a word and disappeared into an industrial park," recalled Bartletti when shooting "Too Hungry to Knock." Many would become field hands on farms in San Diego and the San Joaquin Valley. Photograph June 1992. Courtesy of Don Bartletti.

(*right*) Photographing the U.S.–Mexico border at Tijuana/San Ysidro for his book *To the Promised Land*, documentary photographer Ken Light recorded the path followed by many undocumented farmworkers who first peek through *el agujero internacional* (the international hole). When the coast is clear, they dash north wearing three pairs of underwear and two coats while carrying some extra shoes and their life's possessions in a plastic shopping bag. Courtesy of Ken Light.

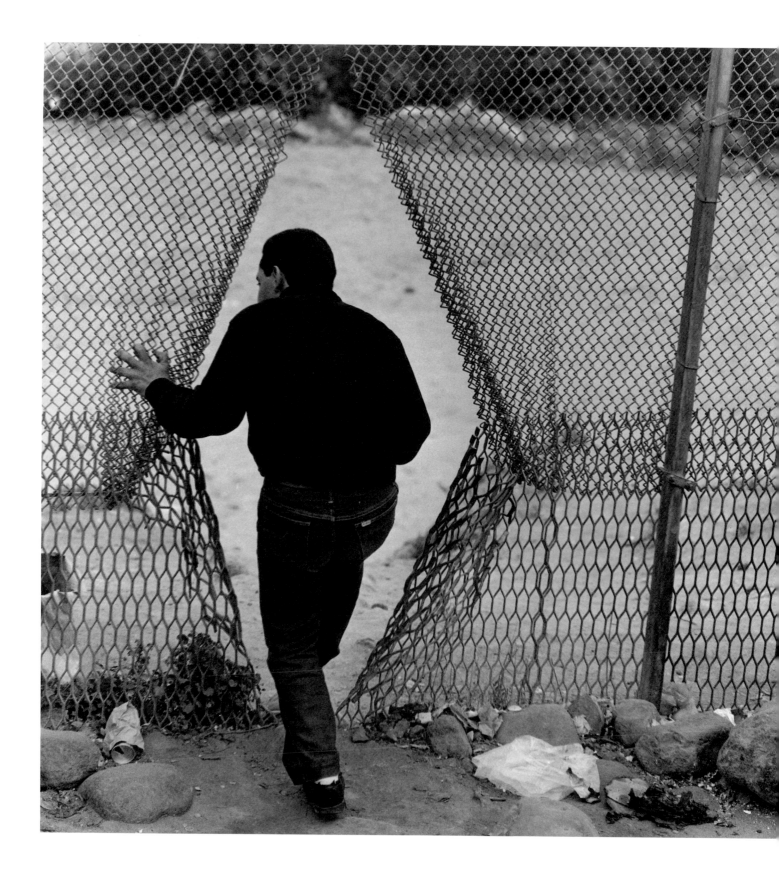

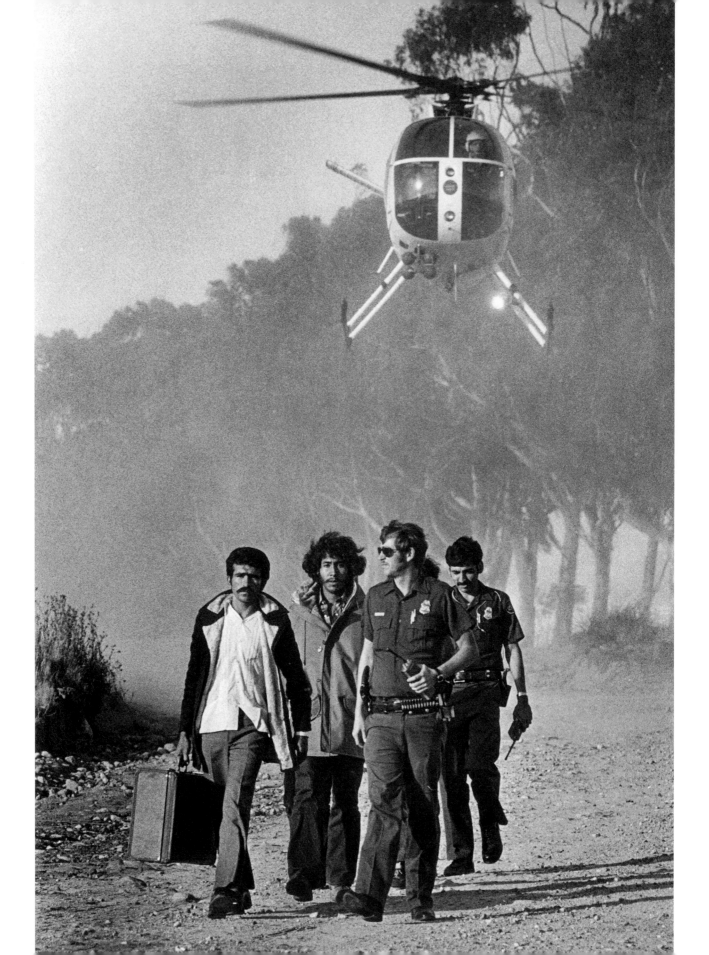

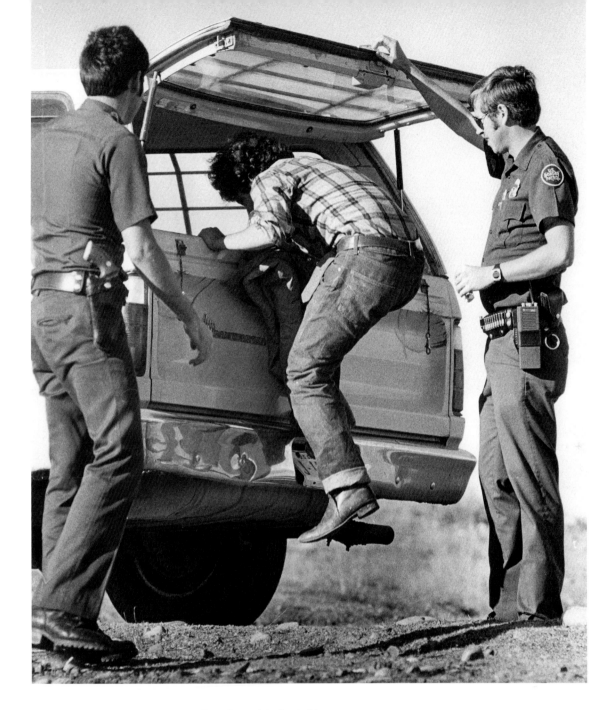

(*above*) While photographing his essay "Faces Beyond the Border," Len Lahman took hundreds of photographs of undocumented workers being arrested, loaded into the backs of Border Patrol vehicles, and carted off to processing centers, ultimately to be "voluntarily" repatriated. Photograph 1980. Courtesy of Len Lahman.

(*left*) Photographing "Faces Beyond the Border," one of the first comprehensive portraits of the undocumented farmworkers traveling north to work in the fields of California, photographer Len Lahman resigned from the *Los Angeles Times* and spent most of 1980 exploring the issue of undocumented immigration. Early one morning on Otay Mesa, Lahman spotted a Border Patrol helicopter and several officers rounding up these undocumented workers. Courtesy of Len Lahman.

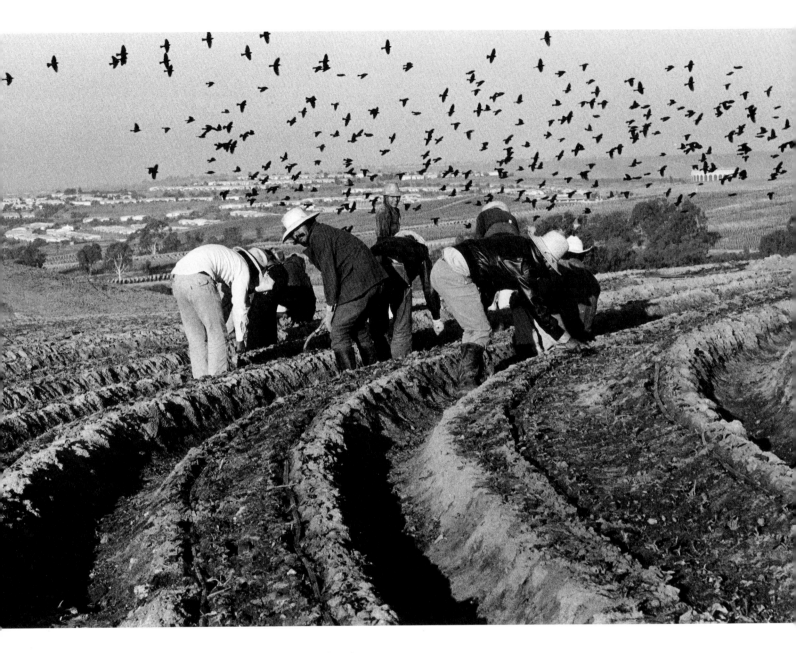

Roger Minick was photographing these men weeding strawberry plants in north San Diego County early one morning in the spring of 1978 when a flock of birds swooped down to feast on worms and grubs. Filling the sky, they added a picturesque dimension, creating a photograph with landscape overtones and documentary value that defies easy classification. Copyright Roger Minick, 1978. Courtesy of Roger Minick.

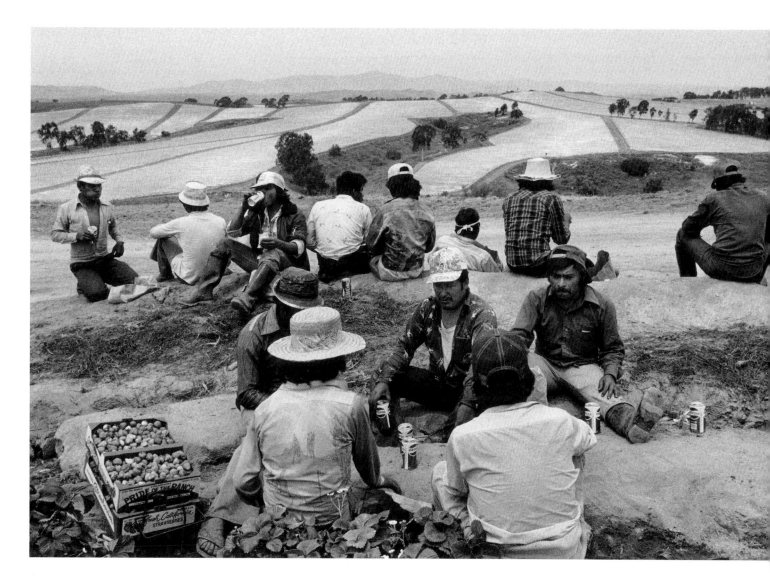

Photographing these men resting in the tomato fields near Oceanside in the spring of 1978, Roger Minick captures the ordered luxury and productive beauty of the hillside farms where they worked. Copyright Roger Minick, 1978. Courtesy of Roger Minick.

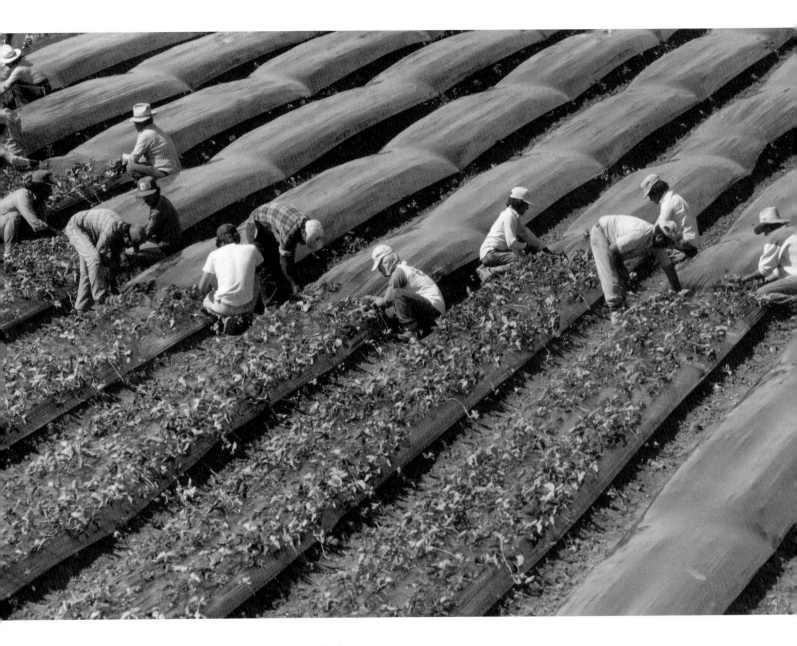

From a hovering height just above the strawberry fields in north San Diego County, I recorded the progress of this crew laying out plastic, burning holes in it, and then pulling strawberry plants through the holes. With drip irrigation lines laid on top of the furrow under the plastic, the technique allowed growers to dramatically reduce their water bills and produce healthier plants. Photograph 1991, from the series *Organizing for Our Lives*, 1992. Courtesy of Richard Steven Street/Streetshots.

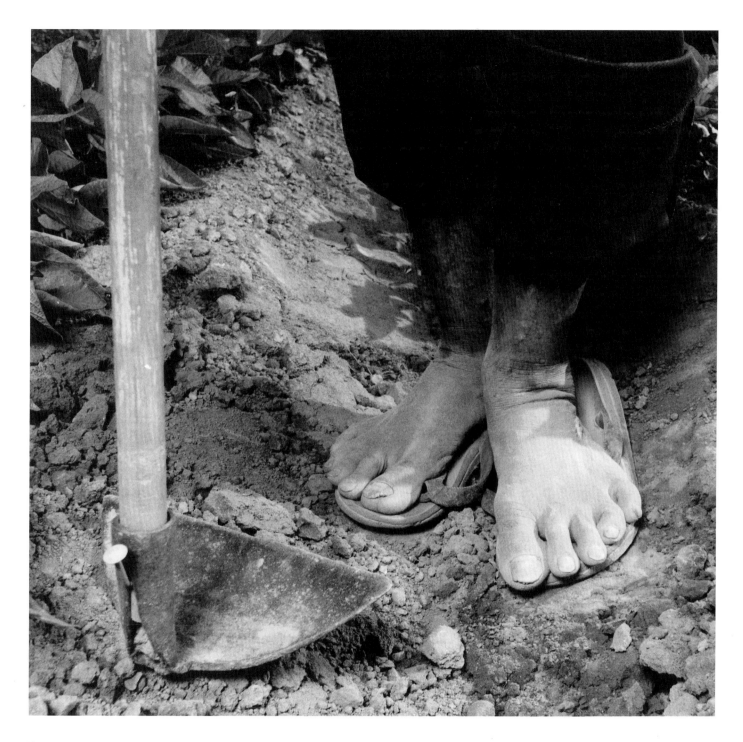

While living with undocumented farmworkers in the canyons of north San Diego County in 1991, I noticed this man hoeing beans in traditional sandals. From the series *Organizing for Our Lives*, 1992. Courtesy of Richard Steven Street/Streetshots.

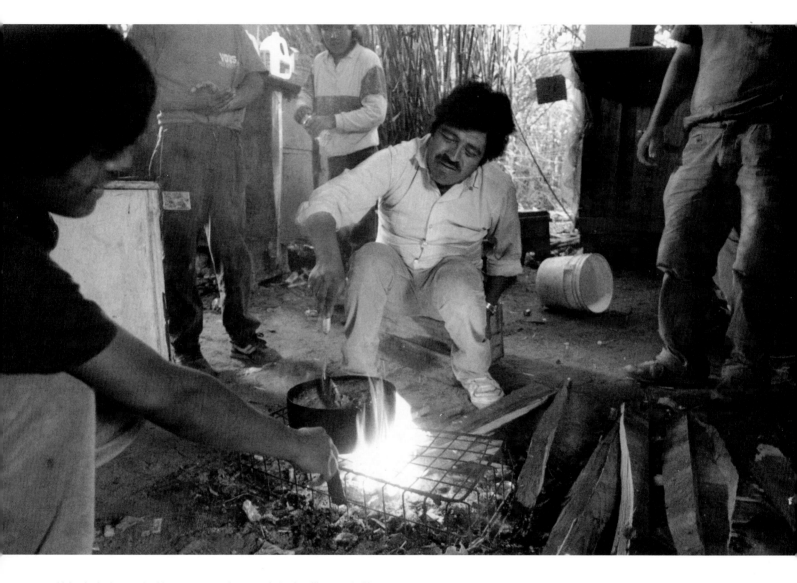

Living in doghouse-sized huts constructed on top of plastic milk carton holders, Oaxacan immigrants in Rancho Yasecoche in the middle of Camp Pendleton Marine Base invited me to sit with them as they turned on their transistor radio for one hour of Mexican music and cooked a meal over a campfire started by dripping burning plastic grocery bags onto kindling. Photograph 1991, from the series *Organizing for Our Lives*, 1992. Courtesy of Richard Steven Street/Streetshots.

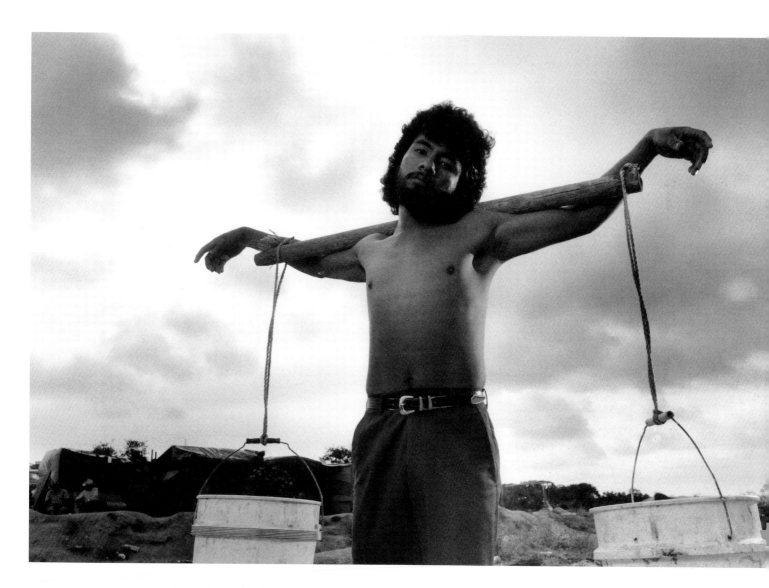

After photographing an immigrant farmworker washing his clothes in a creek bed at Rancho de los Diablos, the largest shack town in north San Diego County, I was invited to accompany Luis Rodríguez to his encampment on the ridge above. After stomping tin cans to turn in at the recycling center for cash, Rodríguez placed a pole on his shoulders, tied ropes to the handles of two five-gallon buckets, attached the buckets to the ends of his pole, and trotted off down the road to retrieve water. Returning, he asked me to photograph him. Photograph 1991, from the series *Organizing for Our Lives*, 1992. Courtesy of Richard Steven Street/Streetshots.

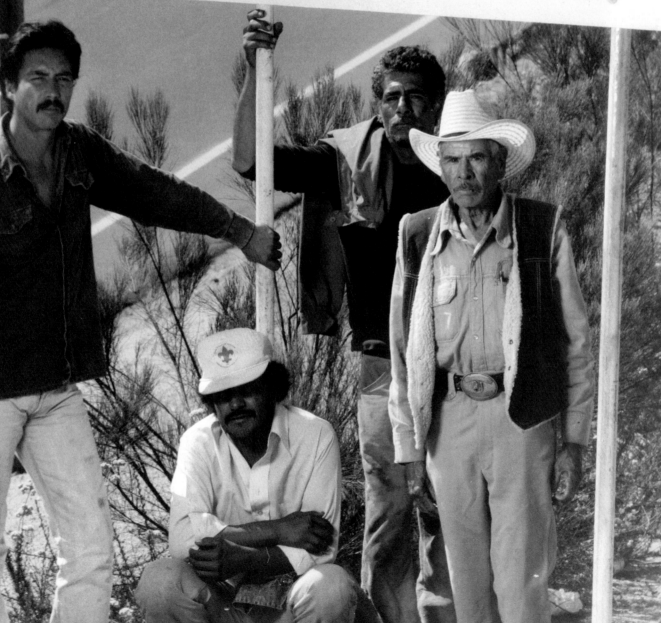

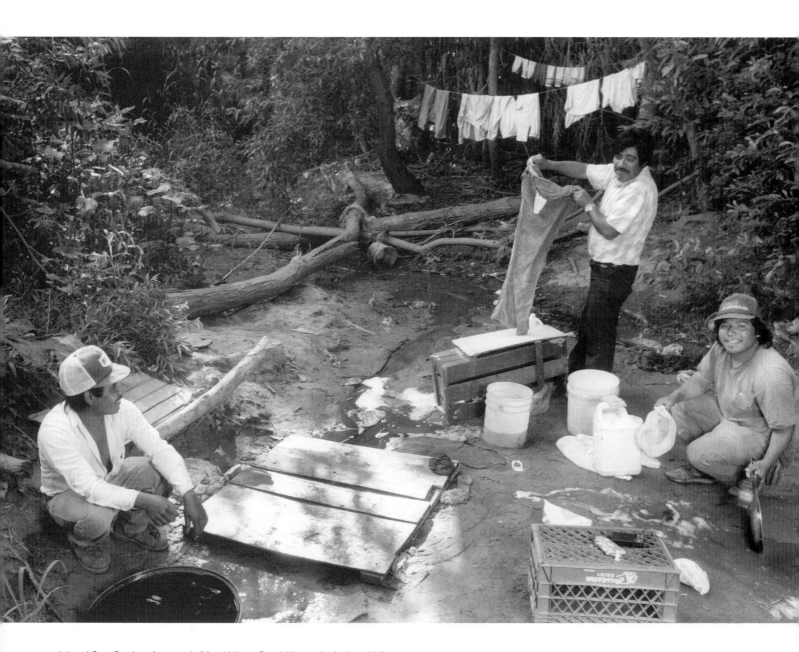

(*above*) On a Sunday afternoon in May 1991, at Ranch Yasecoche in the middle of Camp Pendleton Marine Base, I photographed "Frogman" (right), a leader of a group of Oaxacan immigrants who worked in the nearby strawberry fields, along with his compatriots, washing their laundry and dishes in an elaborate water diversion and settling system. Two years after this photograph was taken, thugs severely beat up all the camp residents, sending several to the hospital. From the series *Organizing for Our Lives*, 1992. Courtesy of Richard Steven Street/Streetshots.

(*left*) Near Alpine, in north San Diego County, in May 1991, I photographed these undocumented farmworkers waiting for work beneath a sign asking local residents not to hire them. From the series *Organizing for Our Lives*, 1992. Courtesy of Richard Steven Street/Streetshots.

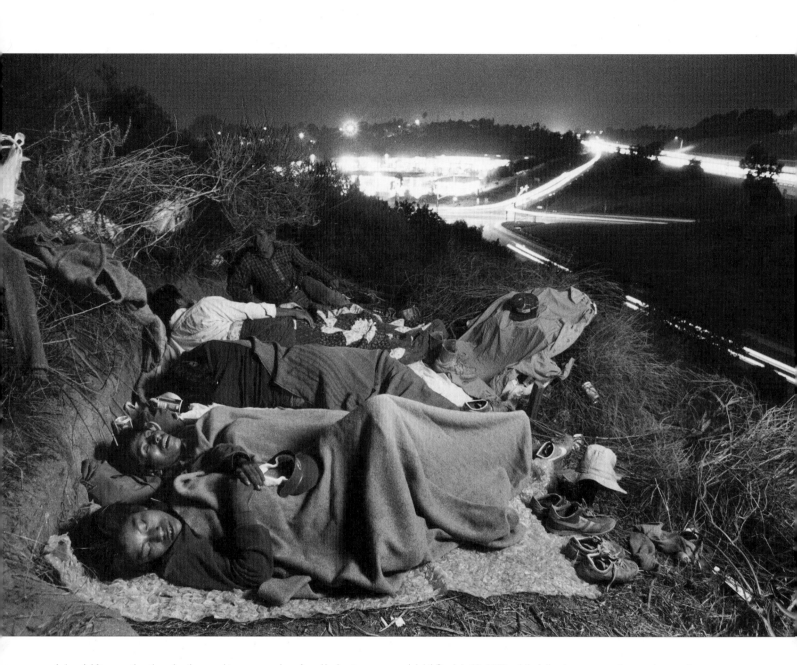

(*above*) After meeting three brothers and two companions from Huehuetenango, Guatemala, who were camped on a steeply sloping hillside above Interstate 5 in Encinitas, *Los Angeles Times* photographer Don Bartletti spent several evenings trying to figure out how to best represent their precarious plight. To make this image, he set his camera on a tripod, focused it using a penlight, popped an off-camera flash, then refocused the camera on the horizon and recorded the lights of cars on the nearby highways and thoroughfares with a two-minute exposure. Photograph July 25, 1989, from the series *Between Two Worlds*, 1992. Courtesy of Don Bartletti.

(*right*) On July 23, 1989, while following a group of young farmworkers from Cuernavaca, Mexico, *Los Angeles Times* photographer Don Bartletti documented them bathing in a flume carrying water to Rancho Santa Fe, one the wealthiest communities in San Diego County. Most of the men worked in nearby nurseries, and a few married women cleaned million-dollar mansions and returned each night to their brush shelters. Courtesy of Don Bartletti.

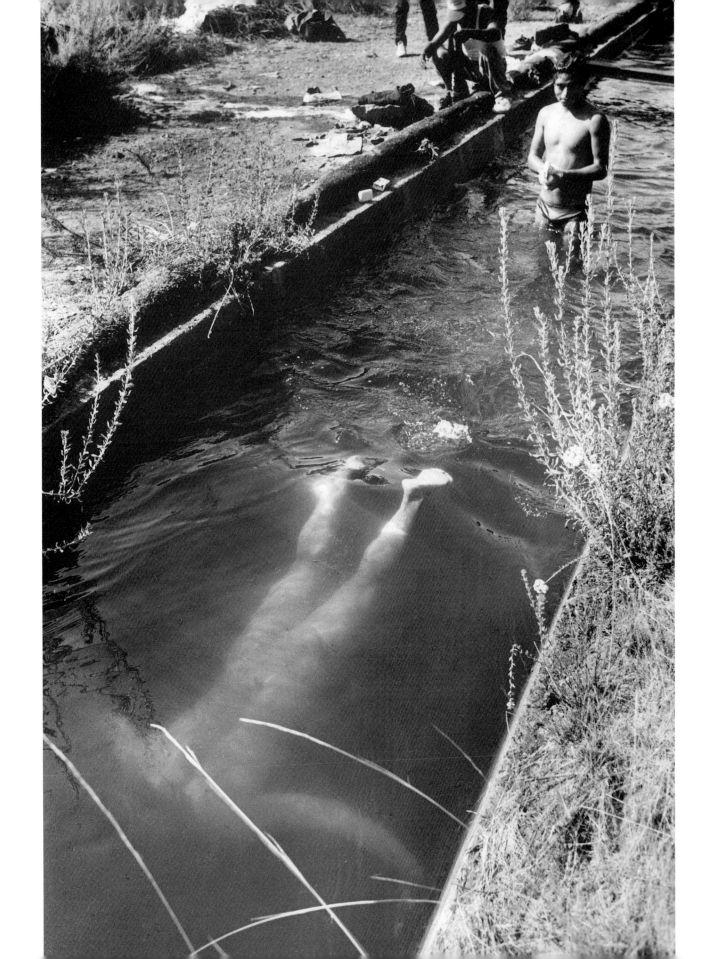

(*above*) Searching for a location to make a group portrait of members of the Mujeres Mexicanas, these four women walked into a neighbor's backyard, stood on some benches beside a cinder block wall, and directed me to photograph from the other side. Photograph May 1991, from the series *Organizing for Our Lives*, 1992. Courtesy of Richard Steven Street/Streetshots.

(*right*) When I was documenting farmworkers at Santa Elena Cooperative in Soledad, I stayed with a family of six in a trailer the size of an average kitchen. Of all the labor camps in California, Santa Elena—with its swimming pool, community programs, and strong sense of pride—seemed to epitomize a hopeful future where children could reach their potential in a safe, wholesome environment. On my last day in Santa Elena, one of the children from the family that hosted me flipped upside down and asked to be photographed as her sister raced by and their father, just arriving back from the fields, puzzled at what was going on. Photograph September 1991, from the series *Organizing for Our Lives*, 1992. Courtesy of Richard Steven Street/Streetshots.

While researching and writing *Photographing Farmworkers in California* I exploited a vast reservoir of scholarship and relied on the help, generosity, and patience of countless colleagues, friends, my cherished parents, and even complete strangers, who believed in me and gave generously, never asking anything in return. First and foremost, I must highlight the pioneering work on photographic history and theory by several generations of scholars, including Van Deren Coke, A. D. Coleman, Richard and Maisie Conrat, James Curtis, Andy Grundberg, Therese Heyman, Drew Johnson, Lawrence W. Levine, John Loengard, Anne Loftis, Milton Meltzer, Beaumont and Nancy Newhall, Karin Becker Ohrn, Elizabeth Partridge, Sandra Phillips, David Peeler, Fred Ritchin, Naomi and Walter Rosenblum, Martha Rosler, Allan Sekula, Charles L. Shindo, Jonathan Spaulding, Maren Stange, William Stott, David Levi Strauss, and Jennifer Watts. Amplifying their contributions and frequently taking issue with their conclusions, I acknowledge that these scholars have excavated the foundation upon which all photographic history in California rests. I also learned more than I expected from my own peers in the photographic profession, including Fred Lyon, Art Rogers, Jo Moss, Douglas Neecke, and Orrin Moon at The Darkroom, and especially Doug Menuez, who taught me more about photography than any living being, and Pirkle Jones, who talked me out of the more elaborate book title of *Shooting Farmworkers: Photographers, Photography, and the Farmworker Experience in California, 1850 to the Present.*

Among the hundreds of photographers I contacted for this book, the following deserve special thanks: Victor Alemán, Felix Adamo, George Ballis, Don Bartletti, Ted Benson, Oscar Castillo, Emmon Clarke, Dan Coyro, Carl Crawford, Loomis Dean, Gayanne Fietinghoff, Bob Fitch, Paul Fusco, Gerhard Gscheidle, Richard Green, Joseph Gunterman, Richard Hammond, John Kouns, Jon Lewis, Len Lahman, Ken Light, Ernest Lowe, Margery Mann, Wayne Miller, Roger Minick, Truman Moore, Joe Munroe, Eugene Nelson, Paul Noden, Don Normark, Fran Ortiz, Rondal Partridge,

Acknowledgments

Glen Pearcy, Clay Peterson, Mimi Plumb-Chambers, Harry Polkinhorn, Joe Rosenthal, Lonny Shavelson, Elizabeth Sisco, Ted Streshinsky, Reesa Tansey, Ronald B. Taylor, Rick Tejada-Flores, Linda Troeller, Sam Vestal, Seema Weatherwax, David Wells, and Max Yavno. They all gave time and loaned photographs. Key participants in the modern side of the story who also gave generously of their time include Doug Adair, César Chávez, Jim Drake, Susan Drake, Marcia Lyons, H. L. Mitchell, and Chris Schneider.

Being in the field as an agricultural photographer provided insights into the practical side of my subject that no book or archive could ever approach, while also allowing me to participate in the story and observe it firsthand even as it was unfolding. For hiring me, I must thank Charles M. Benbrook, National Research Council; Greg Critser, *California Business*, *California*, and *Worth* magazines; Lorna Cunkle, Steve McNamara, and Linda Xiques, *Pacific Sun*, who assigned me an ongoing series of essays on photographers that appeared in the newspaper between 1979 and 1982; Tim Driscoll, Driscoll Strawberry Associates, Inc.; Dan Gerawan, Gerawan Farming, Inc.; James Gordon, *Wine Spectator* magazine; Alexandra Gregson, *Forbes* magazine; Des Keller, *Progressive Farmer* magazine; Marcus Moller-Racke, Buena Vista Winery; Jose Padilla, California Rural Legal Assistance; Steve Pavich, Pavich Family Farms; Harold Rogers, *Western Fruit Grower* magazine; Cheryl Romo, *Sacramento* magazine; Edwin Self, *San Diego* magazine; Elizabeth Kuehner Smith, *Wine News*; and Len Richardson and Richard Smoley, *California Farmer*. Completely understanding of and sympathetic to my attempt at merging a life in scholarship and photography, I thank them for being both generous and flexible in the service of my project.

Two scholars of American visual culture who have helped shape this work are Sally Stein, a friend whose help extended far beyond the academy, and Sarah Burns, whose scholarship has provided a model of inspiration, and who has remained among the strongest and most helpful advocates of my work since our days together at the Stanford University Humanities Center. Toward the end of the project, John G. Morris, the legendary photo editor who handled the work of many of the photographers appearing in this book, waded through the manuscript from his expatriate post in Paris. I appreciate his critique and cherish his endorsement of my treatment of Otto and Hansel Mieth Hagel. I could not have completed the project without the steadfast assistance and inspiration of two old friends, Jacqueline Jones and Tom McCormick.

A number of grants and fellowships allowed me to finish my research and writing. A stint in the Stanford University Humanities Center helped me to flesh out certain ideas concerning layout and cover selection, while an illustrated history course I taught on California farmworkers in the Stanford University History Department provided a chance to place my ideas before a group of excellent students. A Mayer Fellowship at the Huntington Library, San Marino, California, provided access to that institution's vast resources, as well as archives in the Los Angeles area, and a John Simon Guggenheim Fellowship gave me the opportunity to finish much of the research. A Millard Meiss Award from the College Art Association and subvention grants from the Guggenheim Foundation and the Sourisseau Academy for State and Local History, California State University, San Jose, provided funds to offset the costs of publishing. I finished the project while serving as the Ansel Adams Fellow at the Center for Creative Photography, University of Arizona, Tucson, where I worked in the collections of Ansel Adams, Otto and Hansel Mieth Hagel, and Max Yavno. It was my pleasure to deliver some final thoughts on the project as part of the Davies lectures at the University of San Francisco, which also sponsored an exhibition of my own photography in its Thacher Gallery.

Norris Pope, my editor at Stanford University Press, kept the book going. My production editor, Anna Eberhard Friedlander, led me through the thicket of permissions and the process of manuscript refinement, and my copy editor, Matt Stevens, saved me from innumerable mistakes, including bad mathematics, while earning my lasting gratitude and teach-

ing me more than I would like to admit about the craft of writing. Lowell Britson guided the manuscript through the last stages of the marketing morass. I alone am responsible for any mistakes.

Thirteen photographers of California farmworkers died during the long genesis of this book: Ansel Adams, Horace Bristol, Morrie Camhi, Dave Evans, Hansel Mieth Hagel, Peter Leung, Margery Mann, Ralph H. Powell, Chris Sanchez, Ted Streshinsky, Rich Turner, and Max Yavno. Before he passed away, Harvey Richards allowed me to print his negatives, a privilege I cherish. Two outstanding scholars of photographic history died in accidents as this project went to press. Henry Mayer, the biographer of Dorothea Lange, who had just charmed my class at Stanford University, died while riding his bicycle up the Highway to the Sun, and Peter Palmquist, font of all knowledge about Western photographic history, with whom I had explored the farmworker photography of Carleton E. Watkins, died while crossing a street in Emeryville, California. Exemplars of people who write great scholarship without benefit of academic appointment, their loss has robbed me of cherished friends and photographic historians of the best of their profession.

Librarians, archivists, editors, scholars, and other photographers make books like this one possible. So many have helped me at various stages along the way that I fear that I have failed to recall all of them. For providing information and leads into images residing in hundreds of archives, libraries, museums, and private collections in Britain, Germany, Mexico, Spain, the United States, and the U.S. Virgin Islands, I owe an immense debt to the following individuals: Danette Cook Adamson, Special Collections, California Poly Pomona University; Pat Akre, San Francisco History Center, San Francisco Public Library; Bill Appleton and Pat Havens, Simi Valley Historical Society, Simi Valley, California; Polly Armstrong and Roxanne Niland, Special Collections and Archives, Stanford University; Joseph A. Baird, University of California, Davis; Tracey Baker and Marilyn Ziebarth, Minnesota Historical Society, Saint Paul, Minnesota; Frank Bartholomew, Sonoma, California; Galen Beery, Historical Society of La Verne, La Verne, California; Tom Beck, University of Maryland Archives, Baltimore; Linda Blackwell, Southwest Museum, Los Angeles; Barbara J. Blankman, First American Title Company, Santa Ana, California; Trevor Bond, Washington State University Department of Manuscripts and Archives; Lynn Bonfield, Labor Archives and Research Center, San Francisco State University; Eric Brazil, *Salinas Californian*; Debby Burns, Santa Paula Historical Society, Santa Paula, California; Alexis Buss, Industrial Workers of the World, Philadelphia; John M. Cahoon and William Mason, Seaver Center for Western History Research, Los Angeles Museum of Natural History; Karen Carlson, Tenneco West, Bakersfield, California; Terry Carter, Ontario Public Library, Model Colony History Room; Rosa Casanova, Fototeca del I.N.A., Pachuca, Mexico; Howard Chapnick, Black Star Photos, New York City; Heidi Casebolt and Sabine Goerke-Shrode, Vacaville Museum, Vacaville, California; Lisa Christensen, California History Center and Foundation, DeAnza College, Cupertino, California; Janet Clemmensen, California State Library; Jean Coffey, Special Collections, Henry Madden Library, California State University, Fresno; Eileen M. Colla, Wine Institute, San Francisco; Carolyn Cole and Kathy Kobiachi, Los Angeles Public Library Photo Collection; Frank Cowsert, Cowsert Studios, Courtland, California; Harry Crosby, La Jolla, California; Donald Cutter, University of New Mexico, Albuquerque; Maureen Dilg, National Geographic Society Image Sales, Washington, D.C.; John Dixon, Palm Desert, California; Iris Engstrand, University of San Diego; Thomas Featherstone and Mary J. Wallace, Walter P. Reuther Library, Wayne State University, Detroit; Gary Fong and Diane Levy, *San Francisco Chronicle*; Jonathan Friedlander, Near Eastern Studies, University of California, Los Angeles; Roy Flukinger and Linda Myers, Harry Ransom Research Center, University of Texas, Austin; William Frank, Alan Jutzi, Jennifer Watts, David S. Zeidberg, the Huntington Library, San Marino, California; Jennifer Fukunaga, Chino Branch Library, Chino, California; Genie Orcutt Geer, Santa

Paula Historical Society; Tom Gilbert and Kelli Souder, Time-Life Picture Service, New York City; Jann Glissen, Corbis, Bellingham, Washington; Maria M. Gonzalez, Guasti Plaza, Guasti, California; Campbell Gray and Rachel Hoover, Museum of Art, Brigham Young University, Provo, Utah; Lynn Housouer, Pioneers' Museum, Imperial County Historical Society, Imperial, California; Marc Grossman, United Farm Workers of America, Keene, California; Al Guilin, Limoneira Company, Santa Paula, California; Bruce Guter, David Streeter, and Susan Hutchinson, Pomona Public Library Special Collections; Dorothy Haase, Fillmore Historical Society, Fillmore, California; Alfred Harrison, North Point Gallery, San Francisco; Michael J. Hart, Sunny Slope Water Company, Pasadena, California; Pat Havens, Simi Valley Historical Society, Simi Valley, California; Hearst Publishing Company, San Francisco; Maria Henle, the Fritz Henle Collection, Saint Croix, U.S. Virgin Islands; Matt Herron, Take Stock, San Rafael, California; Melissa Heyman, Campbell Historical Museum, Campbell, California; Dolores Higueras, Museo Naval, Madrid, Spain; James D. Hofer, University of Redlands Archives, Redlands, California; Raymond Hoffman, Pajaro Valley Historical Association, Watsonville, California; J. Horner, Nipomo Public Library, Nipomo, California; Donald F. Houghton, Saint Helena, California; Pat Jacobsen, Millennium Fruit Crate Label Collection, Weimar, California; Robin Inglis, Instituto de Historia del Pacífico Español, Vancouver, British Columbia; Steve Iverson, Rancho Los Cerritos Historic Site, Long Beach, California; K. J. Iwagaki, Japanese American Resource Center/Museum, San Jose, California; Charles Johnson, Ventura County Museum, Ventura, California; Drew Johnson, Charles Lokey, Joyce Minick, Bill Mc-Morris, and Therese Heyman, the Oakland Museum, Dorothea Lange Collection; Stephen Johnson, Stephen Johnson Photography, Pacifica, California; Bill Jones, Special Collections, Meriam Library, California State University, Chico; John K. Kallenberg, William B. Secrest, Fresno County Library, California and Local History Room; Shirley J. Kendall, Bidwell Mansion State Historical Park, Chico, California;

James E. Kern, Vallejo Naval and Historical Museum, Vallejo, California; Cindy Krimmel, San Diego Historical Society; Martha Krueger, Academy of Motion Picture Art, Hollywood, California; Armand J. Labbé, Bowers Museum of Cultural Art, Santa Ana, California; Glory Laffey, Sourisseau Academy, California State University, San Jose, California; Jerome D. Laval, the Claude "Pop" Laval Collection, Fresno, California; Lila Lee, Held-Poage Library, Mendocino County Historical Society, Ukiah, California; Carla Leshne, San Francisco; Peter Leung, University of California, Davis; Emma Lewis, Heritage Centre, Norwich Millennium Library, Great Britain; Dave Lorgang, Yosemite Museum, Yosemite Valley, California; Sandy Lydon, Cabrillo College, Aptos, California; Myra Manfrina, Lompoc Historical Society, Lompoc, California; Brian McGinty, Scottsdale, Arizona; Donald McGue, A. K. Smiley Library, Redlands, California; Leonard McKay, Memorabilia of San Jose, San Jose, California; Andrea Morris Metz and Sarah Lim, Merced County Historical Society, Merced, California; Archie Miyatake, Pasadena, California; Lynette Miller, Washington State Historical Society, Tacoma, Washington; Vincent Moses and Marvin Powell, Riverside Municipal Museum; John Mraz, Universidad Autónoma de Puebla, Mexico; Evelyn De Wolfe Nadel, Hollywood, California; Jane K. Newell, Anaheim Public Library, Anaheim, California; Leslie Calmes, Denise Gossé, Dianne Nilsen, Amy Rule, Center for Creative Photography, University of Arizona, Tucson; John Nopel, Chico, California; Kern County Museum; Maria Ortiz, Fresno Historical Society, Fresno; C. C. Keefe-Ostle, Amador-Livermore Valley Historical Society, Pleasanton, California; Breck Parkman, Fort Ross State Park, California; Rondal Partridge, Berkeley, California; Jim Pimentel, *San Francisco Examiner*; David Piff, National Archives, Pacific Region, San Bruno, California; Michael Redman, Santa Barbara Historical Society; Paul Richards, Harvey Richards Collection and Estuary Press, Oakland, California; Charles L. Sawyer, Ralph Milliken Museum, Los Banos, California; Michael Shulman, Magnum Photos, New York City; Steve Simmons, Steve Simmons Photography, Sacramento,

California; John Skarstad, Special Collections and Archives, University of California, Davis; Susan Snyder, the Bancroft Library, University of California, Berkeley; Edward Spalding, Fillmore Historical Society, Fillmore, California; Julie Stark, Community Memorial Museum of Sutter County, Yuba City, California; Elizabeth Steward, San Jose Historical Museum, San Jose, California; Kathleen A. Strauss and Don W. Wilson, Dwight D. Eisenhower Library, Abilene, Kansas; Carmen Bambach-Street, Metropolitan Museum of Art; David Streeter, Pomona Public Library, Pomona, California; Arne Svenson, Arne Svenson Photography, New York City; Marcicarmen Ruiz-Torres, Ontario Museum of History and Art, Ontario, California; Marilyn Thompson, Yolo County Archives/Records Center, Woodland, California; Robert Thurber, Miami, Florida; Dace Taube, TICOR Collection, University of Southern California; Genevieve Troka, California State Archives; Rona Tuccillo, Getty Images, Seattle; Juanita de Valentine, Wheatland Historical Society, Wheatland, California; Crissa Van Vleck, Brendon Williams, California Historical Society, San Francisco.

For permission to use previously published material, I thank the publishers of *American Heritage*, *American History Illustrated*, *California History*, the *Chronicle of Higher Education*, *History of Photography*, *Journal of the West*, *Labor History*, *Pacific Historical Review*, and *Southern California Quarterly*. For permission to publish the work of Ansel Adams, I thank Claudia Kishler and the trustees of the Ansel Adams Publishing Rights Trust.

The abbreviation "ph." is used to mean "photograph(s) of."

Index of Photographers